INSPIRING FAMILY HOMES

FAMILY-FRIENDLY INTERIORS & DESIGN

gestalten

MilK
MAGAZINE

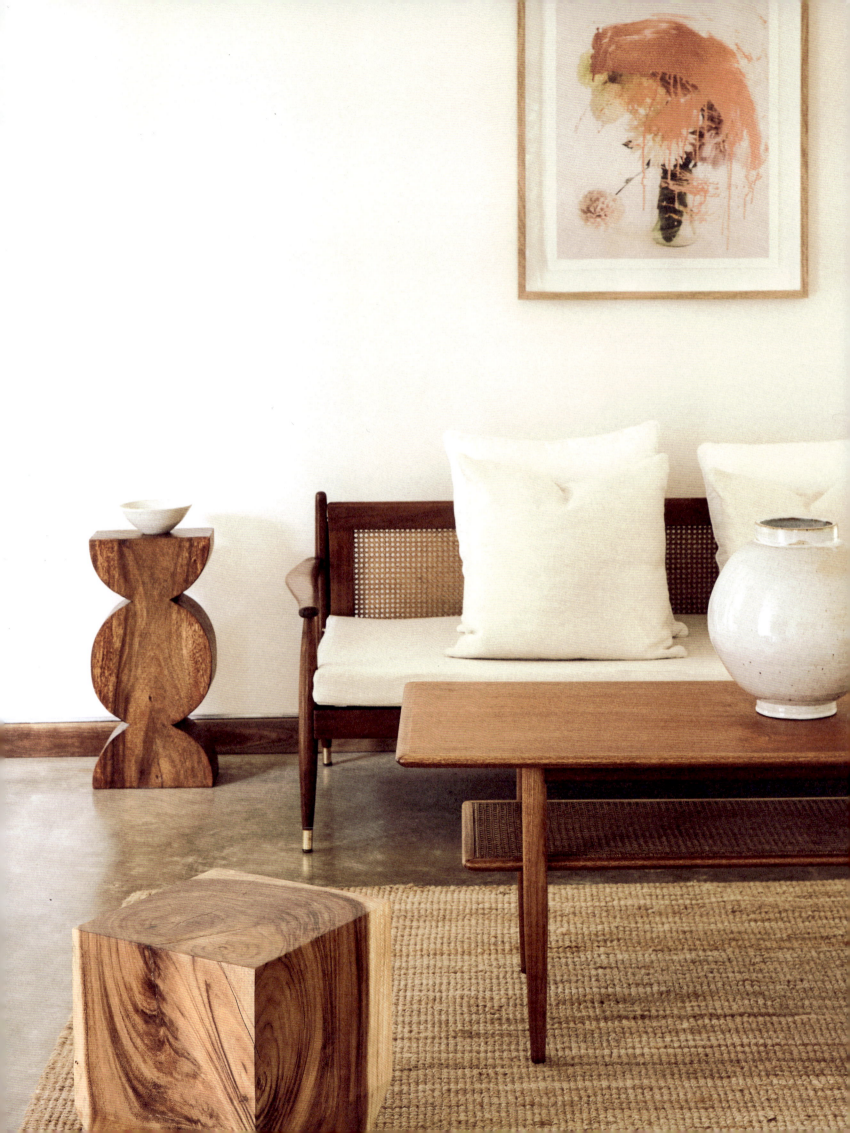

4-5
PREFACE
ISIS-COLOMBE COMBRÉAS
MILK

6-7
INTRO
MILK X GESTALTEN

8-17
**BERLIN
GERMANY**
APARTMENT

18-27
**PARIS
FRANCE**
LOFT

28-37
**BRUSSELS SUBURBS
BELGIUM**
BUNGALOW

38-49
**LONDON
UK**
FACTORY

50-59
**NORMANDY
FRANCE**
FARMHOUSE

60-69
**STOCKHOLM
SWEDEN**
APARTMENT

70-79
**NIIGATA AREA
JAPAN**
HOUSE

80-87
**MILAN
ITALY**
APARTMENT

88-97
**VENDÉE
FRANCE**
HOUSE

98-105
**PARIS
FRANCE**
APARTMENT

106-115
**UMEÅ
SWEDEN**
COTTAGE

116-125
**NUENEN AREA
NETHERLANDS**
FARMHOUSE

126-133
**MILAN
ITALY**
APARTMENT

134-141
**BARBIZON
FRANCE**
HOUSE

142-151
**PARIS
FRANCE**
APARTMENT

152-161
**GHENT
BELGIUM**
CHAPEL

162-171
**VAUCLUSE
FRANCE**
HOUSE

172-179
**TORONTO
CANADA**
HOUSE

180-187
**NYC, BROOKLYN
USA**
APARTMENT

188-195
**VALLDOREIX
SPAIN**
HOUSE

196-203
**BIARRITZ
FRANCE**
CABIN

204-213
**VEXIN
FRANCE**
BARN

214-223
**THE HAGUE
NETHERLANDS**
HOUSE

224-231
**CORSICA
FRANCE**
REFUGE

232-241
**ALMERE
NETHERLANDS**
BUNGALOW

242-251
**BYRON BAY
AUSTRALIA**
HOUSE

252-253
INDEX

255
CREDITS

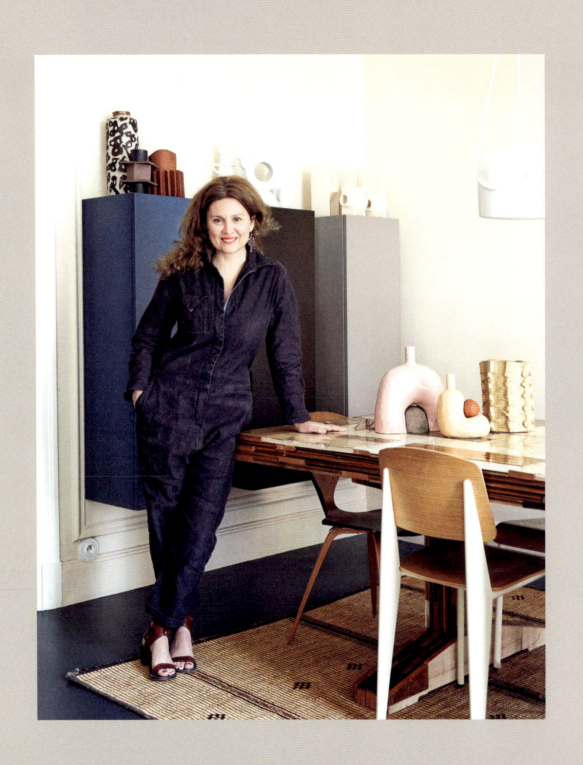

PREFACE

Since *MilK* launched in 2003, family has been at the heart of the magazine. When the idea for the publication first came to me, I was surrounded by loved ones, including my husband, Karel Balas, while the birth of our two young children provided another incredible source of inspiration.

Year after year, we've sought to capture the spirit of the times in the pages of our magazine—all through the lens of striking images and a deep appreciation for bold imagery. We've captured the zeitgeist through fashion, lifestyle, social issues, travel… always with one guiding principle: to give you a taste of the times. But most importantly, it has been our exploration of modern families that has shaped the history of *MilK*. In this aesthetic adventure, my team and I had the privilege of discovering, photographing, and deciphering the interiors of the most inspiring modern family homes. Through the years we've compiled a gallery of vivid and distinctive portraits of people who make their interiors a place to express their creativity, their personality, and their *art de vivre*. These portraits were not staged, but rather, in highly personal interpretations, these interior enthusiasts became the curators of their own decor.

Whether in Berlin, Brooklyn, Normandy, Japan, or the Netherlands, this compilation offers readers a distillation of our various adventures over the years. From the living room to the kitchen, from the parents' bedroom to the nursery, the distinct zones of the home begin to merge, and the worlds of the young and the old fuse and blur. From one continent to another, from family to family, influences of the most incredible variety make an appearance: whether collector, bargain hunter, minimalist, or nostalgic, everyone embodies their own unique brand of style—at *MilK*, we prize each and every one.

This book gathers into one volume the most emblematic and unique stories of the past 18 years and allows us an intimate look at this new generation of parents. These families, made up of aesthetes and hedonists, are part of the community of taste that we have built over time. With a keen eye, we have captured snapshots of daily life and established a unique visual dialogue with families who live in style, both in France and abroad. By allowing you to rediscover these intimate journeys, *MilK* hopes to amaze you, but above all, to give you the keys to a world well within reach so that you, in turn, can imagine your own inspiring interiors for your children and yourself.

Flip through, enter, look around: you are home now.

Isis-Colombe Combréas
MilK, Founder & Editorial Director

FAMILY HOMES, THE NEW SANCTUARIES

"Stay home, stay safe": this is probably the mantra you've heard the most as Covid-19 spread across the globe, imposing lockdowns and requiring us to retreat to our homes. An abrupt interruption, the virus has given us a chance to collectively reassess our priorities and led to unexpected shifts in perception—from realizing that traveling less wasn't such a bad thing, to discovering new forms of quality family time or enjoying shopping locally. Our personal beliefs and family habits have been profoundly shaken, leading to one underestimated consideration: the importance of home.

While our living spaces have transitioned to the new digital era, the health crisis has required us to add further functions and purposes to our dwellings, where many daily activities now happen simultaneously, blurring the lines between rest, work, study, exercise, and entertainment. Houses and apartments have turned into multipurpose spaces where all members of the family converge, fusing routines and bringing children and parents closer both physically and emotionally. This cultural shift has converted our interiors into safe sanctuaries: refuges to comfort and inspire us.

Since 2003, societal evolutions such as these have been documented through the sharp lens of acclaimed French magazines *MilK* and *MilK Decoration*, with their go-to platform becoming a household name in the international landscape of family living. By collecting refreshing portraits of unique family interiors from around the globe, *MilK* has proven that living with kids doesn't mean relinquishing living in style. It has demonstrated that there are many creative ways of sharing an aesthetic family space and no single, ready-made formula to compose stylish, mind-expanding, kid-friendly interiors. Over the past two decades, Isis-Colombe Combréas and Karel Balas (founders of both *MilK* magazines) have been injecting a constant dose of highly desirable, contemporary inspiration into their two publications, which are now considered leading authorities in the family lifestyle and decoration sector.

The diverse domestic worlds showcased in this book encapsulate *MilK*'s DNA and remind us that whatever the location, size, or shape of our homes, what's important is the way we surround ourselves with objects and interior design narratives that boost our mental and physical well-being. More than ever, we are the architects of our own happiness—and family might just be the most precious medicine of all.

WHERE	WHO	WHAT
BERLIN GERMANY	ANNA, FLORIAN, LEO, CARLO, ROSIE	OPEN PLAN APARTMENT

A calm family nest in the heart of bustling Berlin

German photographer Anna Cor, husband Florian, their three children, Leo (14), Carlo (12), and Rosie (7), and dog Mimi live in a beautiful 170 m² (1,830 ft²) apartment in the heart of Mitte, the lively creative neighborhood in central Berlin, Germany. The family moved here in 2008, jumping at the opportunity of a bigger space that could accommodate their growing numbers in a popular area close to their former flat where large apartments are scarce. Then in 2013, their dream scenario came true: as the people next door moved out, they were able to join the two residences, transforming the whole layout, knocking walls down, and creating a small yet clever open kitchen.

Located on the fourth floor, the apartment is now bright and spacious enough for each child to have their own room and Anna her own work space. Another modular and multipurpose room also acts as a passageway that can be closed off by a sliding door and a metal door. "*Most of the space really is open plan as we have no hallway, which is very unusual in Germany,*" explains Anna.

"*I love that because it reminds me of New York dwellings and a summer I spent there. There's this main kitchen-dining-lounge area where we hang out, enjoy quality time together, and receive our friends, so that's a perfect volume and yet each one of us has our own space that we can retreat to when in need of a moment of peace and quiet.*"

The interior design favors sober, subdued hues that create a calm and comfortable cocoon—living in an effervescent city like Berlin for more than 20 years has taught Anna that she needs a tranquil, clean space for her family to unwind in. The furniture is a mix of contemporary and vintage pieces made out of long-lasting, natural materials that will age over time. "*People grow up and age and our home should be able to do so, too,*" she says. "*The time we have spent here is visible: the floor is scratched, the marble tabletop is stained, and the ceramics are cracking—I really like that. I don't want to buy a new dining-room table every five years, I want one that has lived through hundreds of family dinners and inebriated evenings with friends.*"

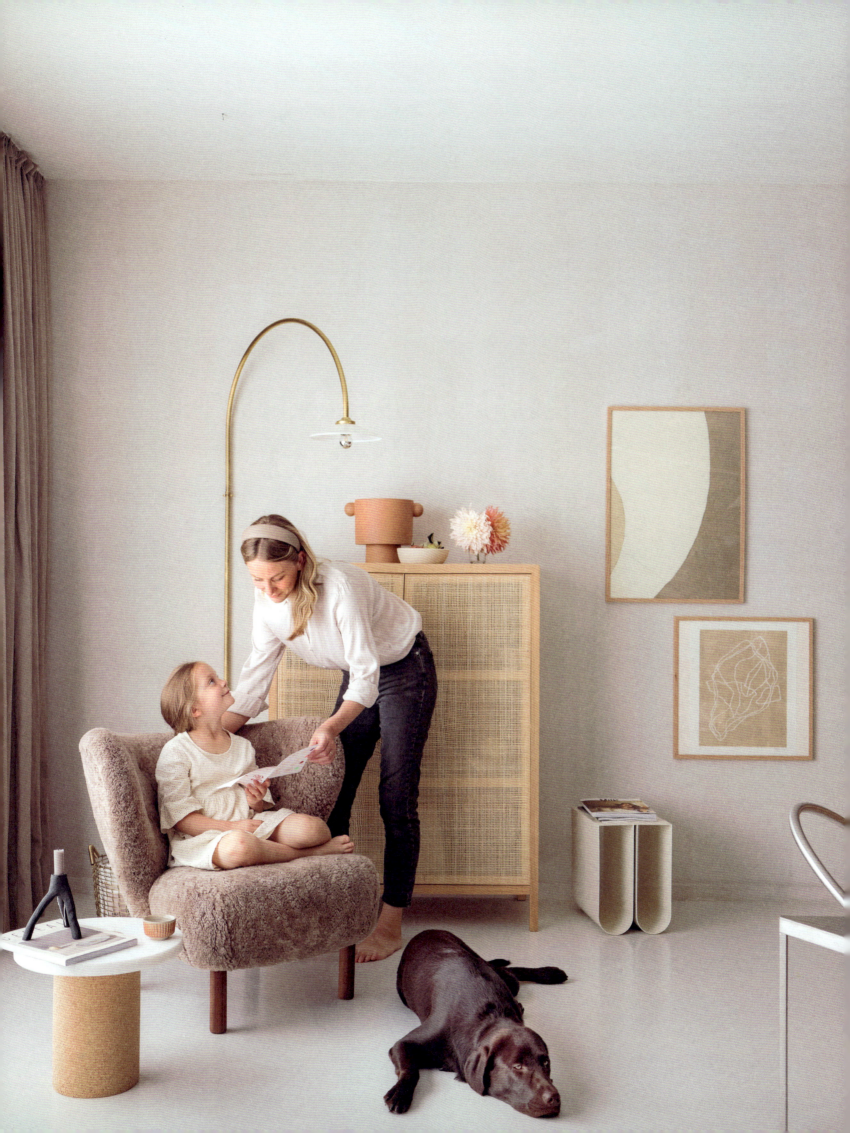

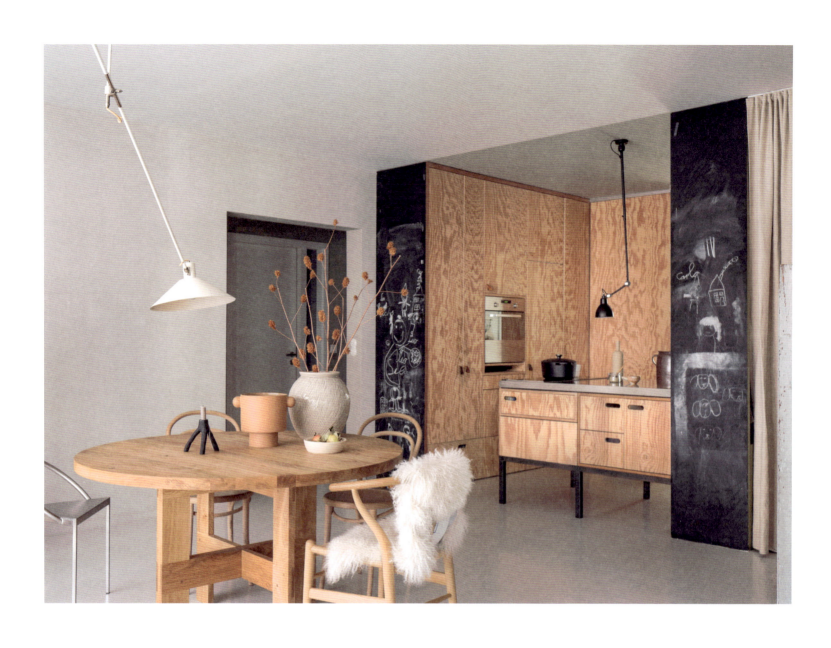

"THERE'S THIS MAIN KITCHEN-DINING-LOUNGE AREA WHERE WE HANG OUT, ENJOY QUALITY TIME TOGETHER, AND RECEIVE OUR FRIENDS, SO THAT'S A PERFECT VOLUME AND YET EACH ONE OF US HAS OUR OWN SPACE THAT WE CAN RETREAT TO WHEN IN NEED OF A MOMENT OF PEACE AND QUIET."

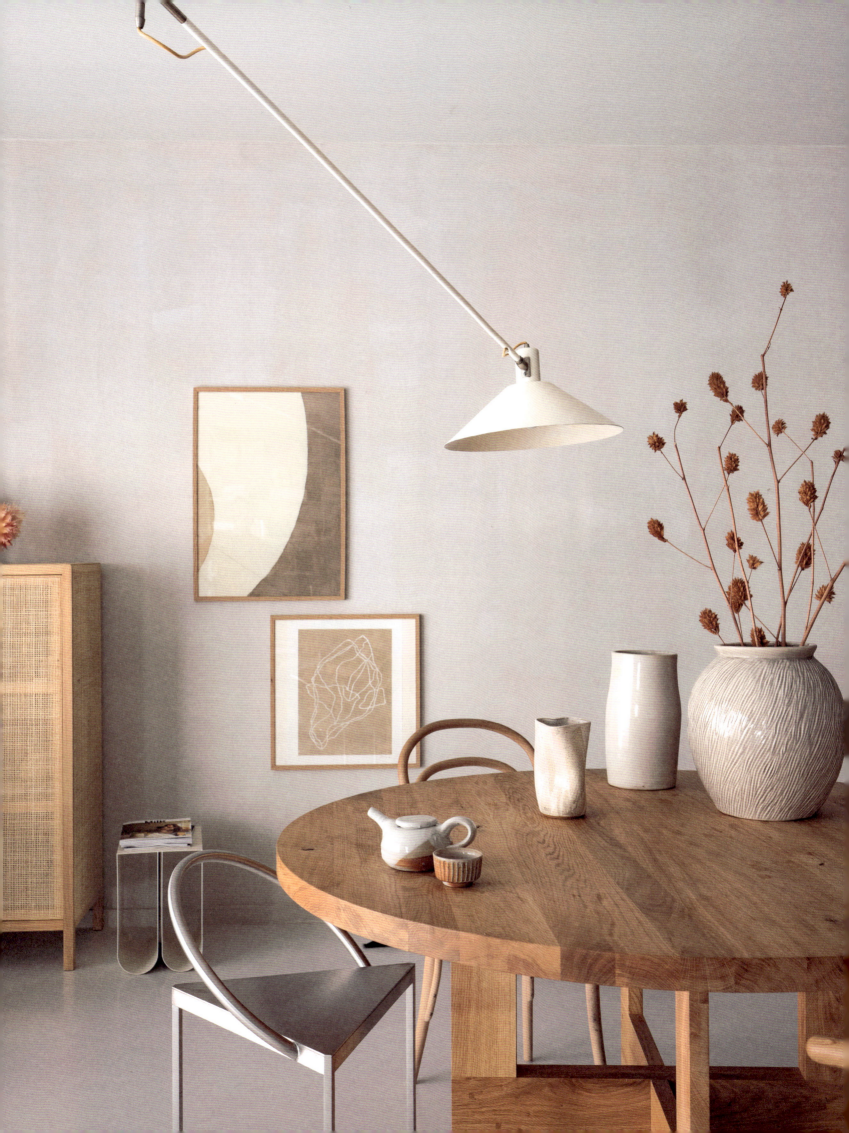

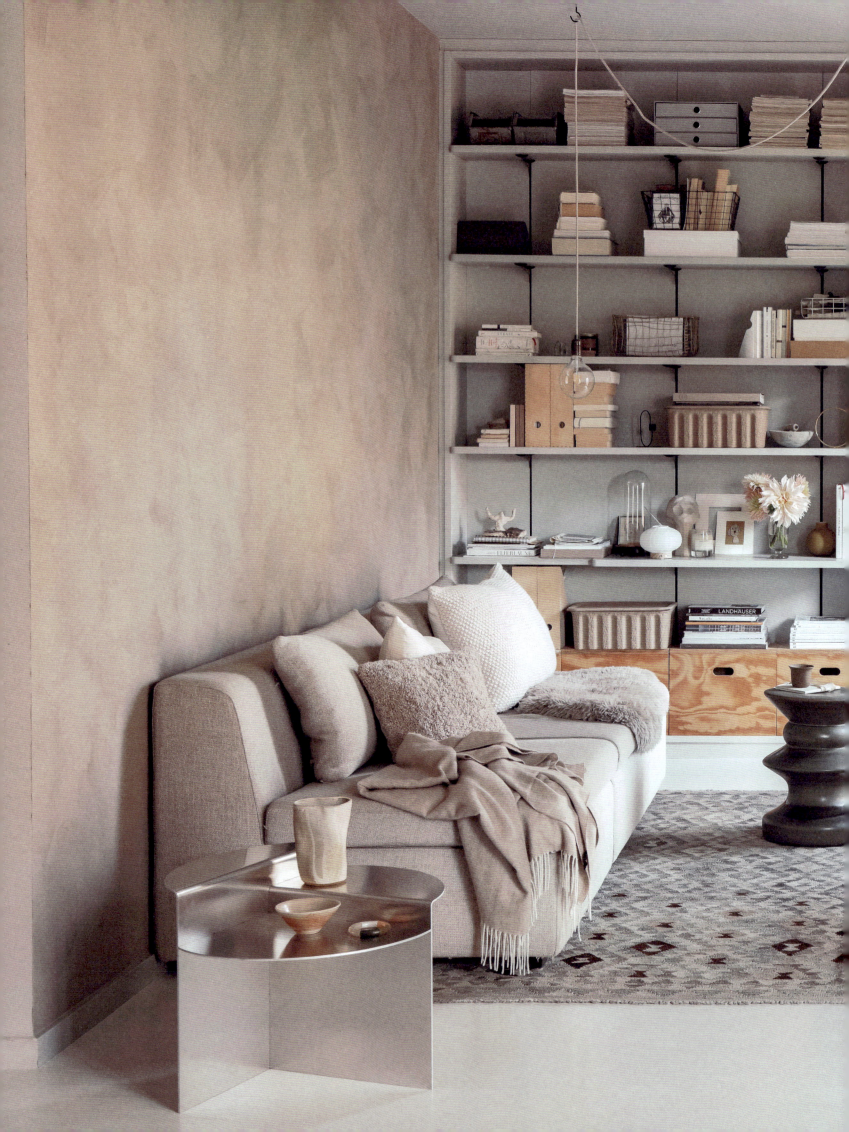

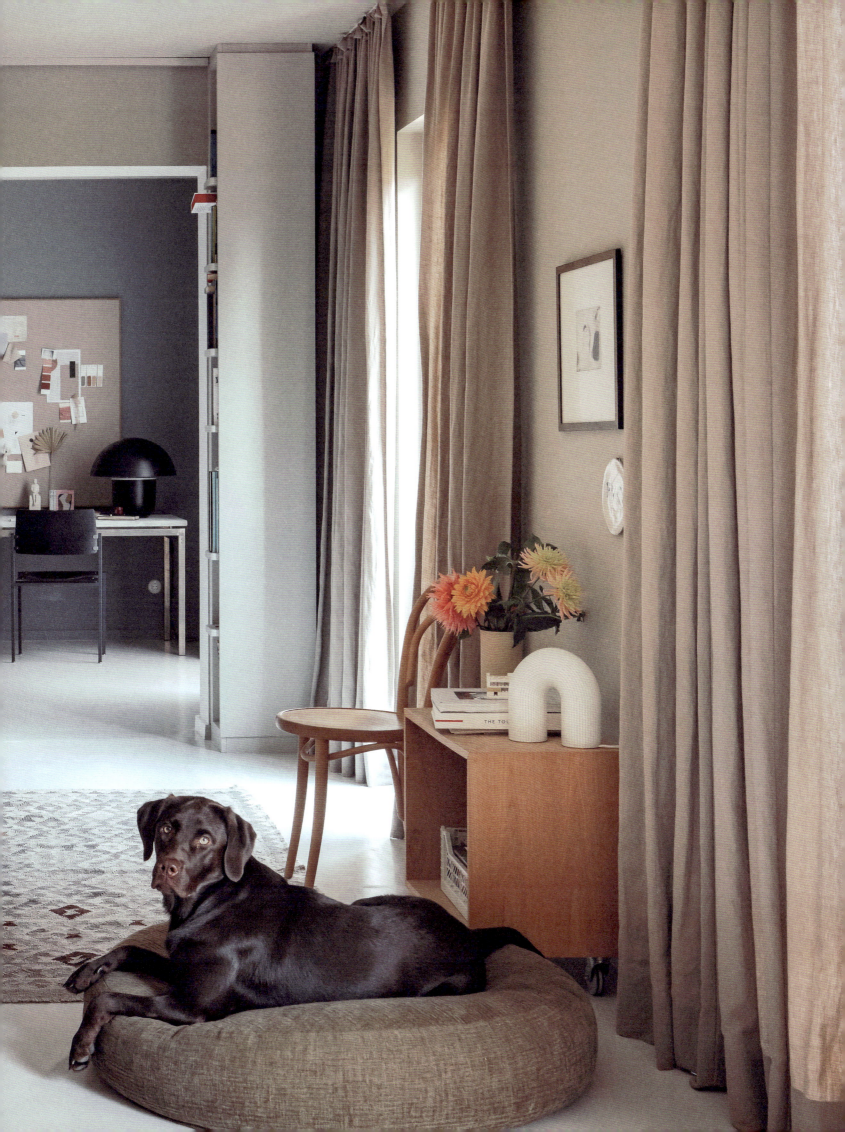

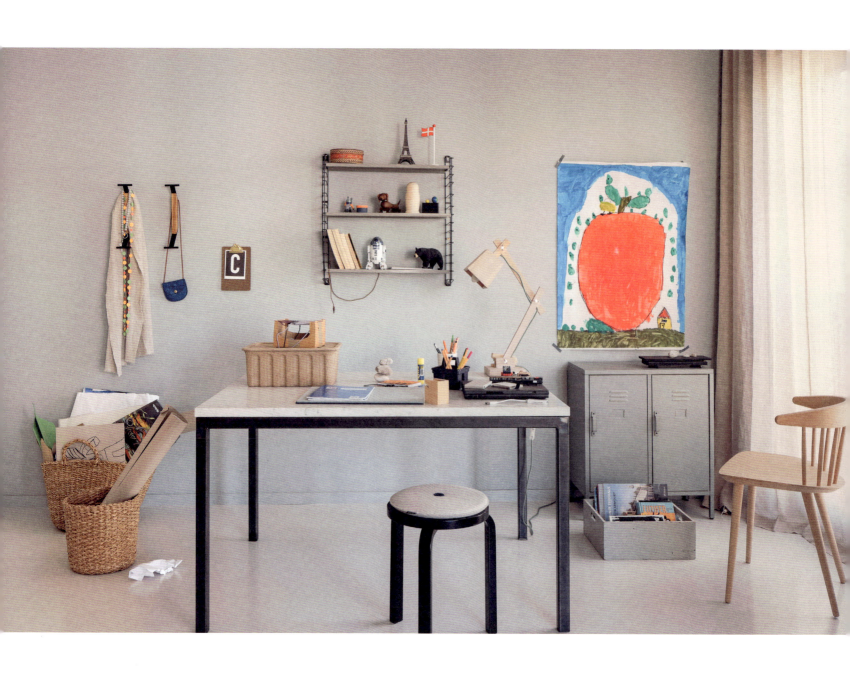

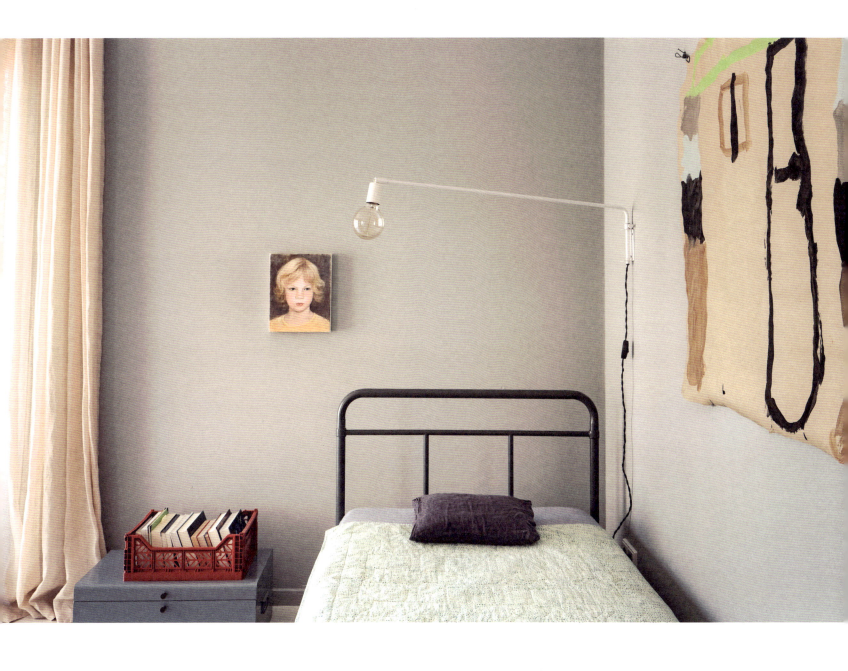

"THE TIME WE HAVE SPENT IN THE KITCHEN-DINING-LOUNGE IS VISIBLE: THE FLOOR IS SCRATCHED, THE MARBLE TABLETOP IS STAINED, AND THE CERAMICS ARE CRACKING—I REALLY LIKE THAT. I DON'T WANT TO BUY A NEW DINING-ROOM TABLE EVERY FIVE YEARS, I WANT ONE THAT HAS LIVED THROUGH HUNDREDS OF FAMILY DINNERS AND INEBRIATED EVENINGS WITH FRIENDS."

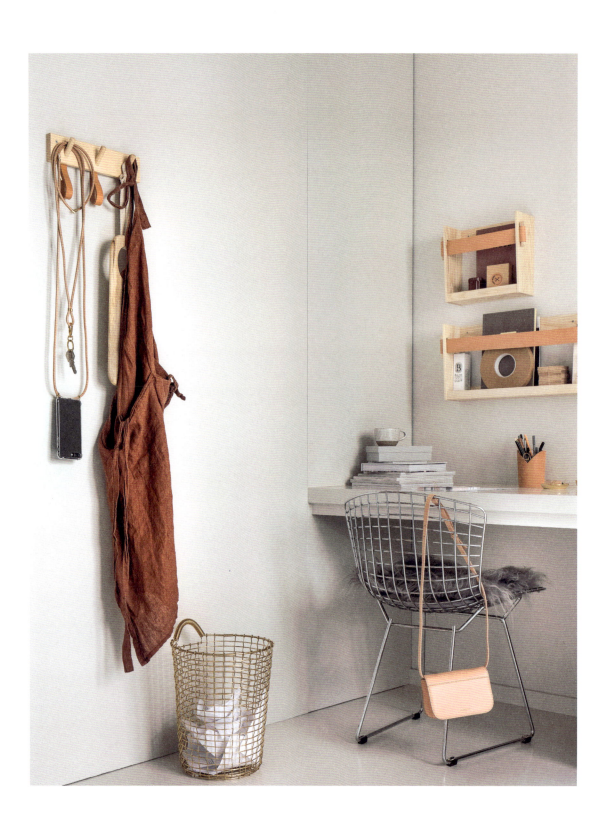

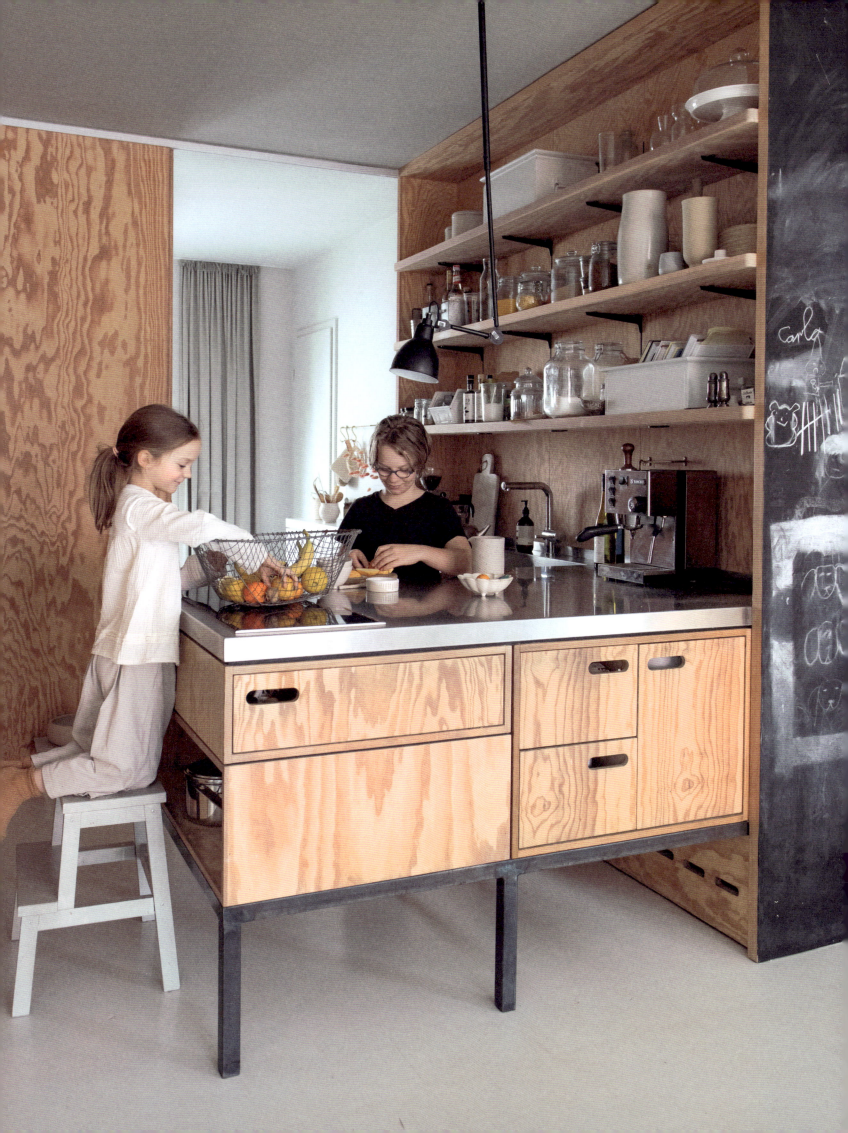

WHERE	WHO	WHAT
PARIS FRANCE	MARIE, GILLES, MARGUERITE, GUSTAVE	WOODEN LOFT

A serene loft full of personality and natural light

When looking at the smooth lines and serene volumes of the Parisian loft of jewelry designer Marie Montaud, with its elegant floor-to-ceiling wood-framed windows opening onto a central open-air patio, it's difficult to believe this place was once a dark warehouse without any openings or any interesting architectural details. Nestled at the end of a typical passageway in the busy 11th arrondissement, the once-sad space has been brilliantly transformed by architect Guillaume Terver, who worked hand in hand with Marie and her husband, Gilles Ballard, to create a quiet home that the couple and their two teenagers could retreat to peacefully and recover from the bustle of the French capital.

"*The challenge was to give life to a site without any past or history,*" says Marie, founder of the delicate jewelry brand Médecine Douce. Very sensitive to soulful things and places, Marie and Gilles decided to emphasize as many of the interesting constructive elements that might be revealed as the space was stripped. These included cut-stone walls in the bedroom, glass tiles in the living room ceiling, and a majestic central wooden pillar, while stacked timber storage boxes found in the warehouse inspired the concept's unifying component—wood.

Structuring proportions and defining scale, pinewood flows through the different volumes of the house—doors and window frames, a staircase or entire wall section—and is ingeniously used to create a striking tailor-made bookshelf that metamorphoses into a sleek, open kitchen. High-end architectural details and a curated selection of designer furniture combine elegantly with the bare cement floor that unifies all the rooms, infusing some placid, sober vibes into the space. The result is a new canvas full of personality, where the family can gather and spend quality time together in the luminous living room or enjoy fresh air in the little garden patio, recharging their batteries and getting inspired.

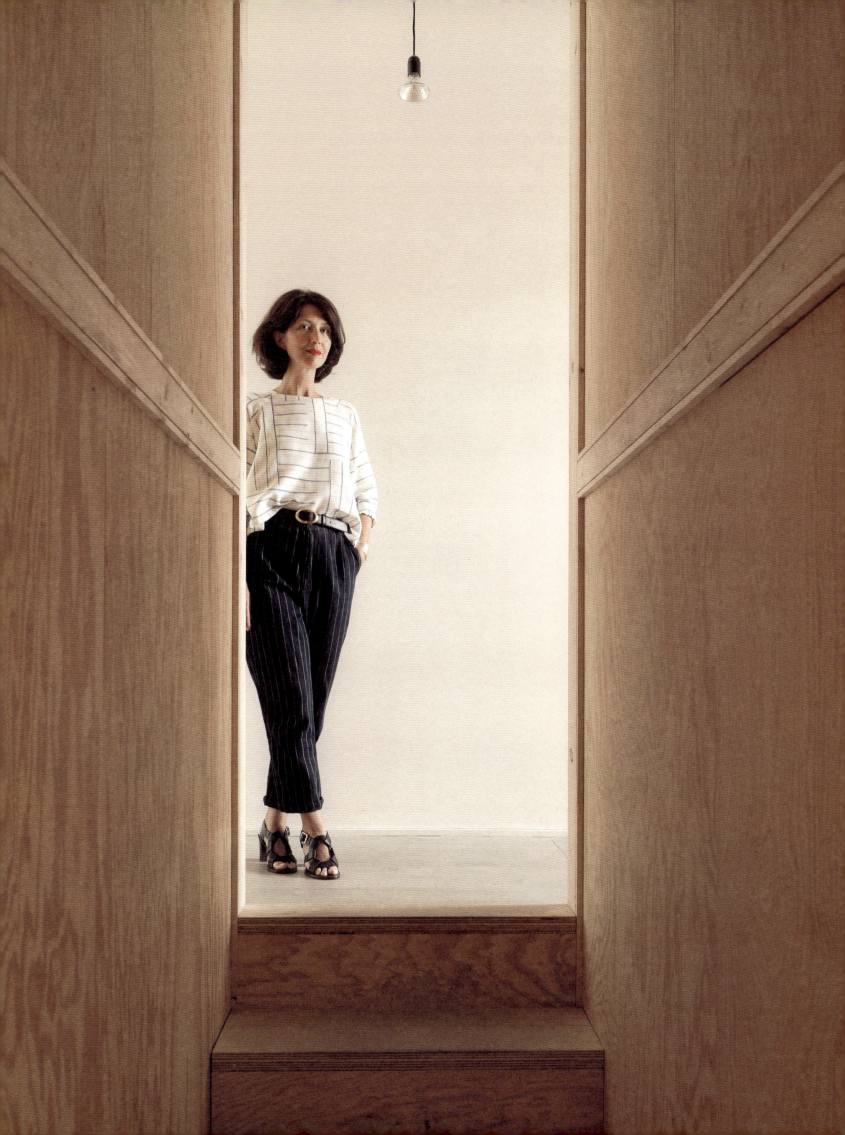

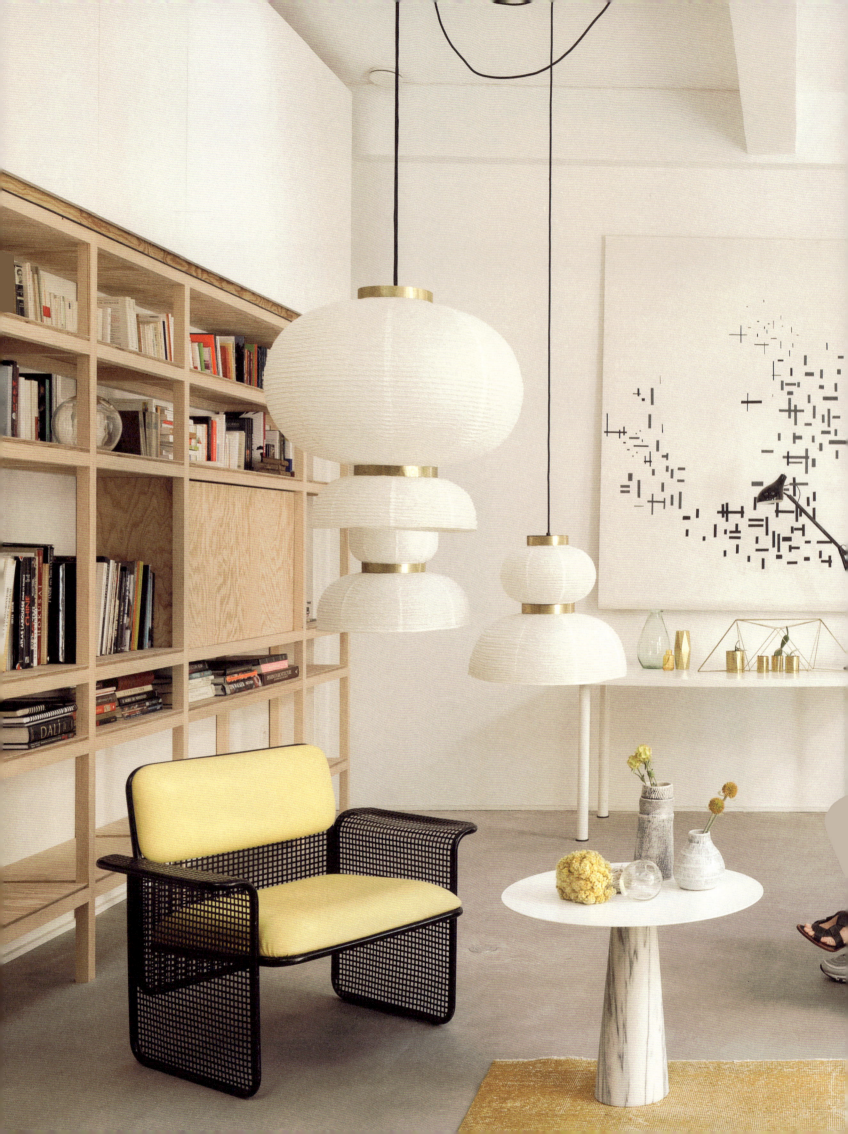

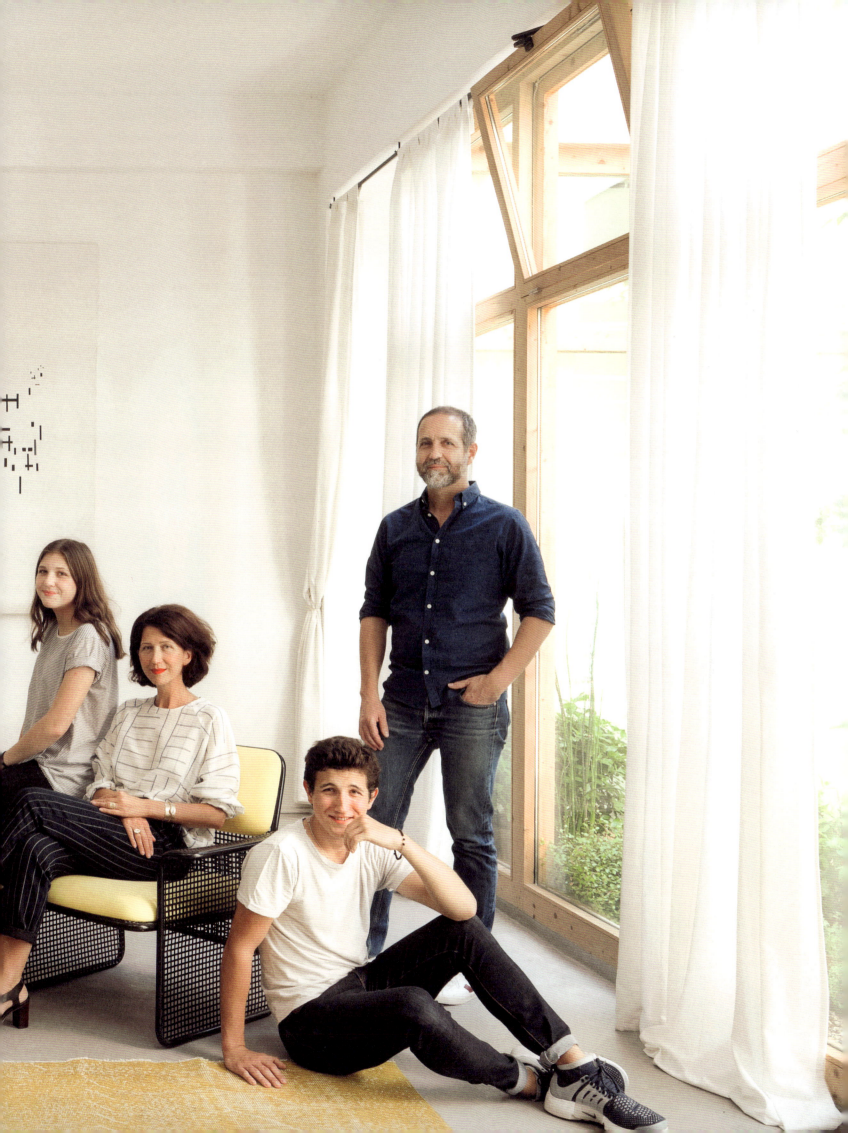

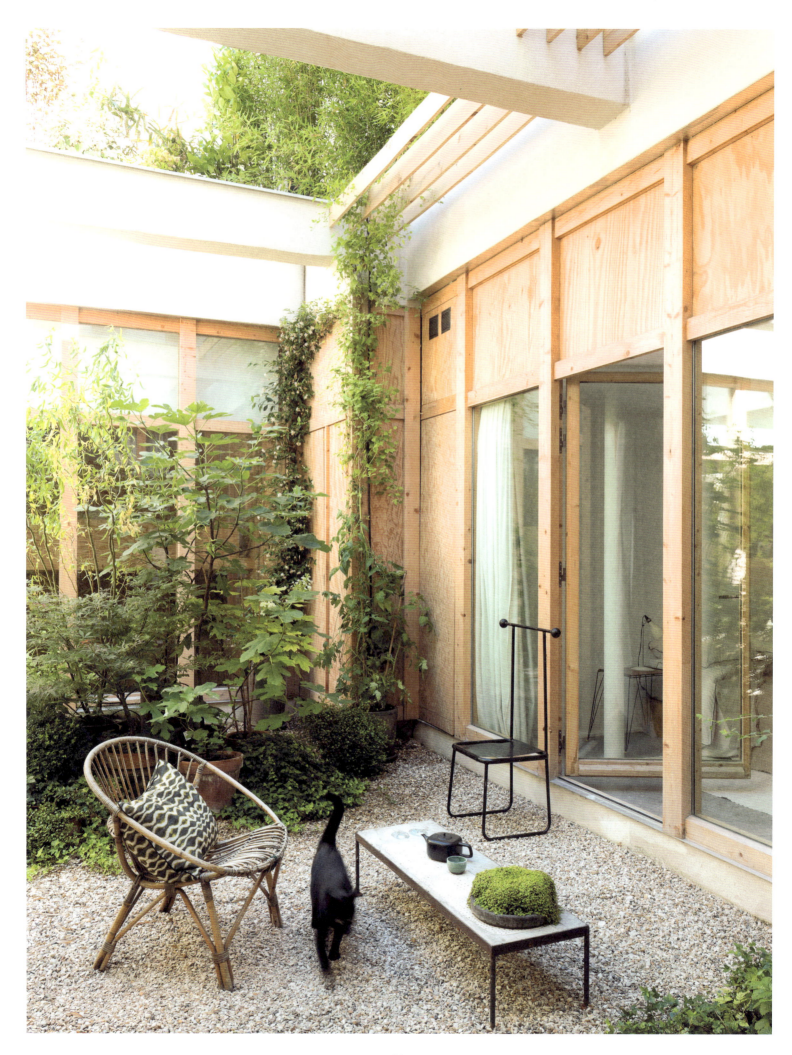

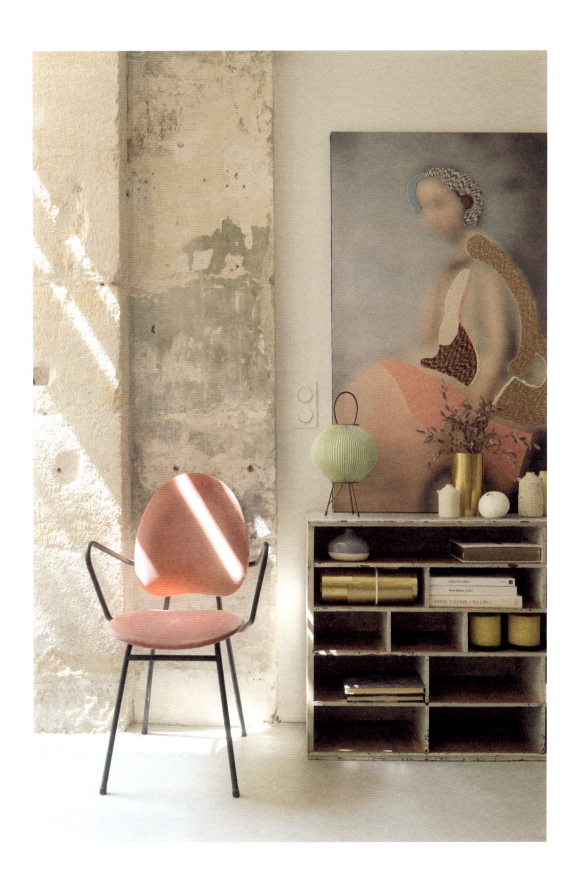

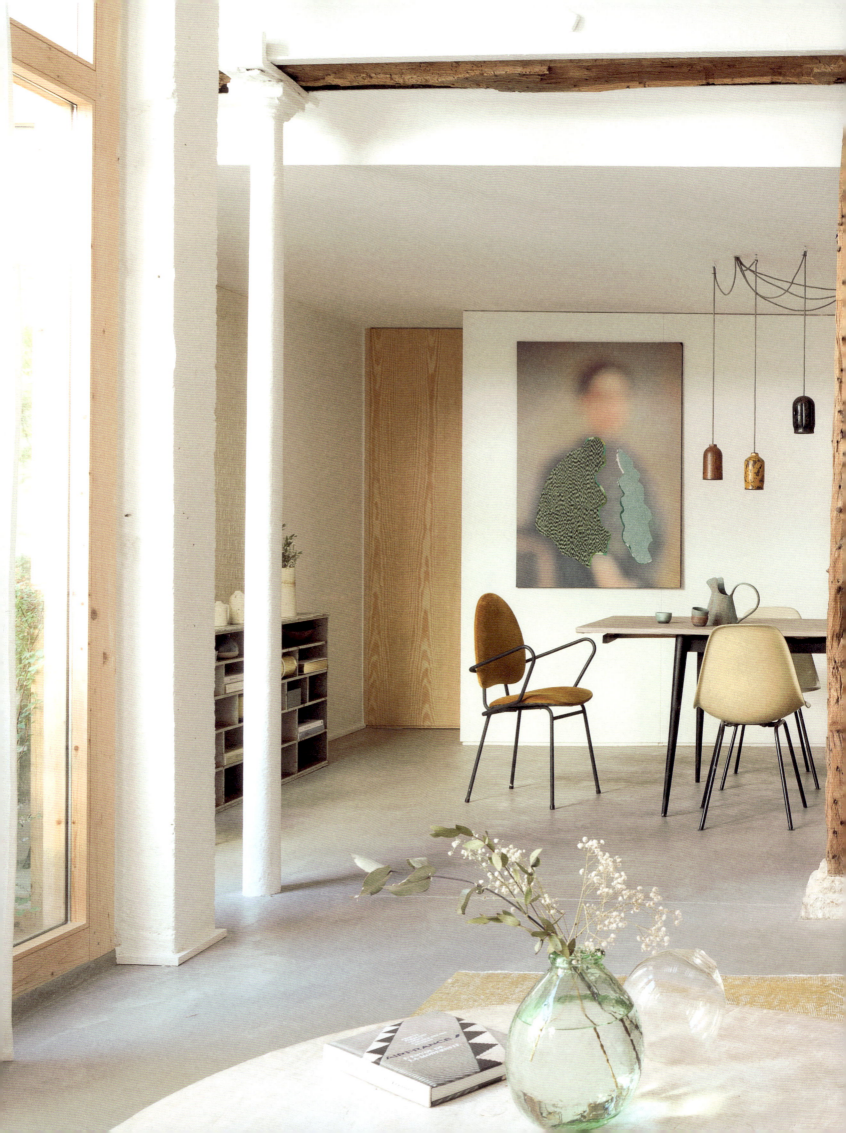

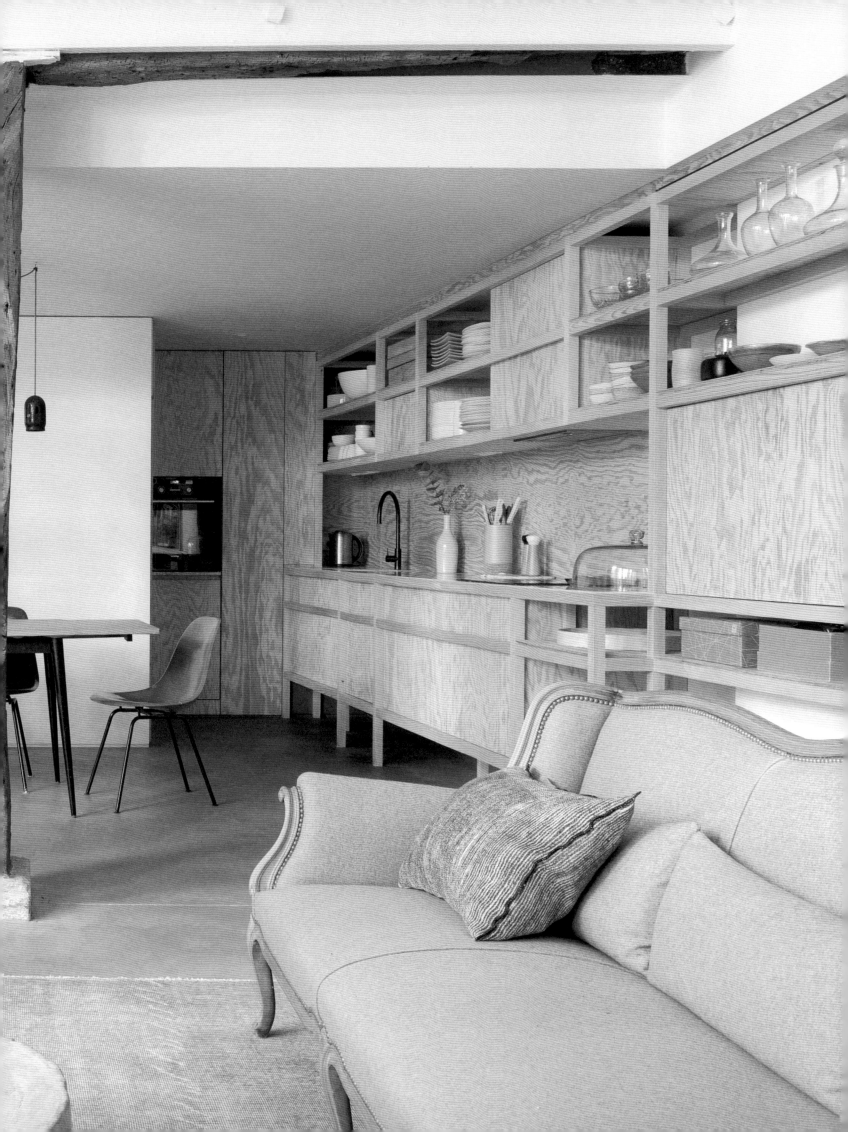

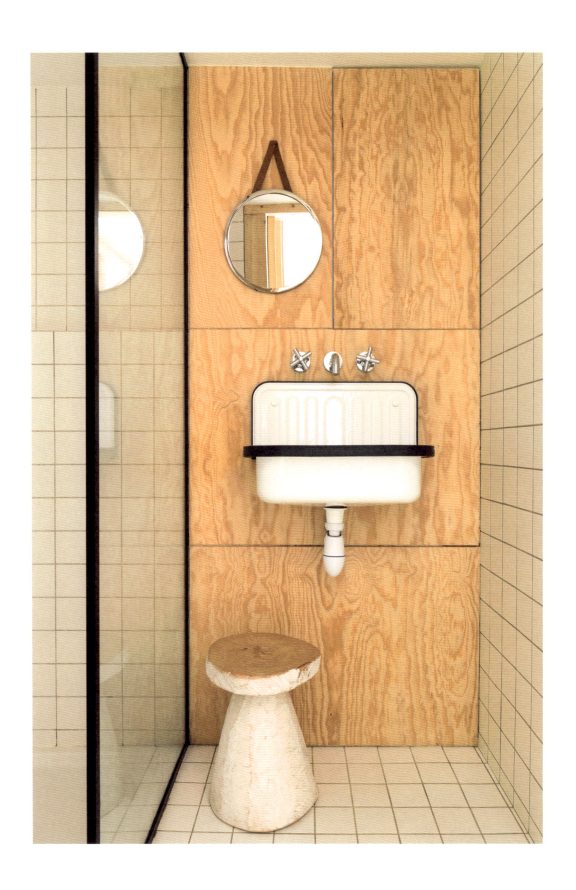

WHERE	WHO	WHAT
BRUSSELS SUBURBS BELGIUM	KATRIEN, OLIVIER, THELMA, MALO, RICHARD	MINIMALIST BUNGALOW

A harmonious bungalow in the middle of the woods

"*We live surrounded by nature so our interior changes along with each new season's light. And I love that the kids' school is just a five minute walk away, through the pine trees,*" says Katrien Vandenberghe, the woman behind the ceramic brand Atelier Ukiyo and mum-of-three: Thelma (9), Malo (7), and Richard (5). Villa Verde is the name of the elegant bungalow she bought with her husband, Olivier, back in 2018. Positioned on a peaceful 4,500 m² (48,438 ft²) tree-filled plot of land in the suburbs of Brussels, the home is an inspiring, minimalist haven where slow-life principles punctuate the family's daily routine.

With the help of an interior designer friend, Katrien's immaculate renovation retained as many of the 1950s glass bungalow's original features as possible, including its charming U-shaped layout, which wraps around a little patio. The house's bone structure was refreshed, two rooms were transformed, and an independent unit was built in the garden to accommodate Katrien's atelier, so that she can work without being far away from her kids.

Adjacent to the new kitchen is an entire wing dedicated to the children. Full of low, soft architectural features and floor-to-ceiling windows that let the natural light pour in, the space encourages their free play and energy flows. On the other side of the patio, the parents' wing hosts a bedroom and bathroom, plus a large multi-use space with a piano and fireplace that make it the perfect spot to hang out or have a family yoga class.

As for decoration, Katrien is pretty instinctive: "*I love uncluttered spaces where serenity prevails, so here I favored natural materials such as wood, stone, and white bricks.*" The house's neutral palette radiates peacefulness with a curated range of textures and objects that convey a warm, unassuming artistic mood. It's an ideal canvas to highlight Katrien's beautiful selection of vintage furniture, including the Hans J. Wegner table that blends in effortlessly with the rest of the space, where both children and adults can play, work, laugh, gather, and chill out together in perfect harmony.

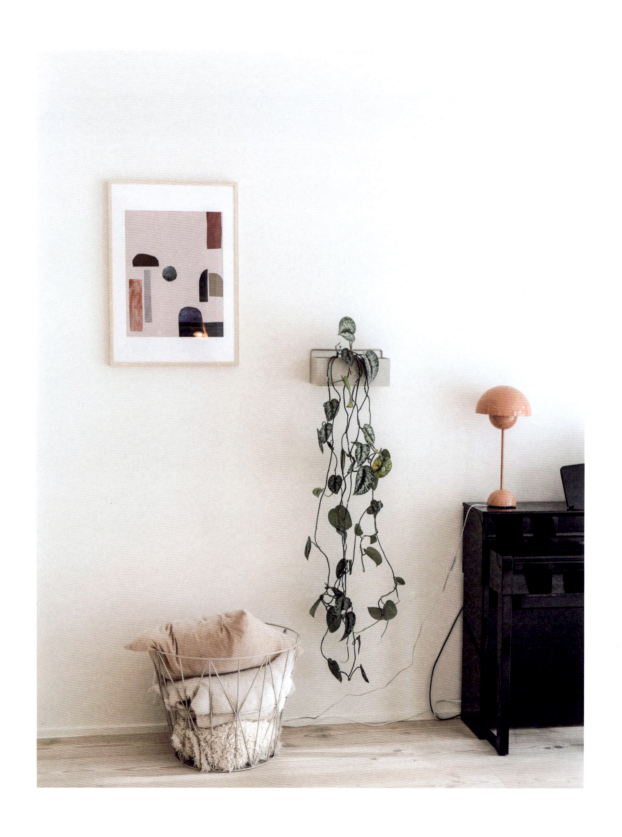

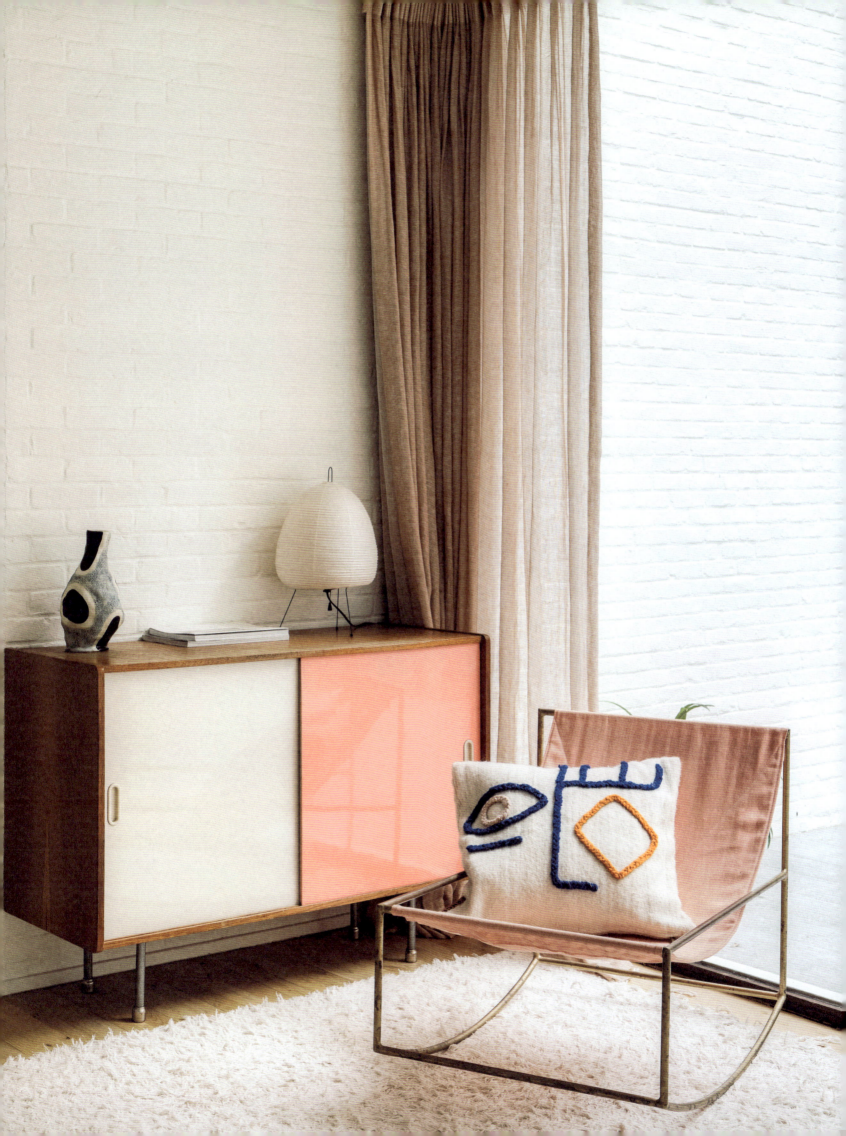

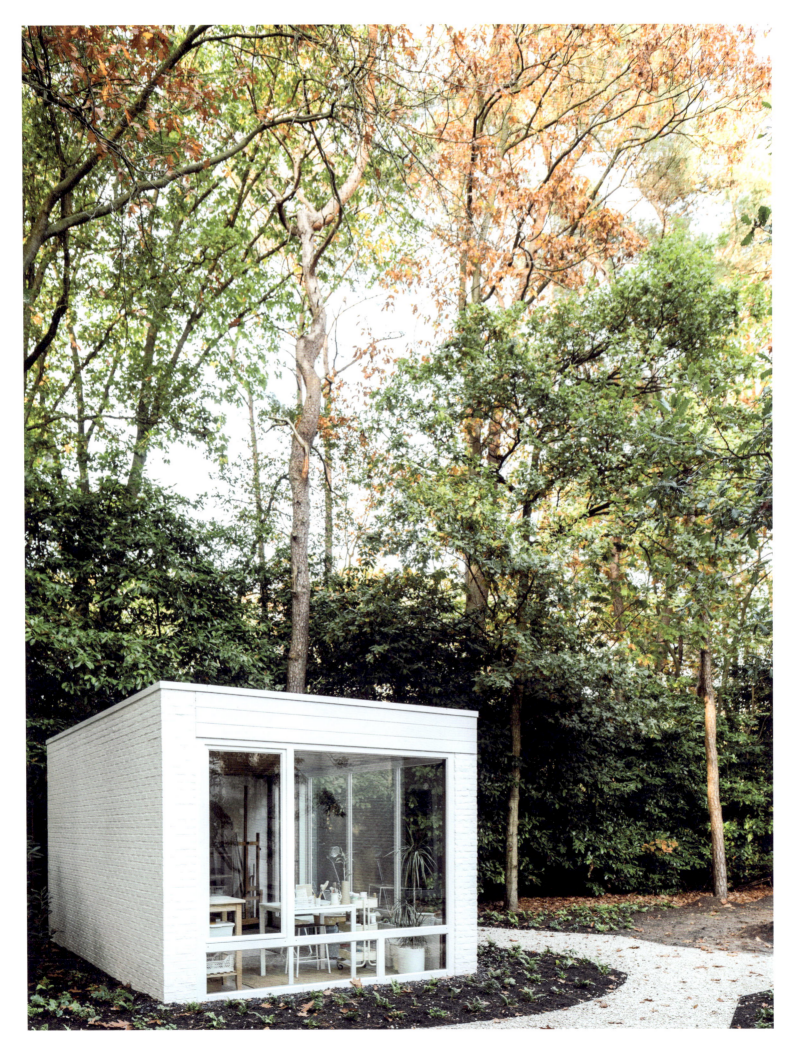

"WE LIVE SURROUNDED BY NATURE SO OUR INTERIOR
CHANGES ALONG WITH EACH NEW SEASON'S LIGHT.
AND I LOVE THAT THE KIDS' SCHOOL IS JUST A FIVE MINUTE
WALK AWAY, THROUGH THE PINE TREES."

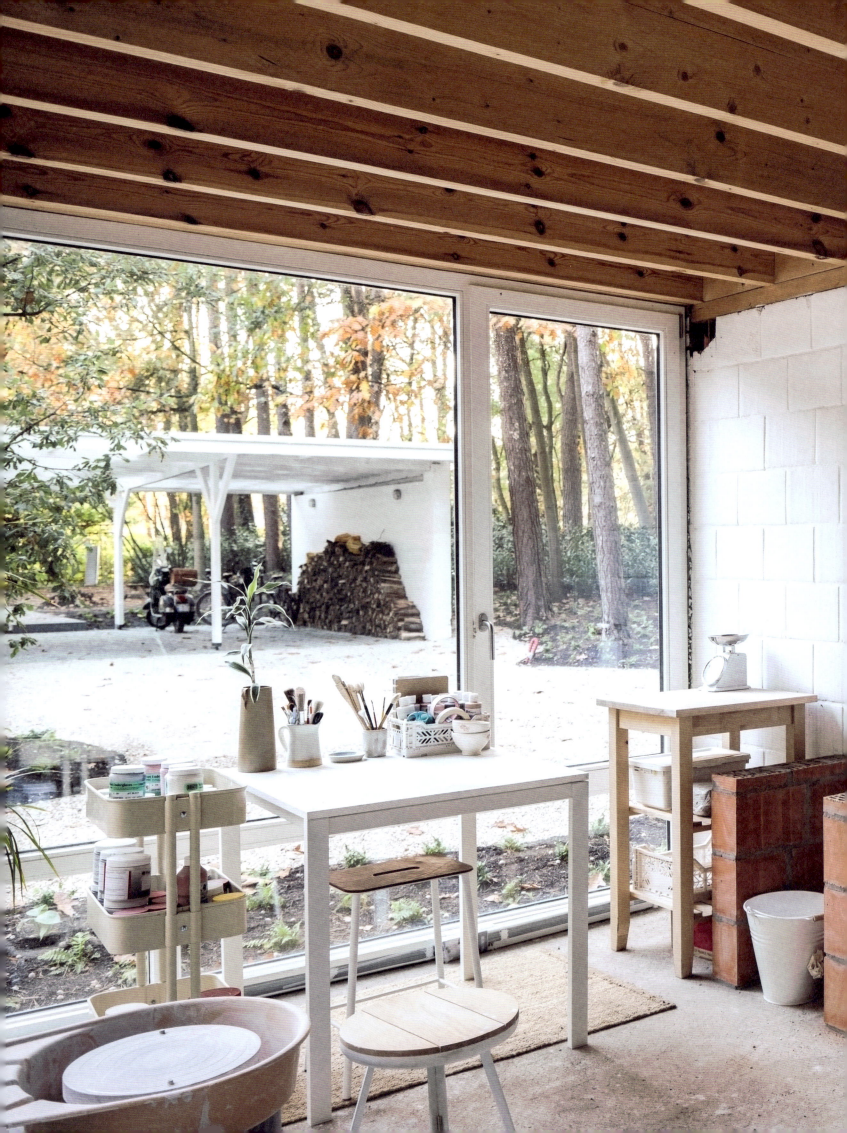

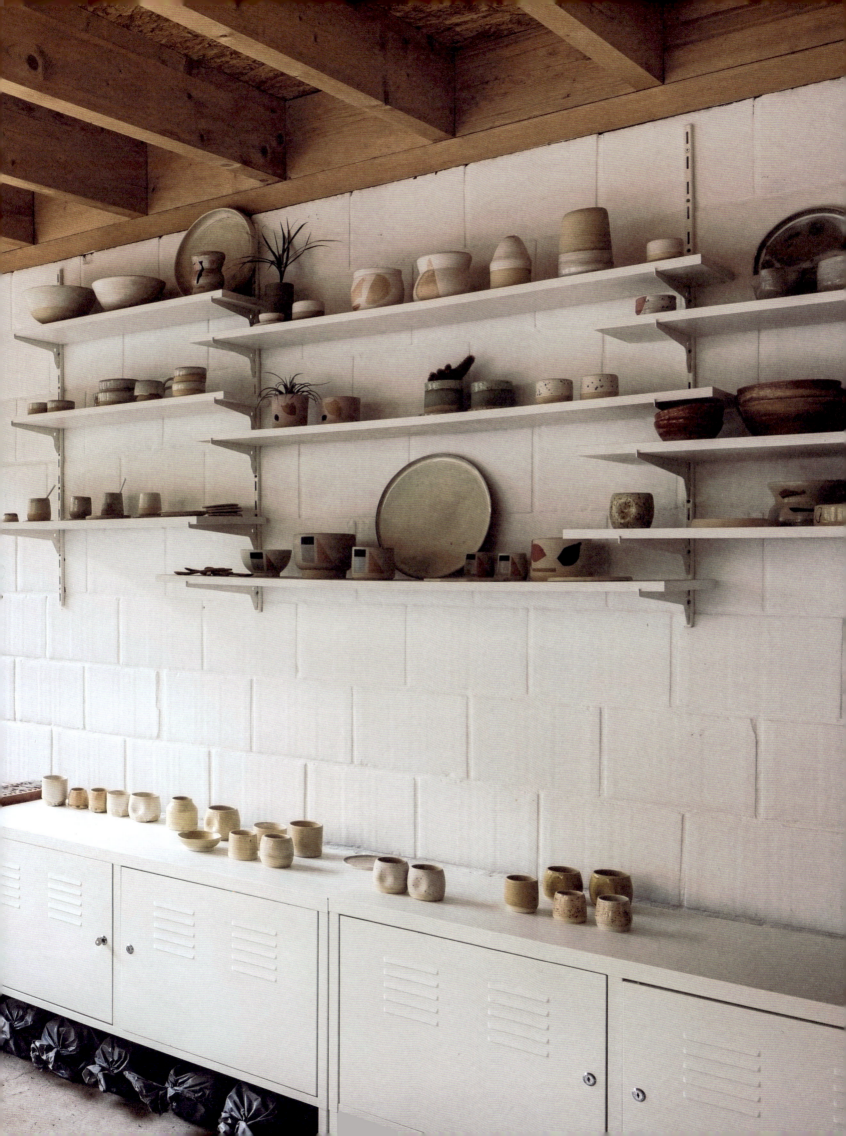

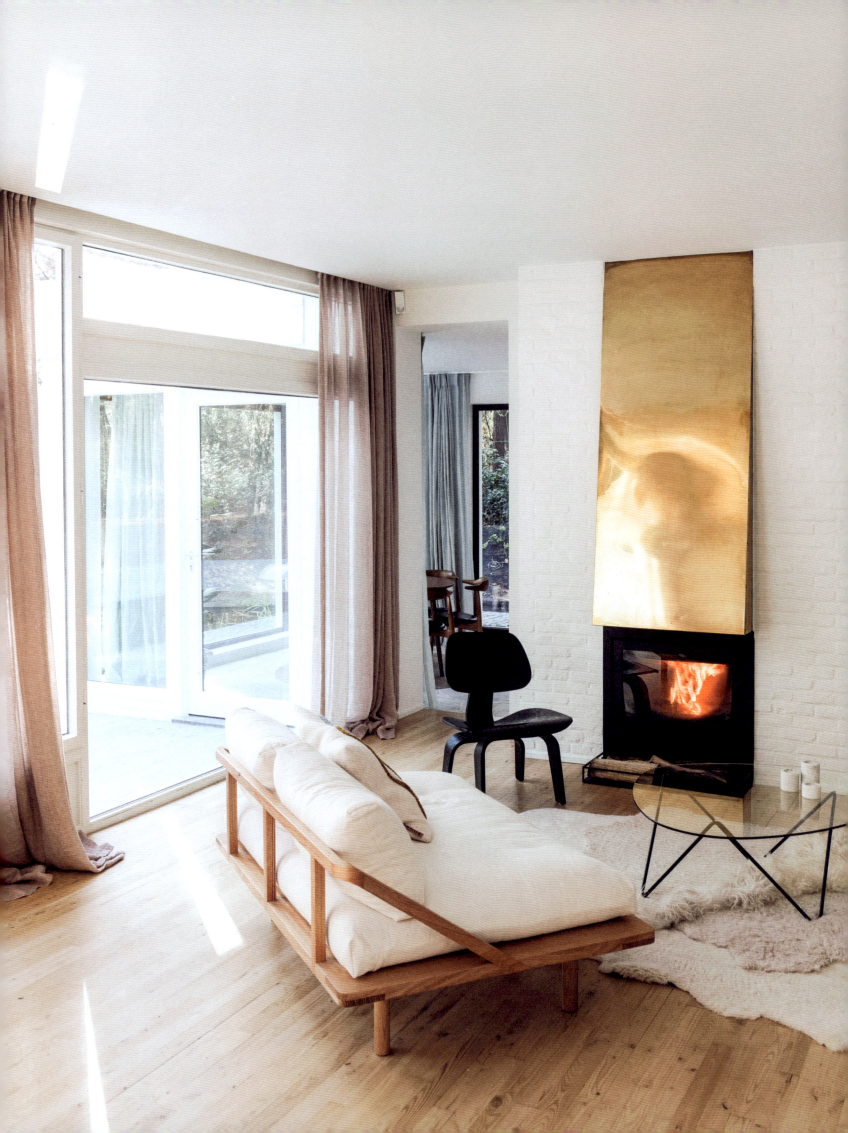

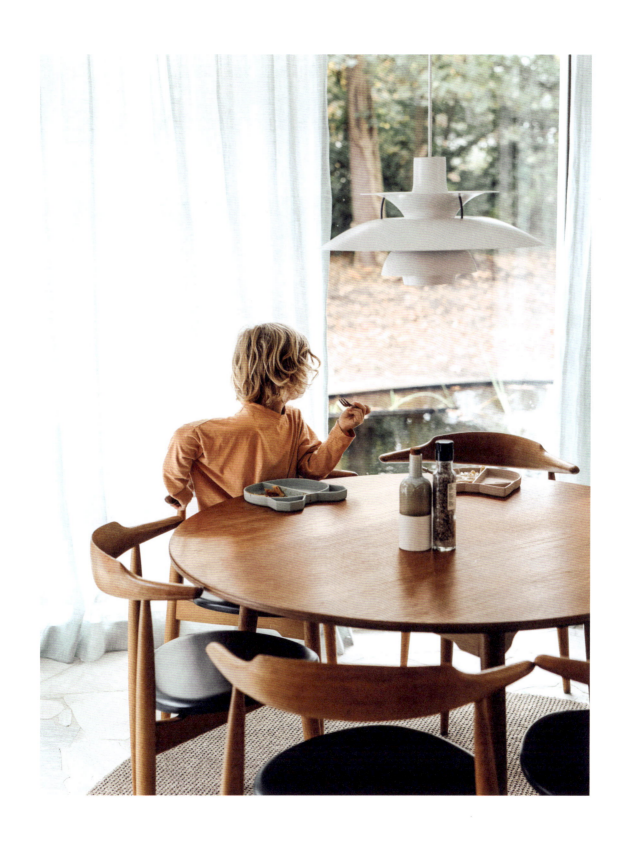

WHERE	WHO	WHAT
LONDON UK	ZOE, MERLIN, MAX, RIVER	CONVERTED FACTORY

An old shoe factory converted into a crisp, contemporary loft

"*We create houses with our minds, our hands, and our souls,*" say architect couple Zoe Chan and Merlin Eayrs. The young duo are shaking up the architecture and interior design worlds with a daring lifestyle and business model: instead of looking for clients, they look for properties, buy them, and move in with their two children, Max (4) and River (1). Then begins a slow, immersive, creative process where Zoe and Merlin take time to fully absorb the space's atmosphere before envisioning a new, highly crafted interior that honors the property's vernacular history while infusing their contemporary sensibility into the space's volumes and materiality. It's an organic method that can take up to two years, allowing the duo a creative freedom that thrills the senses and touches the soul.

Called The Beldi, this generous London-based apartment, located in an old shoe factory, was converted by Zoe and Merlin into a verdant oasis in the lively Shoreditch district. After peeling back the layers of time to expose the building's bare industrial charm, the couple combined imperfect handmade materials and traditional techniques inspired by their travels to Morocco and China to create a cozy, open space with some sharp contemporary lines. The view over the treetops of nearby St Leonard's church inspired the delicate "fennel," "avocado," and "olive" green shades, which softly invite the outside in.

Craftsmanship is at the very heart of the duo's approach, and the eye-catching floor sets the space apart: laid by hand using zellige and bejmat tiles, the neutral herringbone pattern and basketry motifs gently articulate flow and movement around the apartment. This feeling of fluidity is instilled all through the space with sweeping lime plasterwork and smooth oak carpentry, while luxurious, handcrafted elements—including a green lacquered bench by Sue Skeen, Jochen Holz glassware, and the bedrooms' hand-painted quilts by Faye Toogood for Once Milano—complete the utterly refined and cohesive composition. The next work currently on their list is a Hampstead house nested in nature—a new, exiting playground for this wholly creative family.

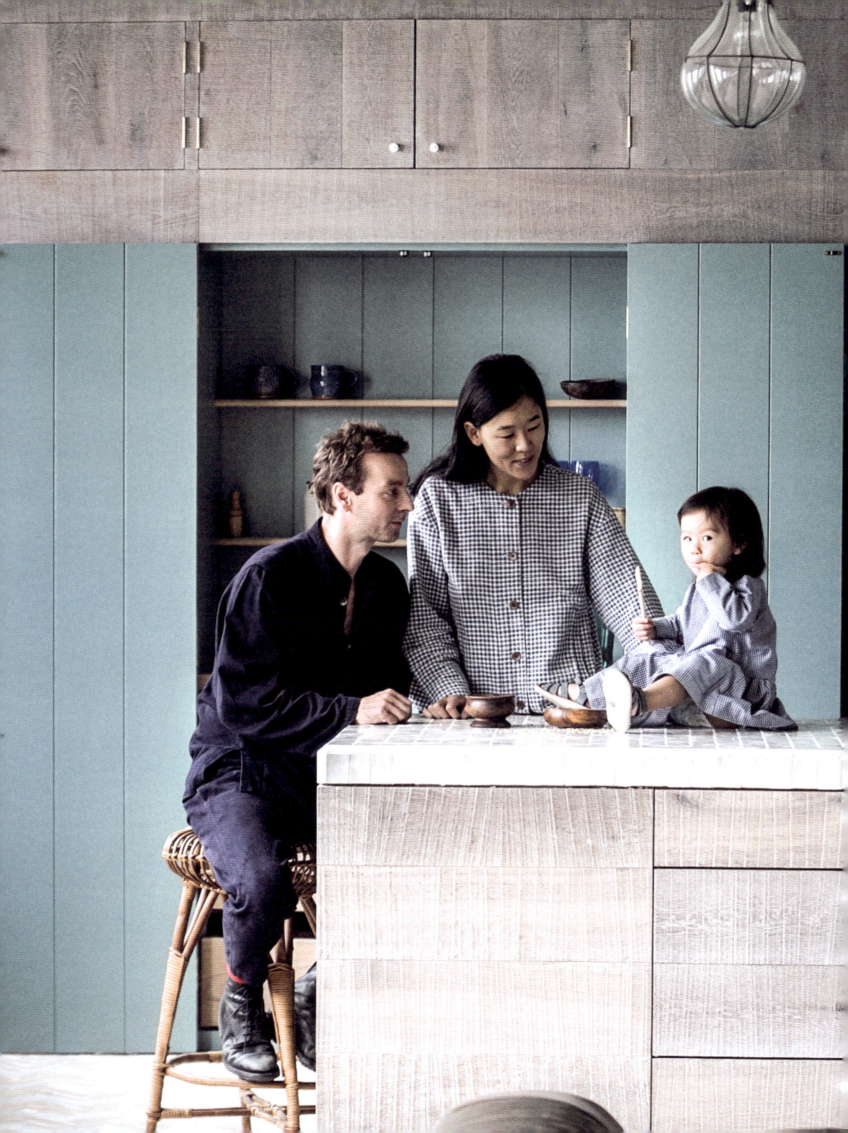

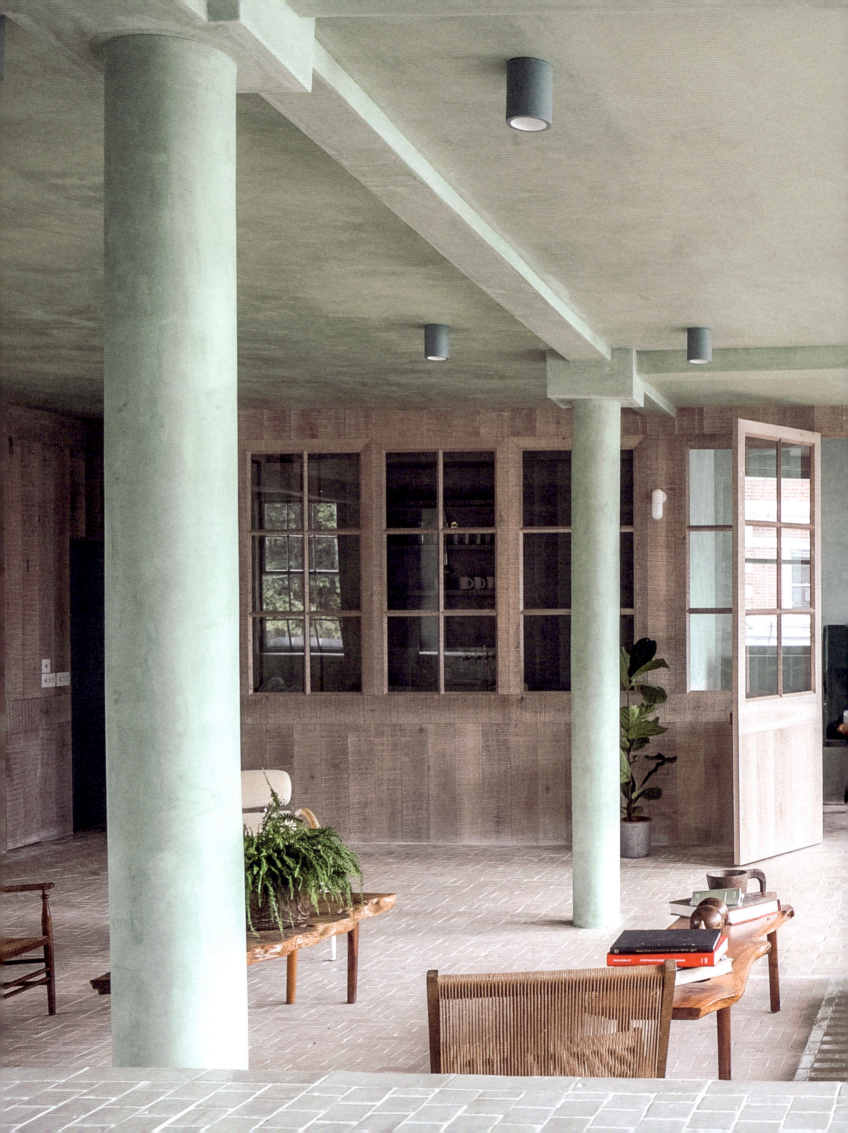

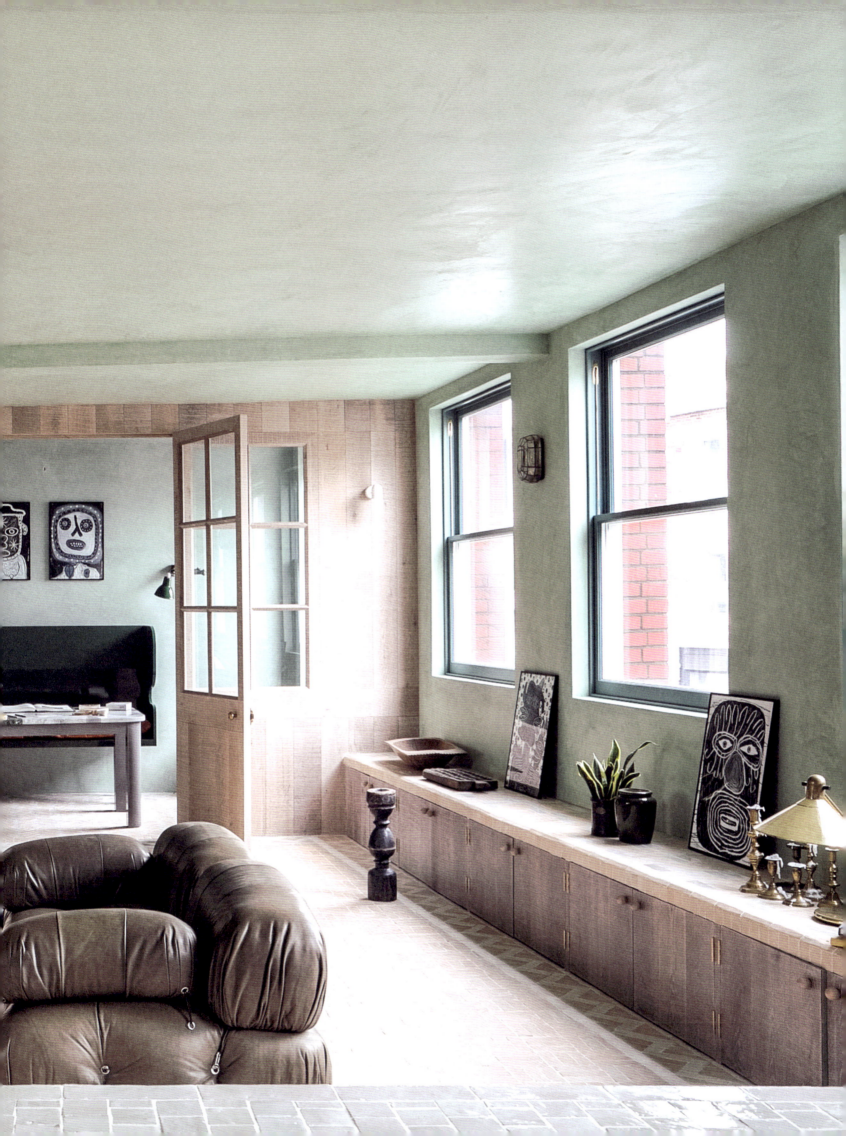

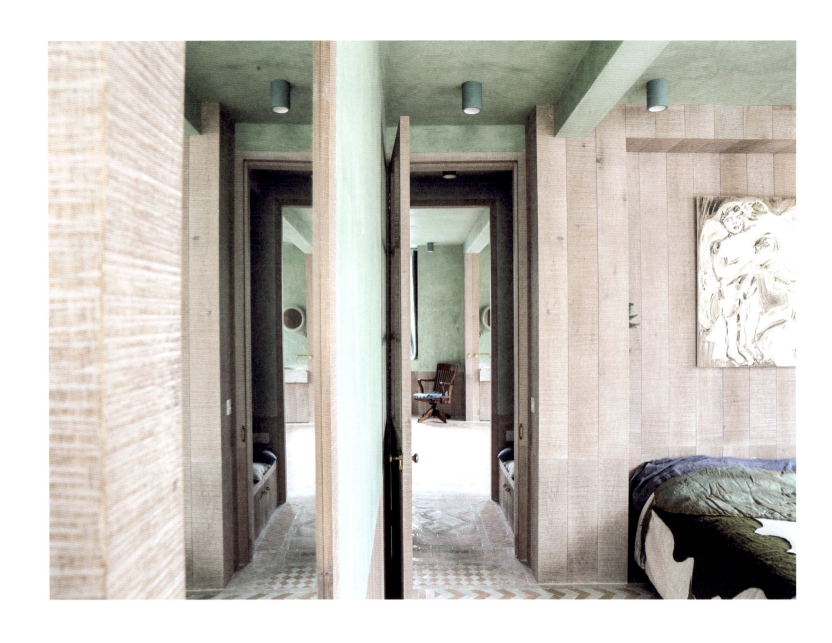

THEIR WORKFLOW IS AN ORGANIC METHOD THAT CAN TAKE UP TO TWO YEARS, ALLOWING THE DUO A CREATIVE FREEDOM THAT THRILLS THE SENSES AND TOUCHES THE SOUL.

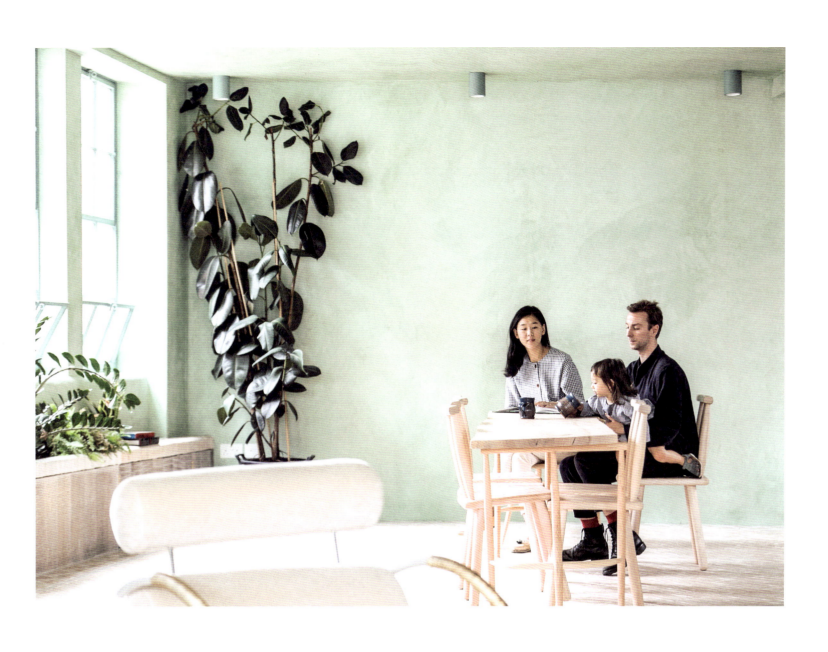

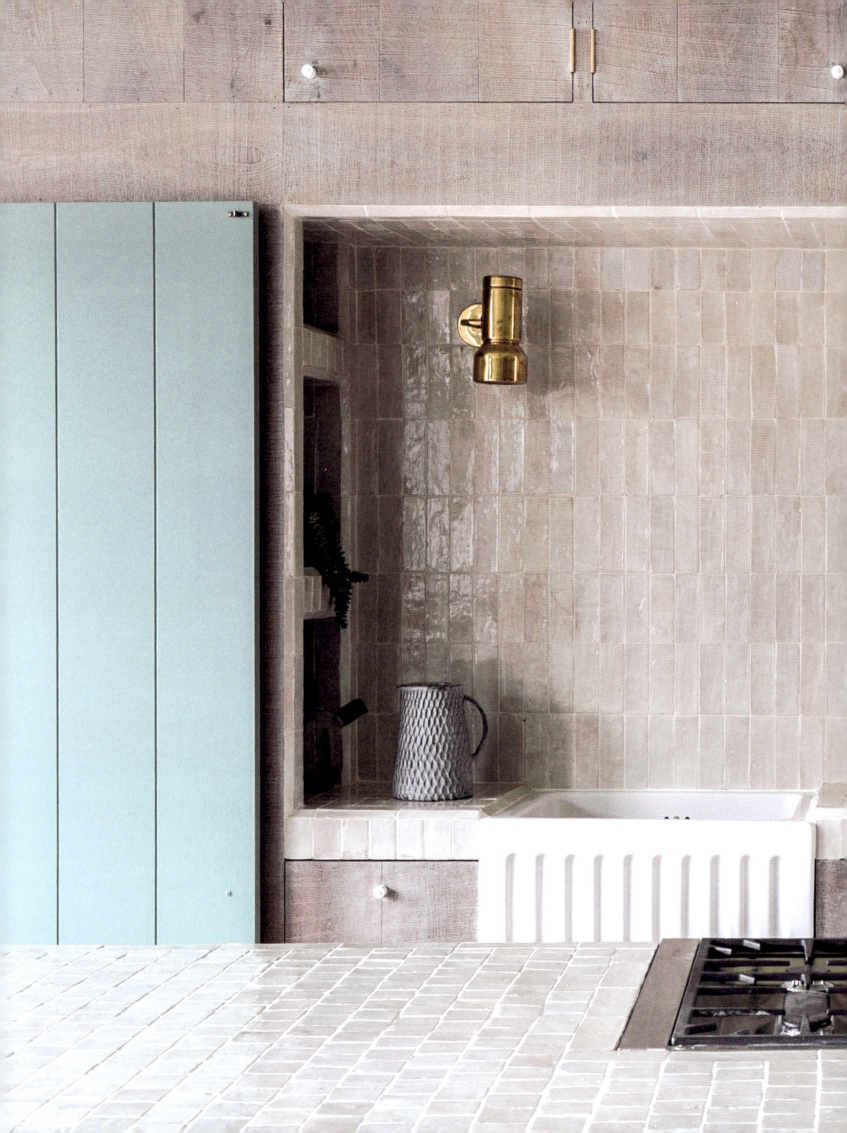

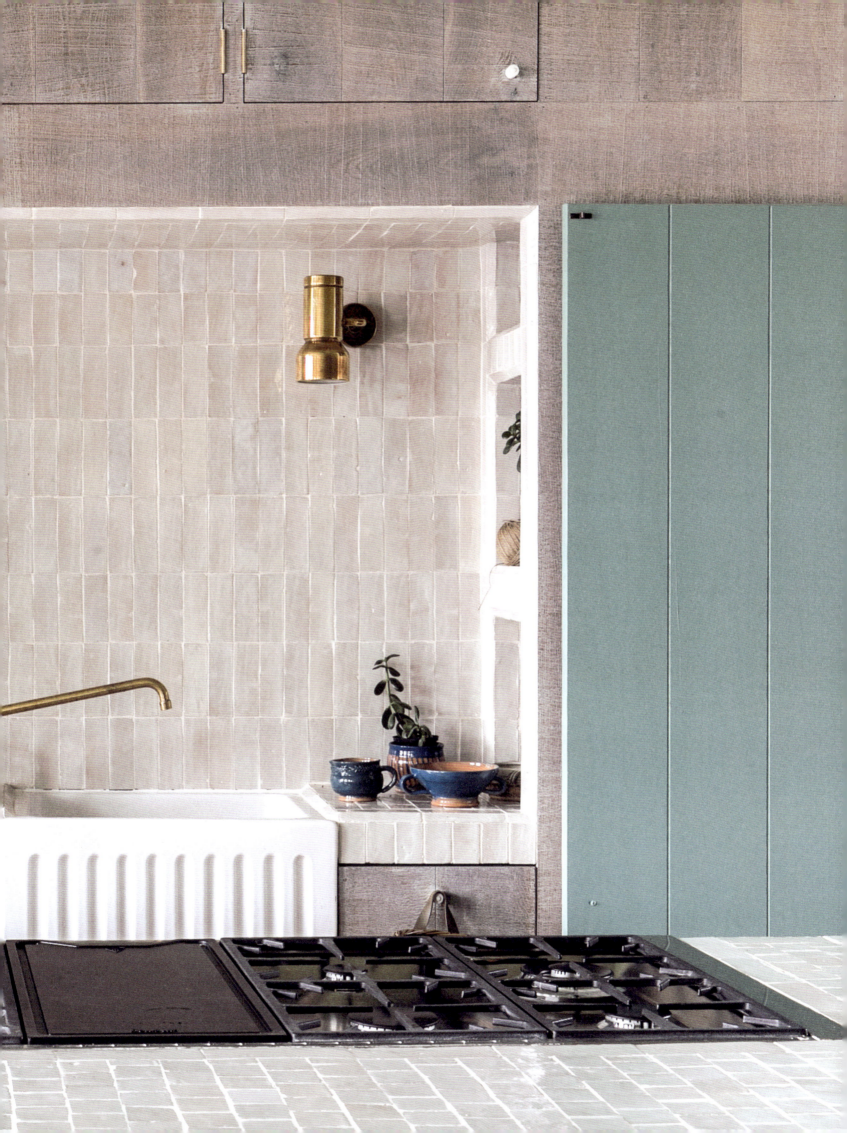

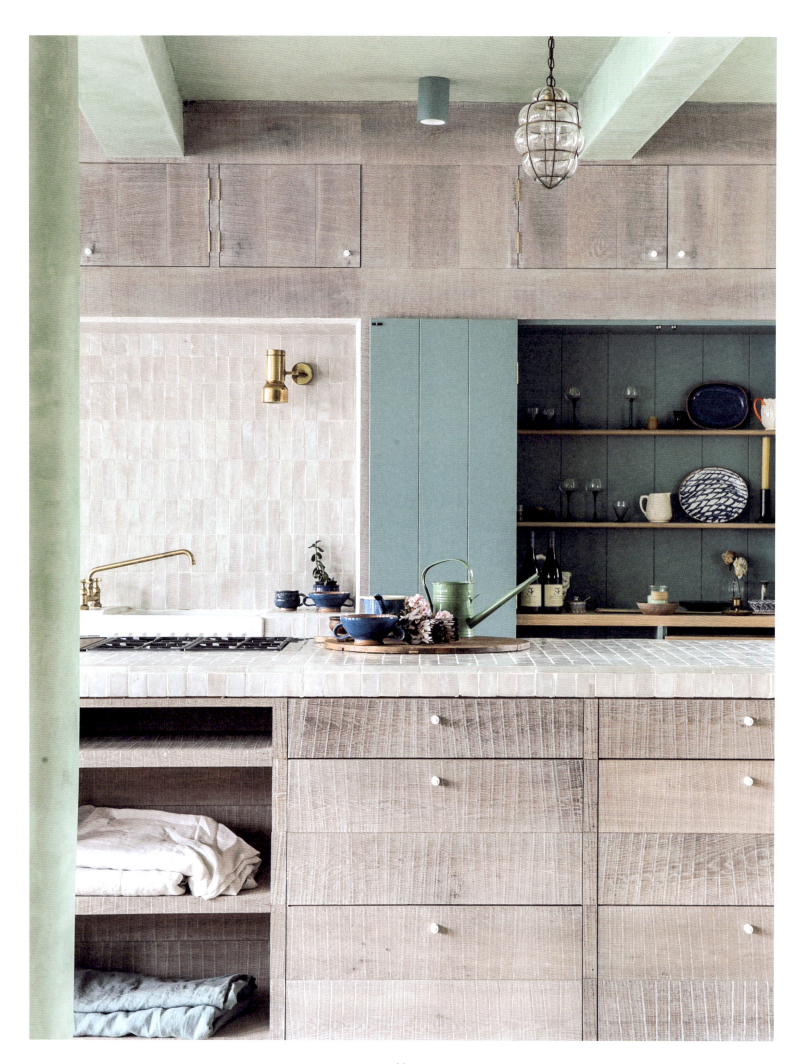

WHERE	WHO	WHAT
NORMANDY FRANCE	PIERRE, ÉMILIE, GEORGES, MARIN	COZY FARMHOUSE

A cozy farmhouse anchors happy family gatherings

Escaping to the country is what makes Pierre Frey happy. Director of communications for the luxury French textile company Pierre Frey that bears his grandfather's name, Pierre loves recharging his batteries in the Normandy-based farmhouse he purchased two years ago with his scriptwriter and film director wife Émilie. A place to retreat from the city, it provides the perfect way to keep his well-traveled professional life in balance while passing his love of nature onto his sons Georges (5) and Marin (9 months). The couple chose this region, close to Paris, to enjoy as much quality time with their wider family as is possible: "*Our house is near my father's, so it makes it easy to take the kids from one place to the other and have the whole crew of cousins over,*" says Pierre. "*The benefits of spending time with friends and family in a different context are amazing: rather than running between two places to have dinner together in Paris, we head to the countryside to unwind, to succumb to the charm of nature and gardening. Whatever the season is, I'm here in the garden with my son Georges all weekend long.*"

The traditional farmhouse is located in Vallée de l'Eure, a picturesque region of undulating landscapes, sloping rivers, and impressive aqueducts. It's a perfectly lush, bucolic setting for this comfortable home, the charming interior of which infuses elegant yet unassuming classic French style with a contemporary twist as the couple's eclectic selection of second-hand objects and furniture is skillfully mixed with curtains, cushions, and throws encapsulating the Pierre Frey aesthetic DNA: colors and motifs. The house is also filled with heirlooms that once belonged to Pierre's grandma: "*My grandmother Geneviève [daughter of renowned designer René Prou] was a textile designer and a keen collector of antiques with an extraordinary eye for artifacts. She would be so happy to see our whole family here surrounded by some of her lamps, bowls, china, or paintings.*"

Passion for interior decoration is a family affair for the Freys, whose business began in 1935 as a designer and manufacturer of furnishing fabrics, expanding later into wallpapers, rugs, and carpets before launching their own line of furniture in 2002. "*A family business indeed—these bonds of blood truly are our best working tools,*" adds Pierre.

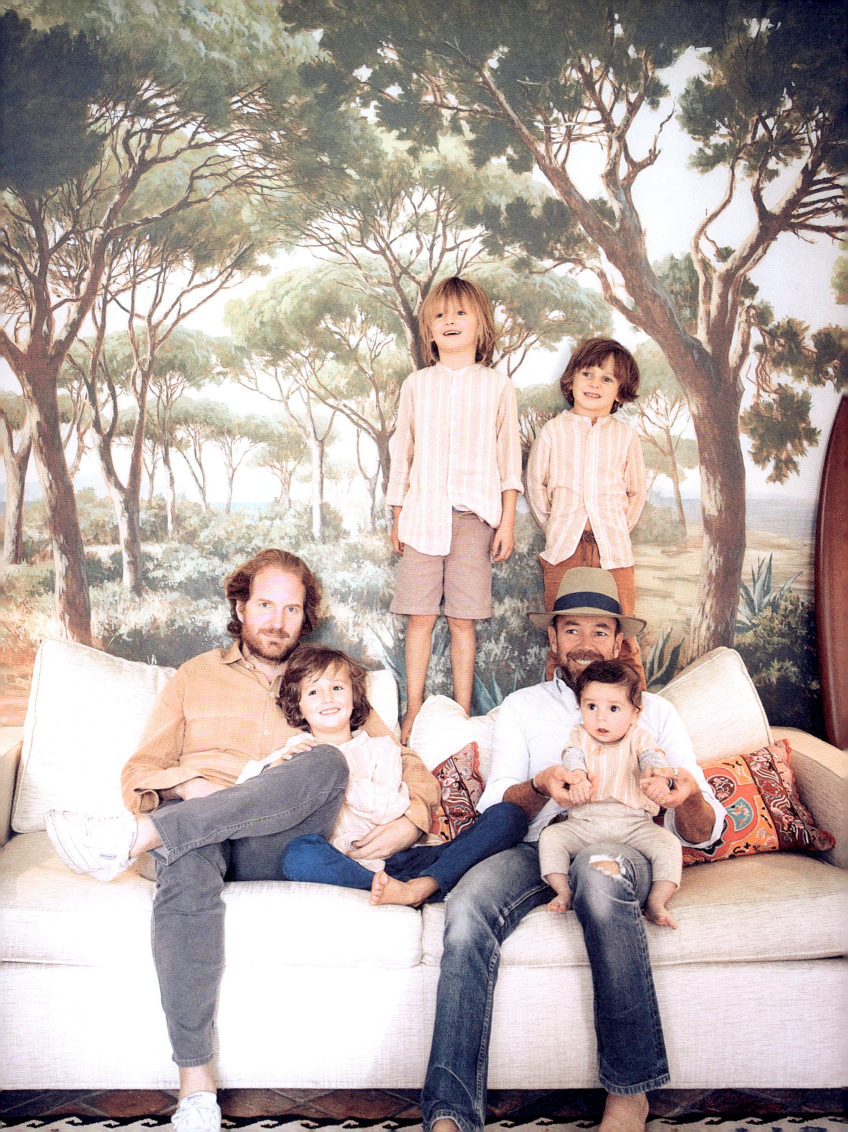

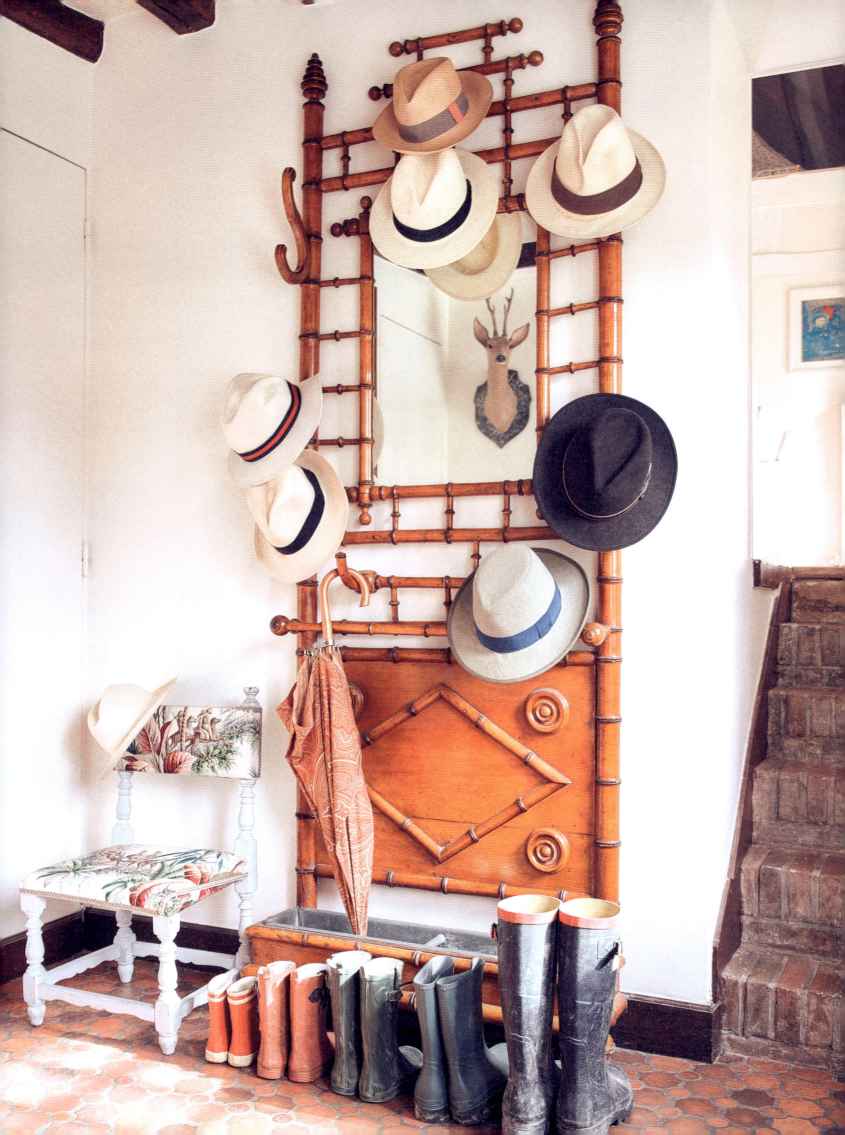

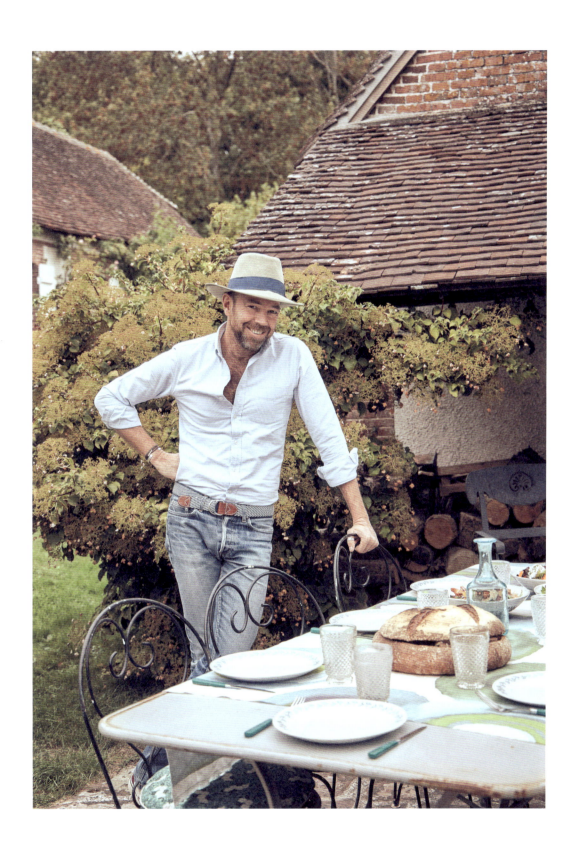

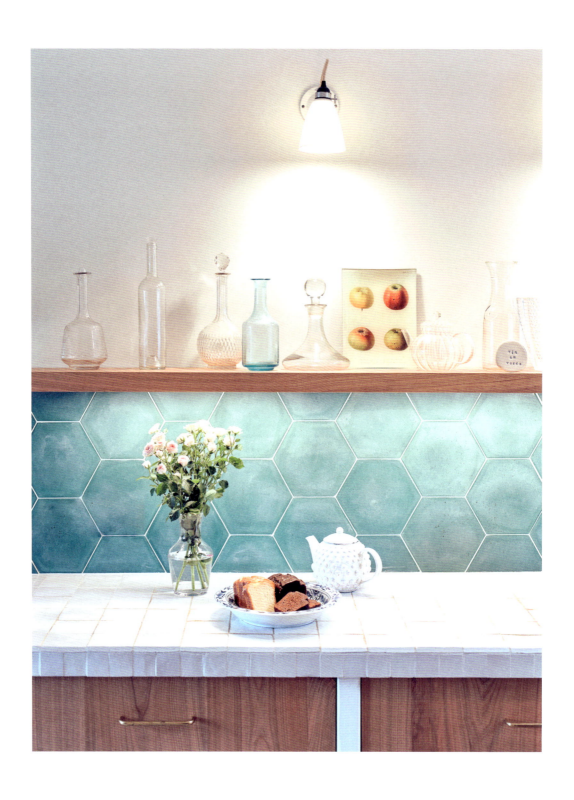

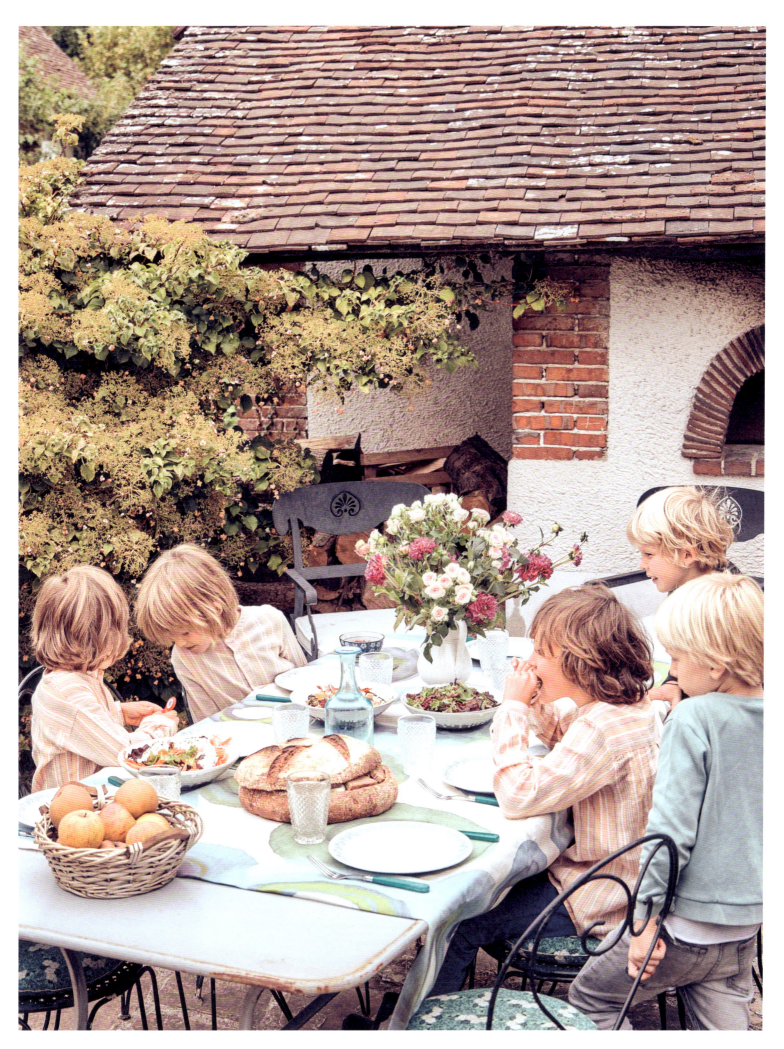

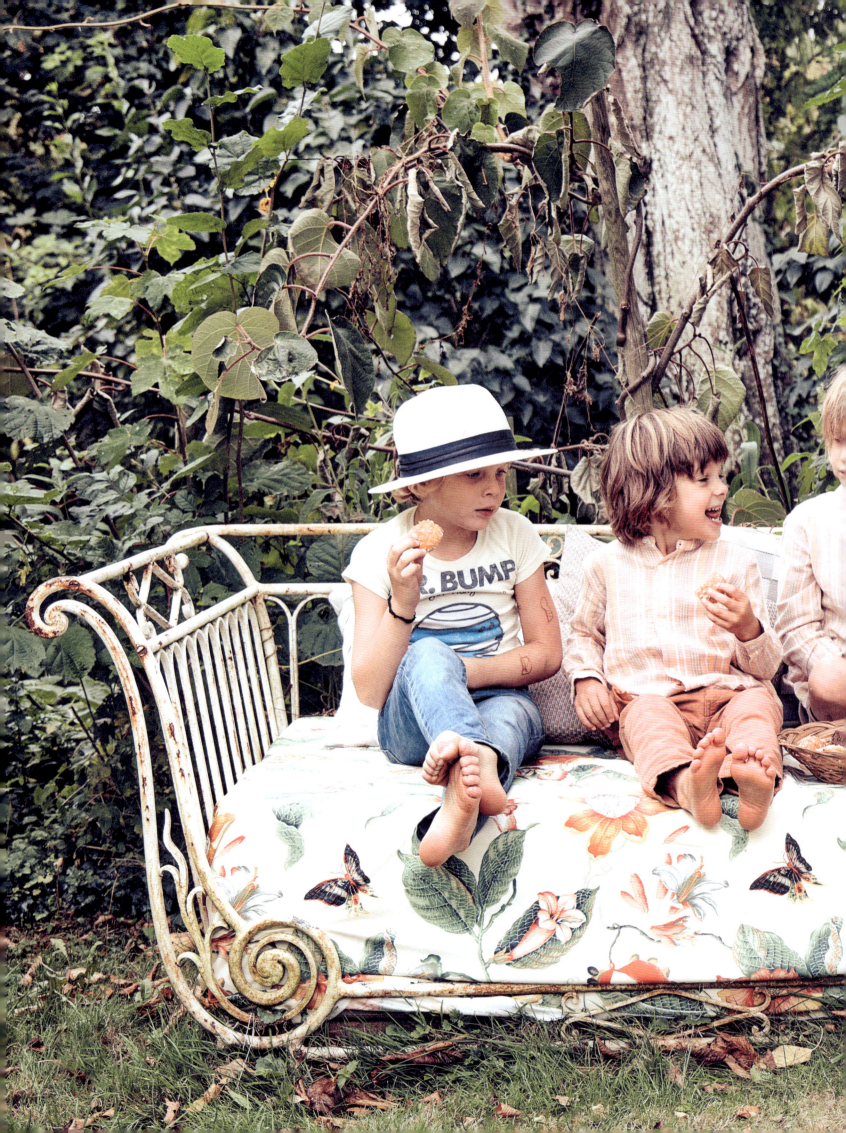

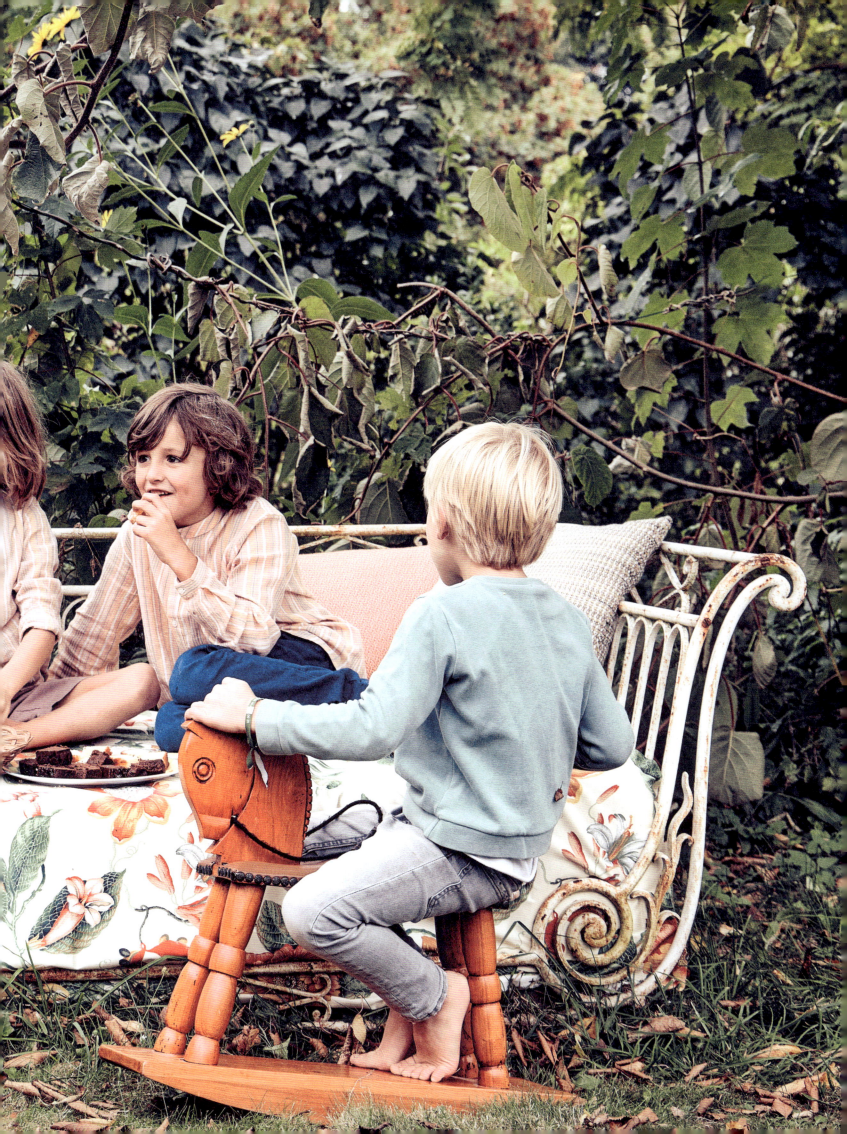

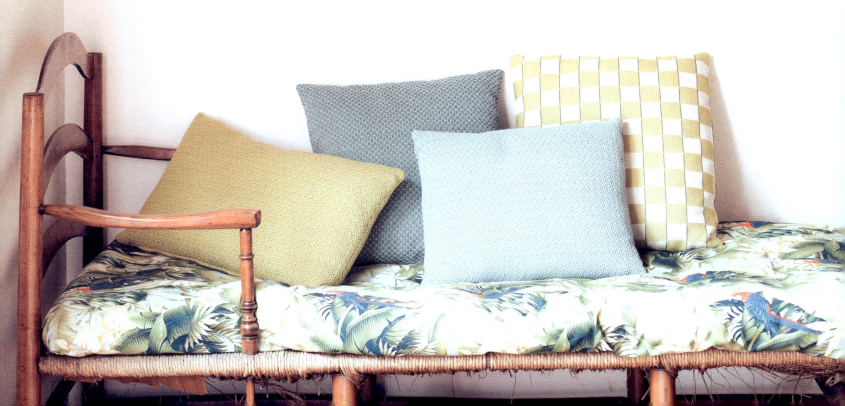

WHERE
STOCKHOLM
SWEDEN

WHO
MAGNUS, JULIA,
SANDER

WHAT
ARTISTIC
APARTMENT

A cozy apartment fuses two artistic worlds

"*This bike is worth more than me!*" jokes Swedish designer Magnus Elebäck about the beautiful Argon 18 high-performance racing bike standing in his bedroom—it's a passion the co-founder of Swedish furniture brand Massproductions shares with his best friend and business partner Chris Martin. This love for both racing bikes and modern Scandinavian furniture is palpable in the beautiful Stockholm apartment Magnus shares with his photographer wife Julia Hetta and their eight-year-old son Sander. Located in the central Södermalm neighborhood where Magnus grew up, the comfortable space threads an elegant dialogue between Magnus and Julia's artistic worlds, where the sculptural lines of Massproductions' furniture fuse effortlessly with Julia's giant photographic prints of romantic still-lifes, which are arranged alongside floral displays and Japanese ceramics.

When the family moved in five years ago, the apartment was a rather insipid all-beige space, but with the Stockholm housing market being particularly intense in this sought-after district, the creative couple didn't hesitate. Today, the 110 m² (1,184 ft²) space has been transformed into a cozy artistic cocoon full of personality, where each person's passion softly impregnates the atmosphere. "*A real home is the result of the combination of the people who live there,*" adds Magnus. With its rational layout, the bright, light-filled apartment is divided between the main living area on the street side—where the kitchen, lounge, and living room are linearly arranged—and the bedrooms, separated by a corridor and taking advantage of a calm courtyard to the rear.

As Magnus and Julia travel a lot for their work, they enjoy spending time at home with their son Sander, relaxing with a good book, and throwing dinner parties for friends. Their kitchen and dining-room tables—the latter of which can accommodate up to 12 guests—were both made by Magnus from wooden floorboards treated with linseed oil and painted white. These he installed on top of signature Massproductions bases so that when they don't host lively dinners, the tabletops gets covered with art and photography books—a perfect way to chill or get inspired anytime of the day.

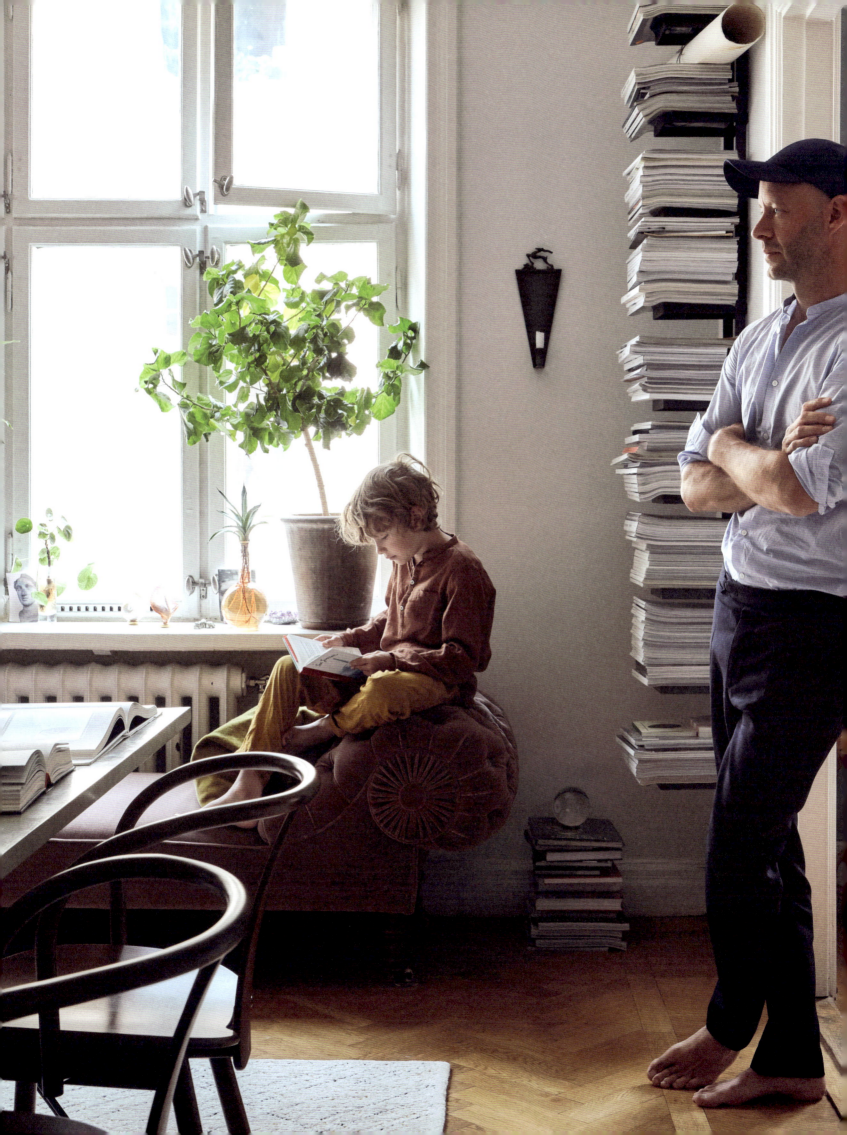

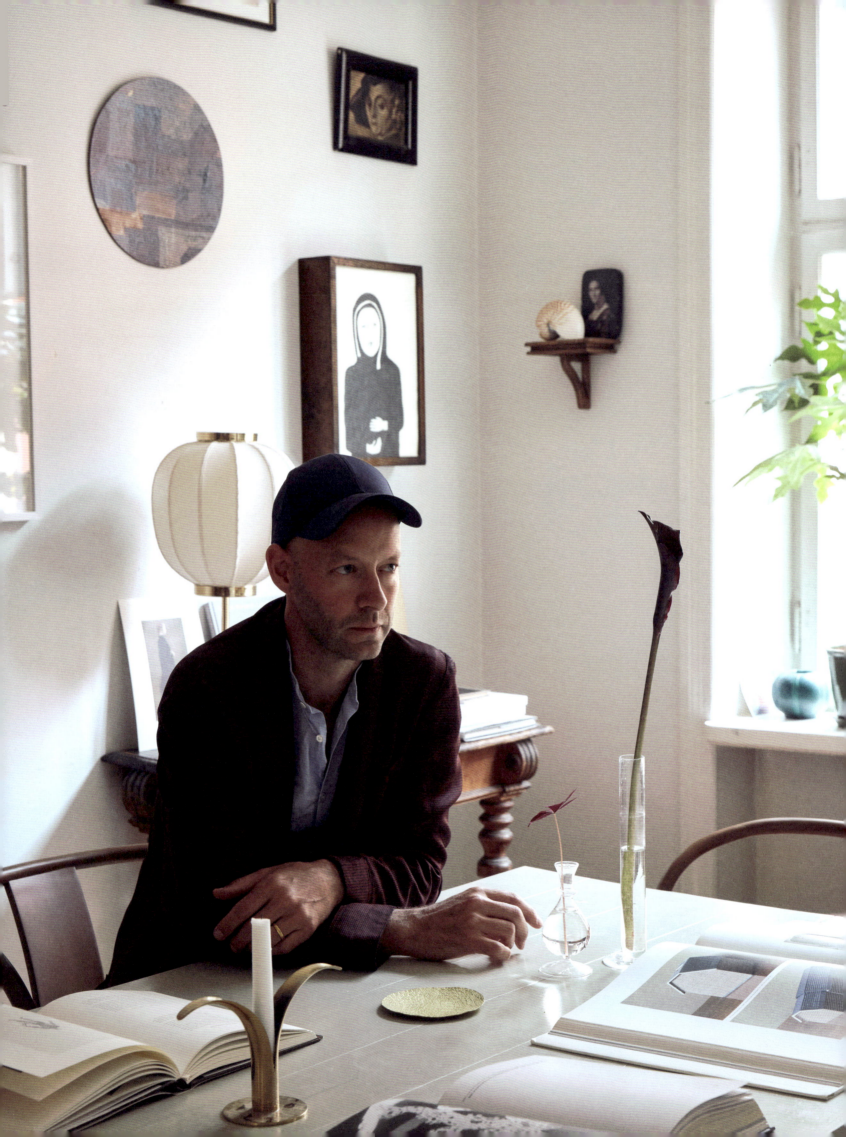

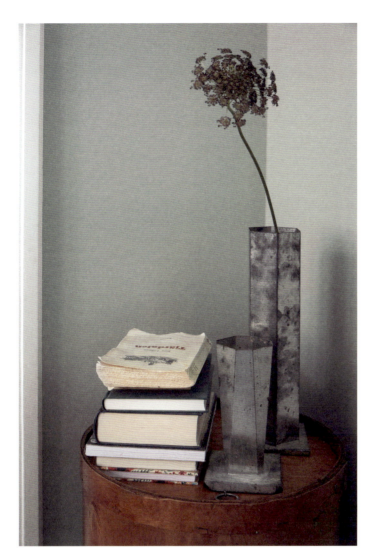
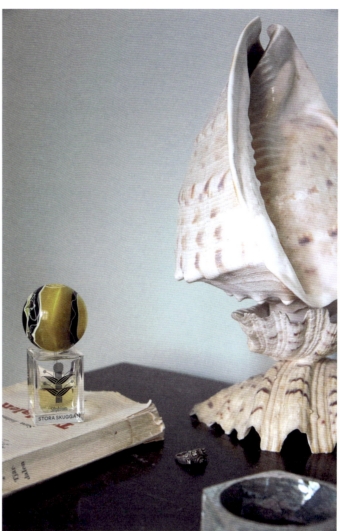

THE 110 M² (1,184 FT²) SPACE HAS BEEN TRANSFORMED INTO A COZY ARTISTIC COCOON FULL OF PERSONALITY, WHERE EACH PERSON'S PASSION SOFTLY IMPREGNATES THE ATMOSPHERE.

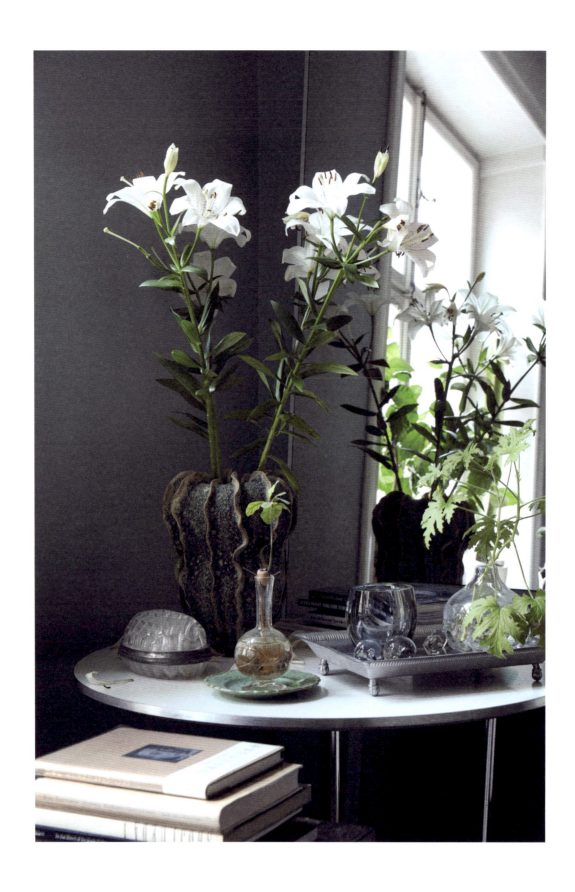

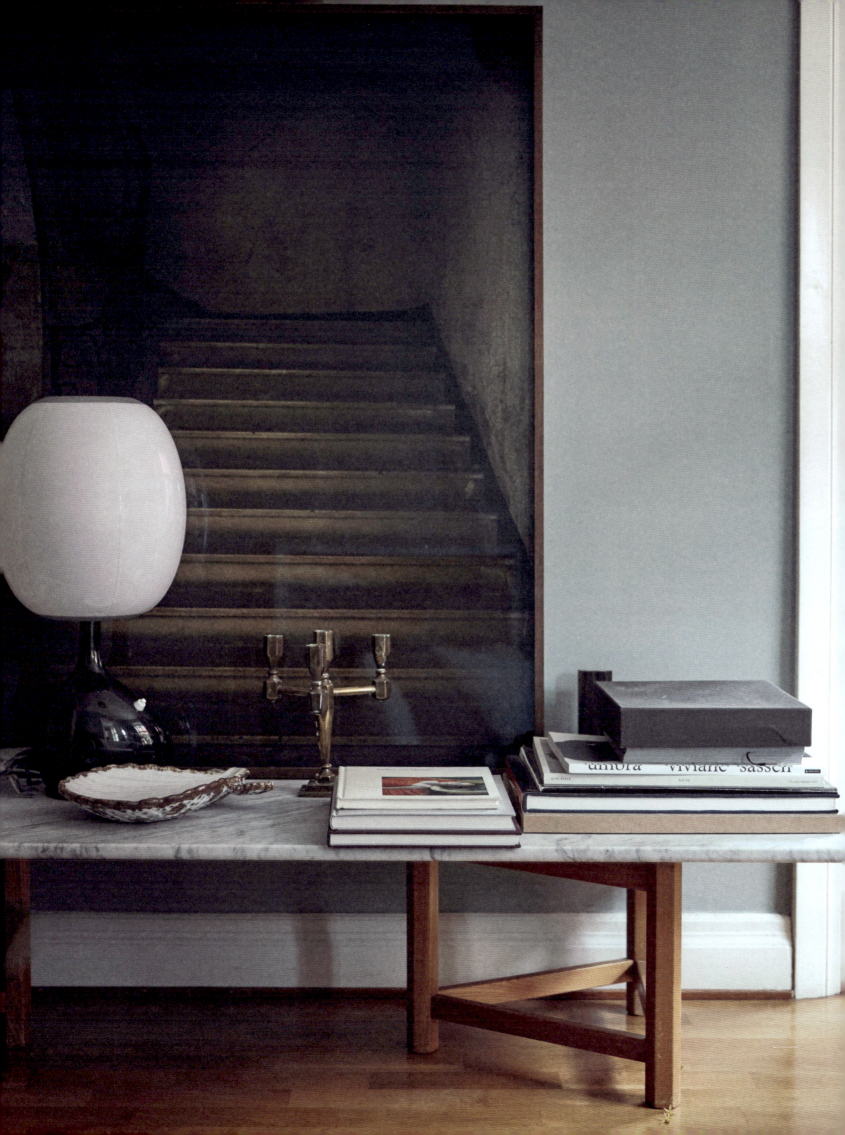

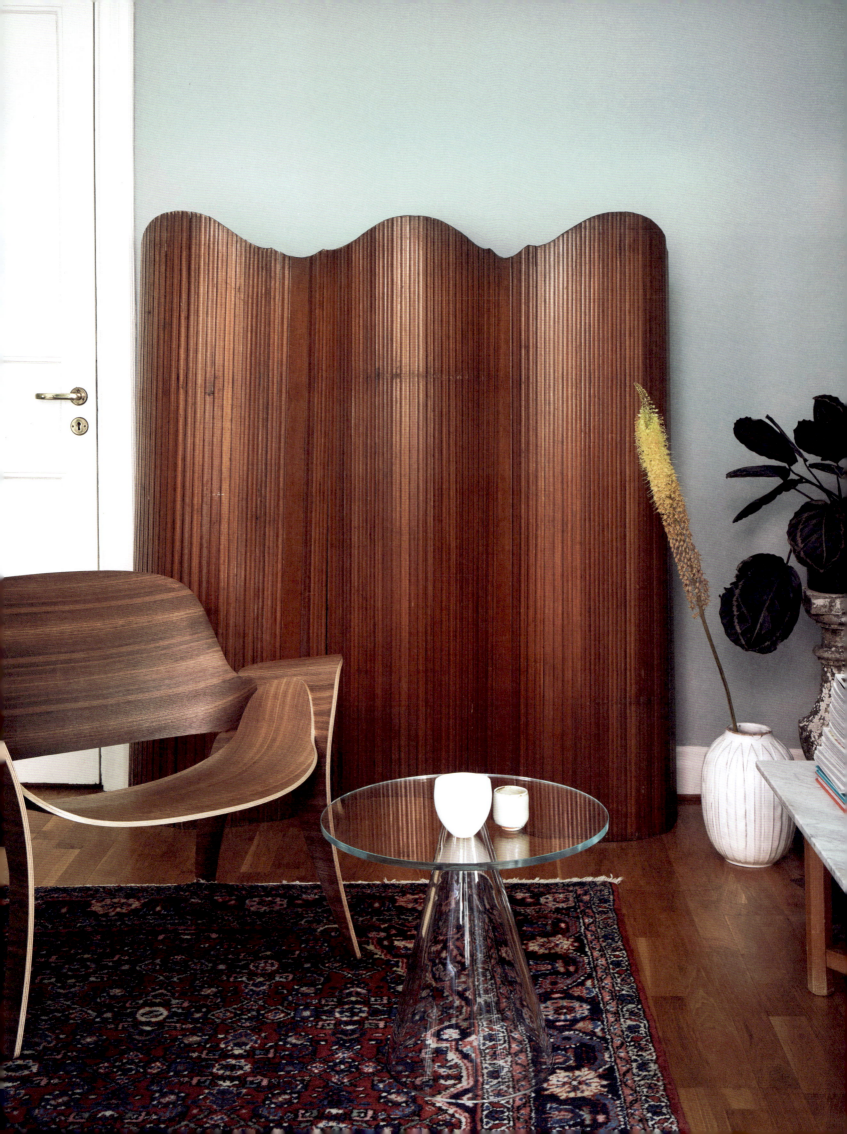

"A REAL HOME IS THE RESULT OF THE COMBINATION
OF THE PEOPLE WHO LIVE THERE."

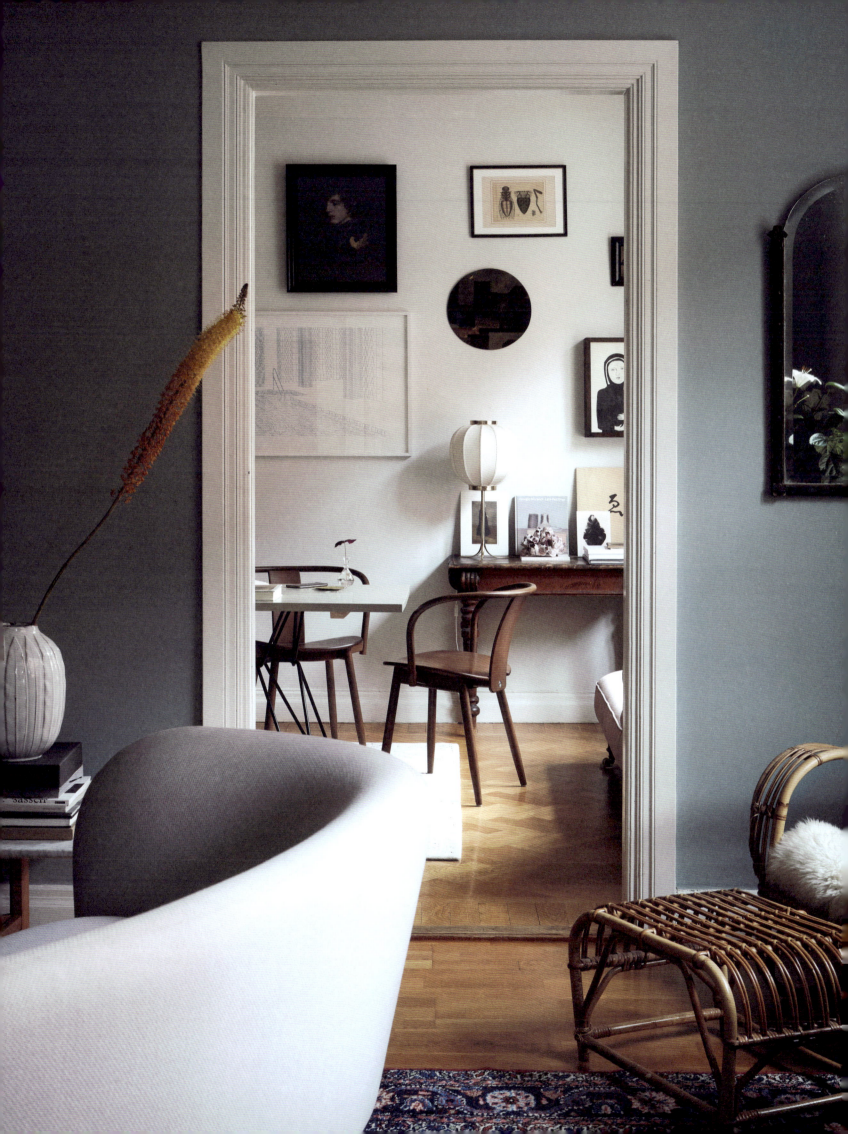

WHERE	WHO	WHAT
NIIGATA AREA JAPAN	SATOMI, YOSHIKAZU, ICHIE, WAKA	WOODEN HOUSE

A bucolic Japanese retreat blending ancestry and modernity

Located half an hour away from the town of Niigata (north of Tokyo, Japan), this simple wooden house, nestled in a lush garden surrounded by mountains, embodies the quintessence of bucolic living where nature and architecture cohabit in a ravishing, balanced way. Japanese jewelry designer Satomi Sekiya and her husband Yoshikazu chose this idealistic location three years ago, with the idea of offering their children Ichie (7) and Waka (5) the opportunity to grow up in a vivacious, natural environment. By celebrating Japan's ancestral lifestyle, where nature's ever changing seasons infuse the tone and tempo of day-to-day living, the couple created a routine for their kids where the principles of mindful simplicity meet modern habits and technologies.

"*We believe that living with nature enables us to broaden our potential and activity,*" says Satomi. "*We want our kids to discover freshness, to fear or love on their own, beyond words. We're teaching them age-old techniques such as lighting a fire or tying a knot on a rope, as well as introducing them to modern technologies—and we love to listen to what they have to say.*" The family grows its own fruits and vegetables in the garden that surrounds the house, which has proven to be a fertile ground for shared activities and quality family time, as Satomi and Yoshikazu consider education to be in osmosis with the environment.

Satomi's jewelry brand Monshiro also encapsulates the spirit of this unique place, impregnating her delicate designs, each a poetic tribute to ephemeral flowers and crafted by local women. "*In Japan, each season brings dazzling fragrances, but the scent of spring is particularly awe-inspiring to me.*" This is one of the reasons Satomi wanted a wooden house that could "breathe," where interior and exterior are connected in such a way that her children could constantly benefit from the fresh mountain air. "*Nowadays, houses are too insulated,*" she explains. "*We prefer the old ways of ancient Japanese wood construction techniques.*" Fans of vintage furniture, the couple's white and wood interior scheme is simple and allows for the children to run around, from inside to out, while the selection of objects made of natural materials mixed with modern, connected devices creates a peaceful balance, a new order.

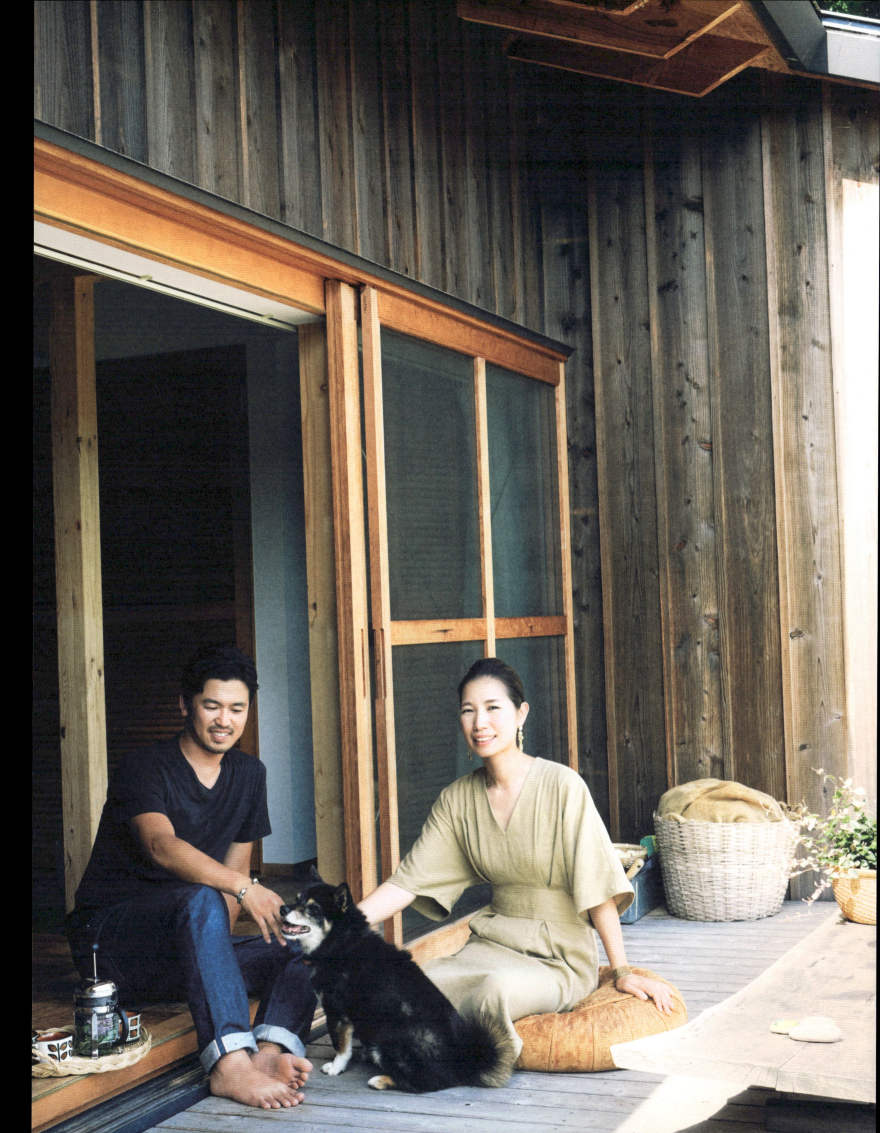

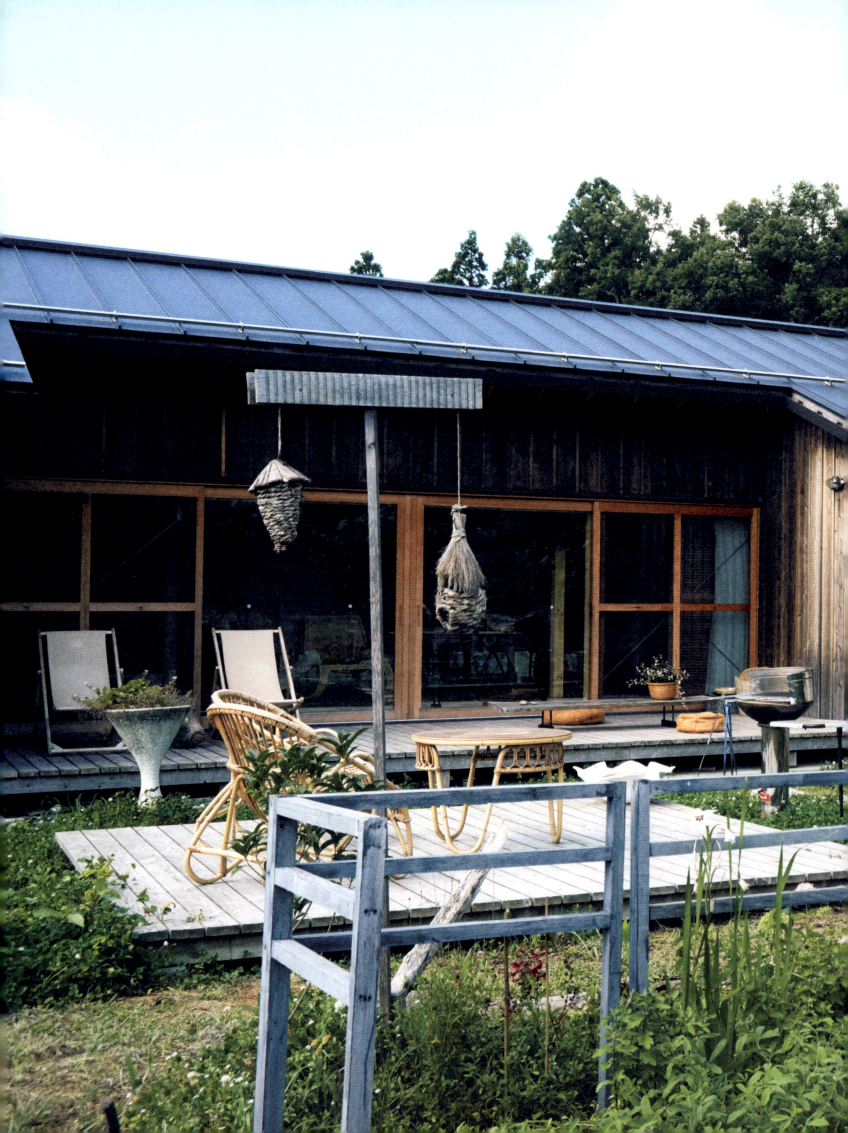

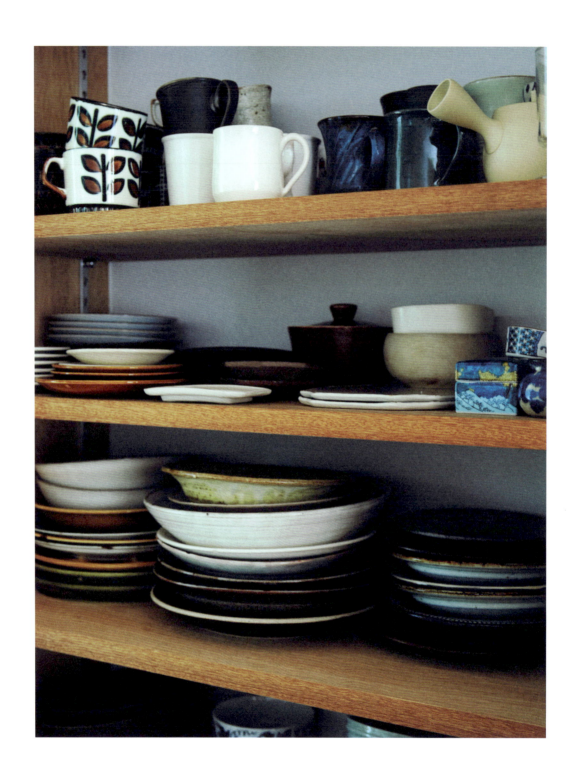

BY CELEBRATING JAPAN'S ANCESTRAL LIFESTYLE, WHERE NATURE'S
EVER CHANGING SEASONS INFUSE THE TONE AND TEMPO OF DAY-TO-DAY LIVING,
THE COUPLE CREATED A ROUTINE FOR THEIR KIDS WHERE THE PRINCIPLES
OF MINDFUL SIMPLICITY MEET MODERN HABITS AND TECHNOLOGIES.

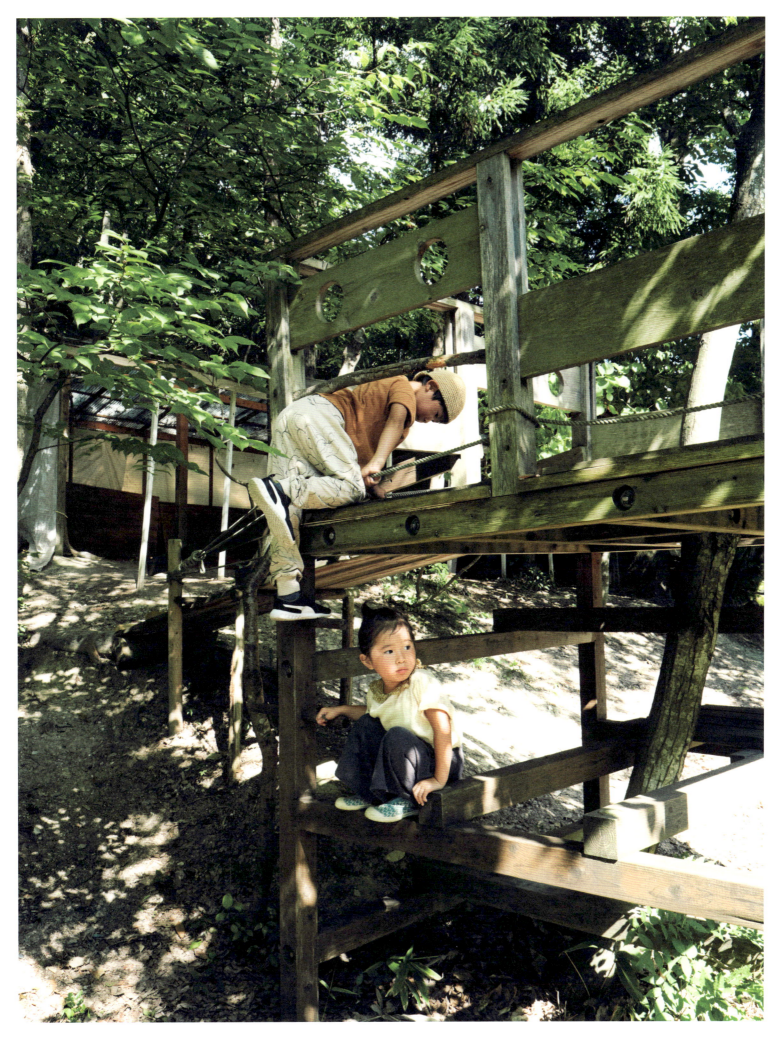

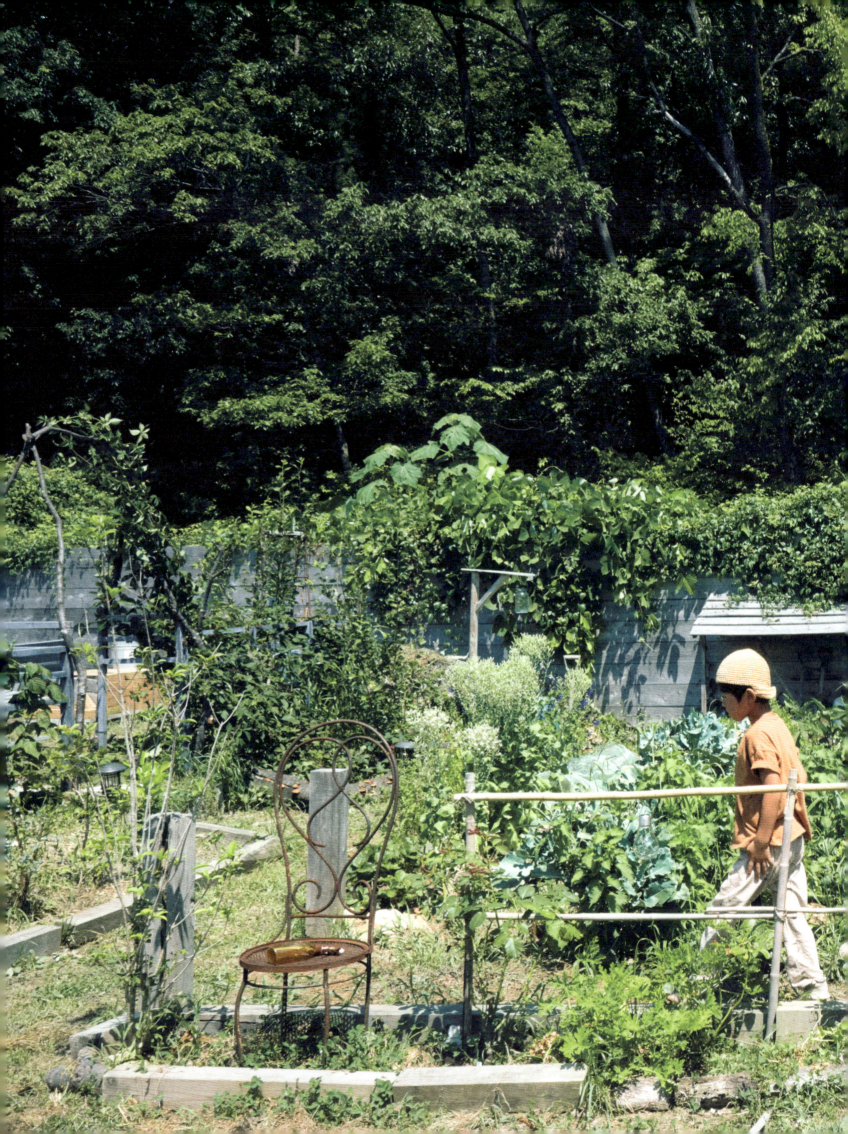

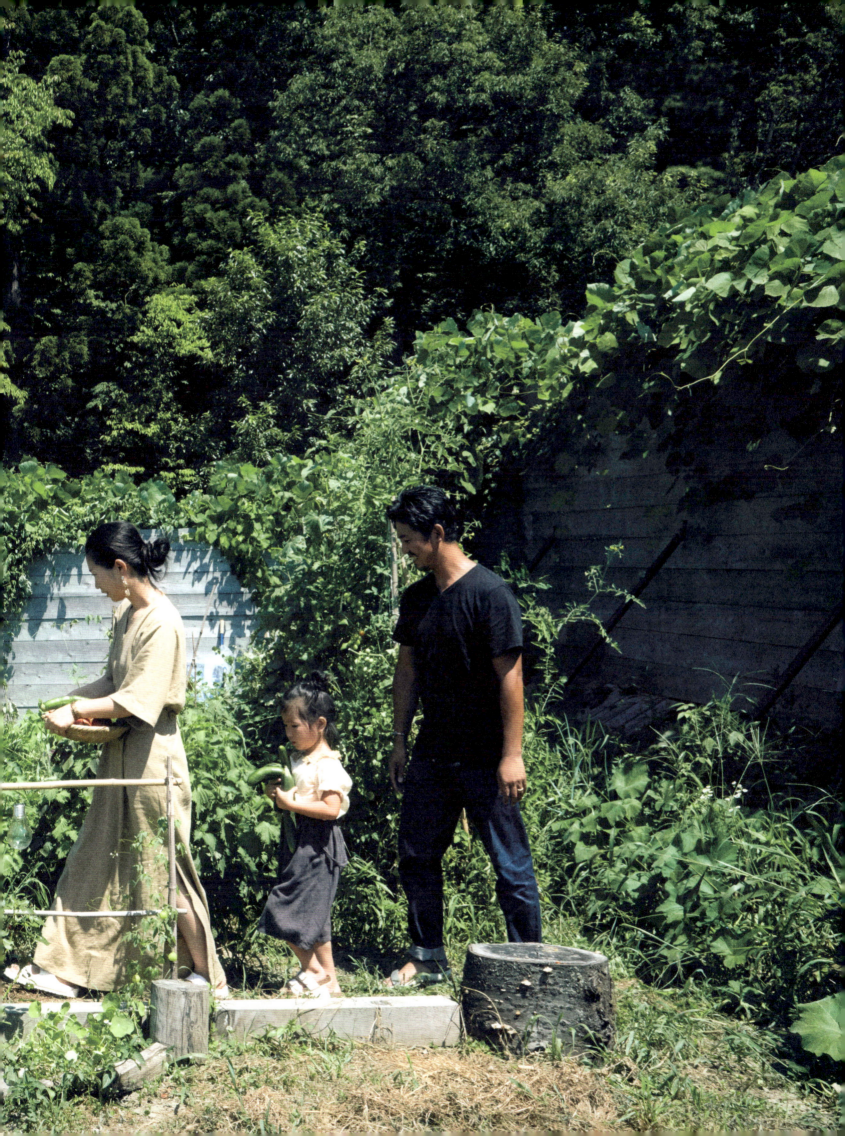

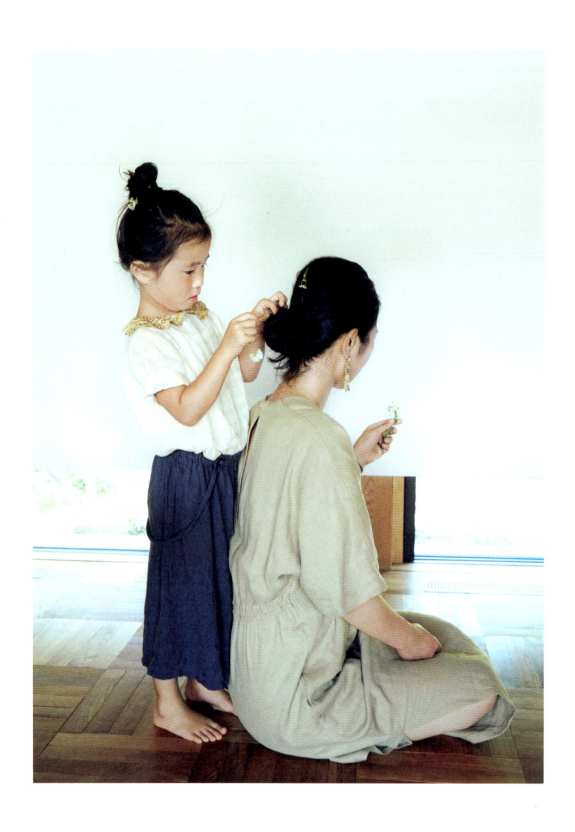

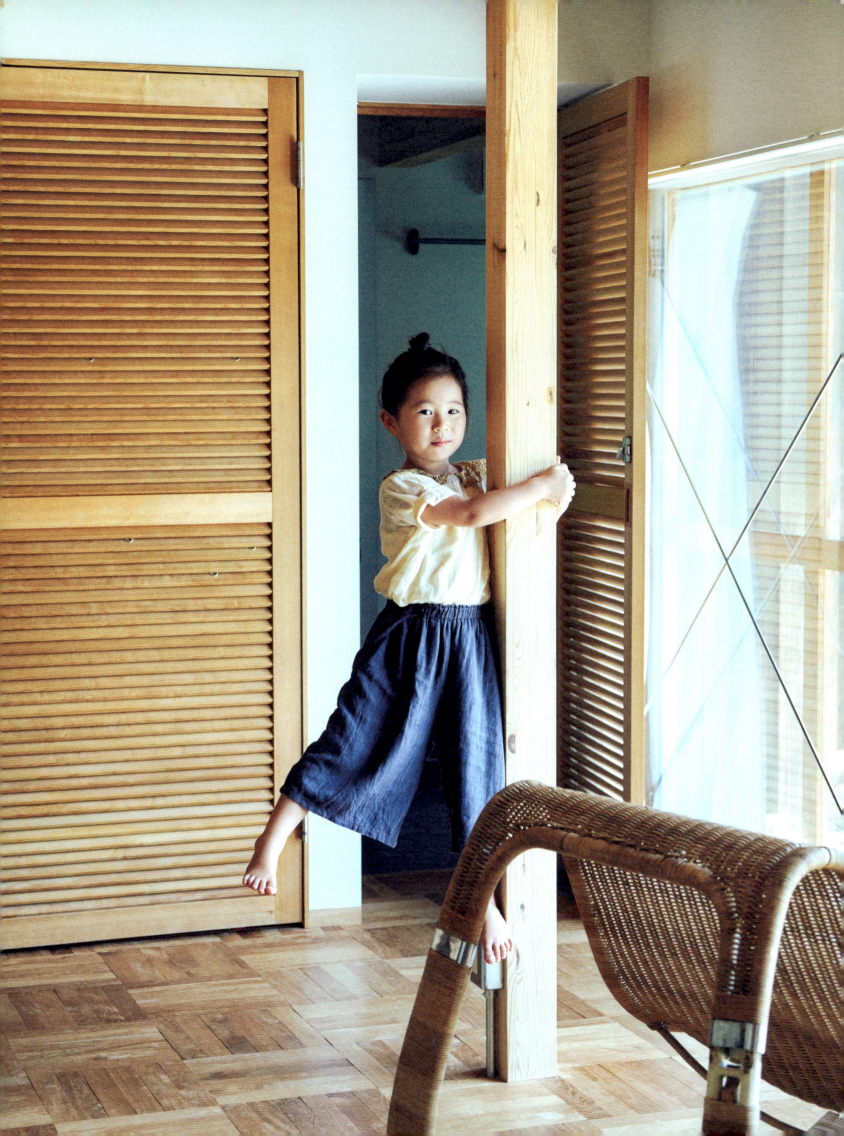

WHERE	WHO	WHAT
MILAN ITALY	LISELOTTE, JONAS, WIM, AVA	1930s RESTORED APARTMENT

Cosmopolitan mix-and-match meets classical volumes

"*I rarely buy new things as shops full of brand-new objects depress me. Flea markets and auction houses, you name it—that is my happy hunting ground!*" jokes Swedish artist and illustrator Liselotte Watkins. For six years now, Liselotte has been living in Milan with husband Jonas Falk (director of communications for Jil Sander), their two young children, Wim and Ava, and dog Huntis. The couple settled in a former office space turned large, bright family apartment that celebrates the classic Italian architecture: all of the 1930s details of the space have been exquisitely restored, from the ornate ceiling and moldings to the living room's original wooden parquet and entrance's ancient stone slabs.

The result is an elegant, soulful interior with a minimalist Swedish twist that favors clean lines and functional yet warm elements and textures—a space Liselotte envisioned to be as relaxing as possible since it also doubles as her work studio. Shutting the wooden sliding doors between the living and dining rooms, this is where she creates and draws for many brands and international magazines—*Bon*, *Vogue Italia*, *Harper's Bazaar*, *The New York Times*, and *Elle Sweden* to mention a few. Her home is a big source of inspiration for her illustrations.

Liselotte and Jonas's sharp, artistic eye is palpable in the way the family's interior is designed, "*a collage composed of the different places where I have lived—Paris, New York, Stockholm, and now Milan.*" The selection of objects and furniture is a colorful mix-and-match, where low Scandinavian wooden daybeds sit alongside classic second-hand Italian furniture and sophisticated furnishing fabrics that infuse the apartment with a refreshing cosmopolitan-chic vibe. "*It's funny because even though I have lived in many different countries, I still feel at home in Sweden. Our kids feel Italian and are definitely at home here in Milan. Sweden for them is just this exotic place where they go on holiday and where people speak Swedish, this secret language that we only speak at home!*" adds Liselotte.

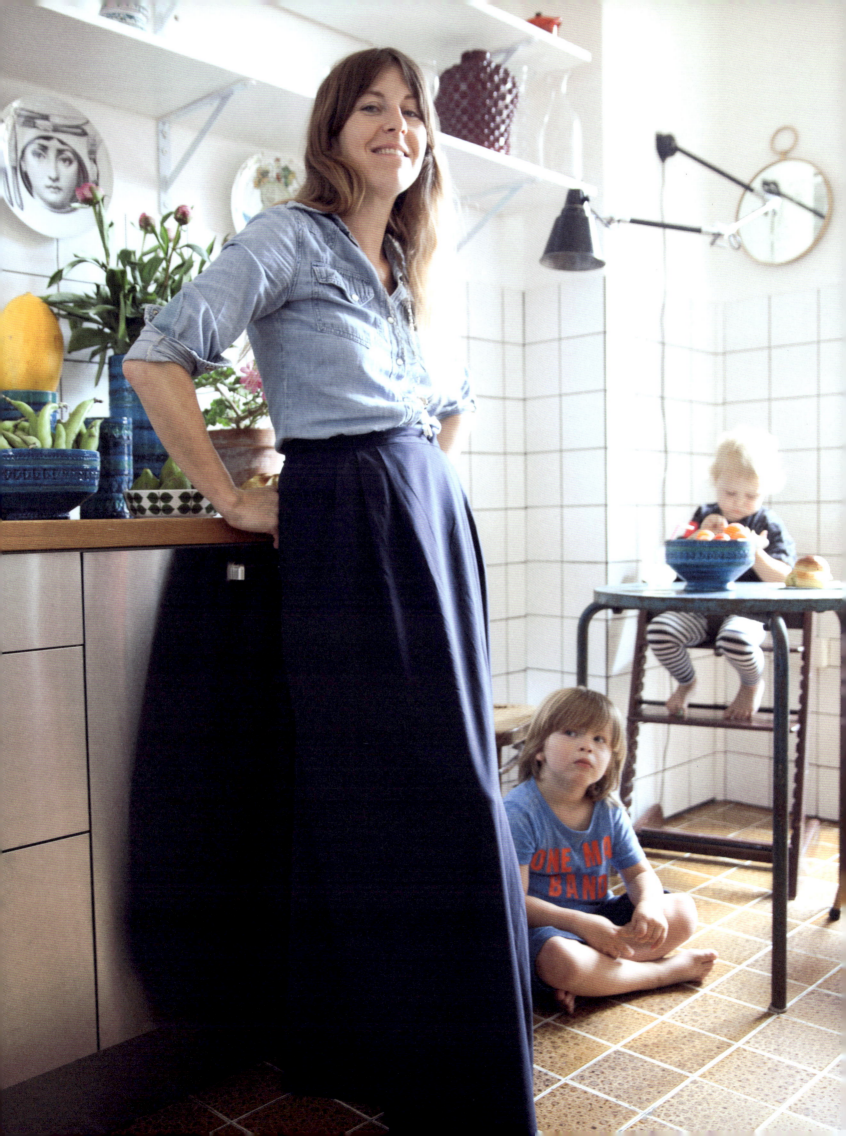

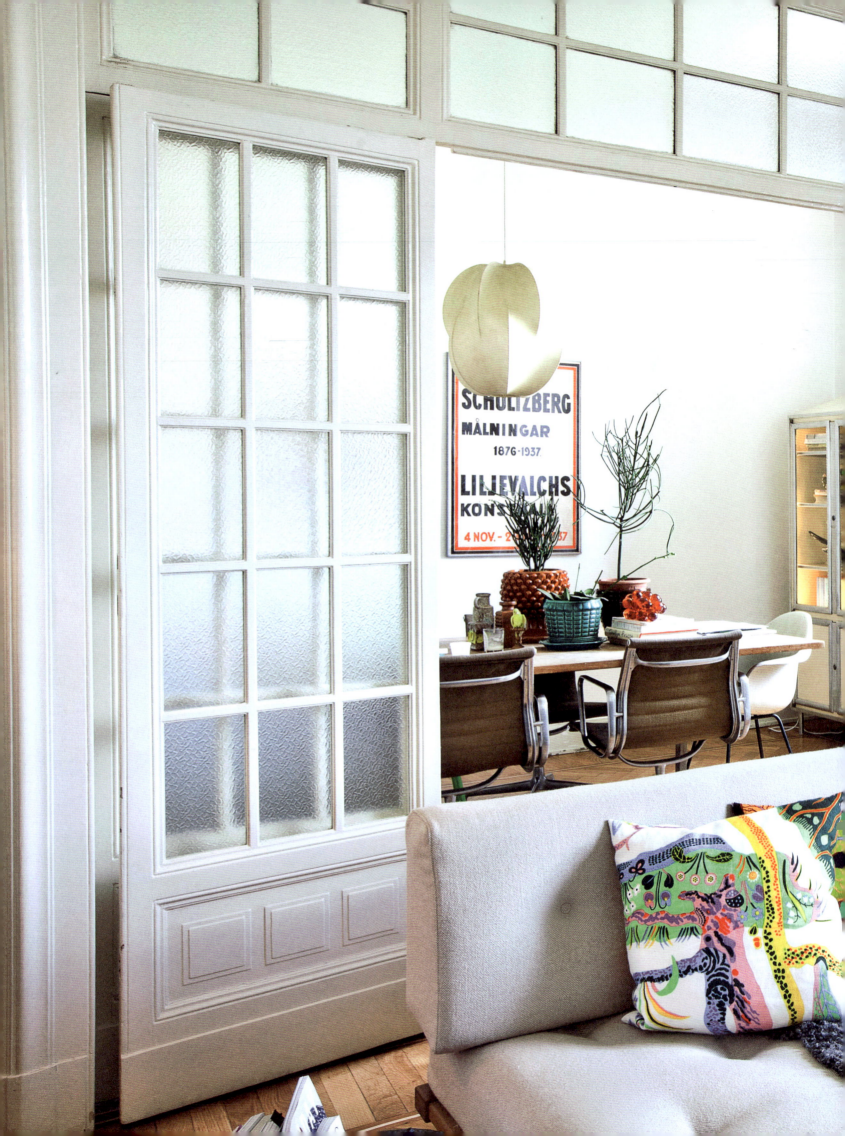

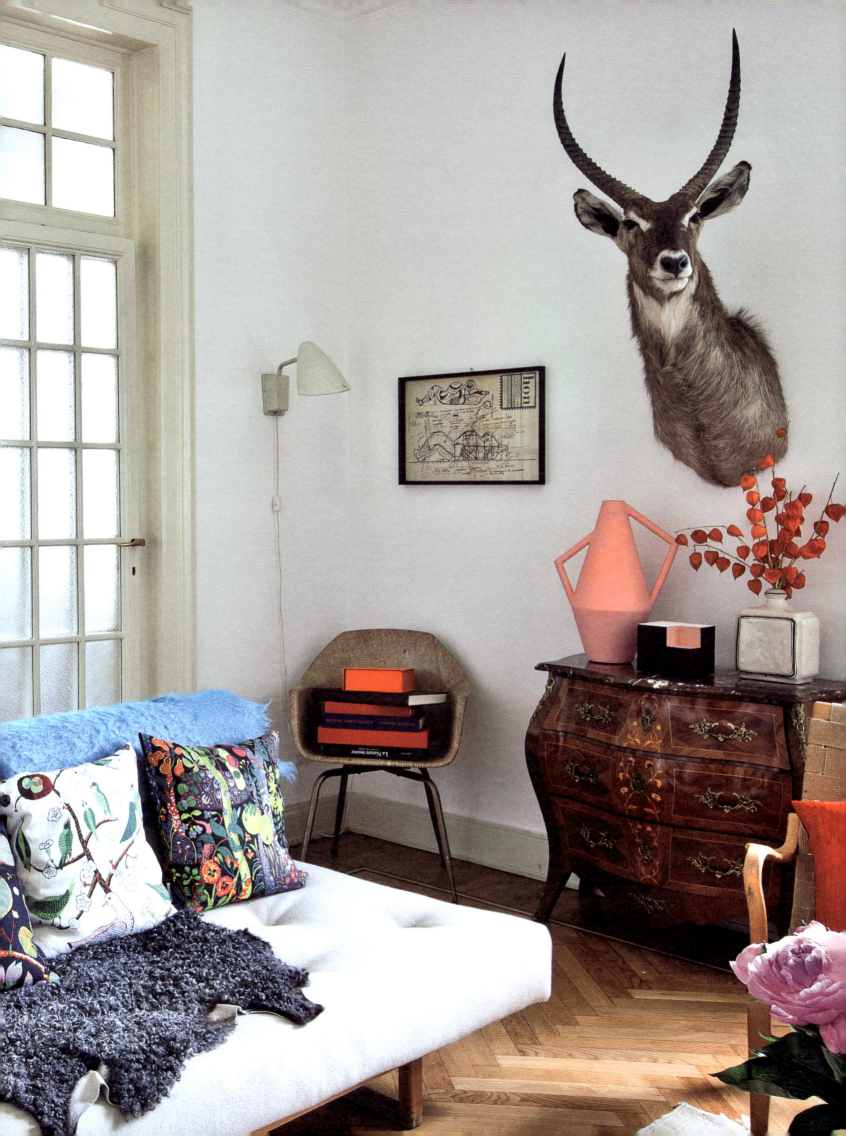

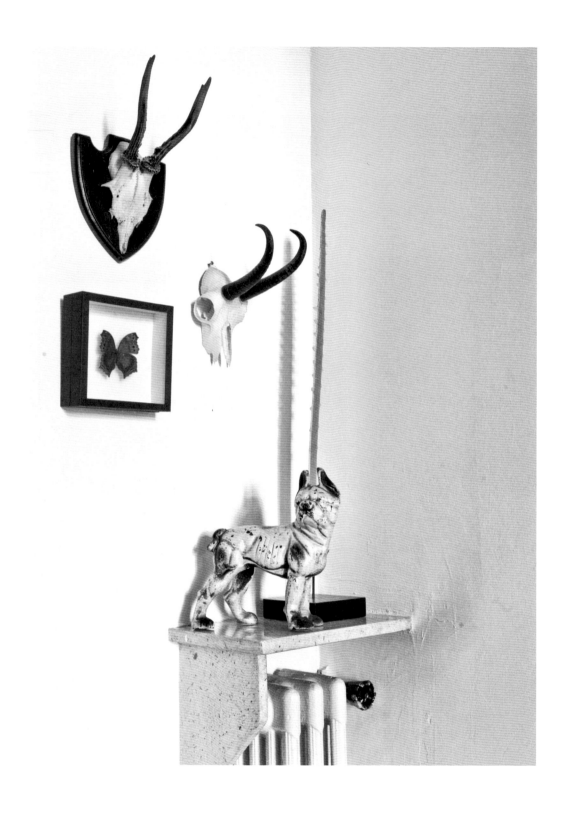

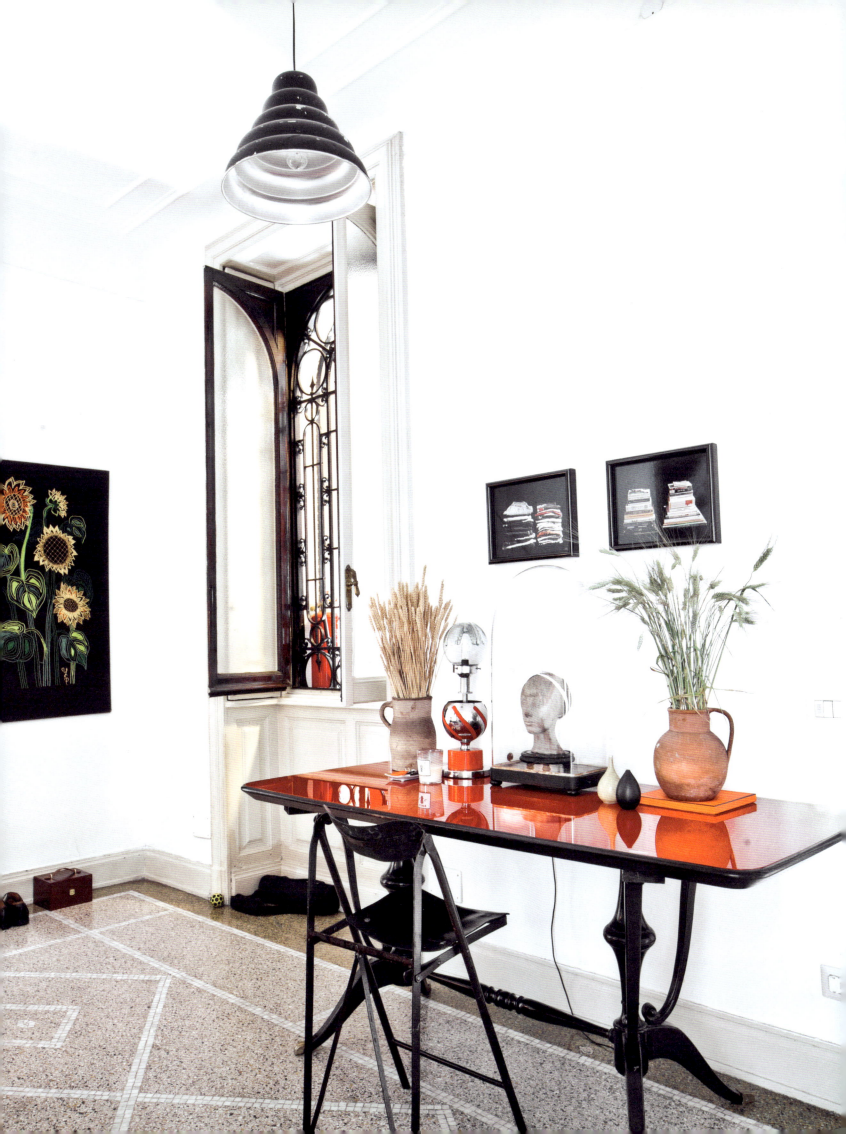

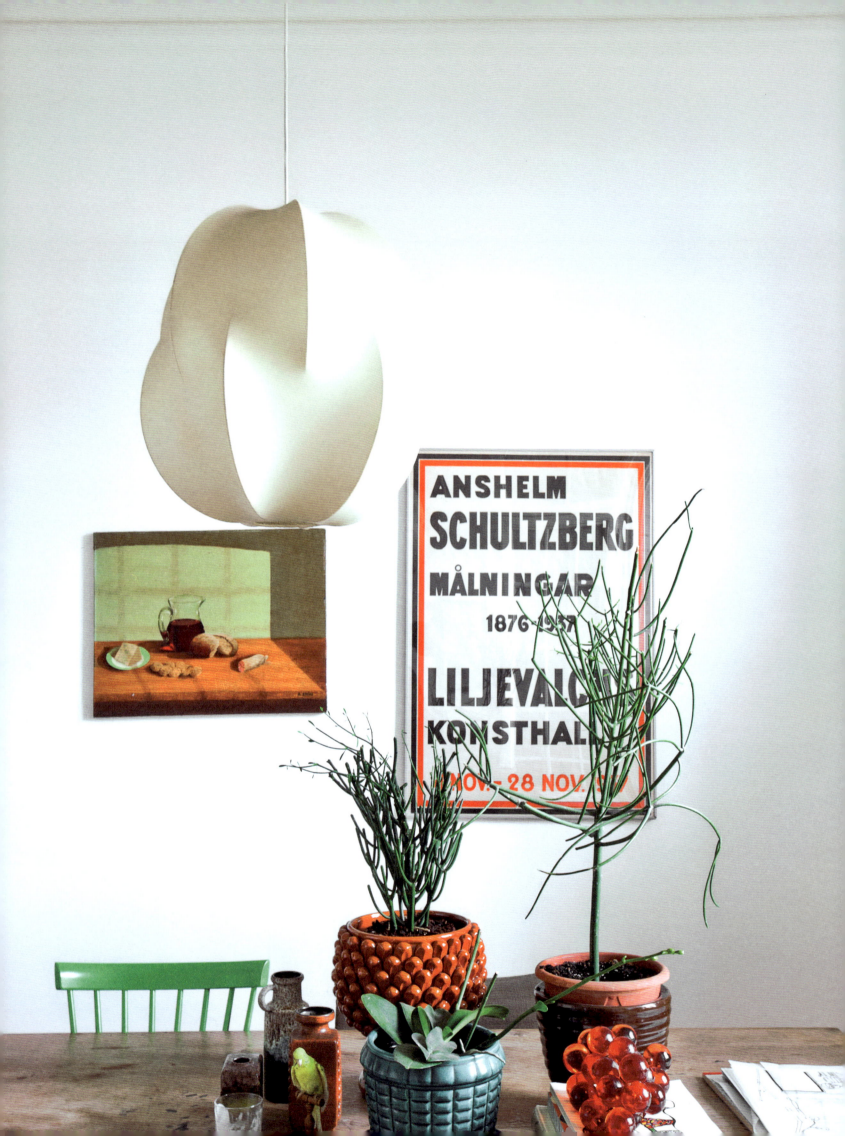

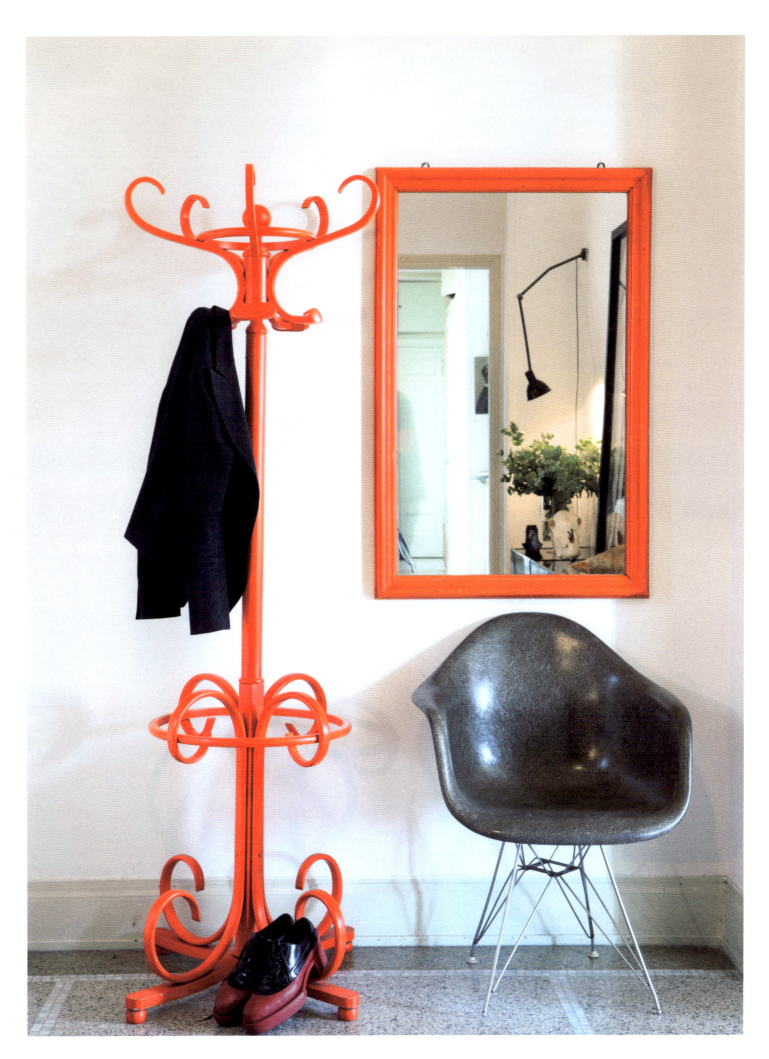

WHERE
VENDÉE
FRANCE

WHO
AURÉLIE, JEAN-CHRISTOPHE,
GUSTAVE, HONORÉ, BLANCHE

WHAT
BEACH
HOUSE

The ocean as playground: a soulful home by the sea

"*The kids converted the beach into their playground, a boundless space of complete freedom. This contributes so much to this feeling of being on holiday all the time, all year long—it's a blessing,*" says French stylist and photographer Aurélie Lecuyer about her three children, Gustave (15), Honoré (11), and Blanche (8). Back in 2018, after several life-changing moves, Aurélie and her husband, Jean-Christophe, decided to relocate closer to the sea, a decision inspired by his love of surfing. It was in Saint-Hilaire-de-Riez, a commune on France's Vendée coast, that an ordinary 1970s house piqued their curiosity: "*The most interesting thing about the house was its location on the edge of a forest, with the ocean right on the other side of the sand dune,*" says Aurélie. Another plus point was that the house did not require major renovation works, just a good eye and a bit of talent to transform its comfortable proportions into something magical—which the couple did with exquisite style.

Stripping down walls, corridors, and suspended ceilings, the heart of the house—where the family gathers—was turned into a simple yet charming rectangular space where the slope of the roof and its raw metal framework adds graceful lightness. The renovation has been a homemade affair, with the family creating new plasterworks, tinting wooden kitchen panels, or chalk-washing walls—touches that bring a harmonious, minimalist feel to the space. Natural light now pours in through a revealed double exposure, inviting the landscape in while the new outdoor deck elegantly extends the living room lines, blending shapes with the landscape.

"*You can hear the sound of the waves from the house and smell the scent of the pine trees. The light by the ocean is so special that we actually let that environment influence us,*" says Aurélie. A soft, white palette favors the house's simple interior decor where natural, undistorted materials combine effortlessly with flea-market furniture and designer pieces. "*We would all feel a massive sense of loss if we had to move away from the sea now.*" Indeed, the relocation has proven to be such a positive lifestyle change for the whole family and has even inspired new creative endeavors, something Aurélie shares with her recent handcrafted ceramic lamp collection, which echoes their home's soulful, slow-life vibrations.

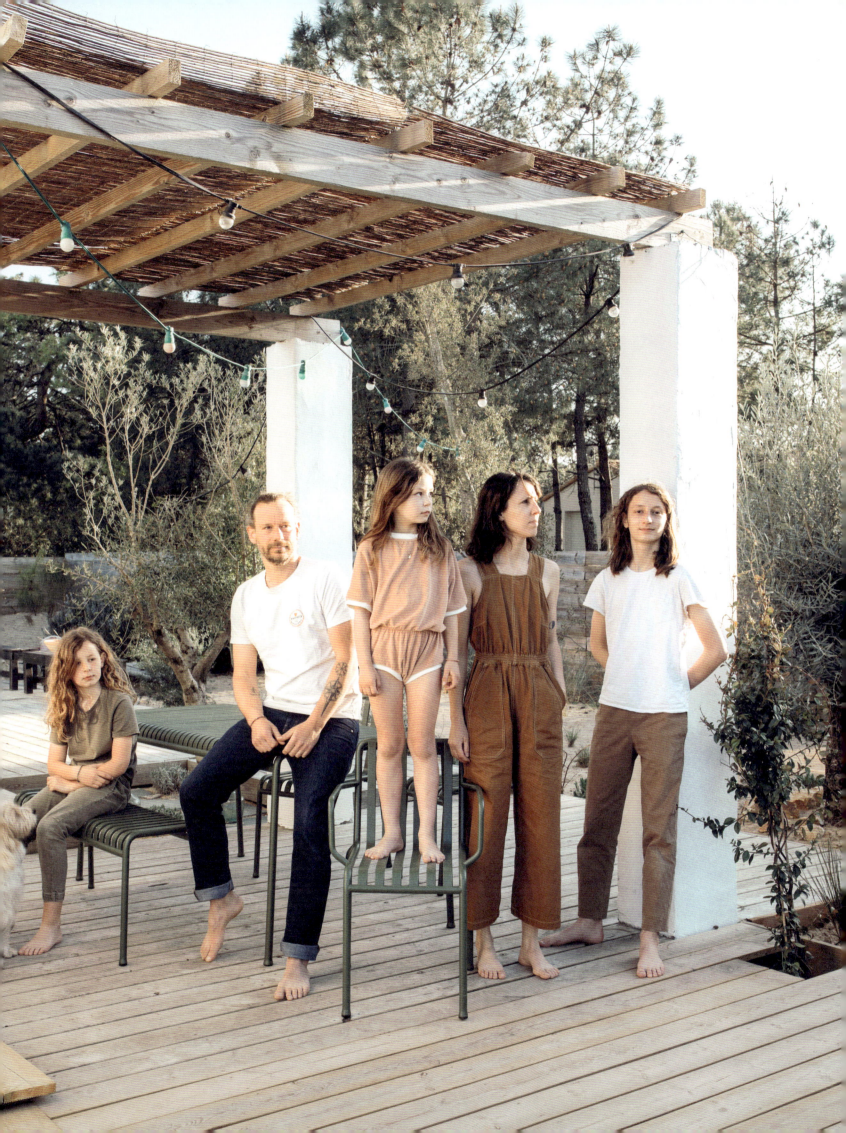

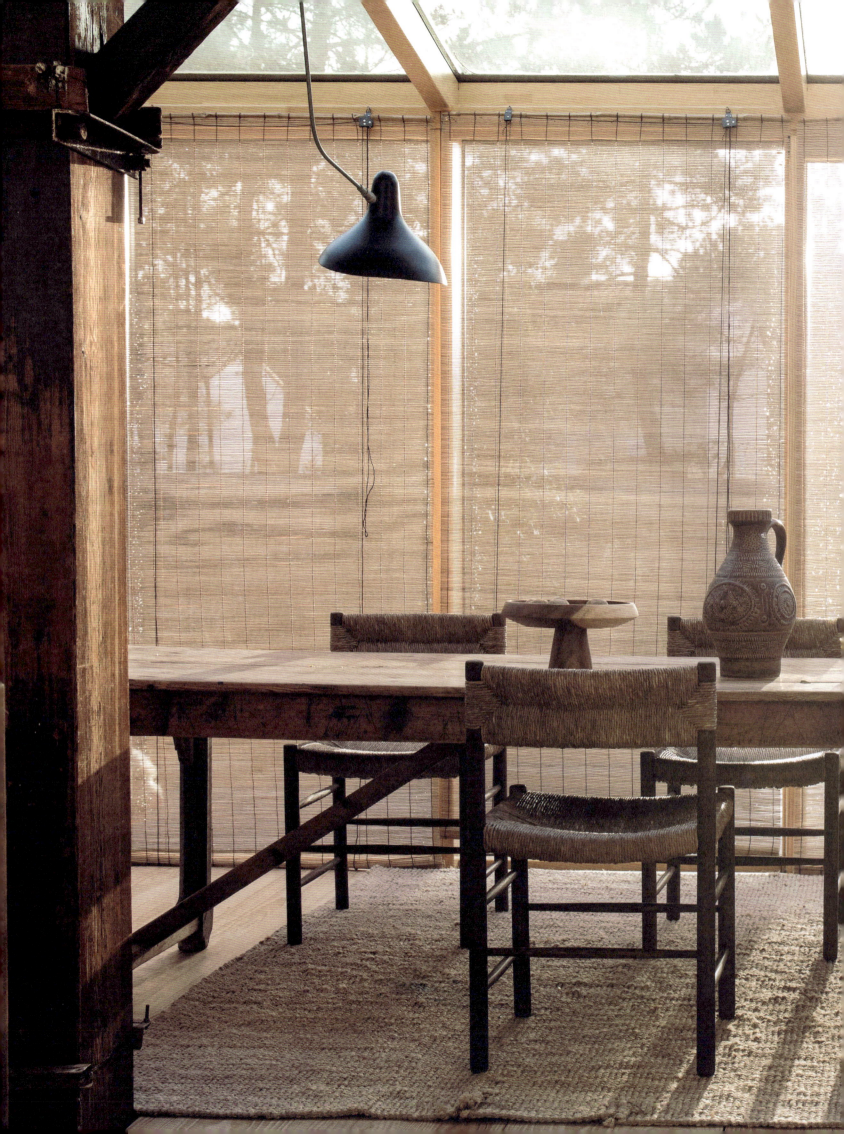

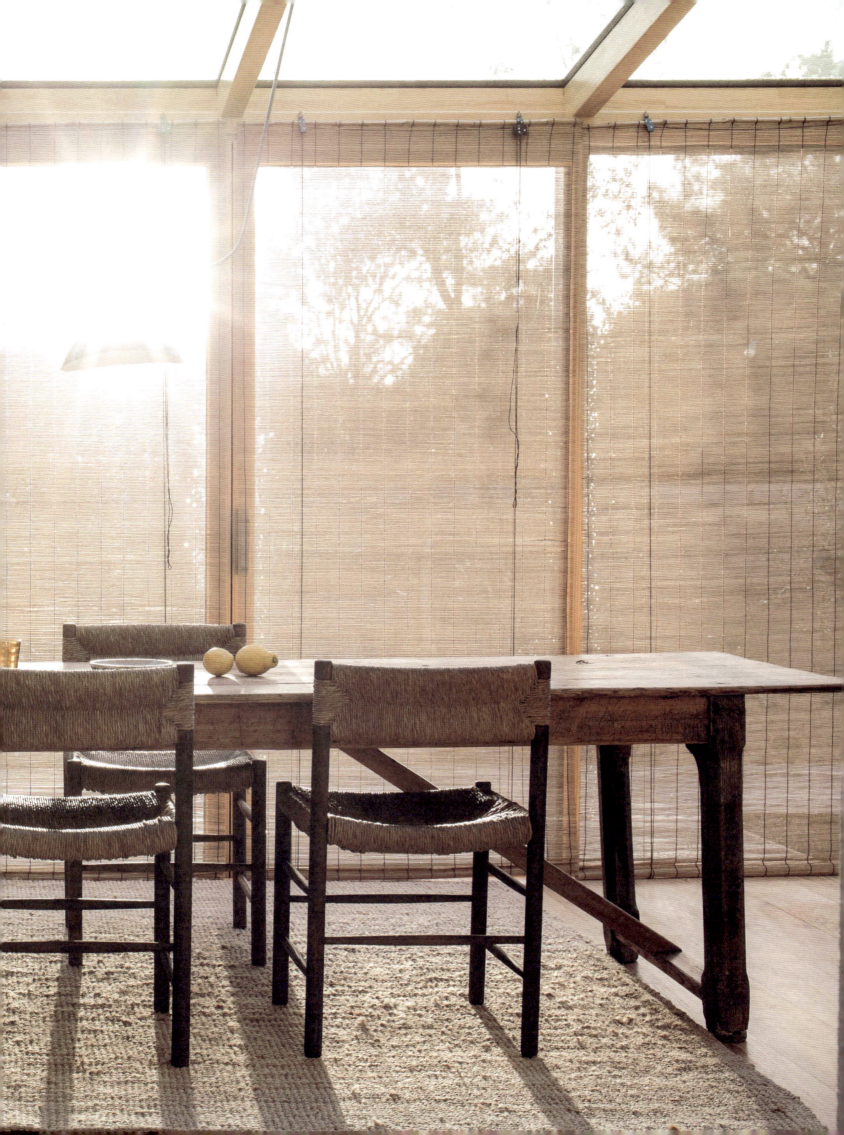

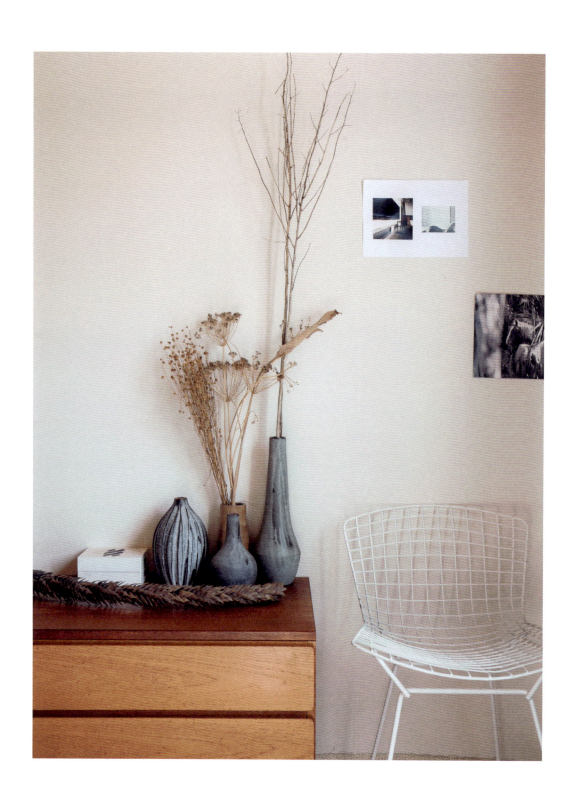

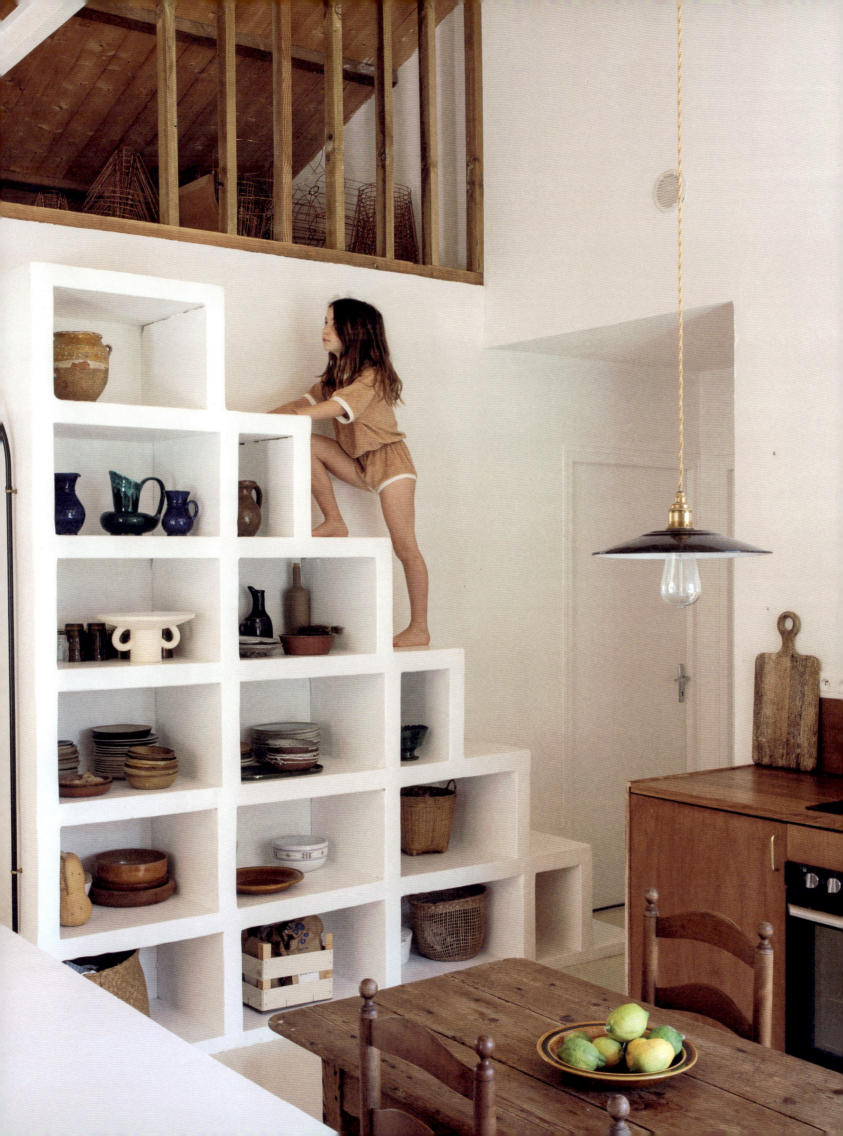

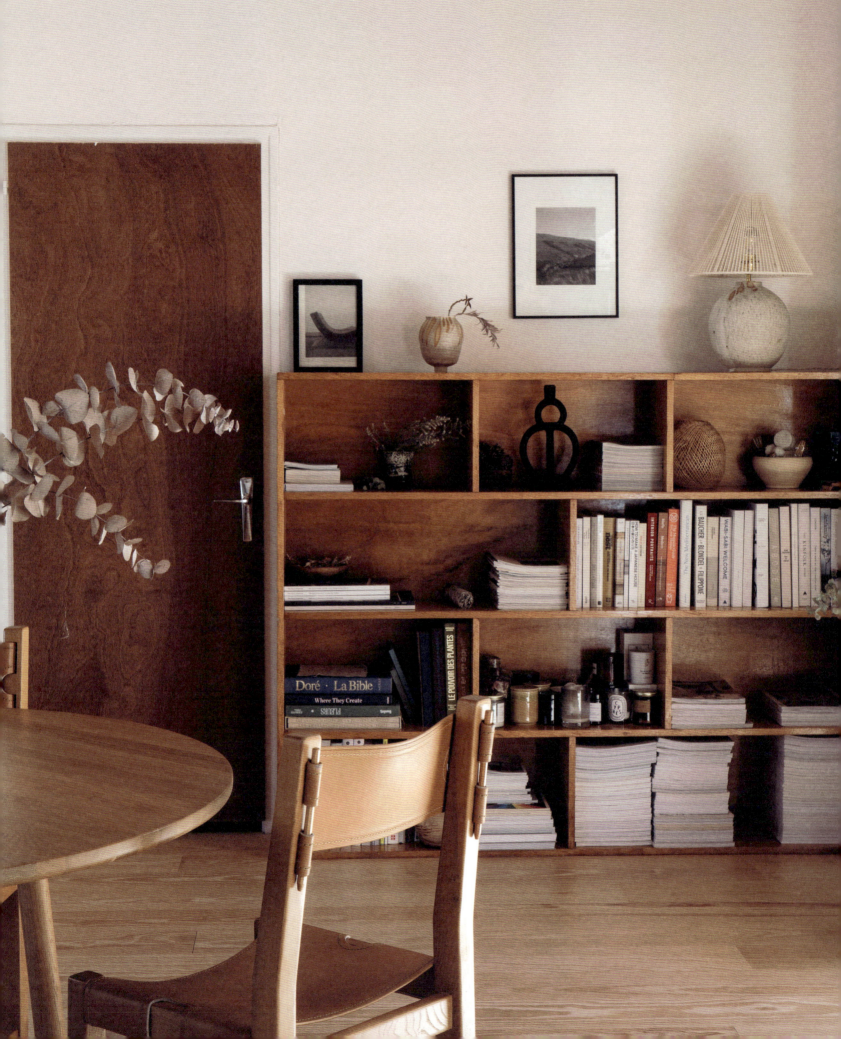

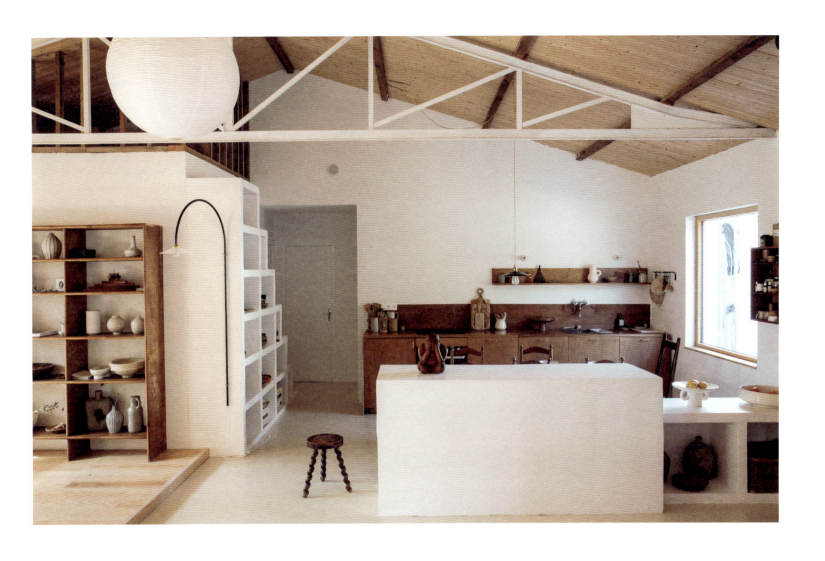

"THE KIDS CONVERTED THE BEACH INTO THEIR PLAYGROUND,
A BOUNDLESS SPACE OF COMPLETE FREEDOM. THIS CONTRIBUTES
SO MUCH TO THIS FEELING OF BEING ON HOLIDAY ALL
THE TIME, ALL YEAR LONG—IT'S A BLESSING."

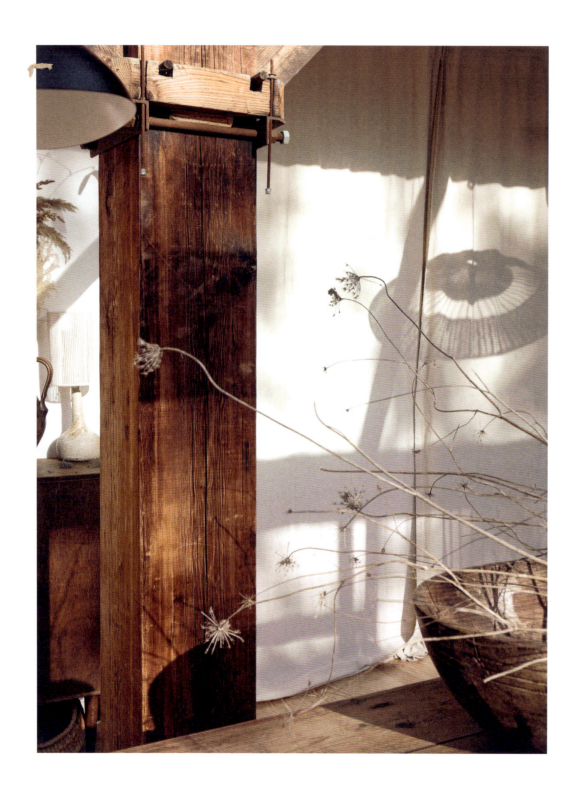

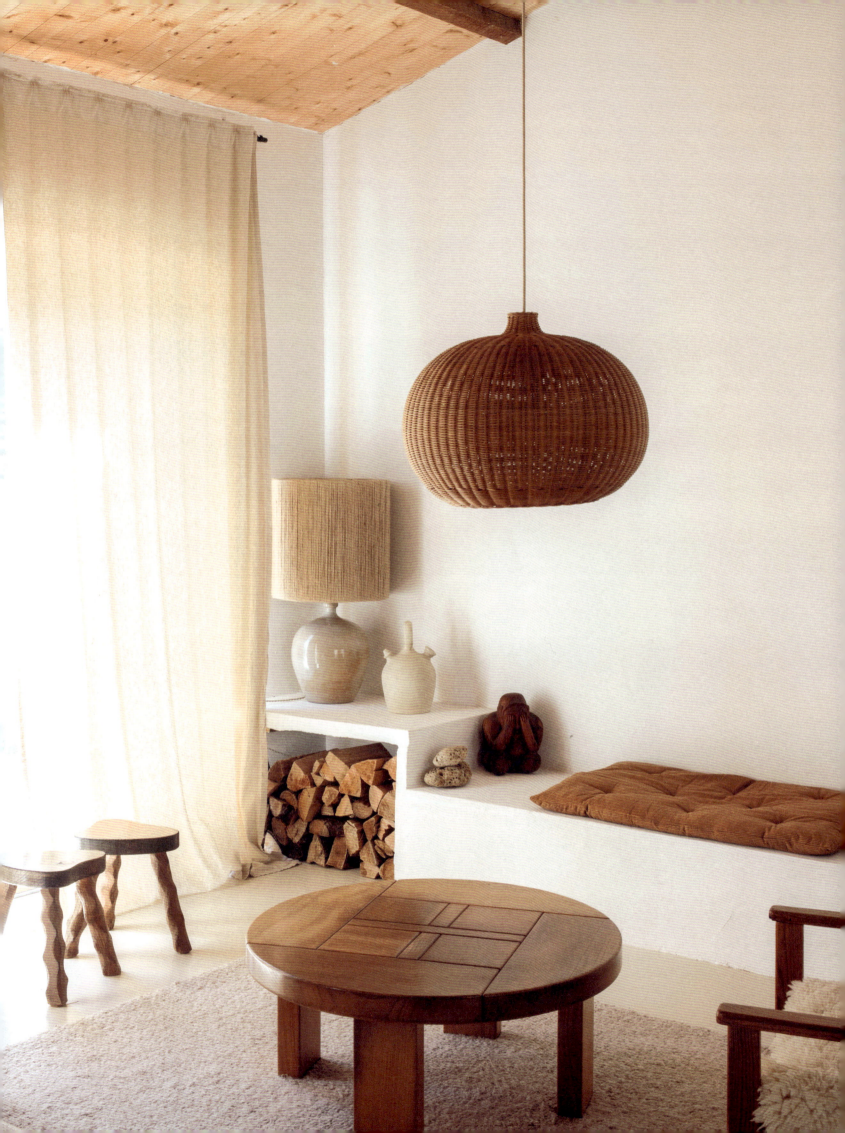

WHERE	WHO	WHAT
PARIS FRANCE	MARIANNE, CÉDRIC, ANOUK, LOULOU	HAUSSMANN APARTMENT

A modern Haussmannian flat triggers curiosity in kids

"*Anouk is named after Anouk Aimée and Loulou after Loulou de la Falaise,*" says Marianne Fersing about the twin daughters she shares with husband Cédric Chabit. The couple—who work in Paris's fashion industry—swapped the classy 8th arrondissement for the Left Bank of the Seine in 2017, hunting for a larger space and a lively neighborhood for their kids to grow up in. There, they stumbled upon an outdated yet beautiful nineteenth-century Haussmann-style apartment, a perfect match for these aesthetes, who were looking for a property to restore and adapt to their needs and tastes. Six months of meticulous renovation work later, the space exudes Parisian flavor with a modern, minimalist sophistication—a perfectly refined canvas designed to trigger the twins' curiosity.

"*Our previous interior decor was a little cold; I wanted something warmer, more flexible, and family-oriented here,*" says Marianne, who orchestrated the interior renewal herself. A white palette highlights the space's majestic Haussmannian architectural details: high, ornate ceilings, floor-length windows with richly detailed handles, delicate moldings, herringbone parquet floors, and a marble fireplace. Classical elements of style skillfully mix with rational lines and the shapes of modernist furniture designers—an original Pierre Jeanneret desk and chairs are pieces dear to Marianne's heart—while happy flashes of color come from an edited selection of design objects and the couple's extensive collection of books. Marianne feels strongly about passing her love of beautiful things on her daughters: "*They love colors and prints—they're already very mindful of beauty.*"

While marble is the key material running through the apartment—softly balanced by elements of wood—the ethereal harmony of the space finds contrast in the darker atmospheres of the children's rooms: each twin has a unique, dream-like universe full of flowery wallpapers and rich, enchanting shades. "*They have different toys: Anouk has a small desk where she loves to draw; Loulou has a miniature theater and a kitchen. They love to put on puppet shows and play tea parties together!*"

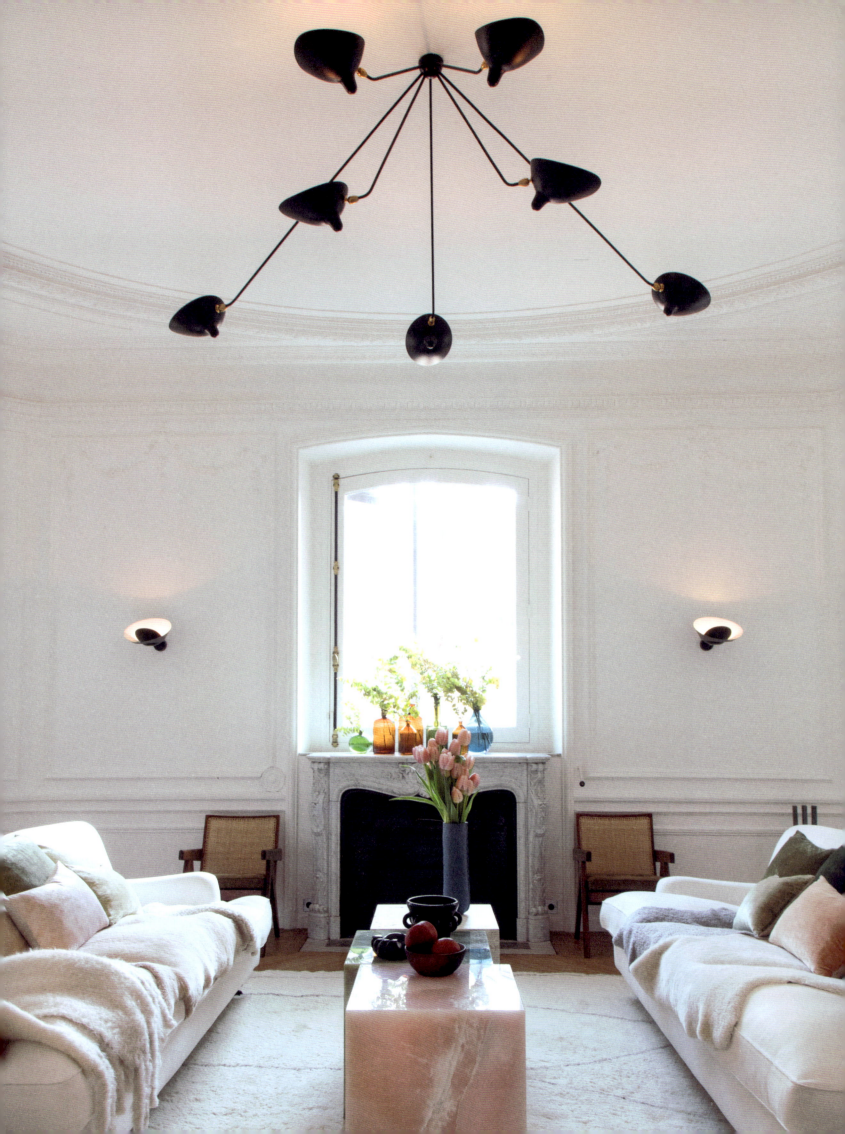

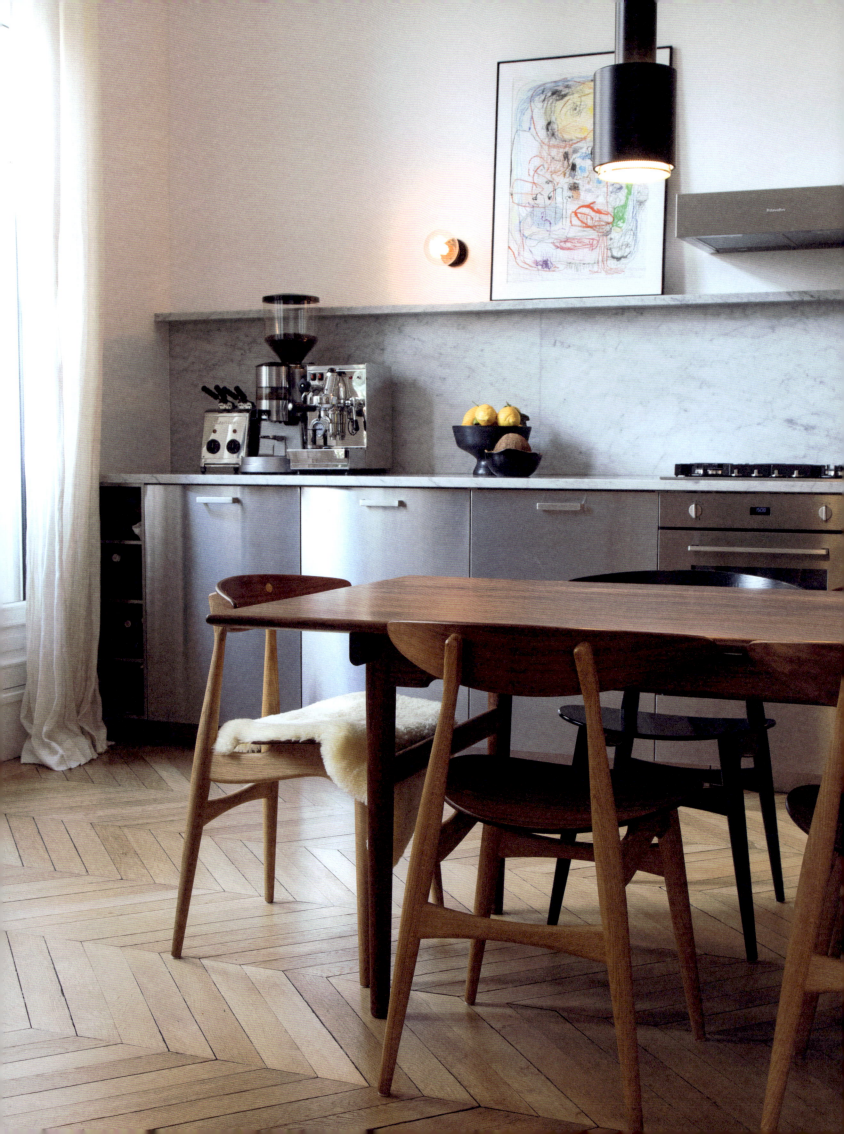

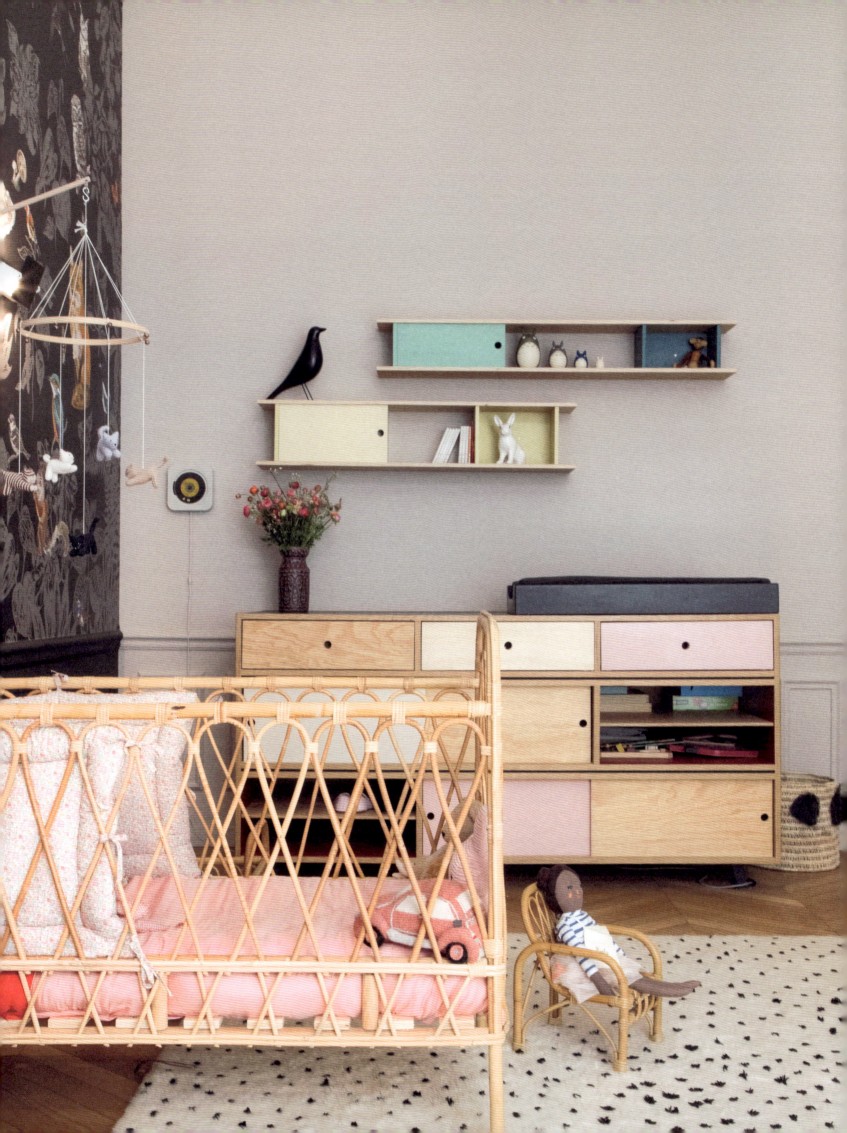

WHERE	WHO	WHAT
UMEÅ SWEDEN	SORAYA, MICHAEL, JACK, JAMES, NOEL, BENJAMIN, CLARA, TIM	18TH CENTURY COTTAGE

A poetic eighteenth-century cottage for a family of eight

Umeå is a Swedish city located 600 kilometers north of Stockholm. This is where designer and interior designer Soraya Forsberg and digital sales manager husband Michael decided to move their big family four and a half years ago, swapping the capital's frenetic pace for the more peaceful lifestyle of Michael's hometown. There, they stumbled upon a decrepit yet graceful eighteenth-century cottage, which came as a great opportunity for the six kids of the family—Jack (19), James (17), Noel (14), Benjamin (10), Clara (8), and Tim (7)—to finally get their very own space while the garden could make Diesel and Bamse (the family's dogs) happy. Above all, the whole revamp project was an ideal playground for Soraya to unleash her fervent creativity.

"*The main floor was originally divided in two parts with a shop at the back, and there was nothing upstairs but a very cold attic. We started the renovation work by re-thinking the ground-floor layout completely, did some painting, and tore up the lino to reveal a magnificent wooden floor. The next step was to transform the first floor into what it is now,*" says Soraya. This upper level now hosts four new rooms, an office, a guest room, and an open area where the children can play and welcome their friends, but the house as a whole has regained its original splendor. The half-timbered walls were whitewashed, exposing their beautiful imperfections, while earthy colors created by Soraya inject a timeless elegance. These combine with a selection of vintage and second-hand objects to enhance the beautiful, classic Scandinavian aesthetic of the house.

"*In Stockholm, the kids always had to share space so they couldn't really have friends over. Now, we often have two to six additional children at home—and I love it!*" Soraya, whose expertise extends to interior styling and product design, recently embarked on studying landscaping. "*When we bought the house, there was nothing but grass in the garden. Today we have a vegetable garden and a greenhouse we built. I really enjoy being outdoors and I'd love to be able to help my clients to imagine both the interior and the exterior of their family home.*"

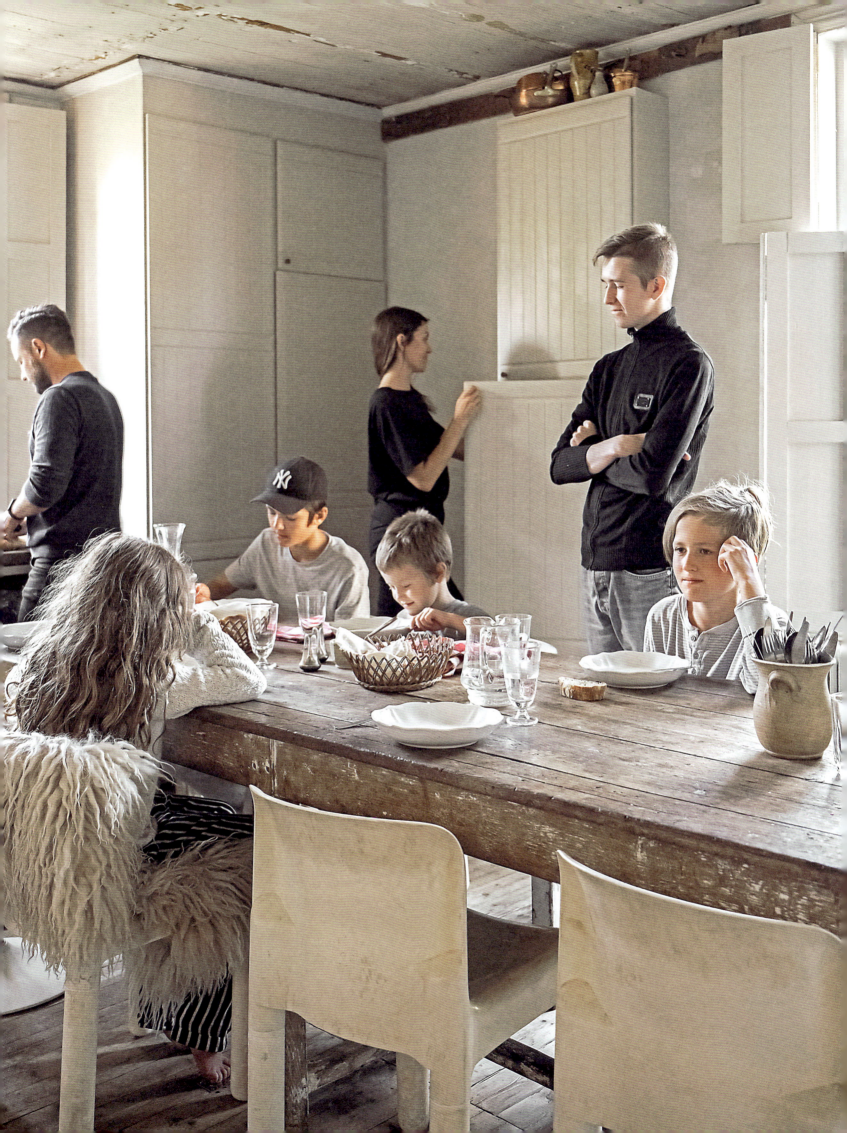

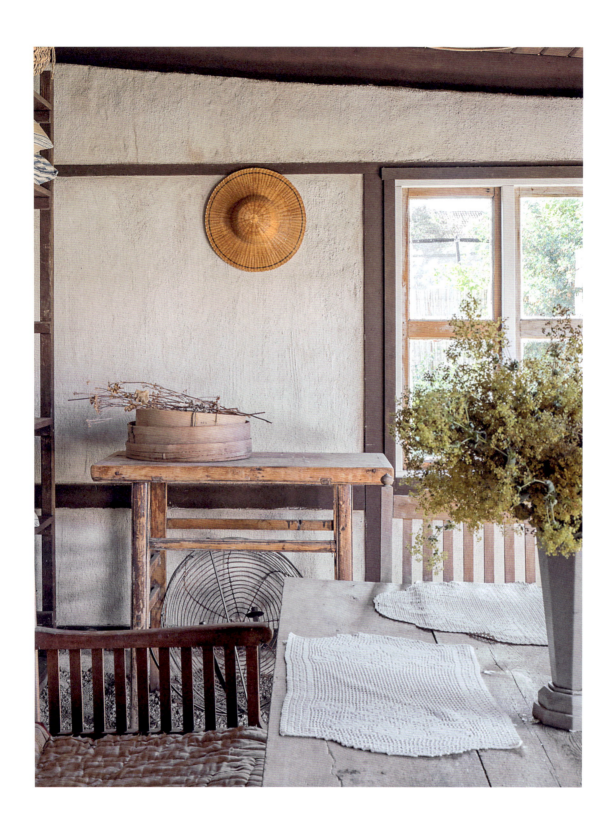

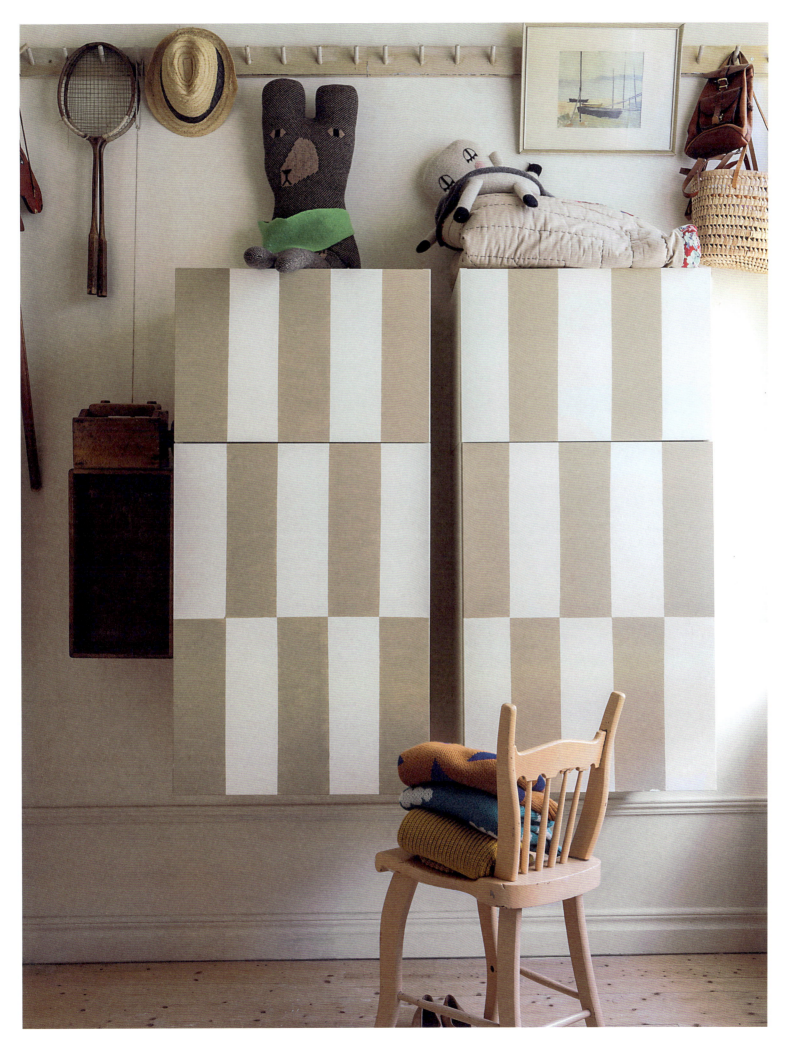

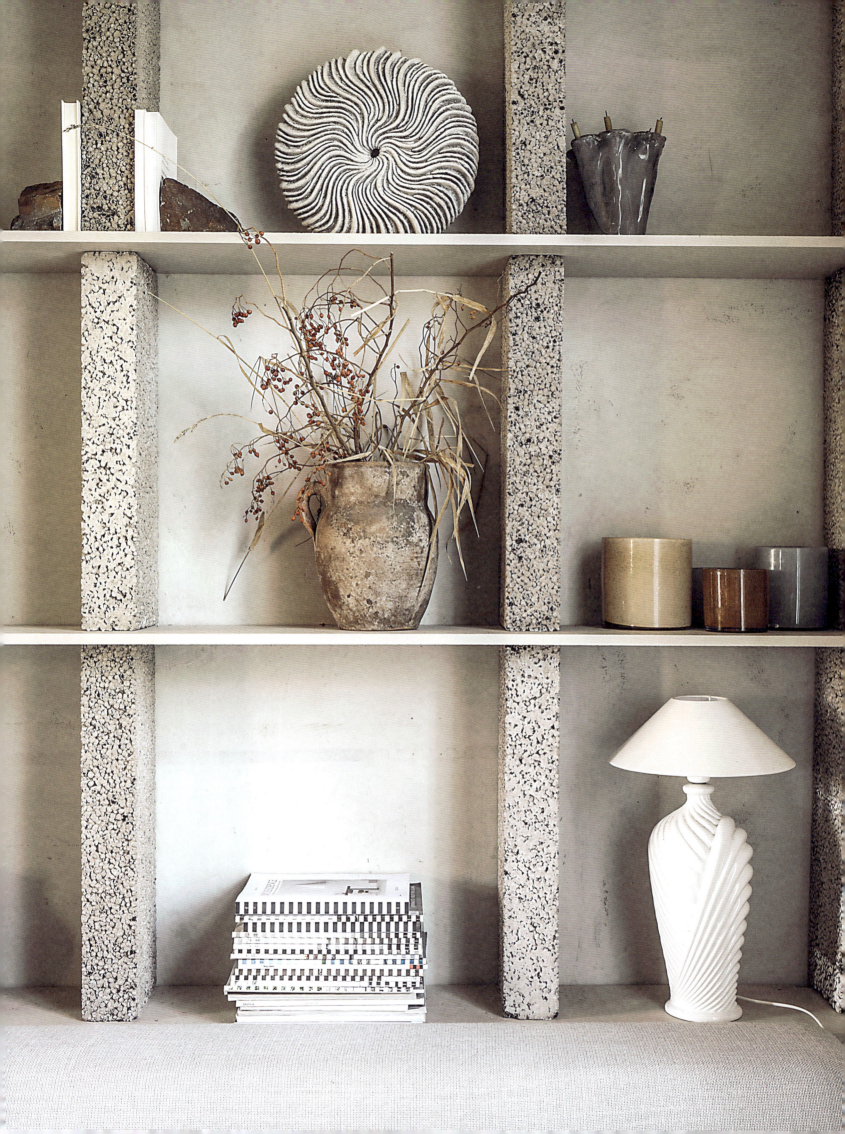

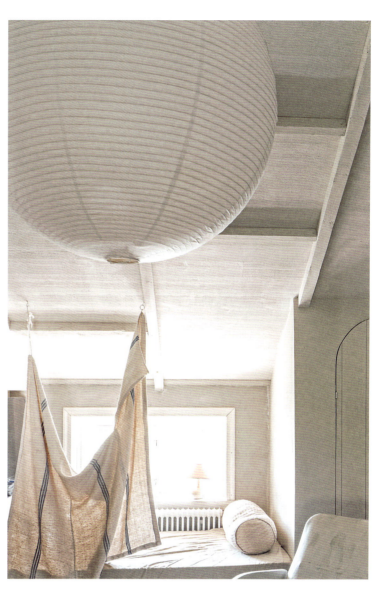

"IN STOCKHOLM, THE KIDS ALWAYS HAD TO SHARE SPACE
SO THEY COULDN'T REALLY HAVE FRIENDS OVER.
NOW, WE OFTEN HAVE TWO TO SIX ADDITIONAL CHILDREN
AT HOME—AND I LOVE IT!"

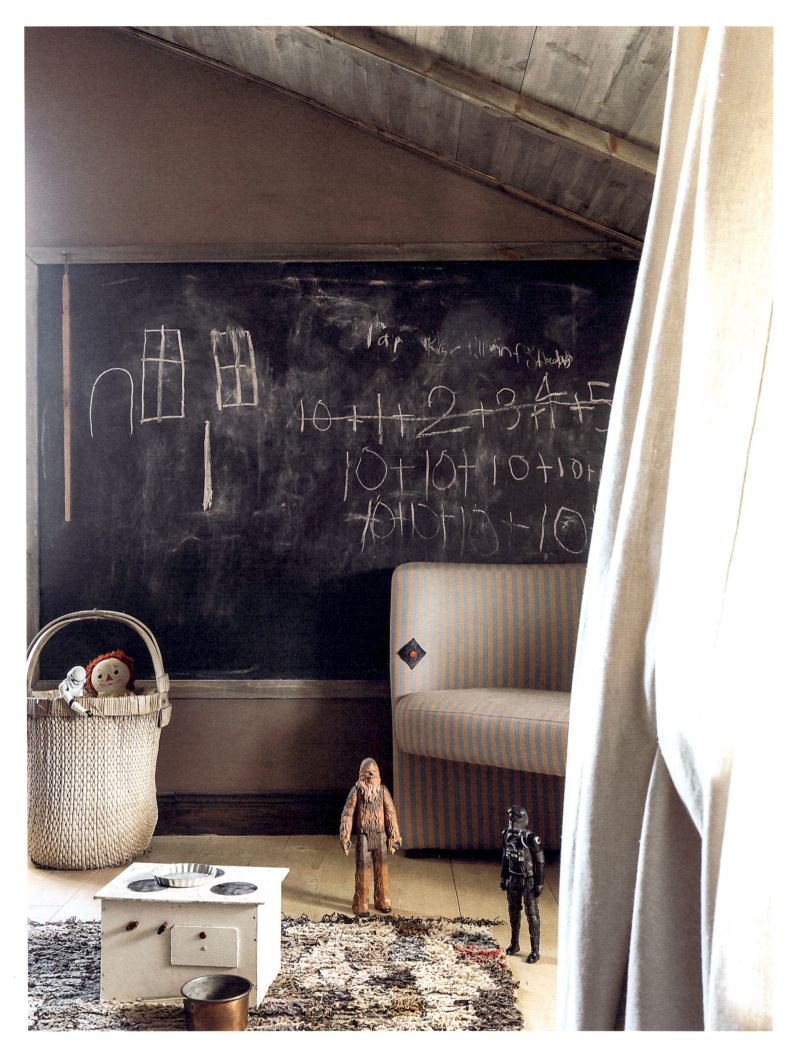

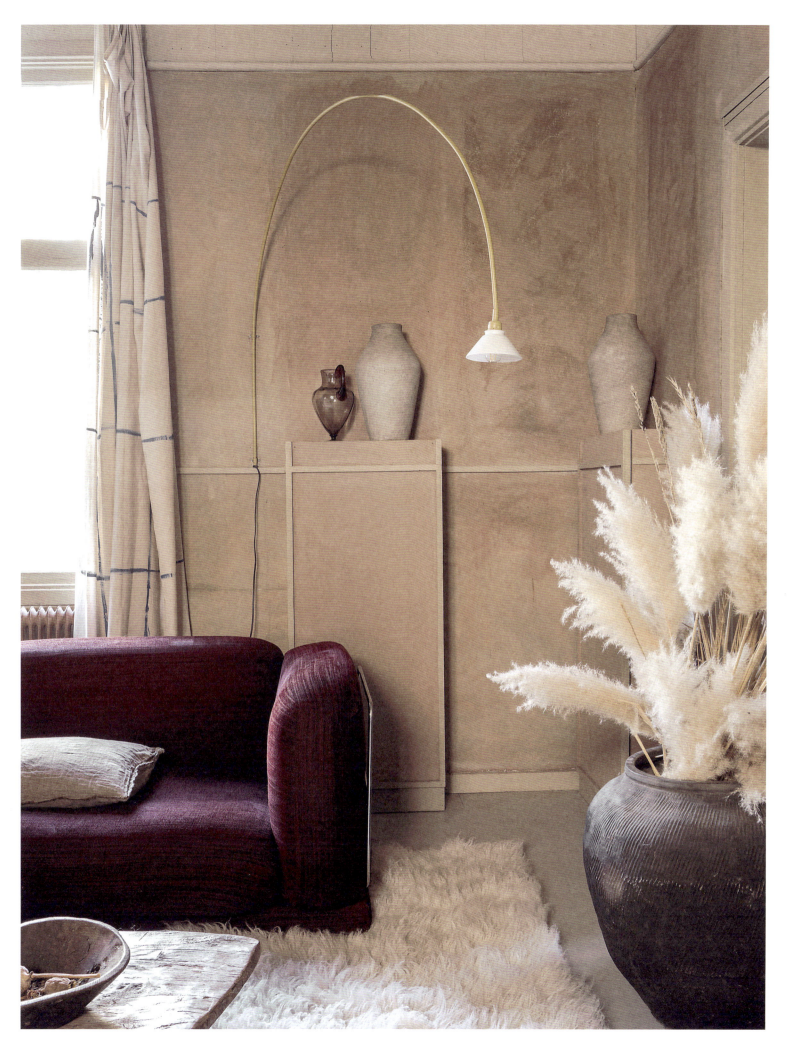

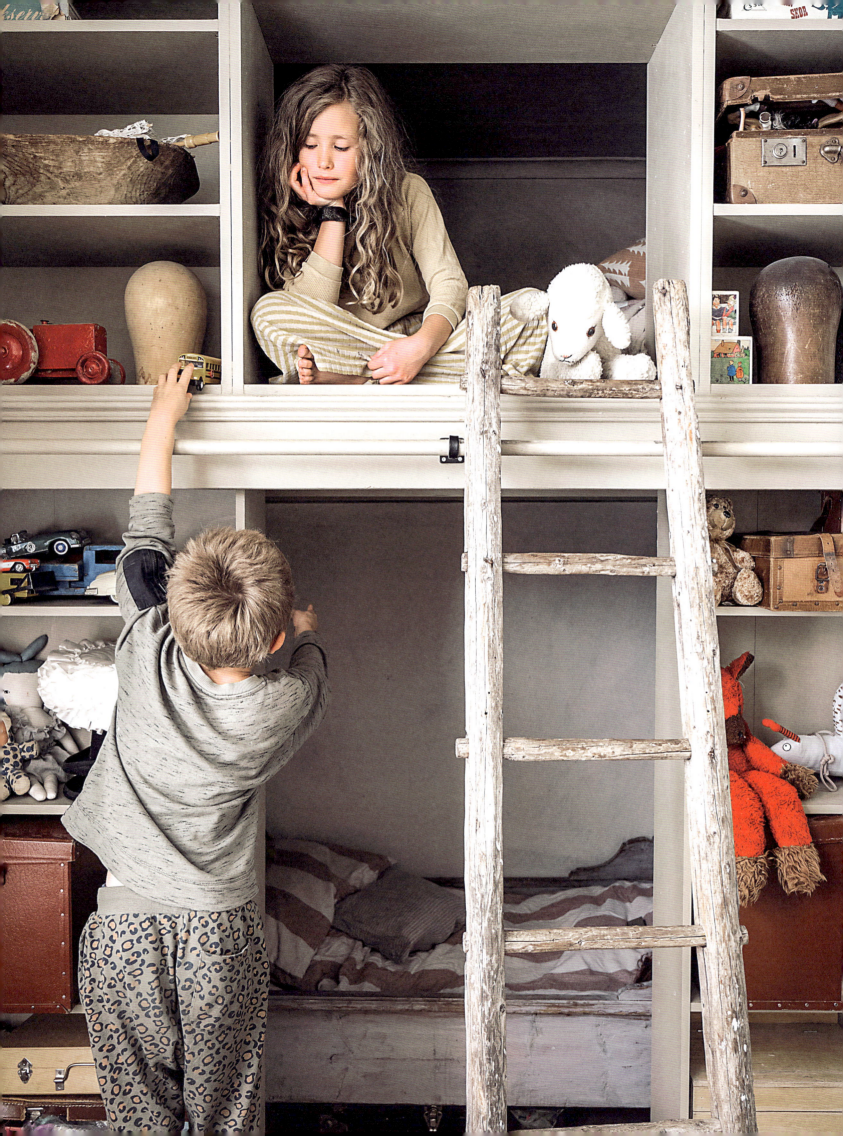

WHERE	WHO	WHAT
NUENEN AREA NETHERLANDS	KIKI, JOOST, PUK, KO	INDUSTRIAL FARMHOUSE

A traditional farmhouse infused with a whimsical industrial feel

"We're close to Nuenen, the village where Vincent van Gogh lived and worked for a few years. We love the idea that he may have walked in these same fields that surround us today," says Dutch designer Kiki van Eijk about the protected natural area enveloping the beautiful 1890 farmhouse she bought with husband Joost van Bleiswijk. Depicted indeed in some of Van Gogh's major paintings from around 1885, Nuenen is a rural area ideally located 15 minutes away from Eindhoven, a perfect match for this designer couple raised in the countryside and their two sons, Puk (5) and Ko (18 months), who were looking to spend more time outside in the open air.

Leaving behind the bustling Strijp neighborhood—the creative epicenter of the Dutch capital—Kiki and Joost undertook a complete transformation of the listed building, maintaining the beautiful 30-meter-long (98-foot-long) outdoor brick walls while opening up the interior of the farmhouse to create an industrial duplex volume. *"We knew we wanted a polished concrete floor and a metal staircase, but we had no precise ideas about interior design. We just tried to find the best solution according to each room's specifications—either a piece of vintage industrial furniture or a unique designer creation—and when we couldn't find a solution, we designed it ourselves!"* The result is an eclectic mix of objects and artworks with a colorful, whimsical feel indicative of Kiki's design DNA, which combines with a few strong pieces designed by colleagues and friends like Maarten Baas or Bertjan Pot, and some of Kiki and Joost's own works or prototypes.

"I love to sit here, in our Hans J. Wegner rocking chair under the 'Construction' lamp designed by Joost for Moooi, with my feet on a carpet I designed for Nodus. It's a perfect place to gaze out into the fields through the bay window," says Kiki about her favorite spot in the large, loft-like space where the kids run and scatter their toys everywhere. Next step for the couple would be adding their very own design studio and gallery to this haven, to fully fuse their personal and professional worlds.

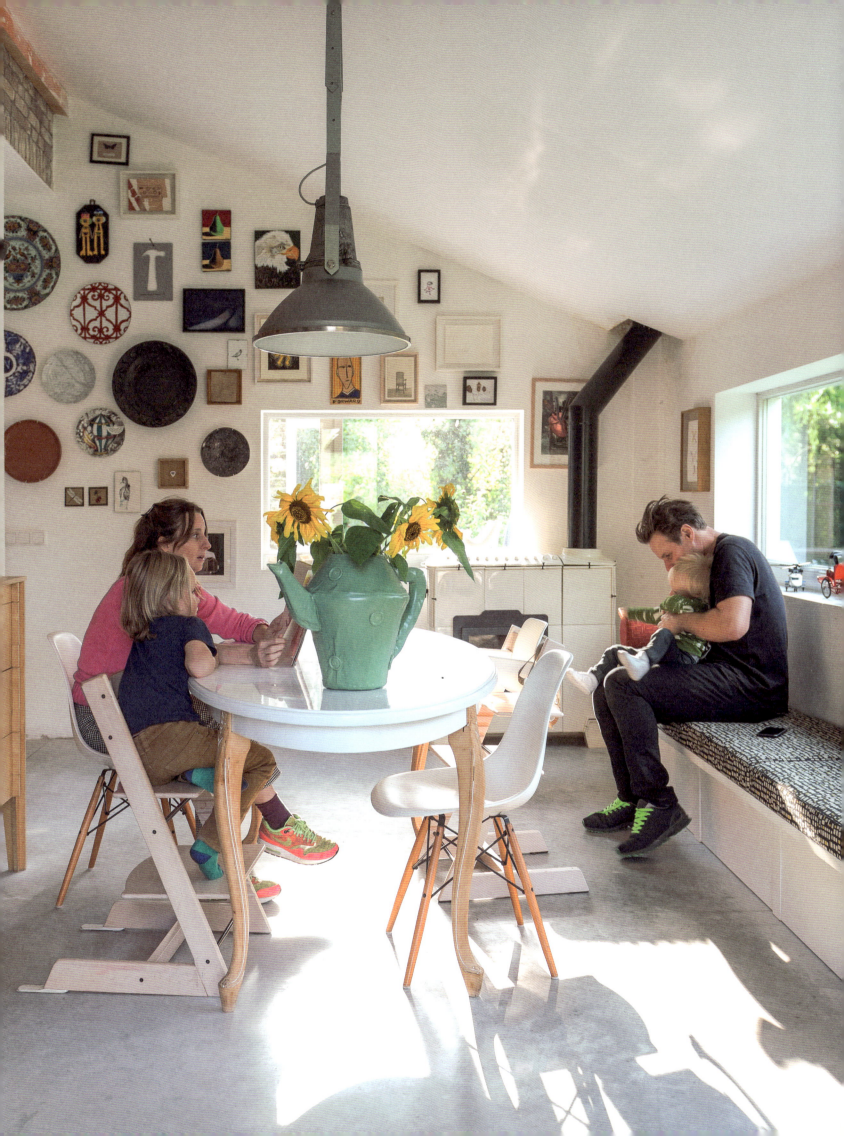

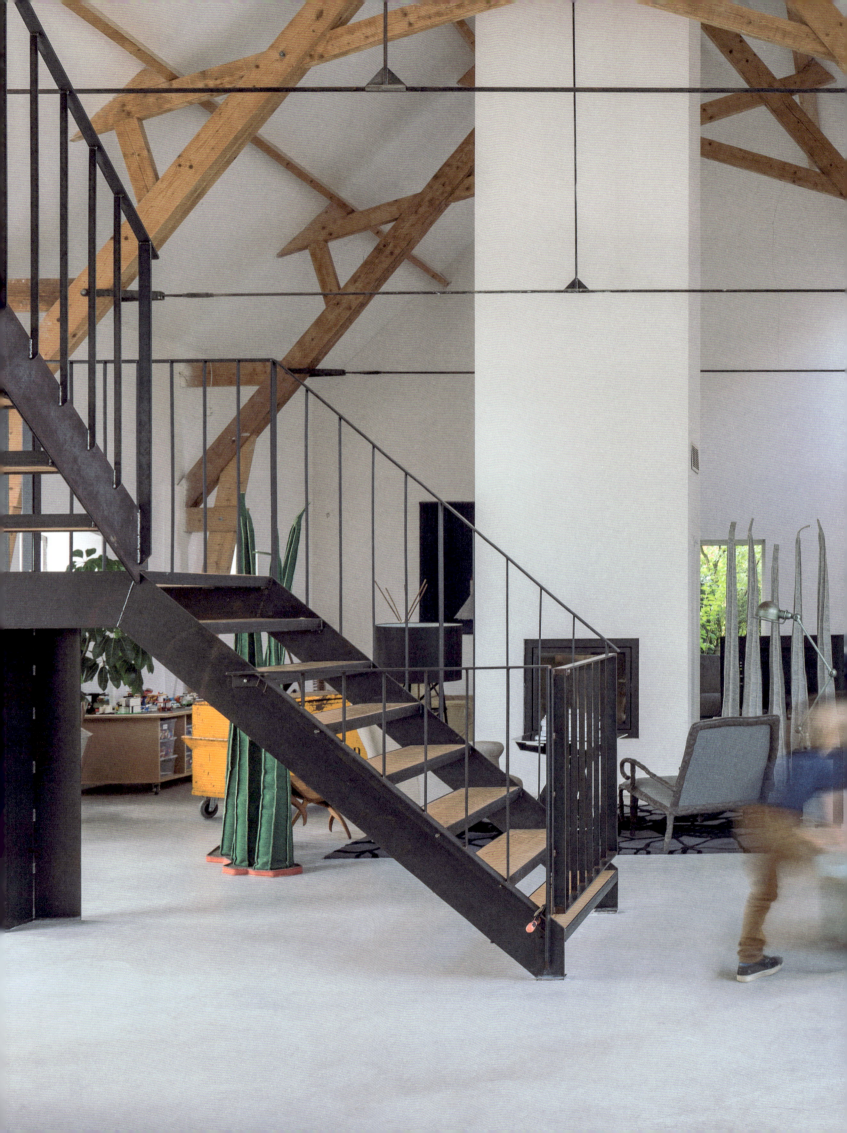

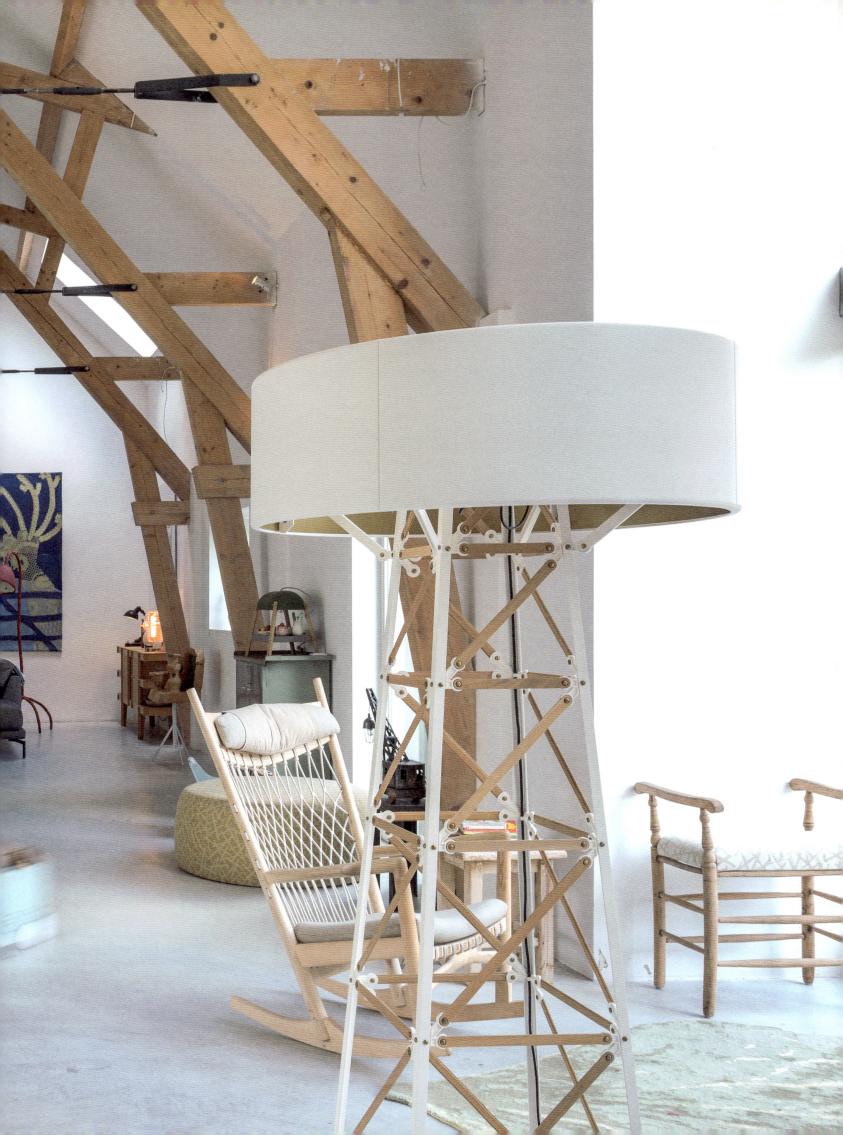

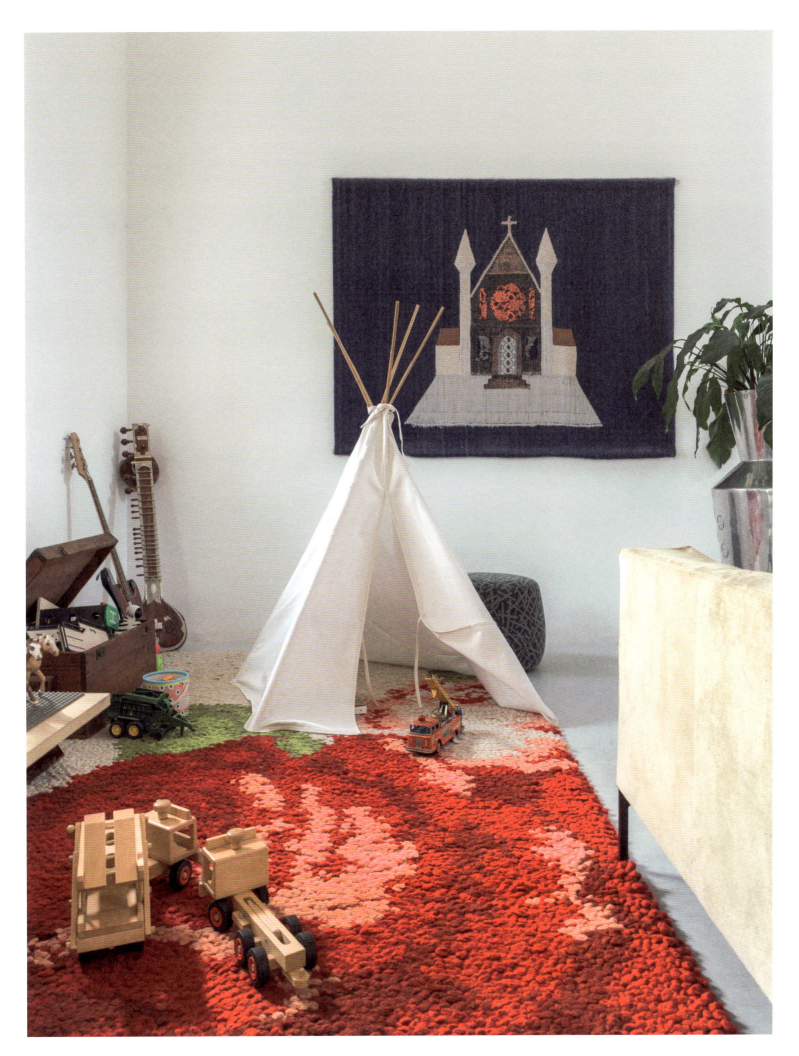

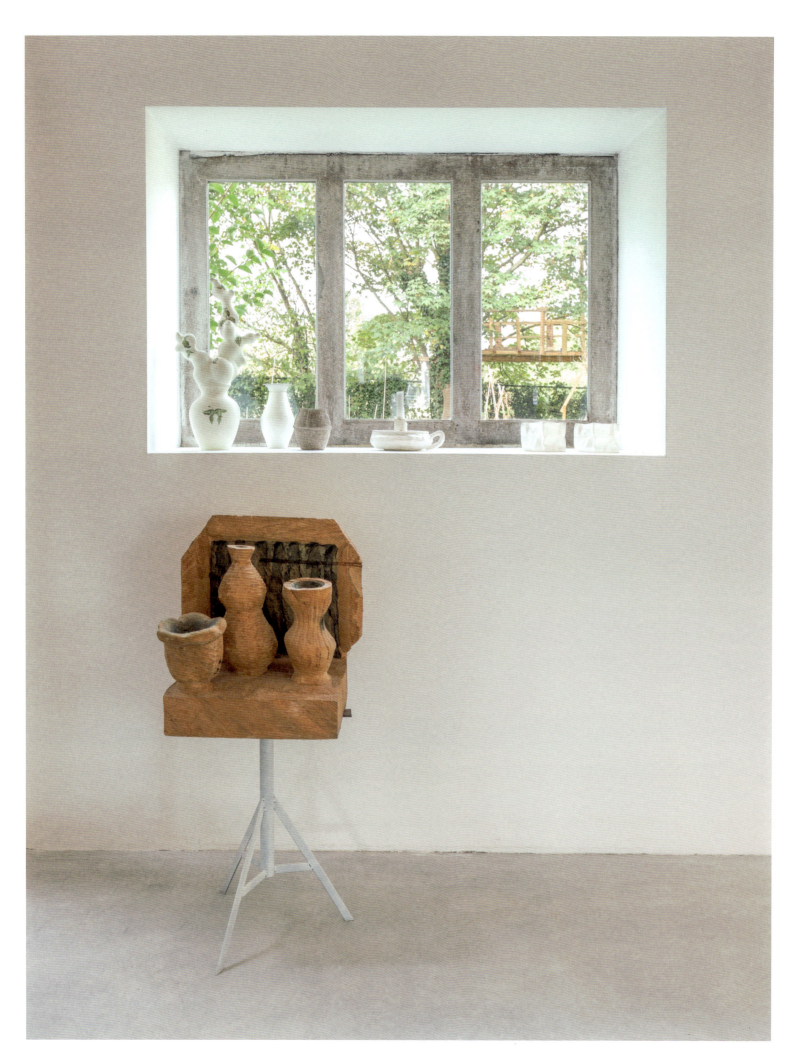

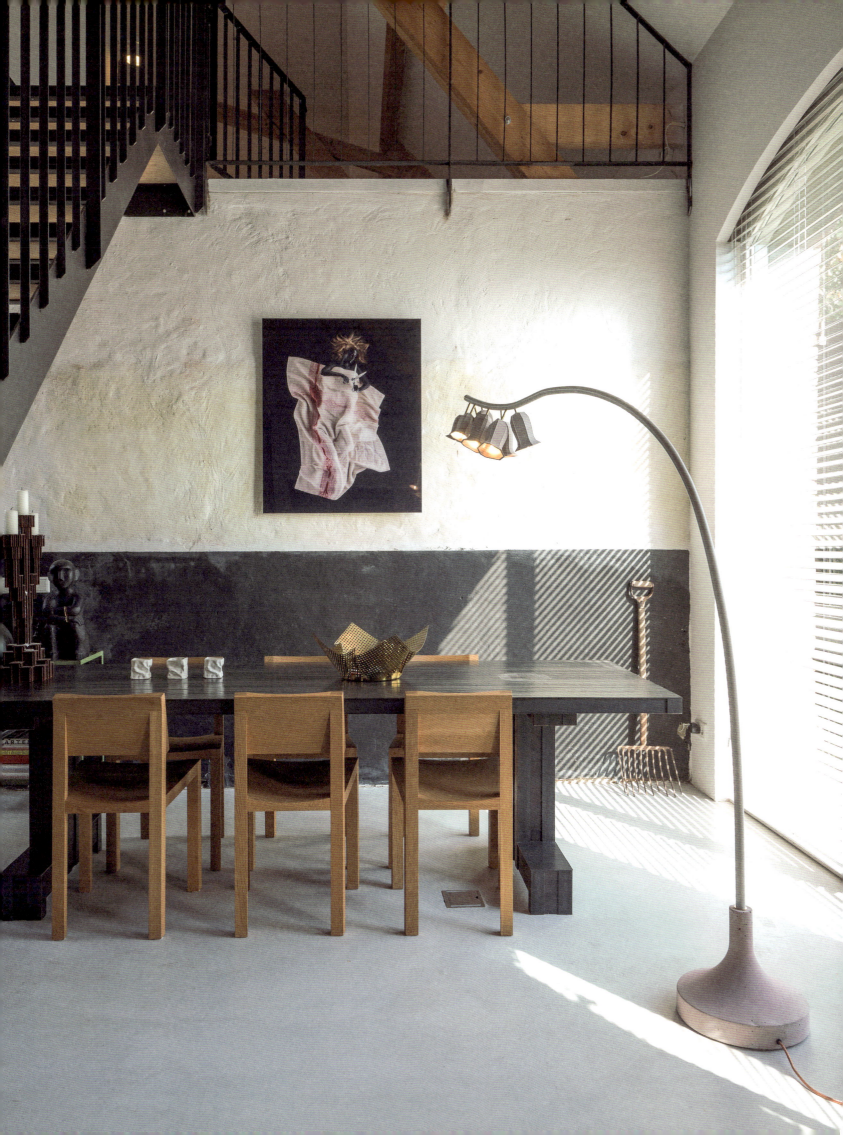

WHERE	WHO	WHAT
MILAN ITALY	MARCO, ISABELLA, VIRGINIA	TIME CAPSULE APARTMENT

Elegance and playfulness invigorate a traditional apartment

The passing of time is a palpable sensation in the Milanese apartment that is home to Marco Lobina, founder of resin floor company Rezina, his wife Isabella, and teenage daughter Virginia. Overlooking a peaceful tree-filled courtyard in the Brera district, the generous proportions of the traditional interior mixes contemporary references and vintage codes in such a refreshing, spirited way that it thrills the senses—as if springtime has permeated every single corner of the vivacious space. Envisioned by Italian architecture duo Andrea Marcante and Adelaide Testa (ex UdA Studio), the interior design project focused on reinterpreting the feel-good atmosphere of a grandmother's house with a rigorous yet playful contemporary eye, creating a family-friendly sanctuary that the trio could retreat to within lively Milan.

"*Interior design for us is about balance: elegance on the one hand, playfulness on the other,*" say Andrea and Adelaide, whose strong signature blends these two narratives with a magical sense of composition. For this project, their inspiration came from the famous 1958 French film *Mon Oncle*, where the simple warmth of Monsieur Hulot's home is favored over a high-tech voguish house where people feel uneasy. Besides adding a bathroom and changing the kitchen's location, the architects respected the apartment's original layout, focusing their attention on volumes by creating colorful, geometric, micro-architecture to divide the space (like the beautiful cane screen separating the living room from the kitchen), framing wooden parquet floors with zesty-colored resin borders, adorning walls with floral papers, and applying darker herbal shades in the corridors. The rejuvenated arrangement is completed with a selection of elegant vintage pieces and tailor-made furniture designed by the architects for the kitchen and the bathroom.

The result is an uplifting space where past and present combine in an unconventionally graphic manner, halfway between a soulful countryside house and an effervescent urban nest where Marco, Isabella, and Virginia can unwind and happily recharge their batteries.

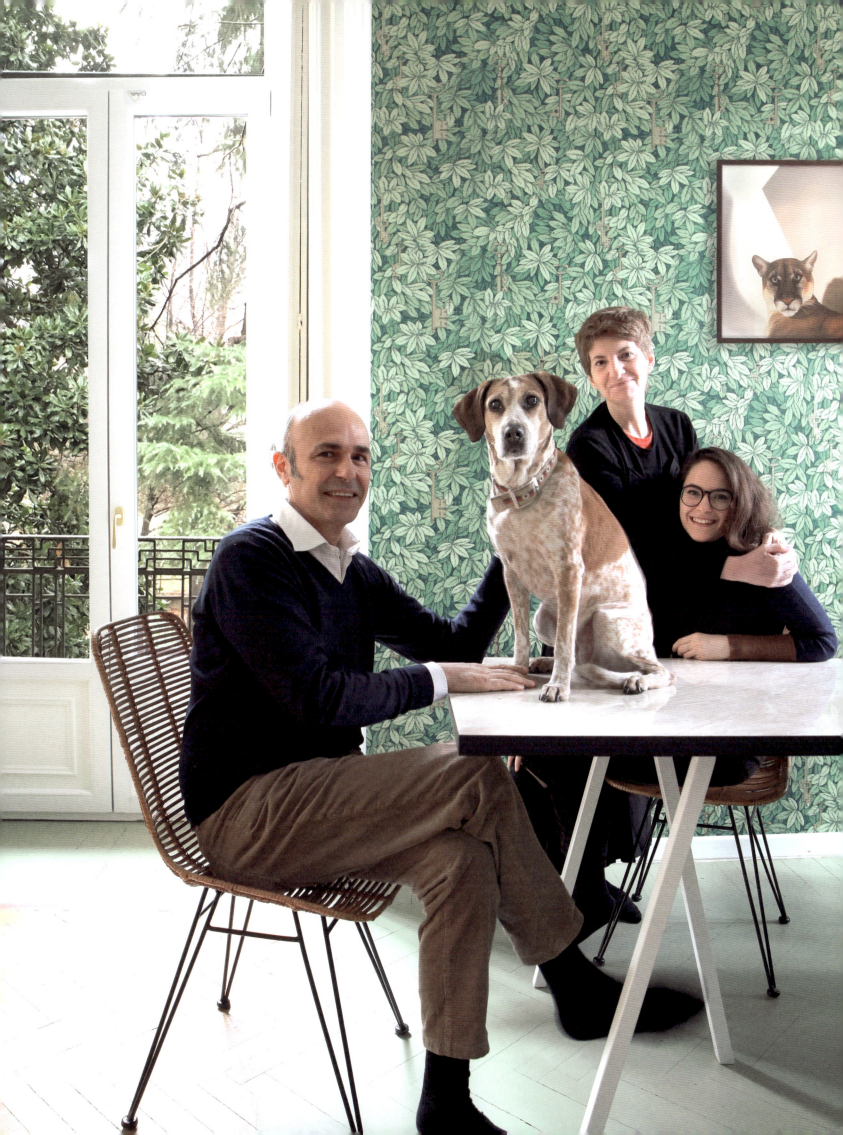

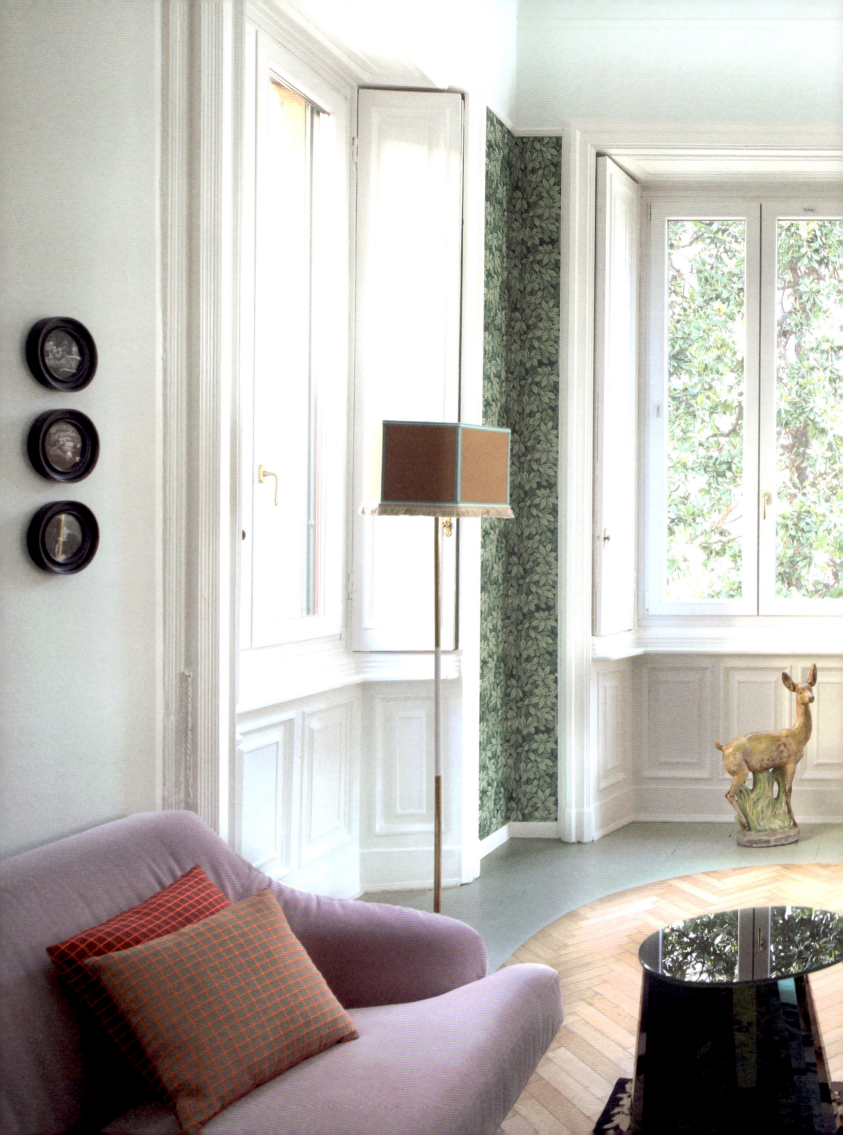

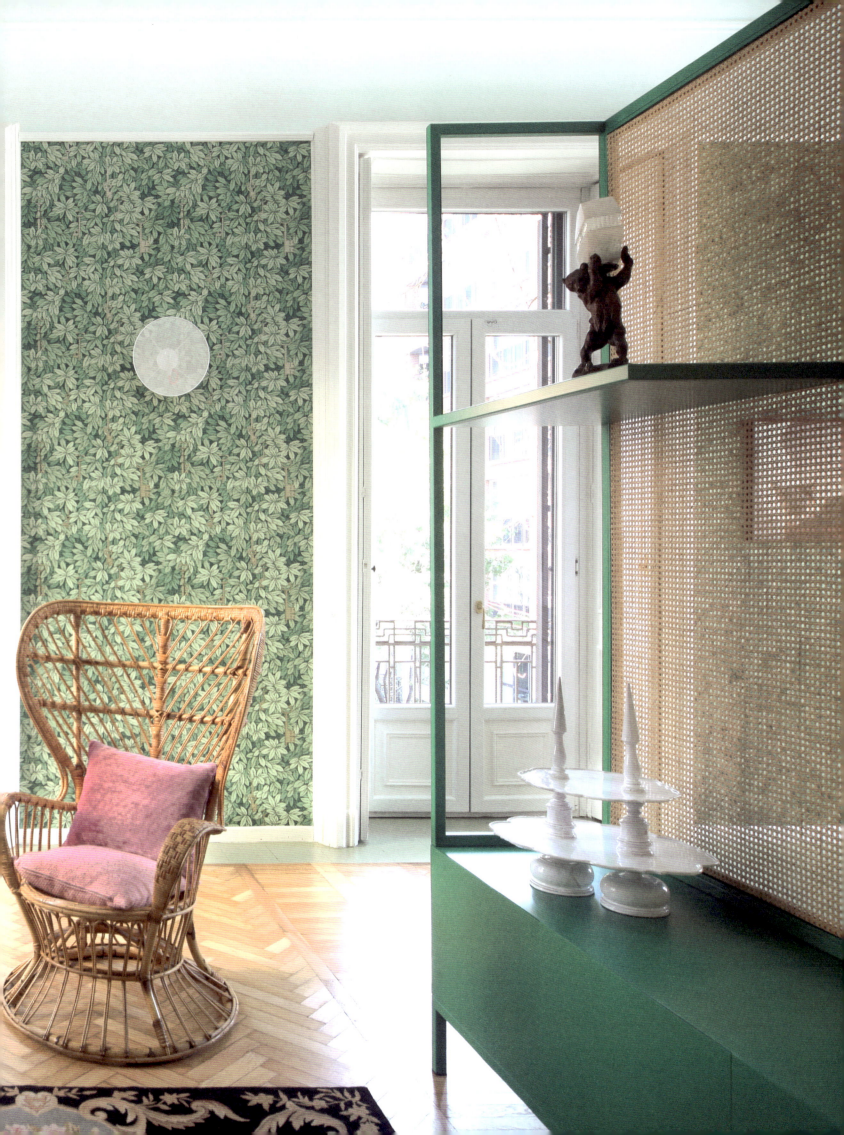

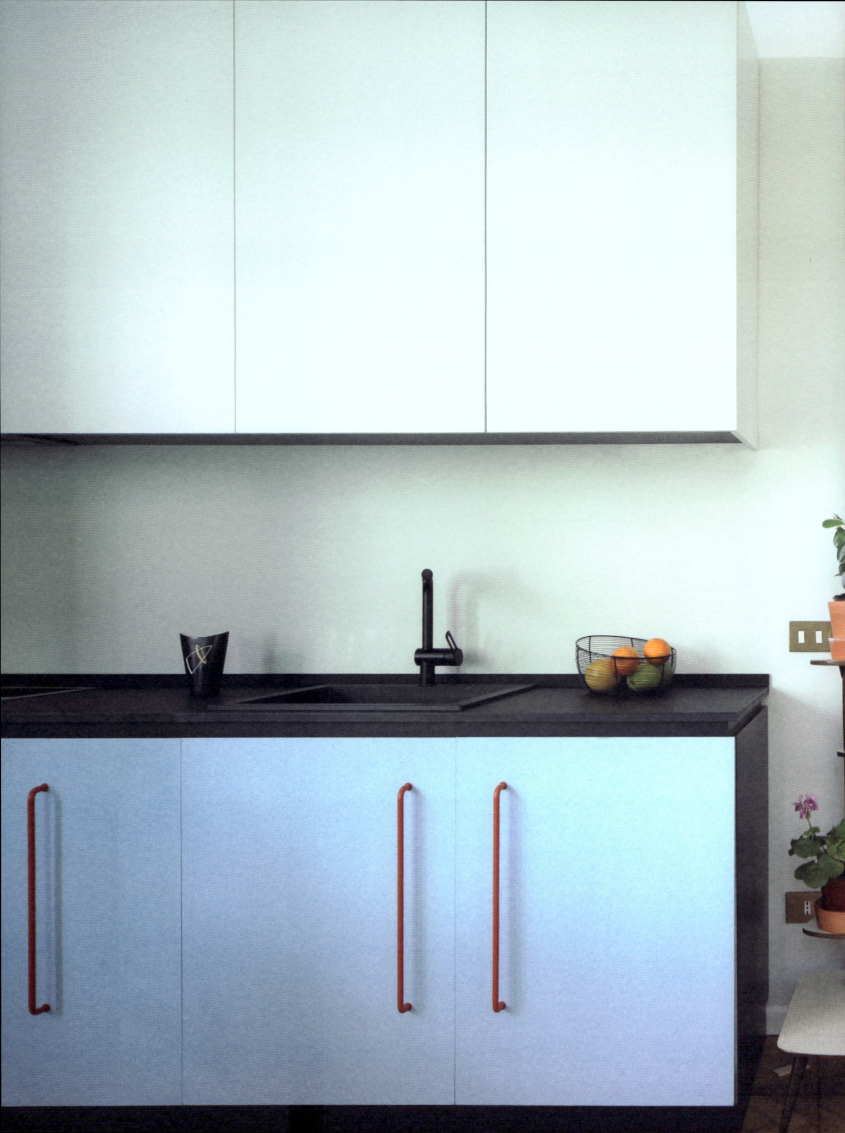

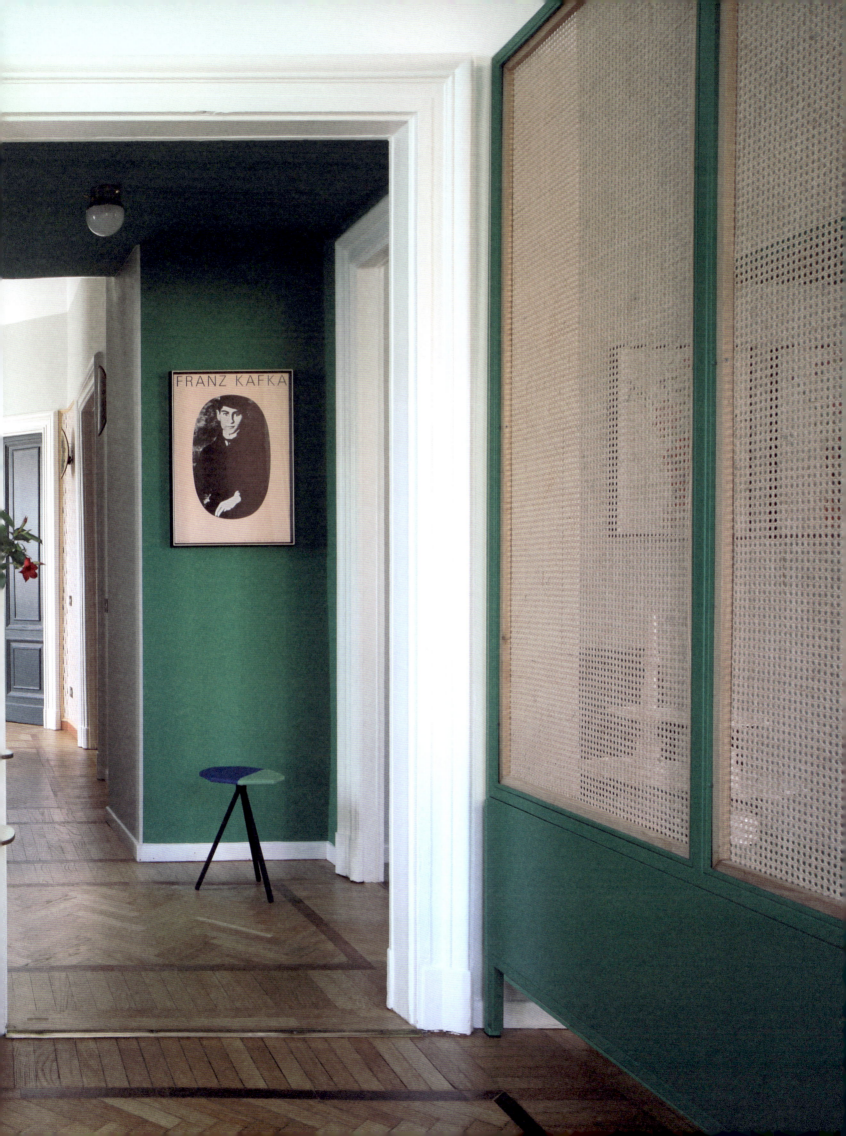

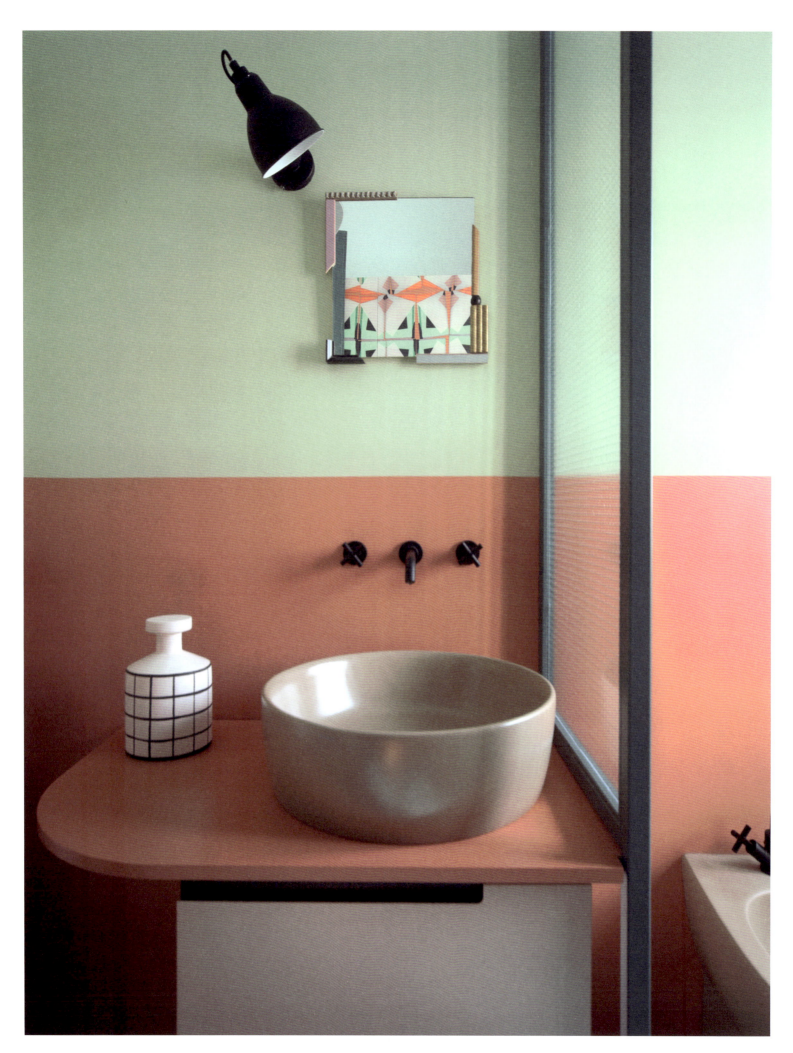

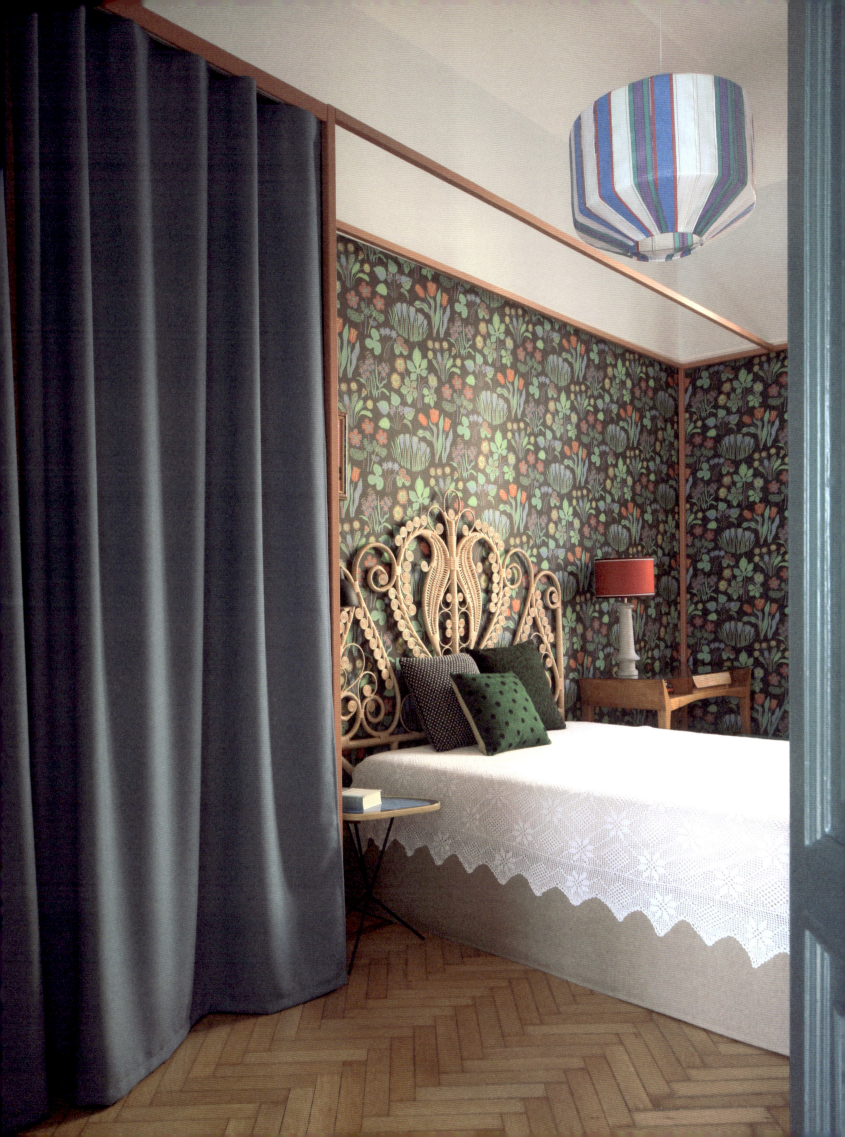

WHERE	WHO	WHAT
BARBIZON FRANCE	CHARLOTTE, EMILIANO, LEONARDO, SOLAL	FOREST HOUSE

A luminous and meaningful wooden house made by hand

"*The house is made from many different types of wood, mostly poplar and oak but also cherry wood, French and Siberian sycamore, and birch and ash in the kids' rooms. Emiliano goes to the sawmill and depending on what he finds there and feels drawn to, he'll create something different*," says French journalist and stylist Charlotte Huguet about her husband, cabinetmaker Emiliano Schmidt-Fiori, who has been renovating their wooden house for the past four years. The couple fell in love with the charming village of Barbizon, located south of Paris on the edge of the Fontainebleau forest and famous for the impressionist painters who used to live there. It proved the ideal location for the couple who aspired to a more sustainable, meaningful lifestyle in the countryside with their two sons, Leonardo (11) and Solal (9). A desire to consume less and celebrate things for the length of their natural life span is something the family now practices daily in this luminous haven where everything from the structure, walls, windows, floors, furniture, and decoration is made of wood.

The original house they bought was far from an ideal natural dwelling where craftmanship and high-quality materials would prevail, so they adapted the entire interior layout to their tastes. "*Emiliano didn't draw an initial layout plan as an architect would. He thinks more like a sculptor; he gets inspired and goes with the flow of the space's lines and proportions as he builds them*," says Charlotte. It was a slow process, but the result was worth the wait. The gorgeous home, designed with the family in mind, now features an open floor plan allowing movement and light to flow organically while the house's structure has gained Scandinavian-like interior insulation. The generous bedrooms, which the boys can retreat to peacefully, are saturated in natural light with giant windows overlooking verdant trees. As for decoration, vintage pieces combine effortlessly with simple objects of sentimental value, including ceramic and wooden tableware by Marion Graux, Astier de Villatte, and Anthony Cardew. Indeed, the family project proved such an inspiration it motivated Emiliano's latest venture: Hibou House, a company selling minimalist, wooden eco houses.

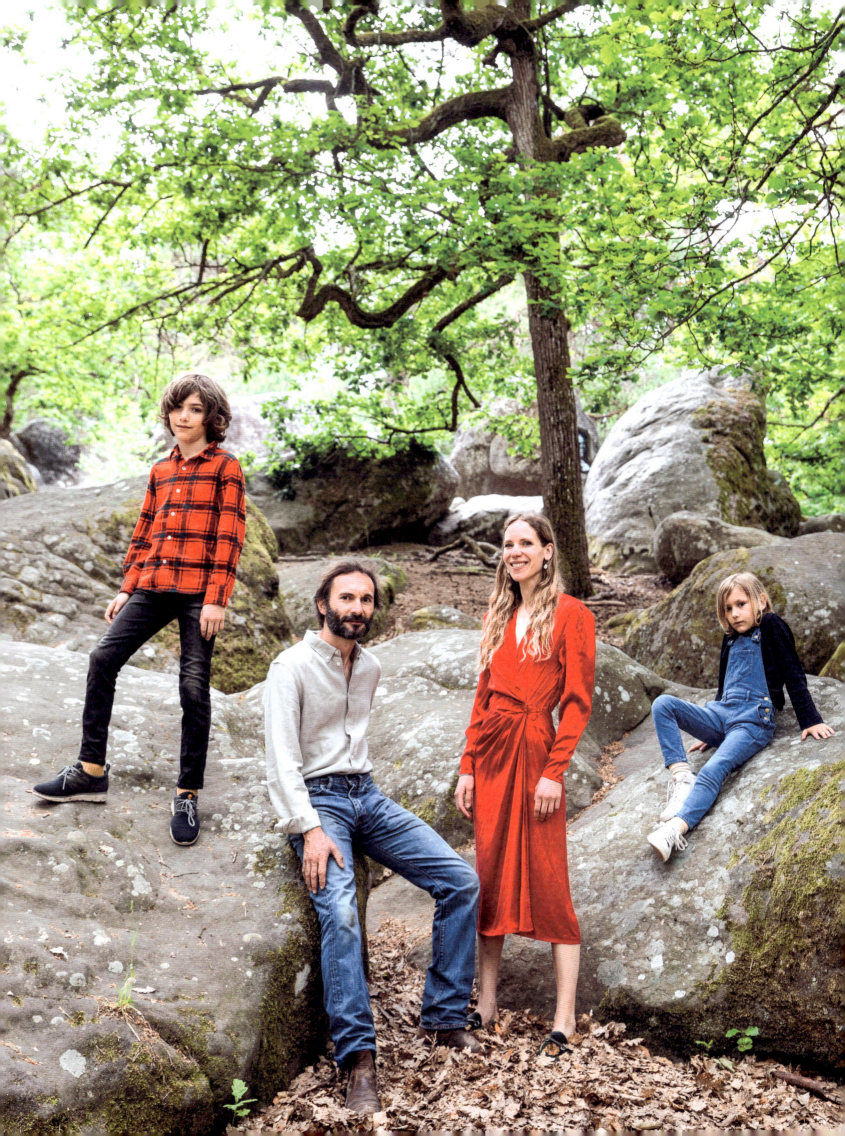

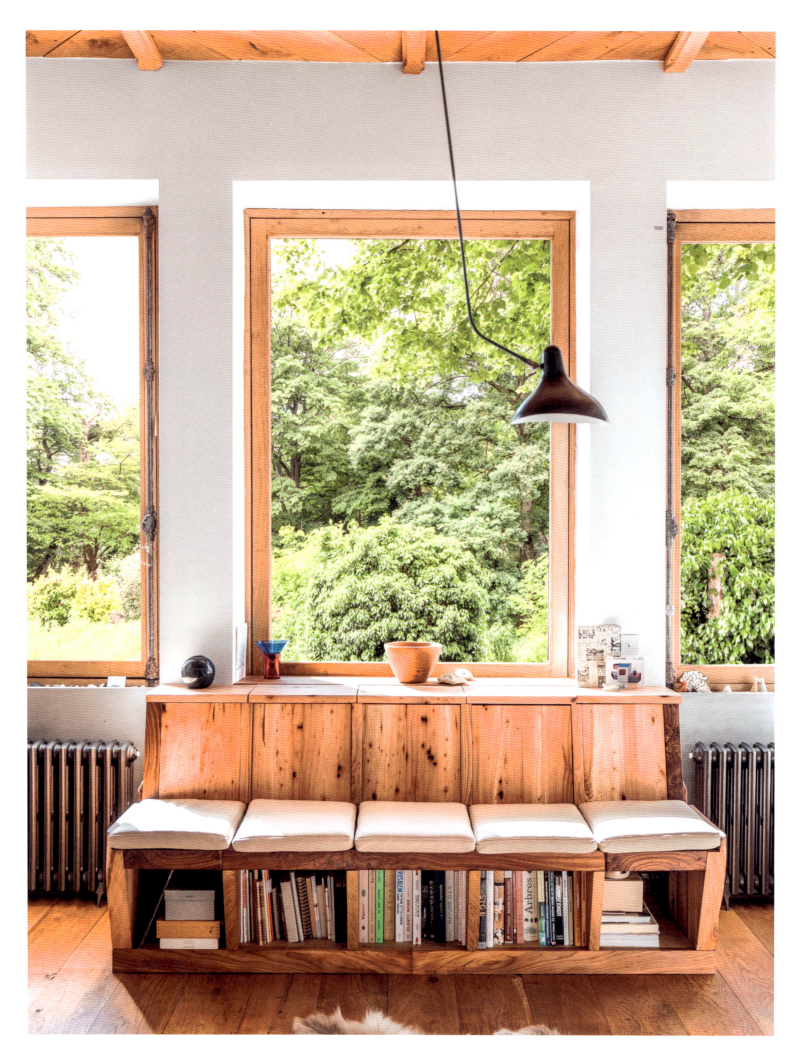

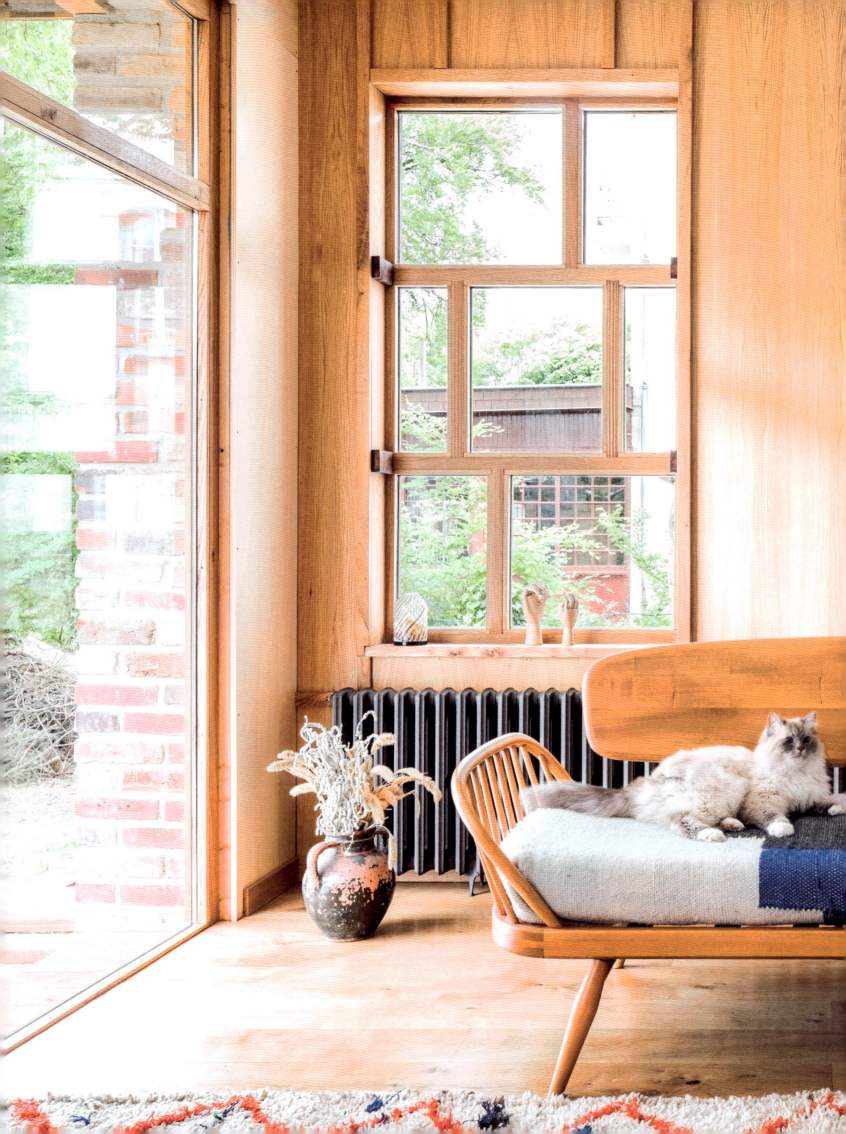

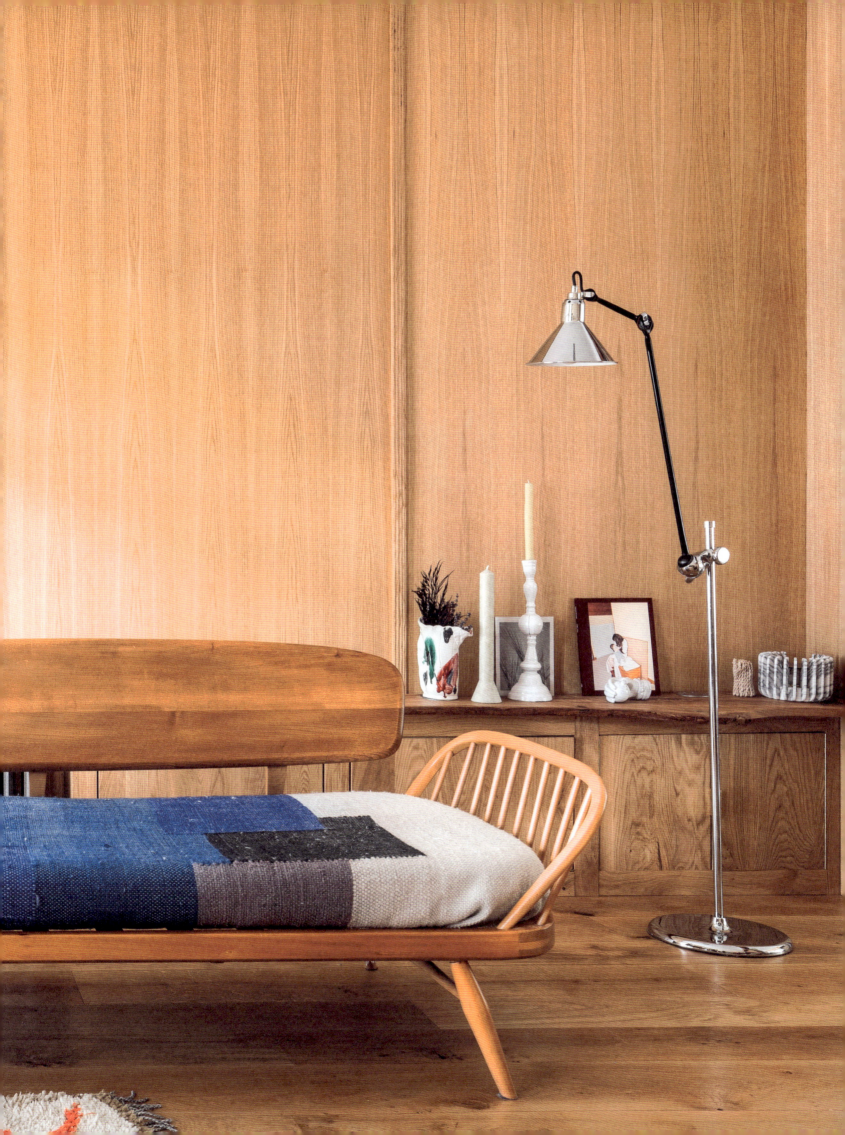

WHERE	WHO	WHAT
PARIS FRANCE	KAREL, ISIS-COLOMBE, ALIOCHA, HIROKO	GRAPHIC APARTMENT

A highly graphic, elegant yet playful 1930s apartment

Isis-Colombe Combréas and Karel Balas are the creative couple behind *MilK* and *MilK Decoration* magazines. Together with their children Aliocha (14) and Hiroko (12), they live in the family-friendly 14th arrondissement in Paris, where they share a vast, bright apartment typical of the city. As the kids got older, the need for separate bathrooms grew stronger (hello teenagers!), so the couple decided to call Italian architects Marcante Testa to the rescue: a complete renovation project was conceived to modernize the space and make it more functional while preserving its airy structure. "*Andrea Marcante wished to pay tribute to our building's 1930s legacy, so we ended up talking about artist Mathieu Matégot, who became a name at the time by working with perforated sheet metal. From there, Andrea envisioned an innovative system made of poles and screens of perforated sheet metal that work as a space dividers,*" says Isis-Colombe.

The result is a highly graphic interior where original 1930s architectural elements are accentuated by a distinct ecosystem of contemporary micro-architecture that injects an unconventional elegance into the apartment's classical volumes. The lightweight structure runs throughout the apartment, delineating areas and contrasting with the moldings, stuccos, and cornices of the walls and ceiling. In the teens' bedrooms, the playful system enhances the uniqueness of each space and simultaneously defines a functional zone for their own personal bathroom. A modern, dark blue resin floor was also laid and colorful cabinets incorporated into the kitchen, office, and bedrooms. "*Everything was tailor-made in Italy and then put together here in Paris by an amazing team of Italian craftsmen,*" adds Isis-Colombe.

As for decoration, the couple composed a meaningful atmosphere where every object or piece of furniture triggers a fond memory from their *MilK Decoration* adventures. "*Our Os & Oos tables, Maarten Baas console, Patricia Urquiola 'Tufty-Time' sofa, 'Aim' ceiling light by the Bouroullec brothers, or Piet Hein Eek table that was the first version to arrive in France: these are our design crushes from the past 10 years. I guess they truly are witnesses of their time.*"

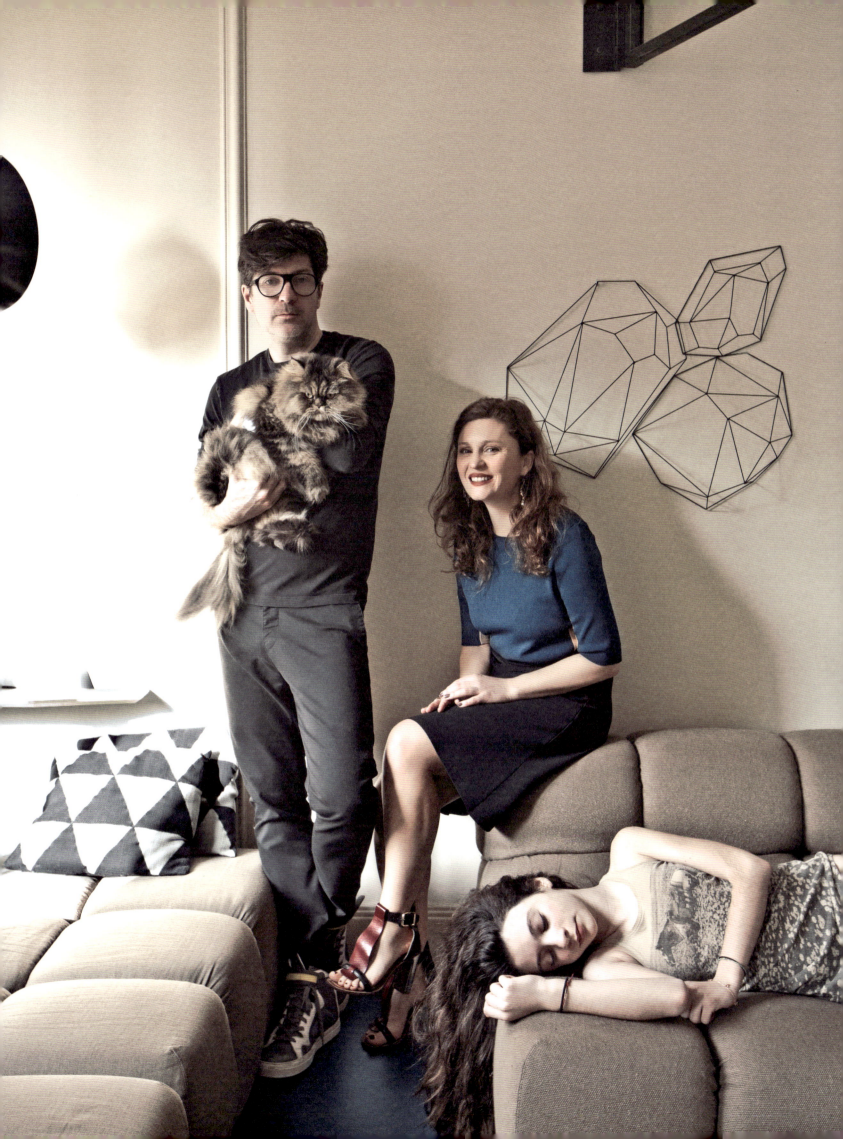

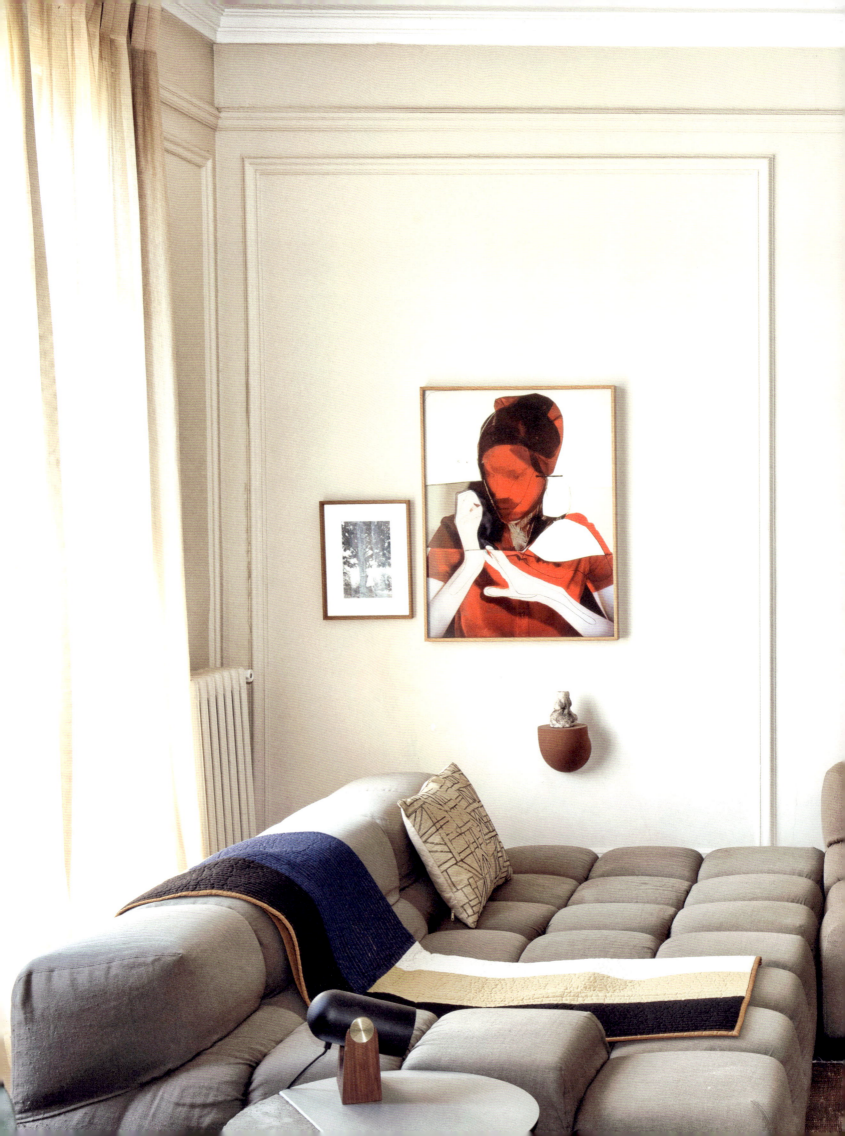

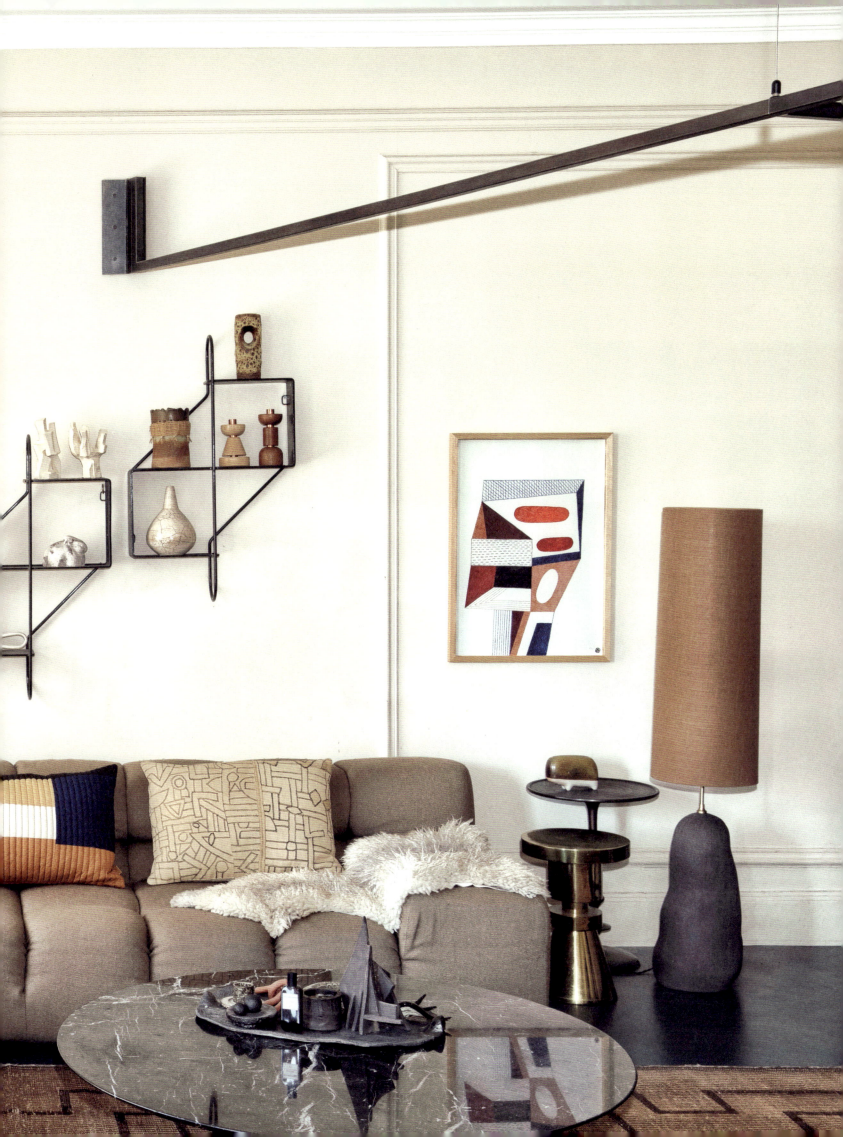

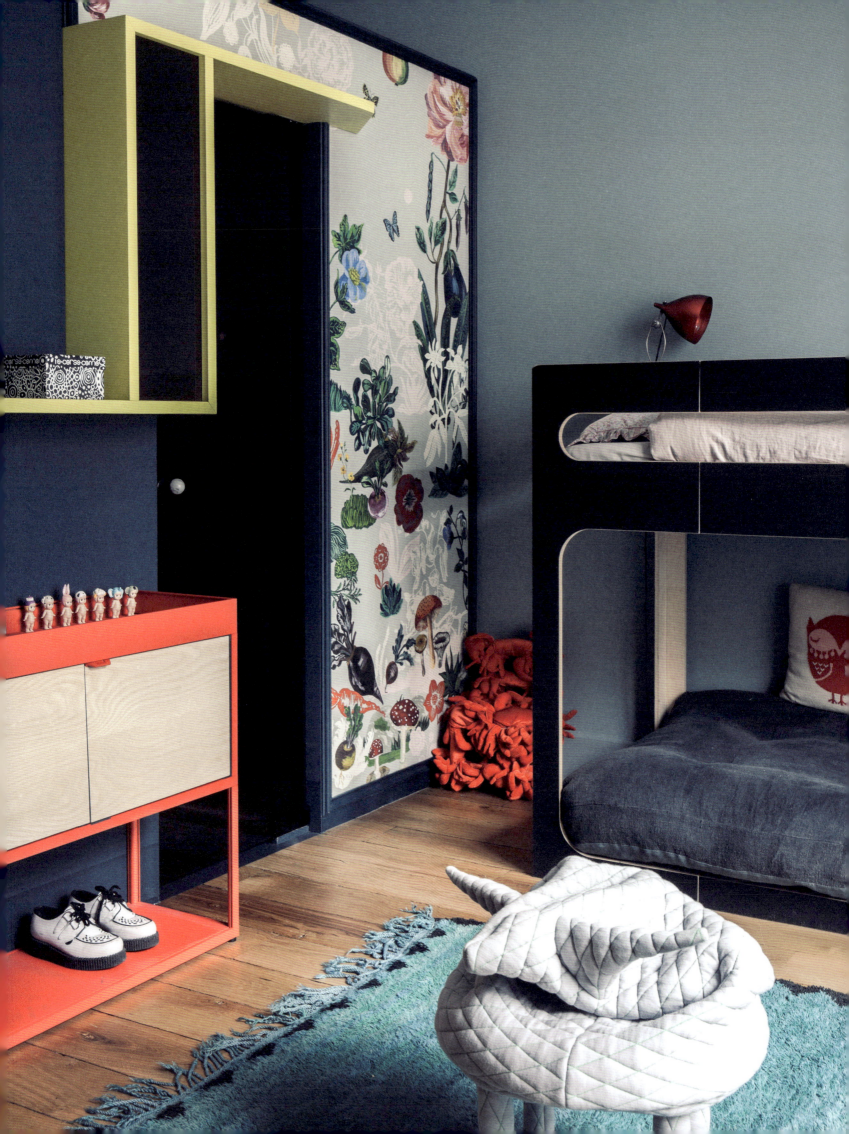

THE RESULT IS A HIGHLY GRAPHIC INTERIOR WHERE ORIGINAL
1930s ARCHITECTURAL ELEMENTS ARE ACCENTUATED BY A
DISTINCT ECOSYSTEM OF CONTEMPORARY MICRO-ARCHITECTURE
THAT INJECTS AN UNCONVENTIONAL ELEGANCE INTO THE
APARTMENT'S CLASSICAL VOLUMES.

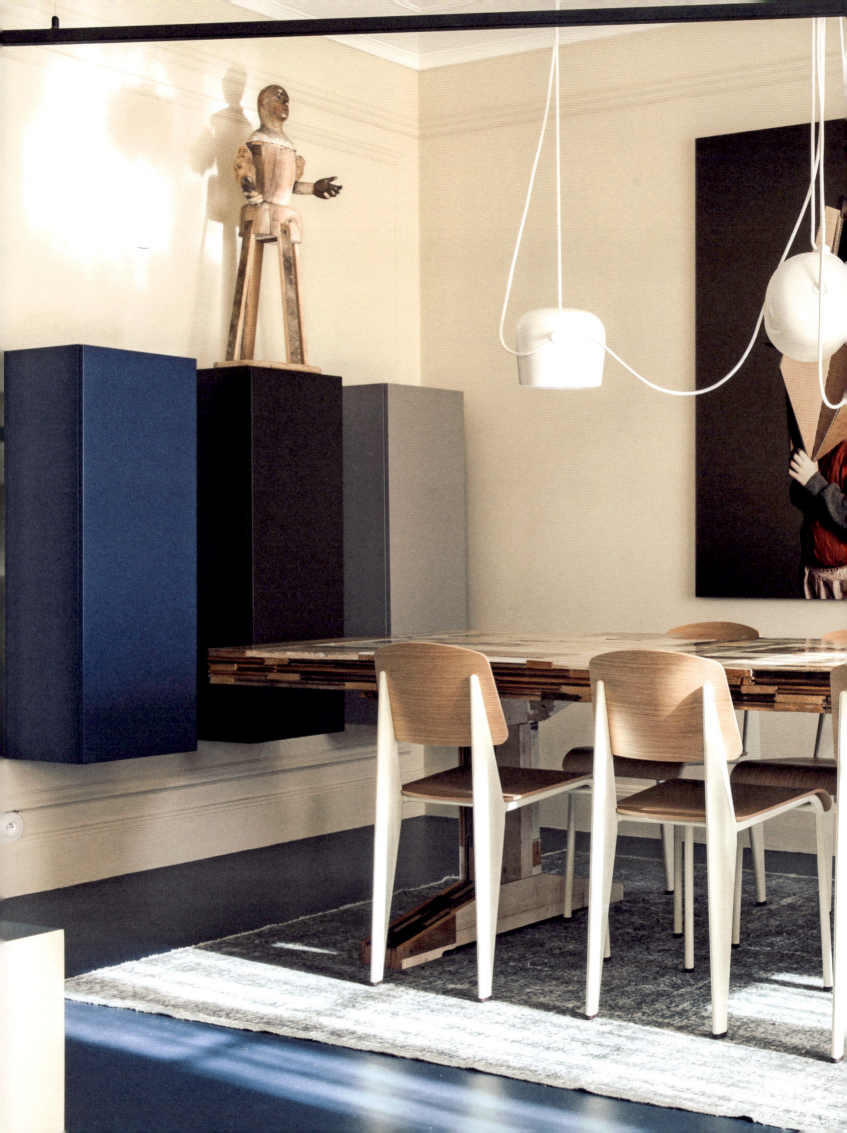

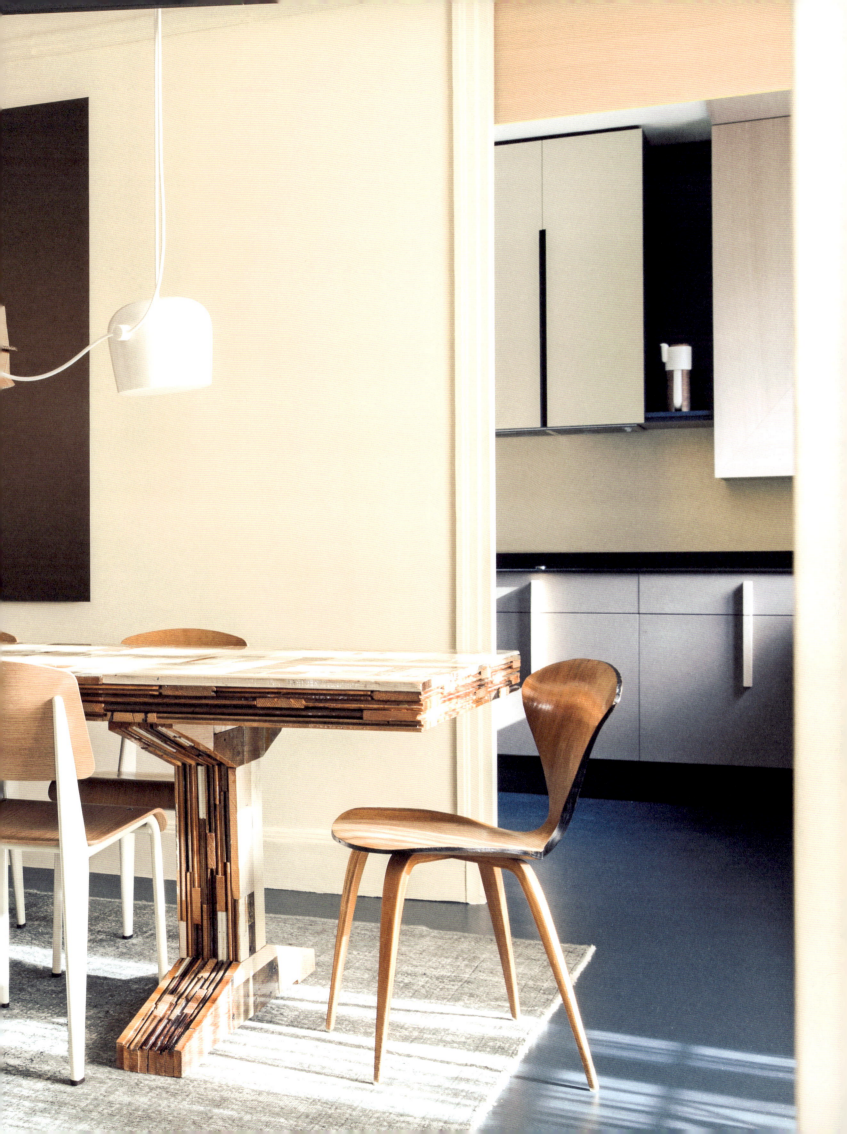

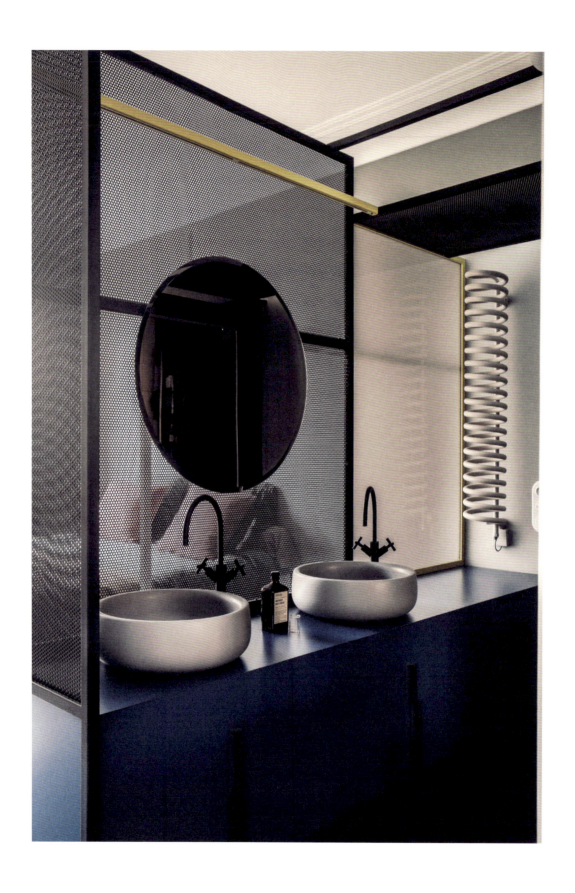

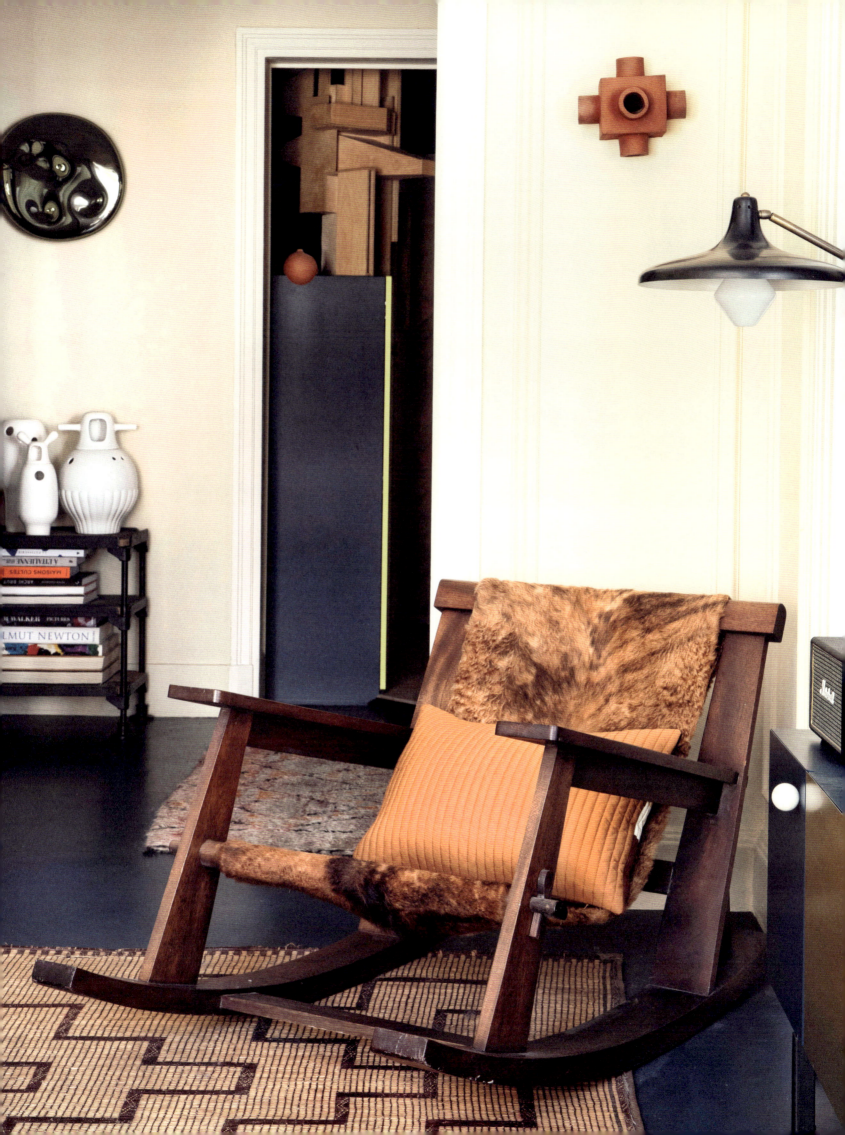

WHERE
GHENT
BELGIUM

WHO
VEVA, JAN, FARAH, IDRISS,
ISAAC, NOAH

WHAT
RESTORED
CHAPEL

An old chapel reimagined for a creative lifestyle

"*We preserved the exterior of the original chapel as much as possible and were inspired by the work of Portuguese architect Aires Mateus for the second floor's sleeping area with its suspended cubes,*" says interior design enthusiast Veva van Sloun about her unconventional home. Ten years ago, Veva and her husband, Jan Wauters, were looking for a house in Ghent—Belgium's second-largest city, rich in medieval architecture—when they came across a rundown elementary school with a garden and seven-meter-high (23-foot-high) chapel. Considering the great potential of the quirky structure, the couple, in conjunction with architect and friend Wim Depuydt, seized the opportunity to take on this daring endeavor, recruiting eight other families to make the financial investment viable.

Located in the Dampoort district—a lively, up-and-coming, multicultural neighborhood—the architectural restoration carved out domestic spaces for each family, while Veva envisioned an ambitious plan for her quarters. She wanted to create a multipurpose space hosting a concept store, bed and breakfast, and cafe opening onto a garden—a quiet, secluded destination in the buoyant heart of the city. Her vision proved a hit: conceived by interior designer Maurice Mentjens and named Clouds 9000, the space is a Ghent hotspot, favored for its cozy cafe as much as the popular concept store that showcases Veva's edit of desirable design objects. The project also proved the perfect way for the couple to combine their personal and professional lives and schedules.

Entering into their minimalist home through the cafe, one gets to glimpse the impressive vertical scale of the former chapel. Veva and Jan's home occupies the widest section, with unusual all-white proportions punctuated by colorful textiles and accessories, refined designer pieces, and handcrafted elements such as the delicate ceramic tiles by Danish brand File Under Pop. Organized around the living-dining-kitchen, the two floors comfortably accommodate their four kids: Farah, Idriss, and twin boys Isaac and Noah, plus the family's big dog. "*Sometimes I think about the younger me dreaming of being a career woman always on the go. The idea of starting a family had never even crossed my mind, but we did, and it's a real gift.*"

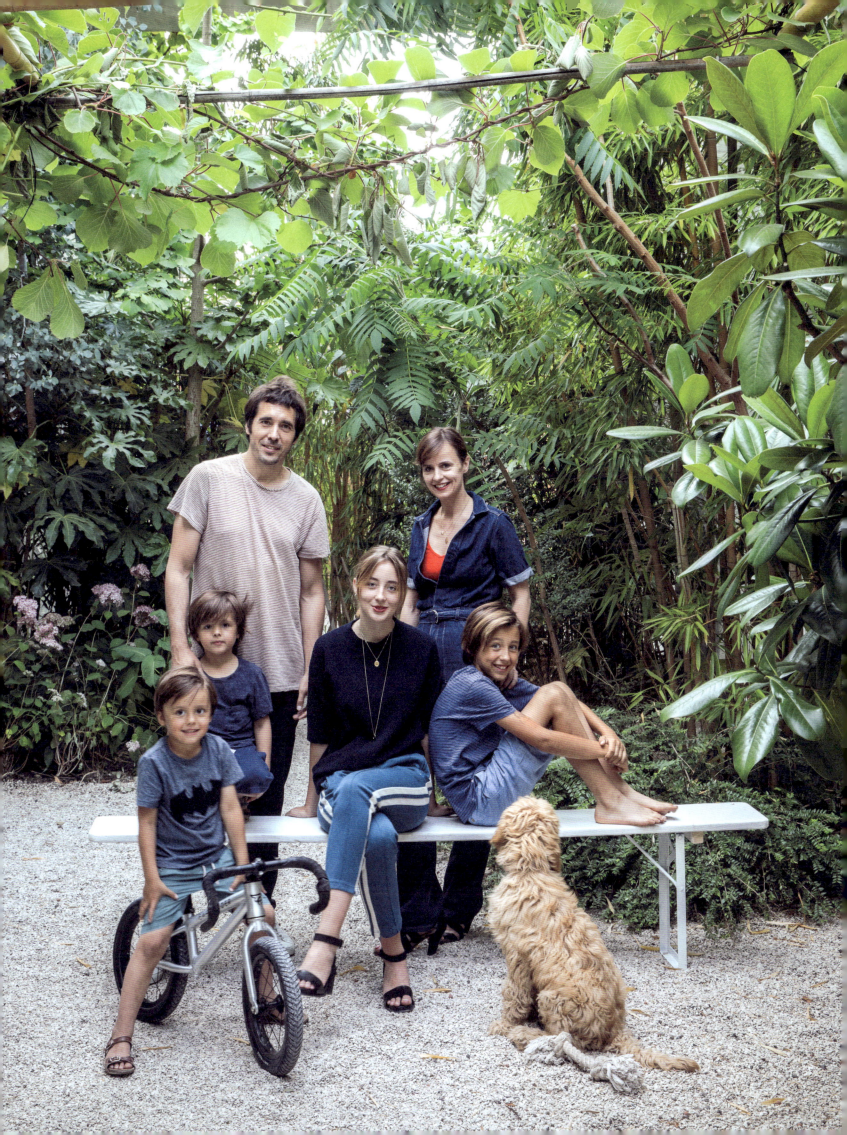

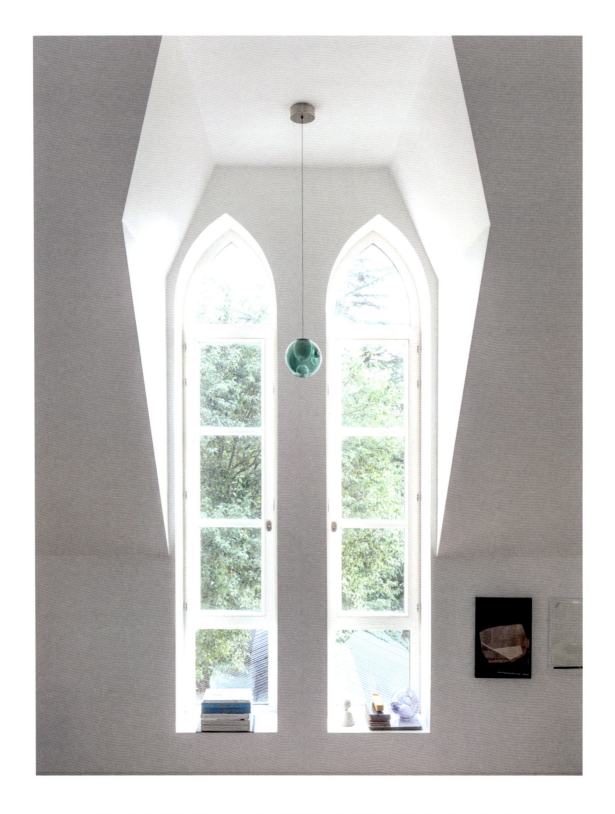

"WE PRESERVED THE EXTERIOR OF THE ORIGINAL CHAPEL
AS MUCH AS POSSIBLE AND WERE INSPIRED BY THE WORK
OF PORTUGUESE ARCHITECT AIRES MATEUS FOR THE SECOND
FLOOR'S SLEEPING AREA WITH ITS SUSPENDED CUBES."

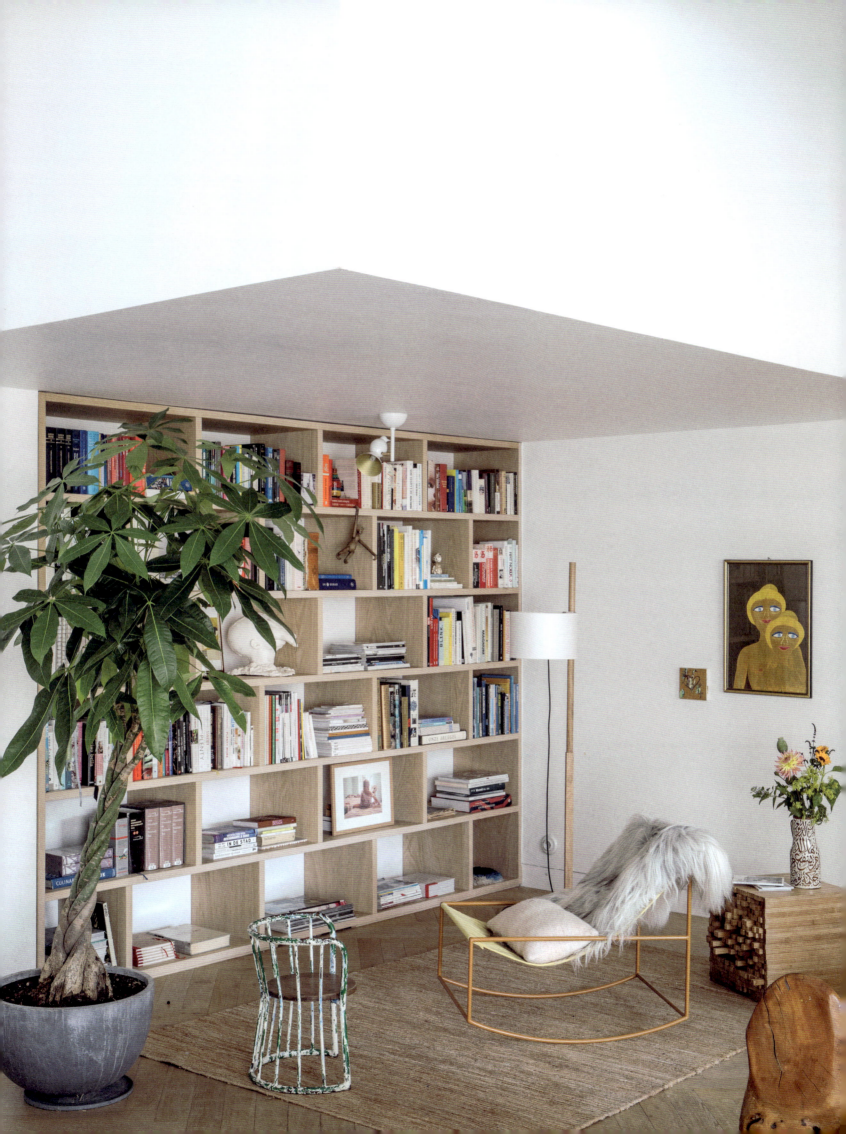

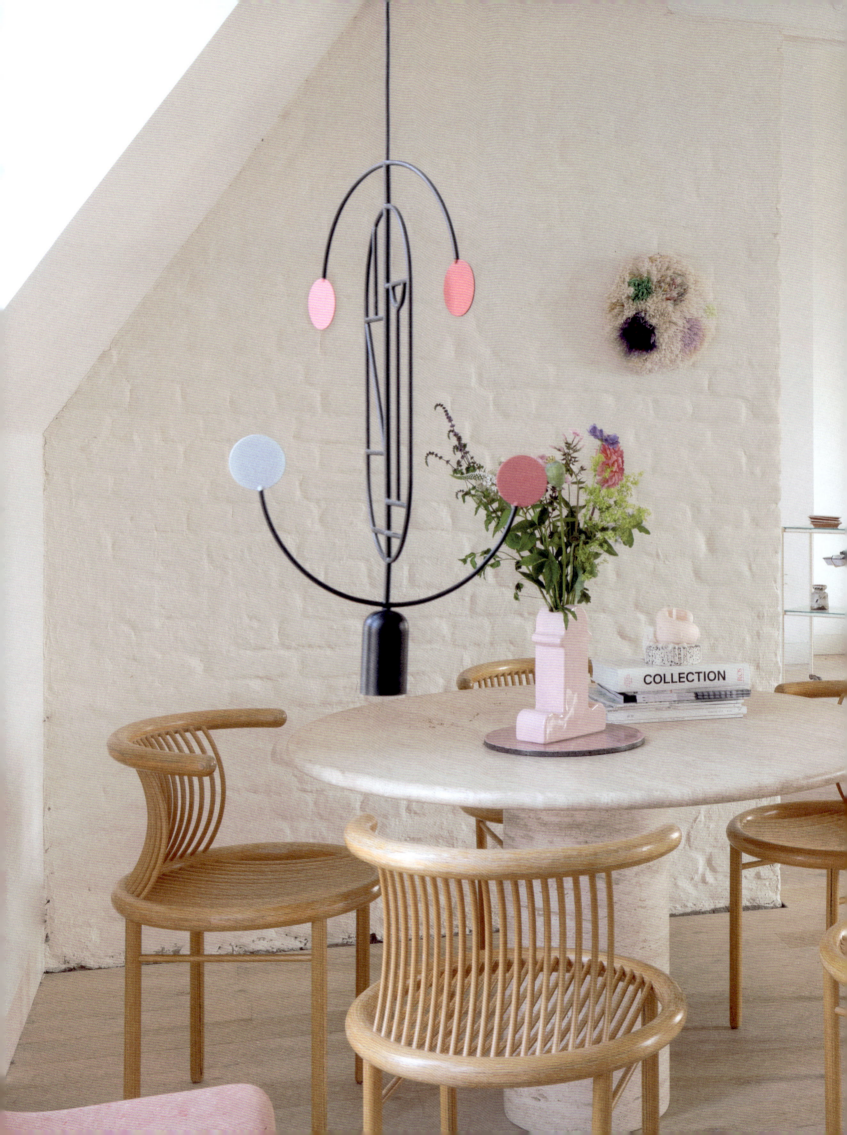

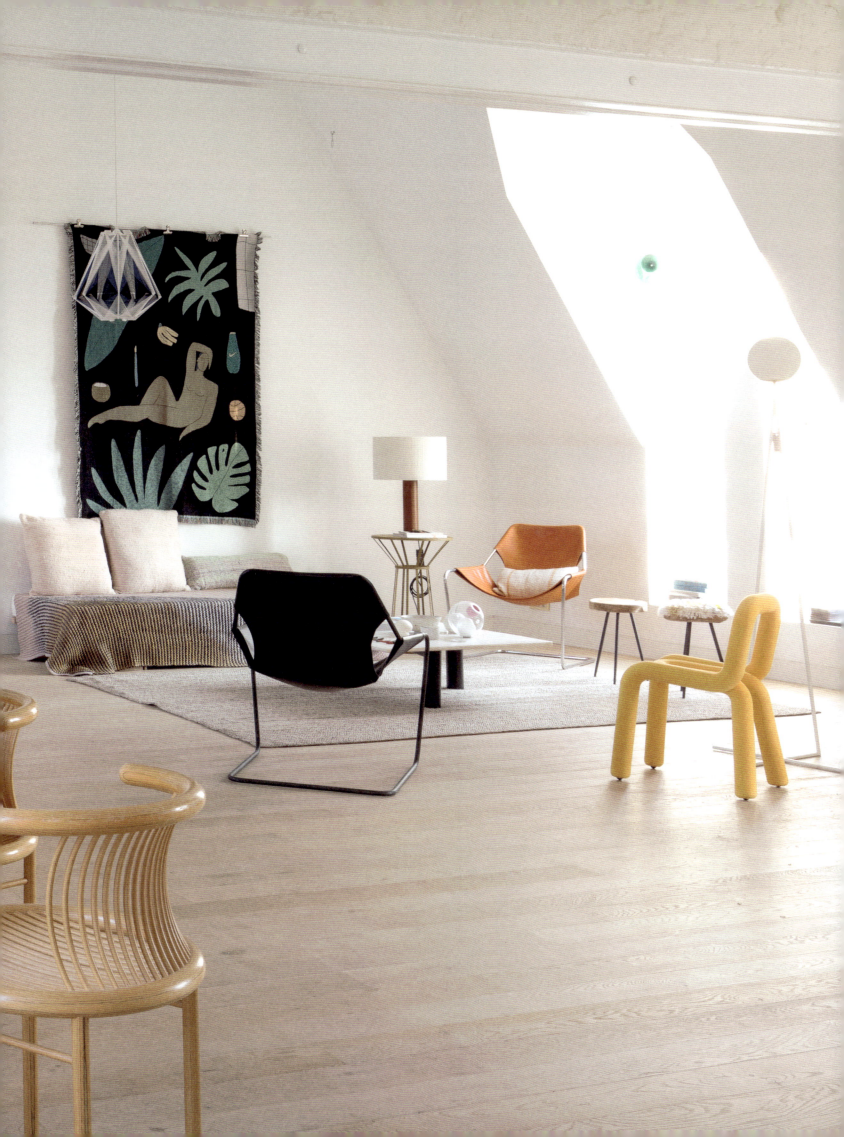

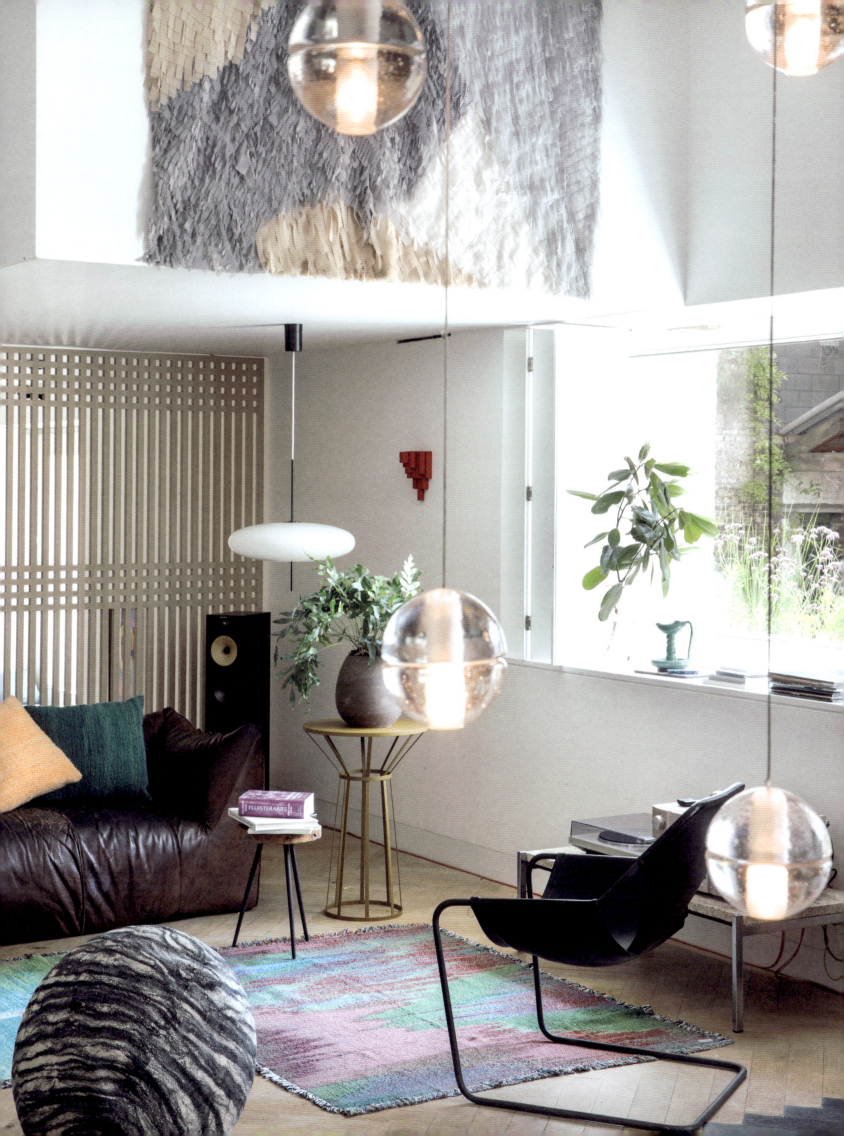

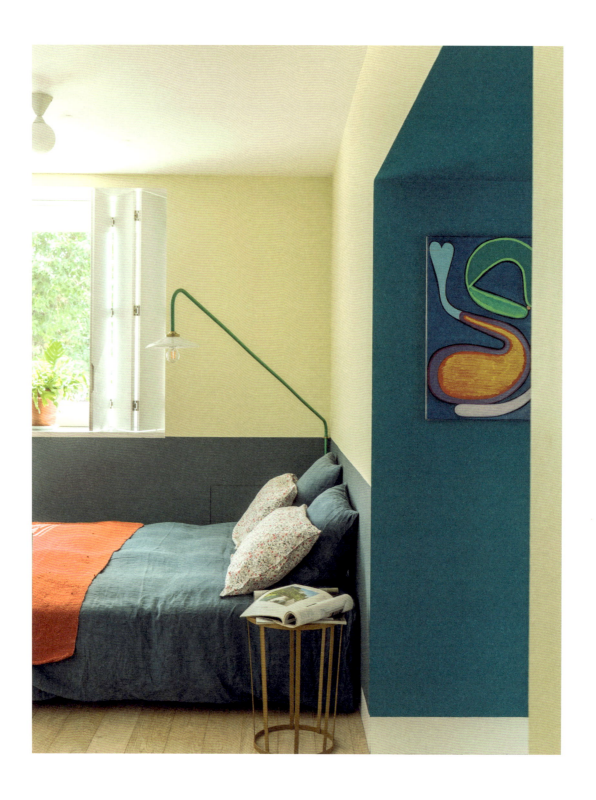

"SOMETIMES I THINK ABOUT THE YOUNGER ME DREAMING OF BEING A CAREER WOMAN ALWAYS ON THE GO. THE IDEA OF STARTING A FAMILY HAD NEVER EVEN CROSSED MY MIND, BUT WE DID, AND IT'S A REAL GIFT."

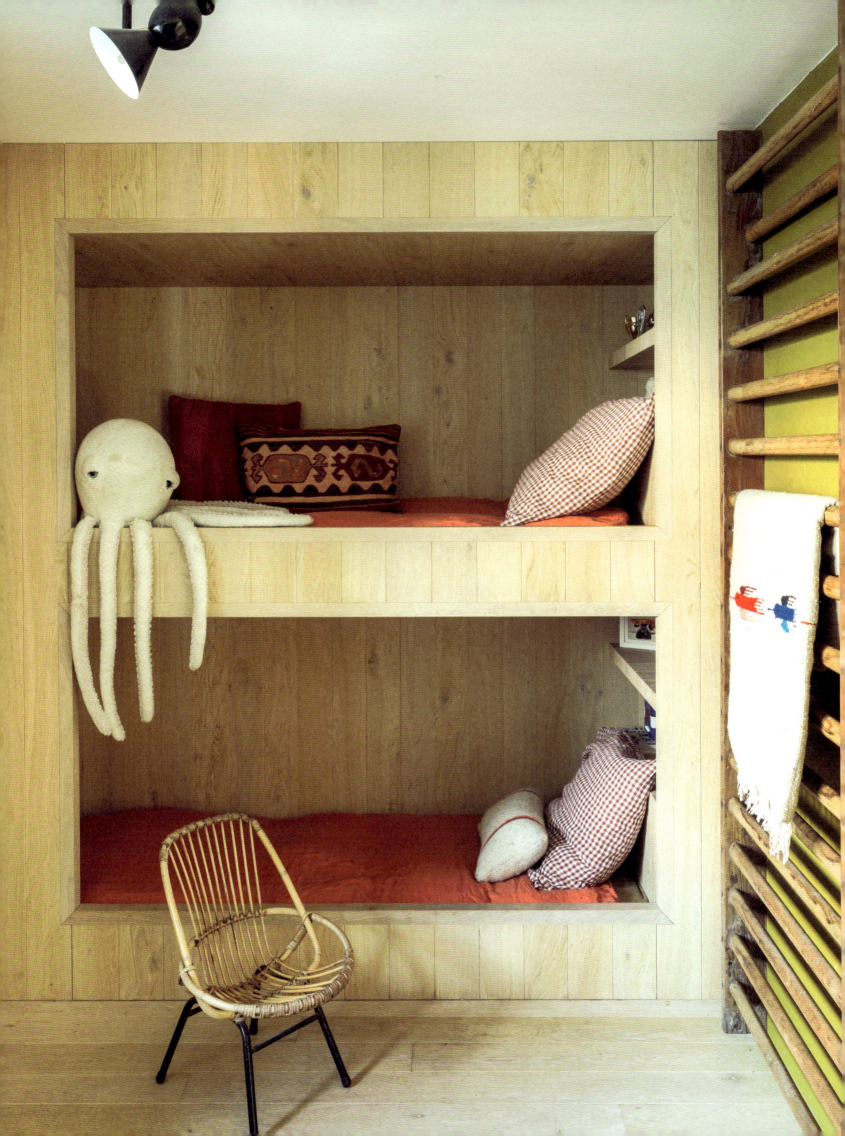

WHERE	WHO	WHAT
VAUCLUSE FRANCE	JUSTINE, JULIEN, ELIA, MALO	GINGER HOUSE

A dreamy family house nestled in a Provençal orchard

It all started with a book: *The Natural Laws of Children,* Céline Alvarez's bestseller about her revolutionary neuroscience-based approach to children's early learning processes, which encourages natural creativity and spontaneous free play. Reading it convinced interior design consultant Justine and her husband, Julien Delon, founder of a meditation app, to leave their 60 m² (646 ft²) Montmartre apartment to find a solution that would organically nurture their young kids Elia and Malo's growing environment. The big move took place in 2017 after the couple fell in love with an old Provençal farmhouse located in Vaucluse, an ideal three-hour train ride away from Paris that ensures short return trips for their jobs. The beautiful mansion called Maison Rousse—"Ginger House" for the reddish-brown color its stone facade takes on at sunset—is now home to this family's inspiring slow-life practices.

Four years, two cats—Mavis and Ariane—and a few hens later, the family celebrates their radical decision every day as they wake up to the sound of nature. The house is nestled in a bucolic orchard composed of dozens of pear, olive, almond, walnut, cherry, apricot, and plum trees where the kids can run, play, and go fruit picking before making fresh juice for breakfast. While they regularly enjoy the inviting swimming pool, complete with enchanting playground setting, Elia and Malo also meditate together with their father, who practices daily guided by Mind, the app he created. The comfortable interior of the old house also received a gentle revamp thanks to Justine's keen eye for organic colors and lines. Each child now has their own room while the easygoing selection of second-hand furniture and vintage finds creates a quiet yet elegant atmosphere.

Visitors are also welcome to experience the Maison Rousse lifestyle with Petite Maison Rousse (an independent two-bedroomed cottage operating as a bed and breakfast) or by renting the main house on Airbnb when the Delons are away for a long weekend: a perfect opportunity to see what slow living in Provençal feels like. And fall in love.

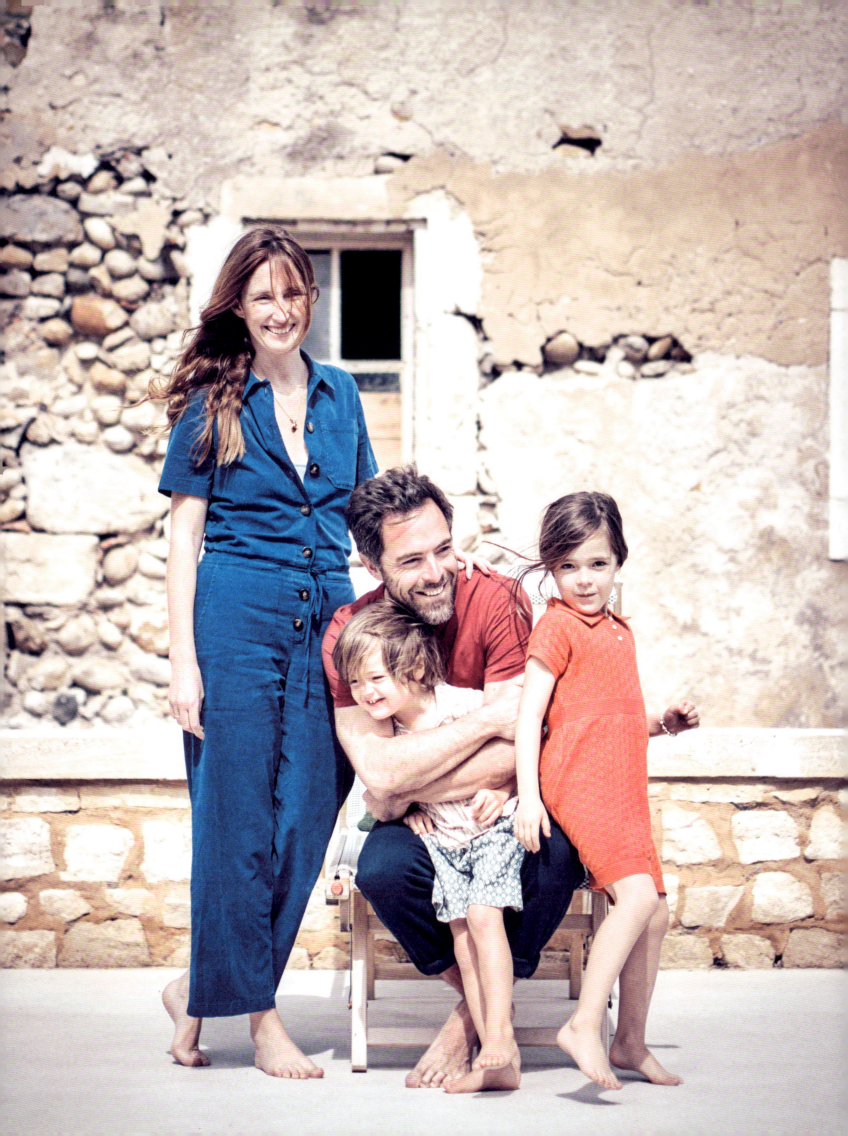

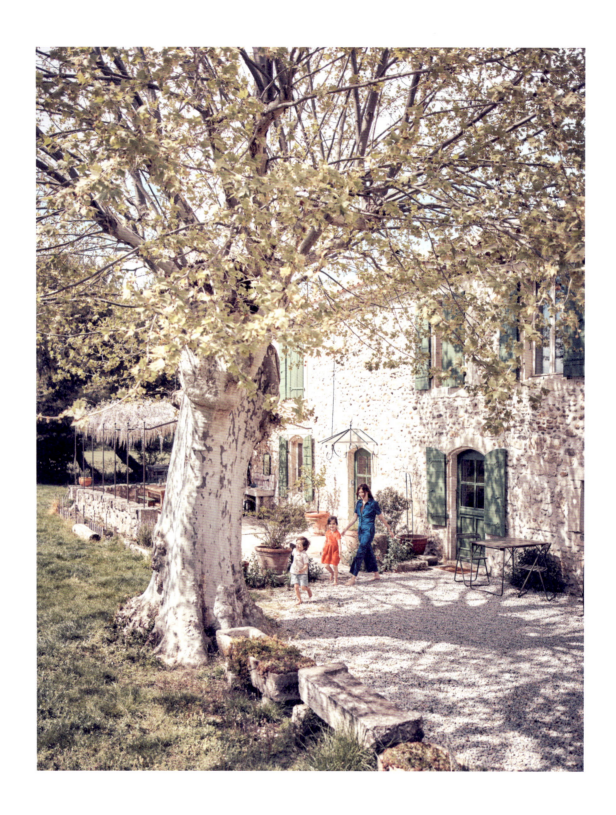

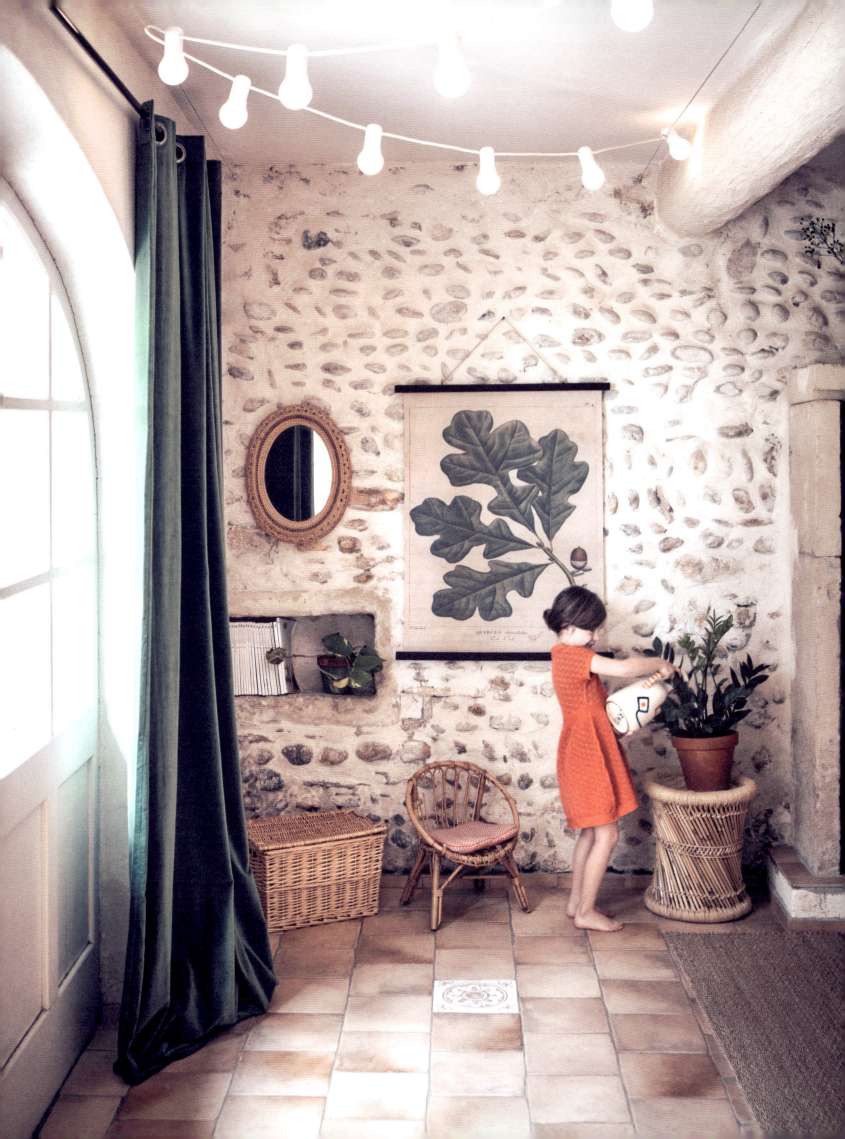

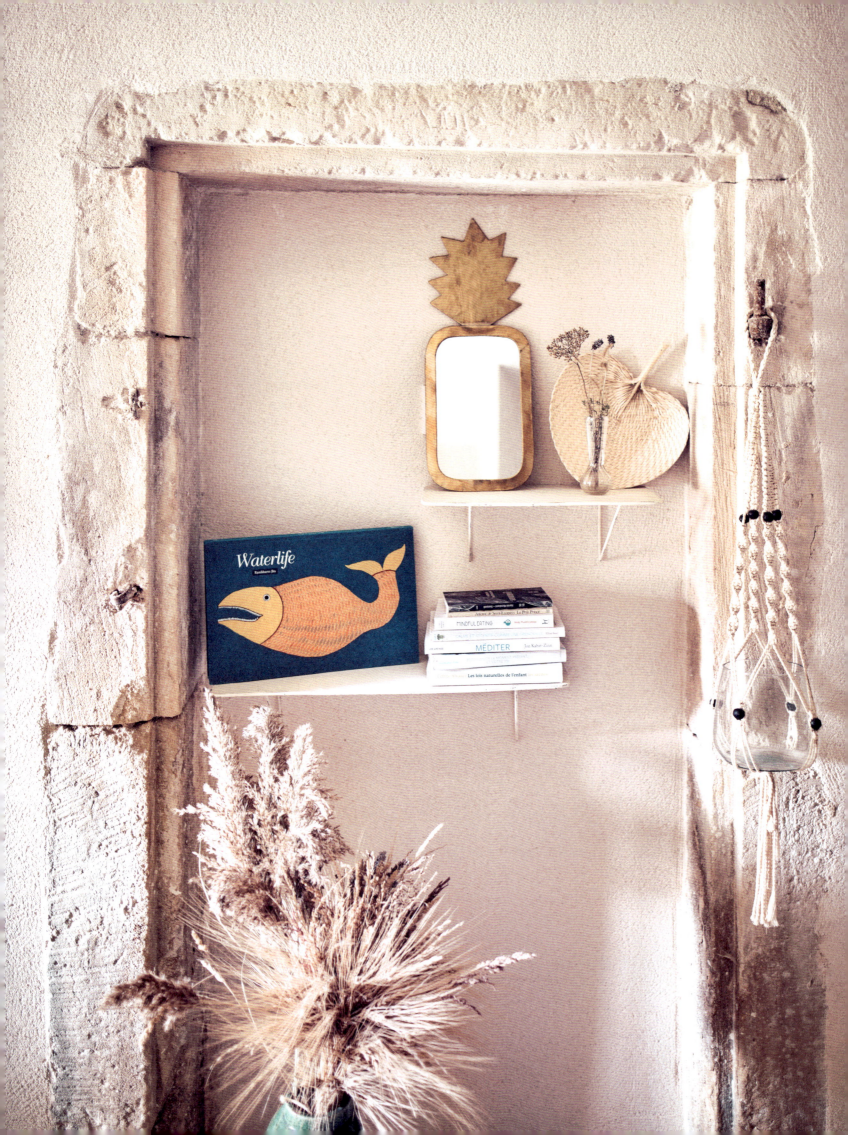

 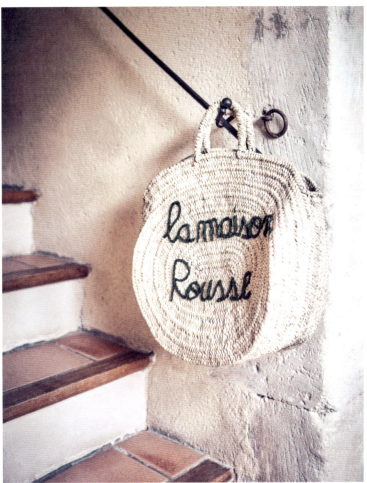

THE FAMILY CELEBRATES THEIR RADICAL DECISION EVERY DAY
AS THEY WAKE UP TO THE SOUND OF NATURE. THE HOUSE
IS NESTLED IN A BUCOLIC ORCHARD COMPOSED OF DOZENS
OF PEAR, OLIVE, ALMOND, WALNUT, CHERRY, APRICOT, AND PLUM
TREES WHERE THE KIDS CAN RUN, PLAY, AND GO FRUIT PICKING
BEFORE MAKING FRESH JUICE FOR BREAKFAST. WHILE THEY
REGULARLY ENJOY THE INVITING SWIMMING POOL, COMPLETE
WITH ENCHANTING PLAYGROUND SETTING, ELIA AND MALO
ALSO MEDITATE TOGETHER WITH THEIR FATHER, WHO PRACTICES
DAILY GUIDED BY MIND, THE APP HE CREATED.

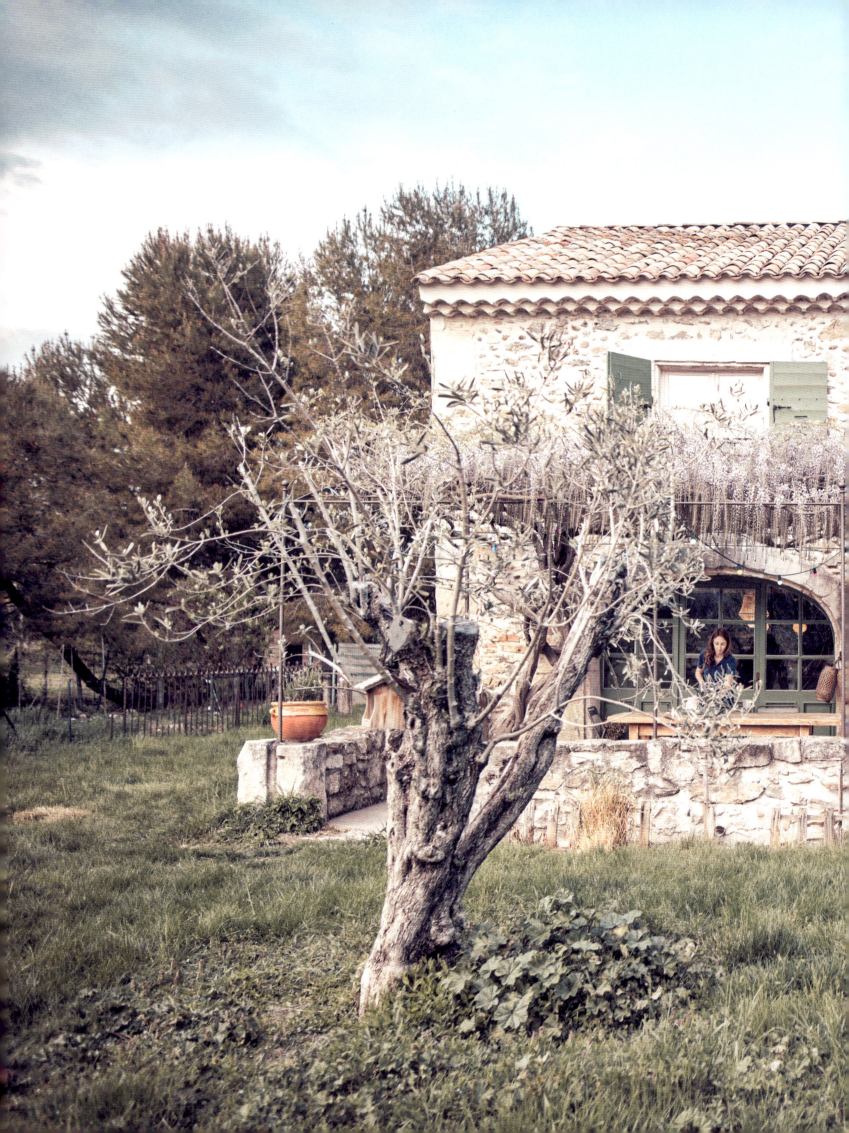

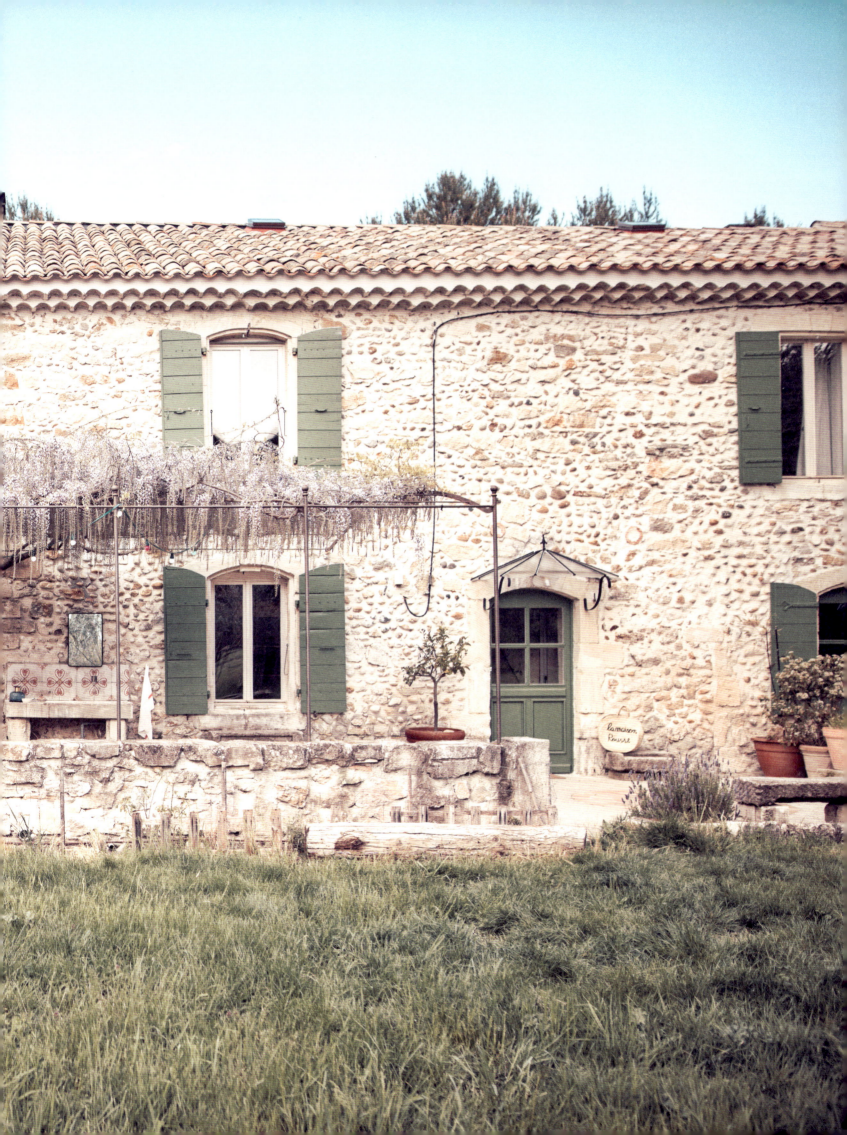

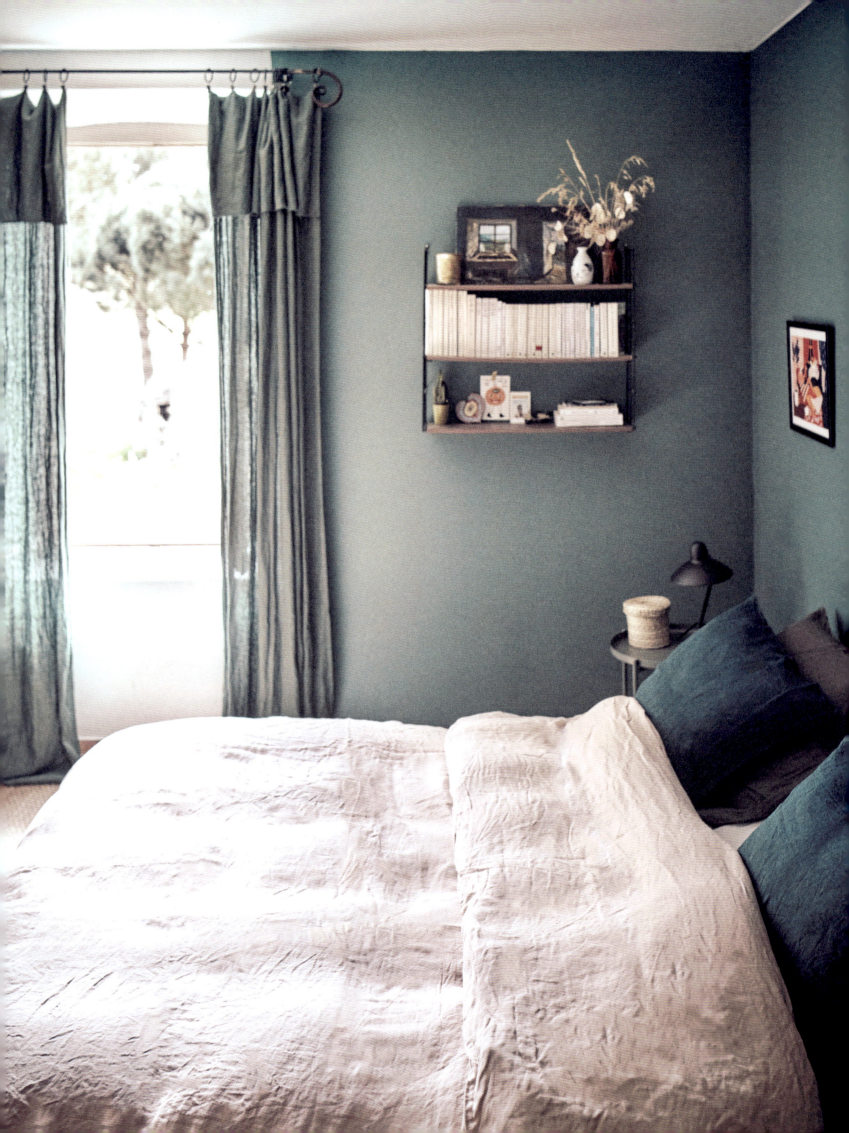

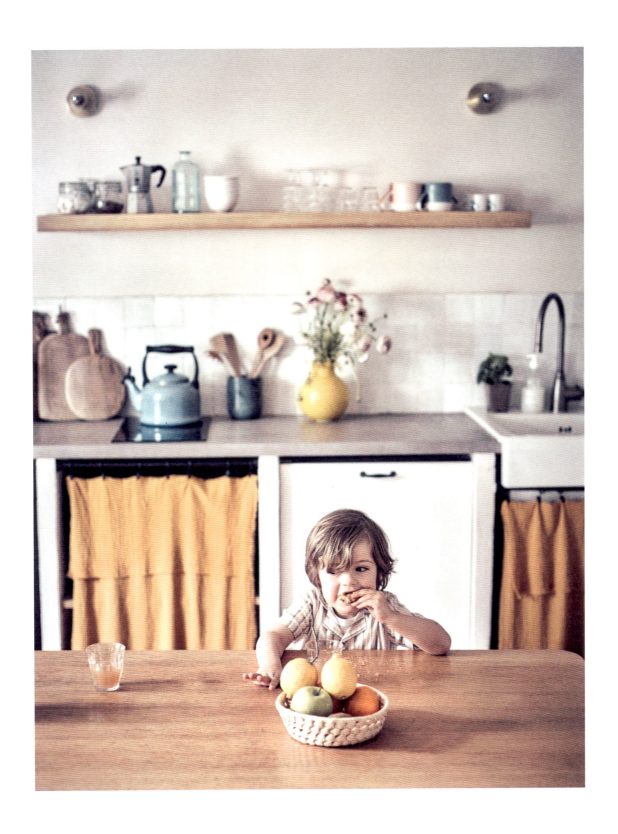

WHERE	WHO	WHAT
TORONTO CANADA	JOHN, JULI, ELODIE, HOWELL	VICTORIAN HOUSE

Scandinavia meets Japan in a brightly revamped Victorian home

In the popular Junction district of Toronto, a traditional 1880 Victorian mansion covered in original and ornate white pewter tiles catches the eyes of passersby, enticing them into the Zen interiors of Mjölk shop, a city hotspot for design-lovers looking for an edited selection of objects with a Japanese-Scandinavian essence. John Baker and Juli Daoust Baker are the duo behind the shop, conceived as an art gallery and located on the ground floor of their beautiful family home, which they completely revamped and opened in 2009. "*Initially, we really weren't thinking about opening a shop as the neighborhood wasn't as lively and trendy as it is today. We were just looking for a comfortable house for our kids to grow in.*"

The two-and-a-half-year-long renovation project was carried out by Studio Junction architects, who managed to drastically transform the old dark house into a bright, peaceful duplex. Organized around a central patio that's open to the sky, the house's new structure and large bay windows invite natural light to penetrate and flow through the space's volumes, creating an ideal playground for children Elodie and Howell to run around and play freely under the eye of their parents. It's an ideal work-at-home option for the couple, who can easily navigate between their private space and the shop-gallery public area.

Materiality is at the core of the couple's renovation, which used local materials such as light wood and Québec stone to honor the Canadian landscape. "*In some ways, light and landscapes are quite similar in Canadian and Scandinavian cultures, where architecture and design are intricately connected to nature. Japan is another country that shares that same celebration of natural elements—this is something we definitely considered,*" says John. Japanese and Scandinavian influences do indeed softly echo each other in the family's clean interior, where modern art pieces are mixed with handcrafted elements like the characteristic Nakashima bench, the large, all-wood, open kitchen that pays tribute to Norwegian architect Wenche Selmer, or the minimalist bathroom inspired by Japanese bathing rituals. "*We intend to create a deep, intimate connection with our home,*" adds John.

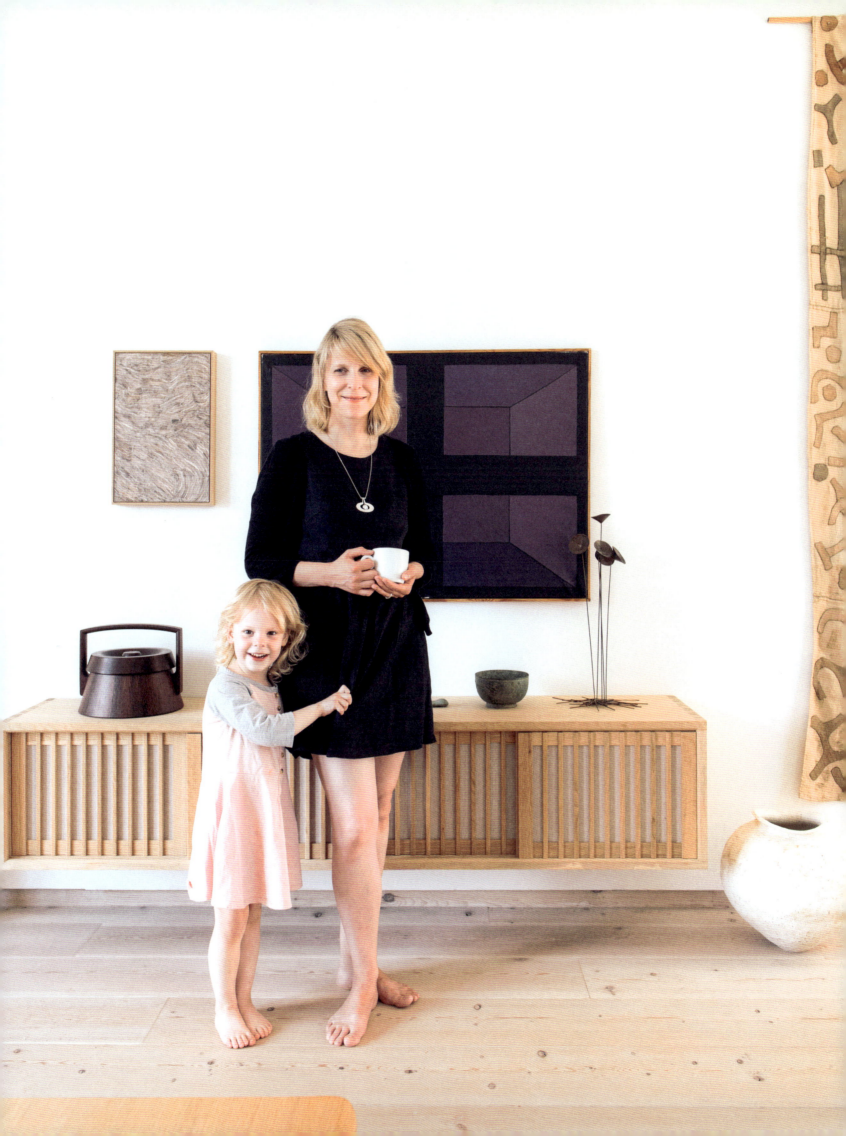

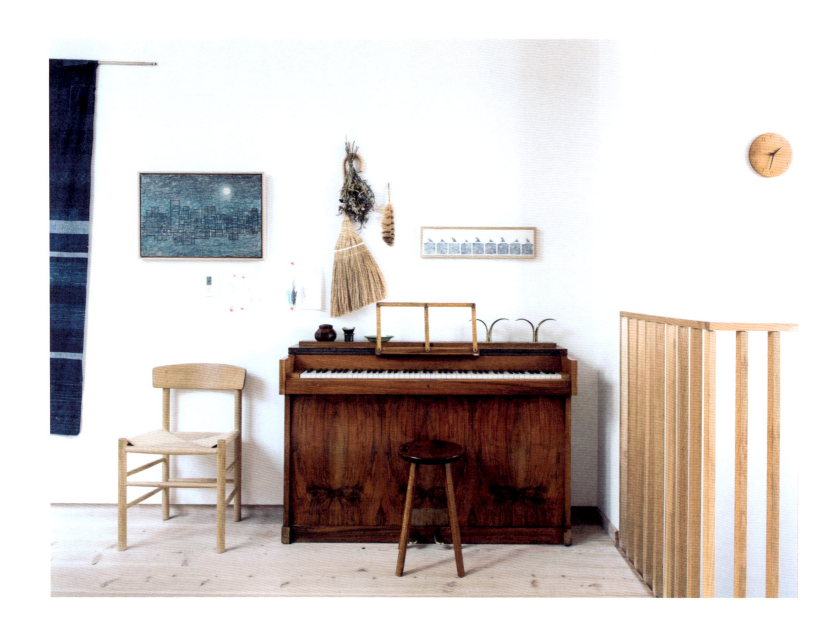

MATERIALITY IS AT THE CORE OF THE COUPLE'S RENOVATION, WHICH USED LOCAL MATERIALS SUCH AS LIGHT WOOD AND QUÉBEC STONE TO HONOR THE CANADIAN LANDSCAPE. "IN SOME WAYS, LIGHT AND LANDSCAPES ARE QUITE SIMILAR IN CANADIAN AND SCANDINAVIAN CULTURES, WHERE ARCHITECTURE AND DESIGN ARE INTRICATELY CONNECTED TO NATURE. JAPAN IS ANOTHER COUNTRY THAT SHARES THAT SAME CELEBRATION OF NATURAL ELEMENTS—THIS IS SOMETHING WE DEFINITELY CONSIDERED."

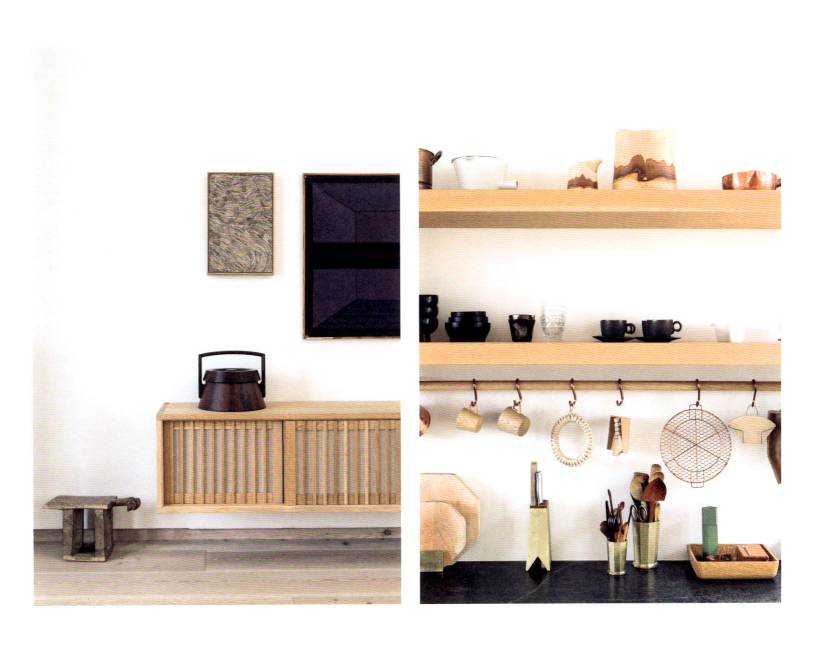

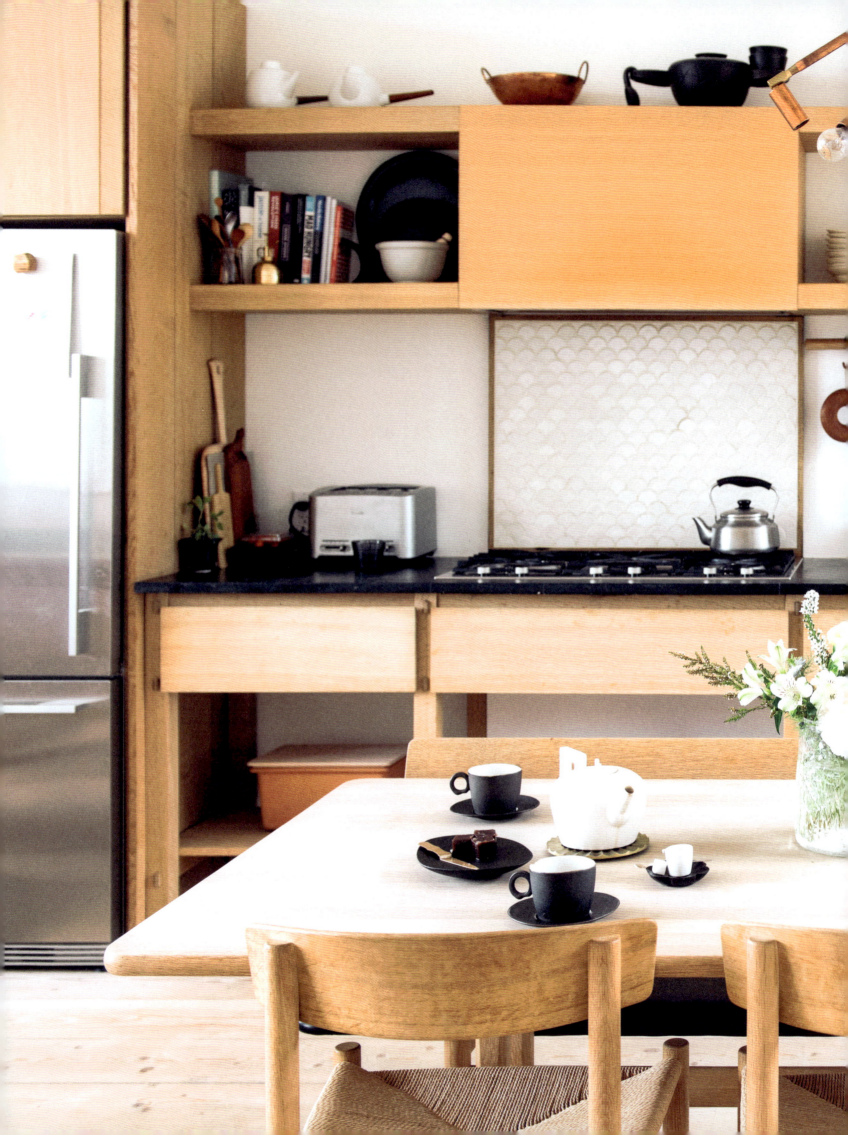

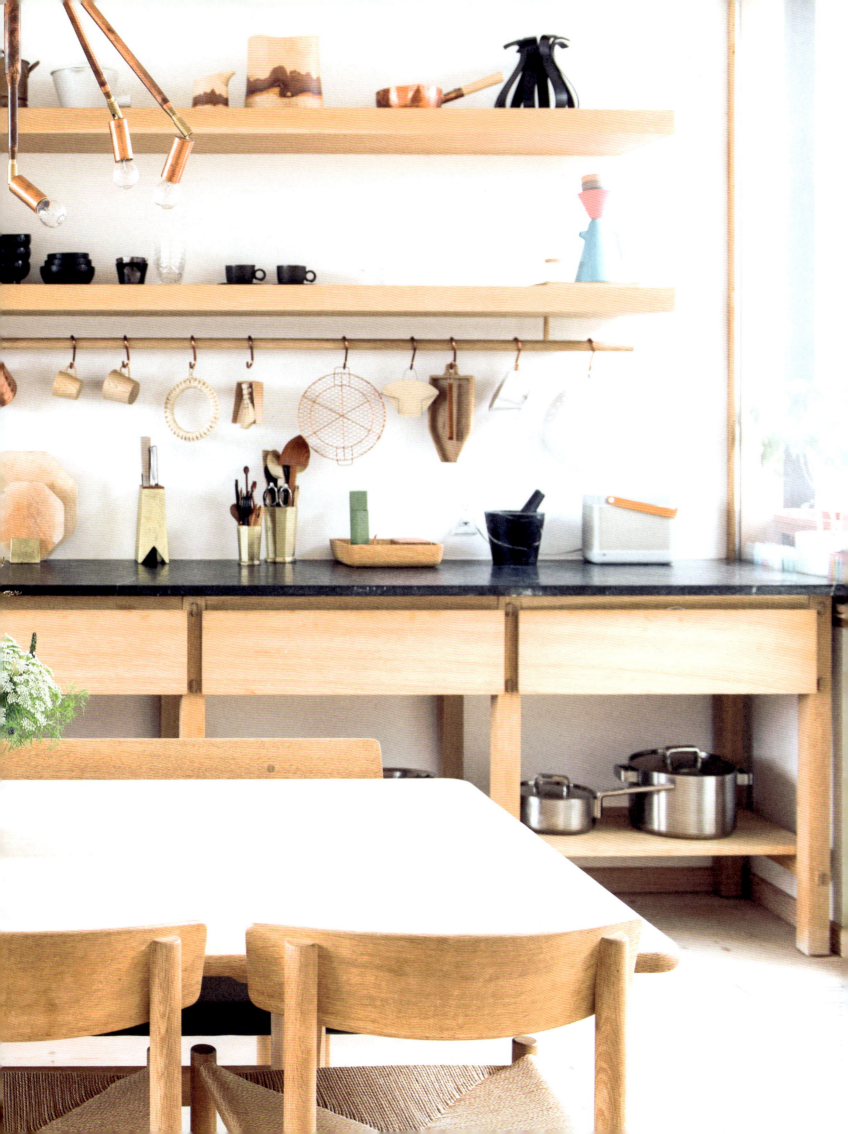

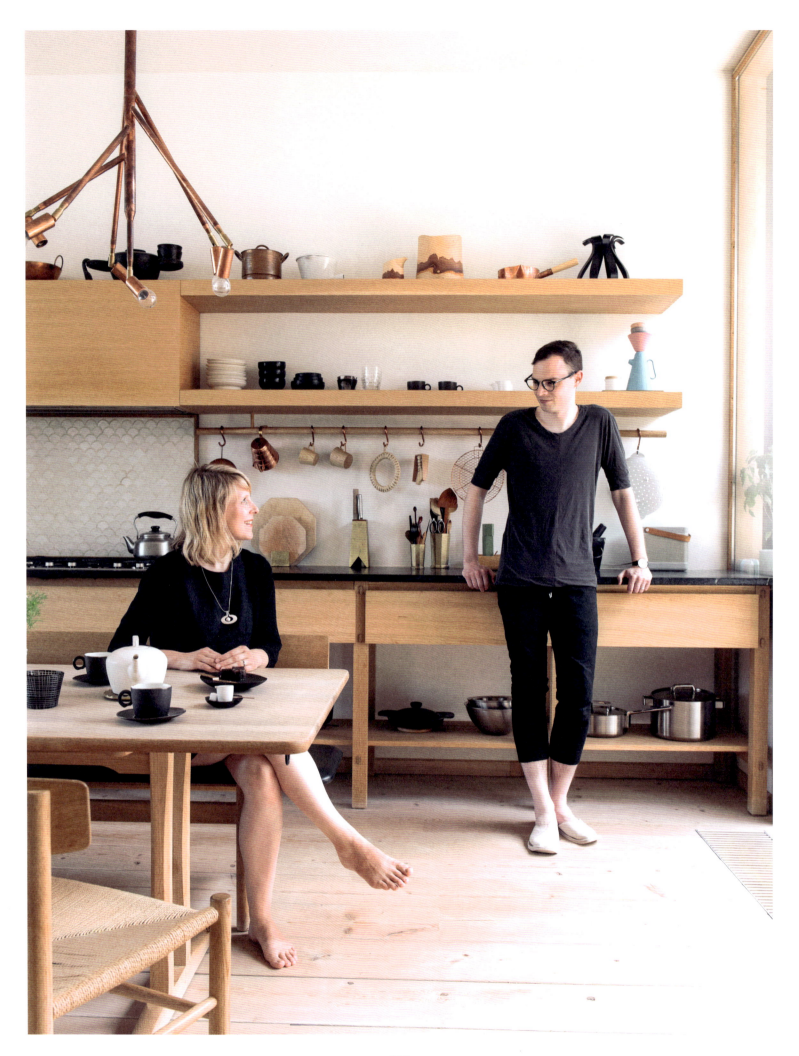

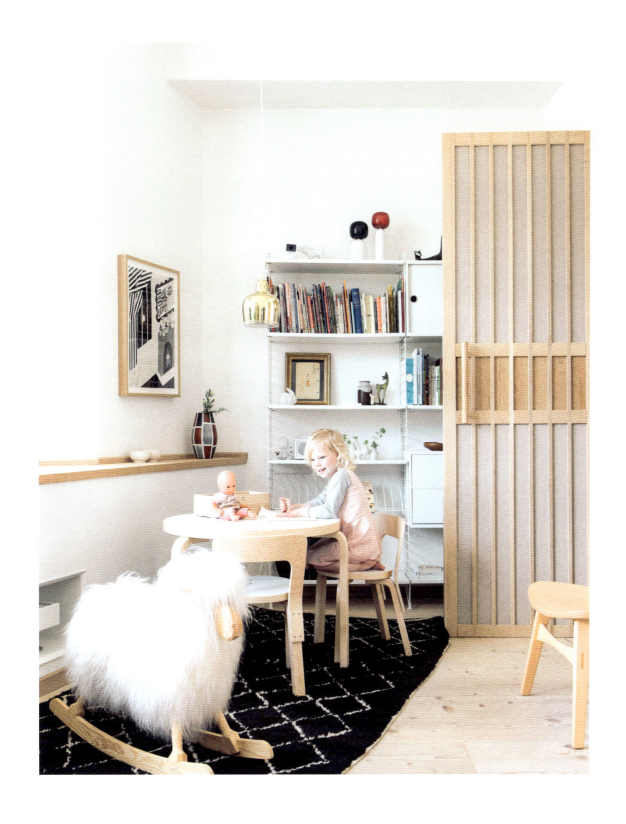

WHERE	WHO	WHAT
NYC, BROOKLYN USA	HANNAH, LANDON, ÈZE	BROWNSTONE APARTMENT

A joyful apartment with a strong visual identity

On the top floor of a typical brownstone in Bedford-Stuyvesant (New York City's creative neighborhood next to Brooklyn) is the joyful apartment of clothing designer Hannah Kristina and her contemporary artist husband Landon Metz, their 21-month-old son Èze, and two cats, Pinpin and Bobo. A comfortable space bathed in natural light, here the two creatives express their colorful visual universes in such a perfectly casual way that they form the ideal interactive playground for Èze to grow up in, surrounded by insightful, eclectic beauty.

"*Living perched so high at treetop level gives us the impression of being in a tree house. I've never had this relationship with the sky in any other house before,*" says Hannah, who moved around a lot with Landon before settling here in 2020. "*The apartment is so sunny and joyful that it helped us get through the difficult year of the pandemic.*" The sharp originality of the couple's interior has much to do with their audacious, unconventional way of displaying objects and furnishings, very aligned with their strong visual languages and unique perception of proportion and scale. In the living room, 100-year-old carved, wooden Swiss chairs combine happily with cutting-edge Alvar Aalto stools, Memphis Milano lamps, imposing sculptures, and handmade ceramics. On the wall, works by artist friends and an abstract monochrome painting by Landon dialogue with the powder-pink metal bars of the stairway that lets air and light flow freely into the white 80 m² (861 ft²) volume. "*Most of the designer pieces we collect are from Italy. I have Italian roots and I love that this sensibility reflects in our home,*" says Landon.

All these creations are an endless source of curiosity for Èze, whose first spoken word was "Dotson," referring to a painting hanging opposite his bed by the family's friend and artist Michael Dotson. "*He used to say 'Hi' to this painting every morning. He ended up calling all the paintings he came across 'Dotson,*" Hannah remembers. "*That's what bringing up Èze here in New York means: being surrounded by a creative community that is empathic, open, and supportive.*"

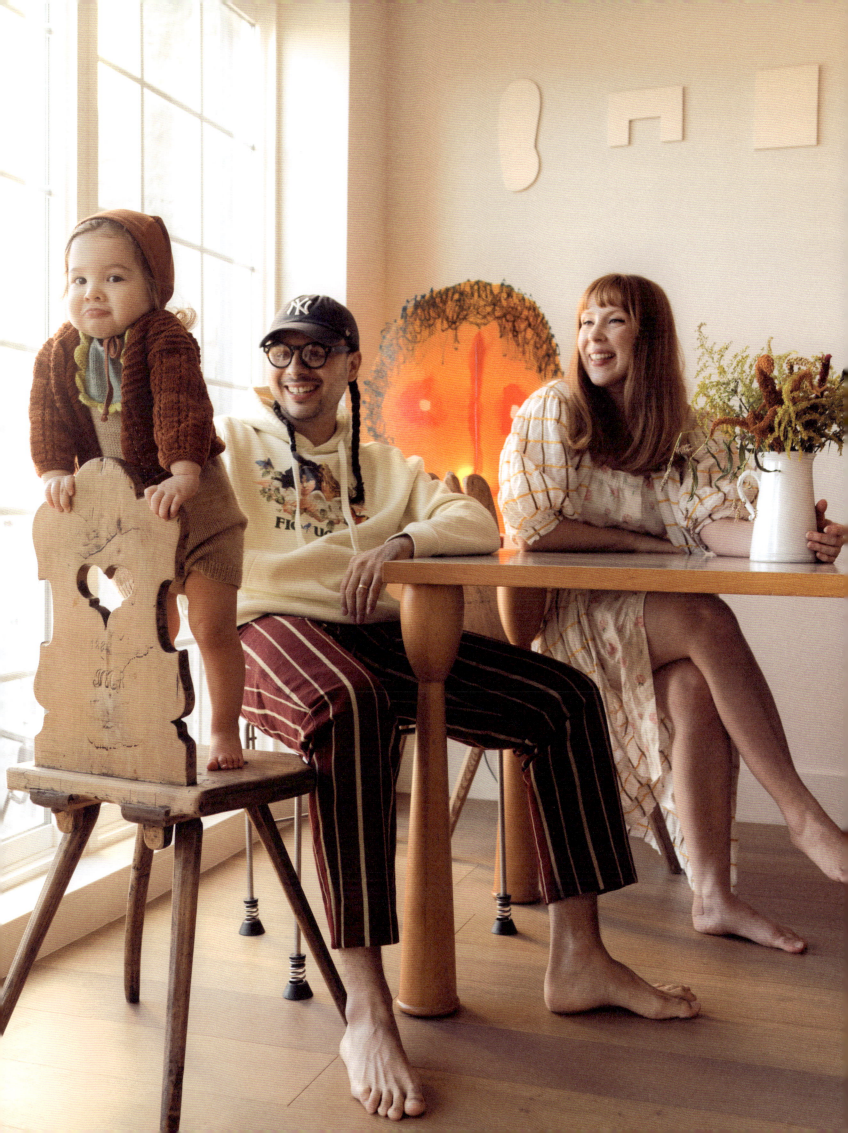

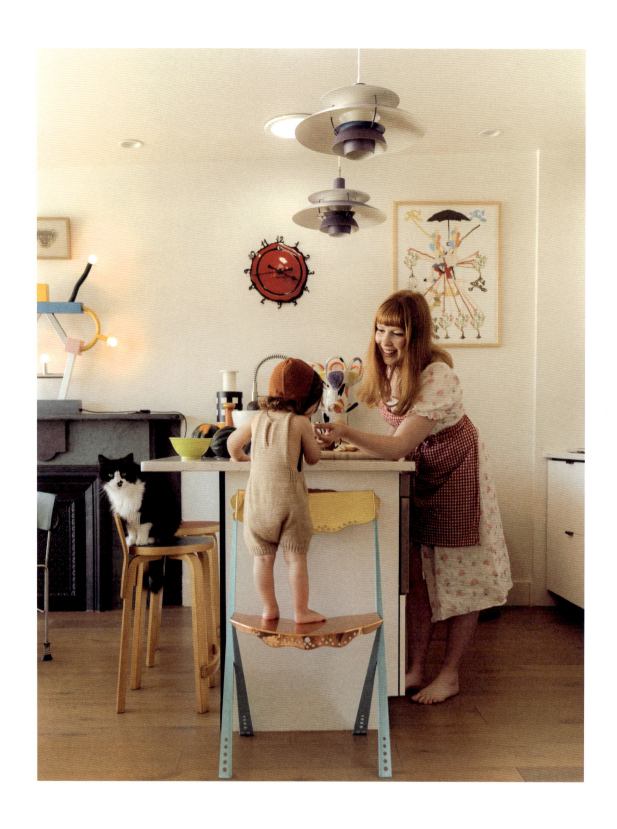

THE SHARP ORIGINALITY OF THE COUPLE'S INTERIOR
HAS MUCH TO DO WITH THEIR AUDACIOUS, UNCONVENTIONAL
WAY OF DISPLAYING OBJECTS AND FURNISHINGS, VERY ALIGNED
WITH THEIR STRONG VISUAL LANGUAGES AND UNIQUE
PERCEPTION OF PROPORTION AND SCALE.

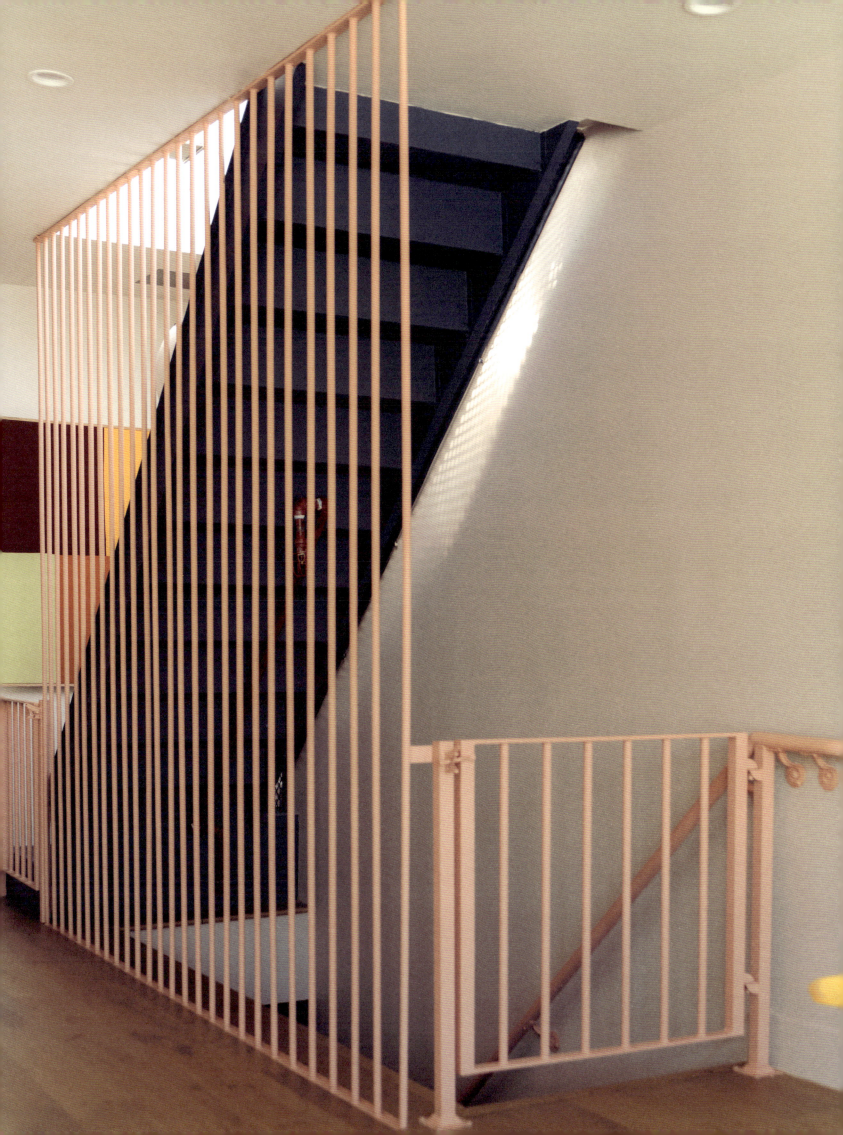

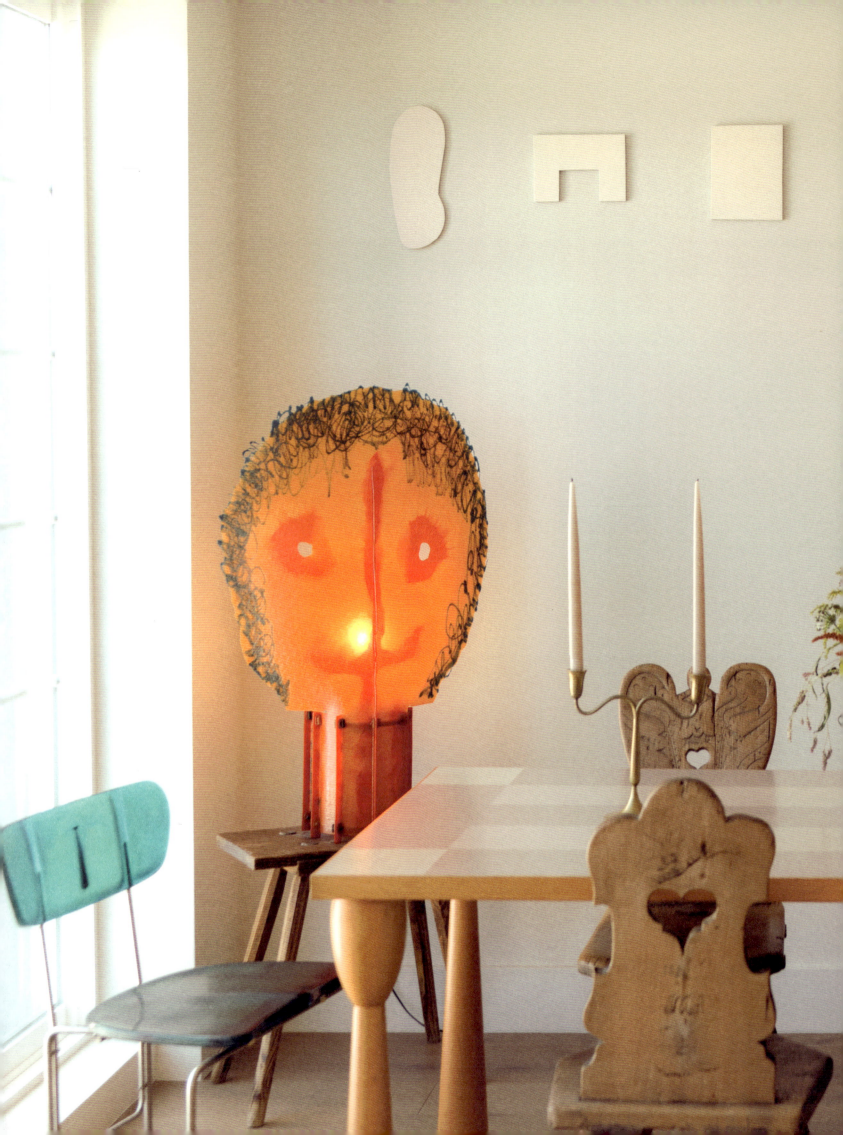

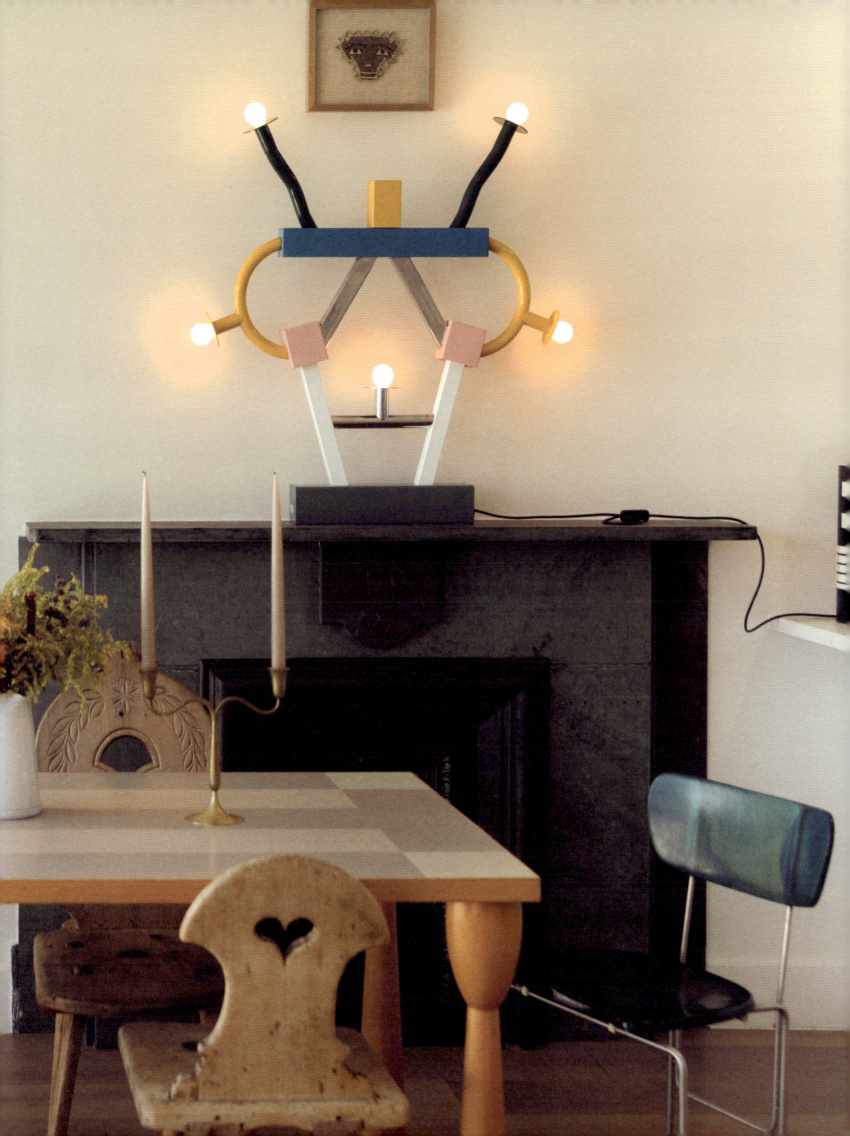

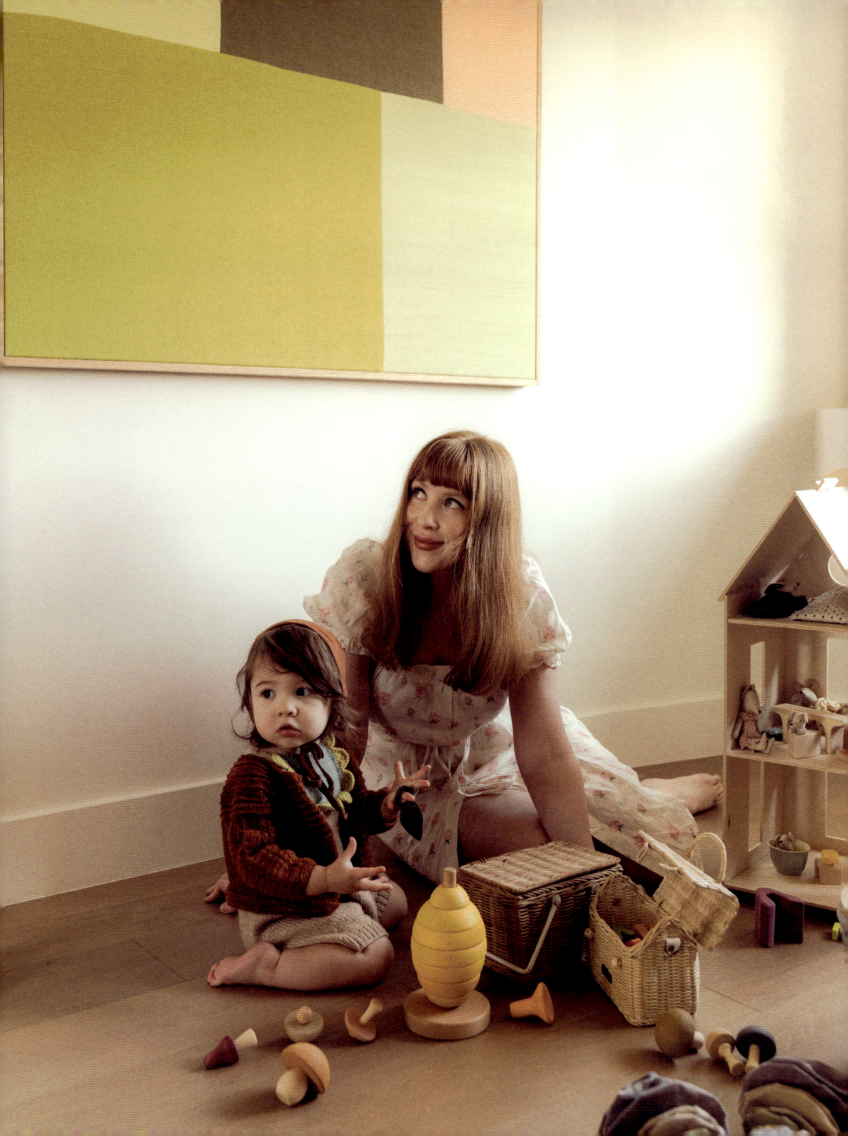

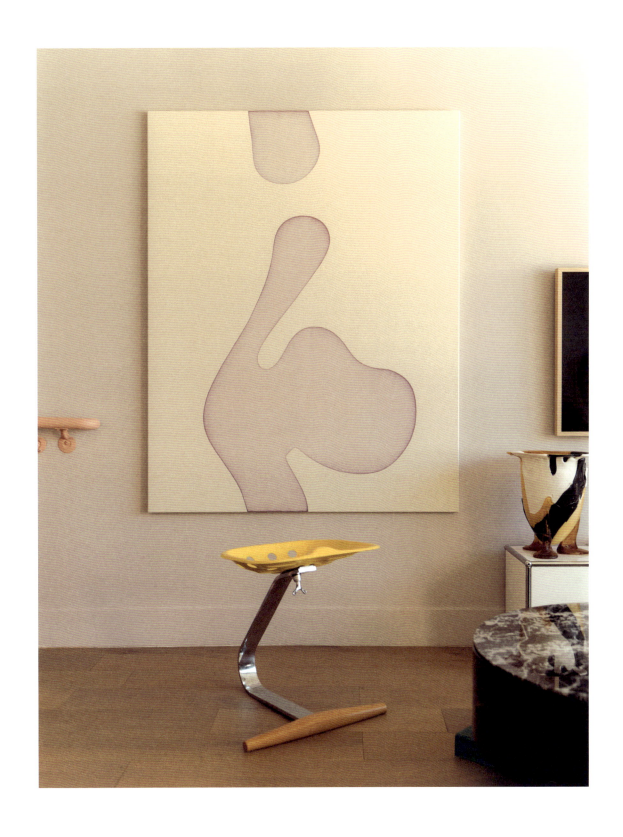

"THAT'S WHAT BRINGING UP ÈZE HERE IN NEW YORK MEANS:
BEING SURROUNDED BY A CREATIVE COMMUNITY
THAT IS EMPATHIC, OPEN, AND SUPPORTIVE."

WHERE	WHO	WHAT
VALLDOREIX SPAIN	BARB, GERARD, CRUZ, CATALINA, GREGORIO, VINCENTE	CONCRETE GLASS HOUSE

A soulful concrete and glass family house

Travel is a major source of inspiration for Barb Bruno and Gerard Lazcano, founders of Barcelona-based children's textile brand Tiny Cottons. Ten years ago, together with their three children, Cruz (now 16), Catalina (now 15), and baby Gregorio (now 10), the Argentinian couple left their native Córdoba and respective jobs—psychiatry for Gerard, fashion design for Barb—to start a new life in Europe, wishing to better balance their personal and professional lives. The couple opted for Barcelona, attracted by the cultural energy of the cosmopolitan city. It proved to be a judicious move, given the incredible success of their Tiny Cottons venture and the happy recent addition to the family, fourth son Vincente.

Barb's passion for clothes goes back to her childhood. After her first year in Spain looking after baby son Gregorio, she joined the local Adidas design team before launching Tiny Cottons in 2012, offering high-quality products with a bold visual identity. The brand's popularity quickly skyrocketed and Barb asked Gerard to get on board. Since then, the duo have divided their time between their headquarters in the heart of Catalonia's capital and their family house in Valldoreix, 15 minutes outside of Barcelona. Positioned in a protected natural area with stunning views over the undulating forest of Sant Cugat del Vallès, their beautiful concrete and glass house is the perfect place to relax together with their kids. The couple's preference for sober, minimalist white and natural wood—a palette that is characteristic of their boutiques' style, too—is mixed with soulful, second-hand furniture finds from Mercantic, a well-known local flea market where the whole family enjoys strolling around and having lunch on weekends.

The house's large kitchen—made-to-measure in rich, light wood—opens onto the living-dining room where parents and children love to gather over typical Argentinian meals. Gerard, who takes his Argentine legacy very seriously, has built an amazing outdoor multi-use cooking fireplace: "*On the left, I can cook paellas, bake pizzas in the middle, and braise on lava stones on the right—and there's obviously a parilla space for grilling meat. Now, my next project is to build a fireplace inside.*"

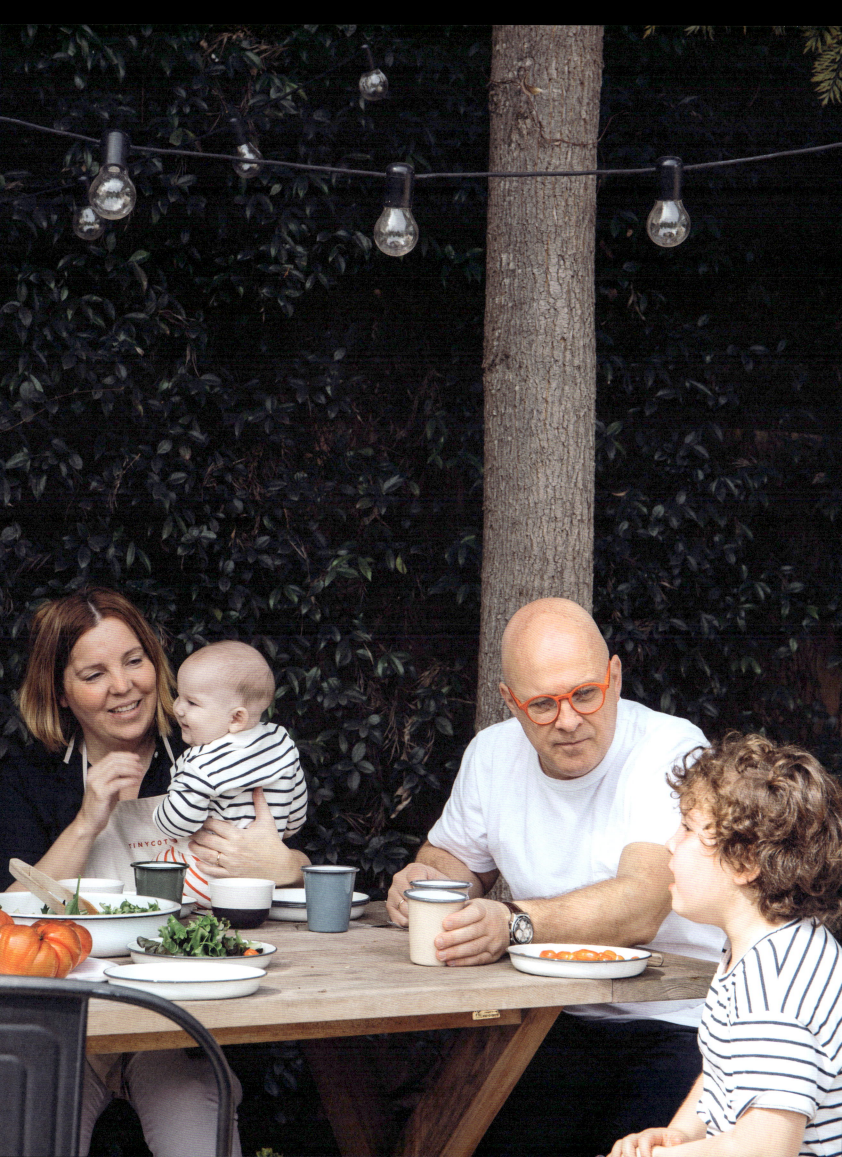

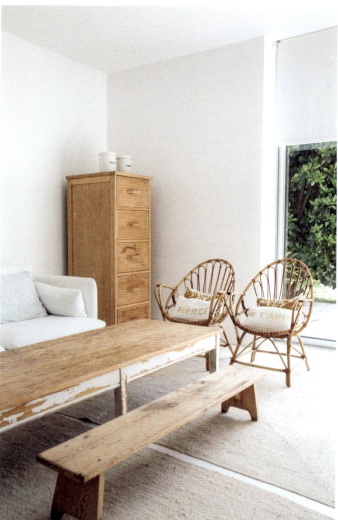

POSITIONED IN A PROTECTED NATURAL AREA WITH STUNNING
VIEWS OVER THE UNDULATING FOREST OF SANT CUGAT DEL
VALLÈS, THEIR BEAUTIFUL CONCRETE AND GLASS HOUSE
IS THE PERFECT PLACE TO RELAX TOGETHER WITH THEIR KIDS.

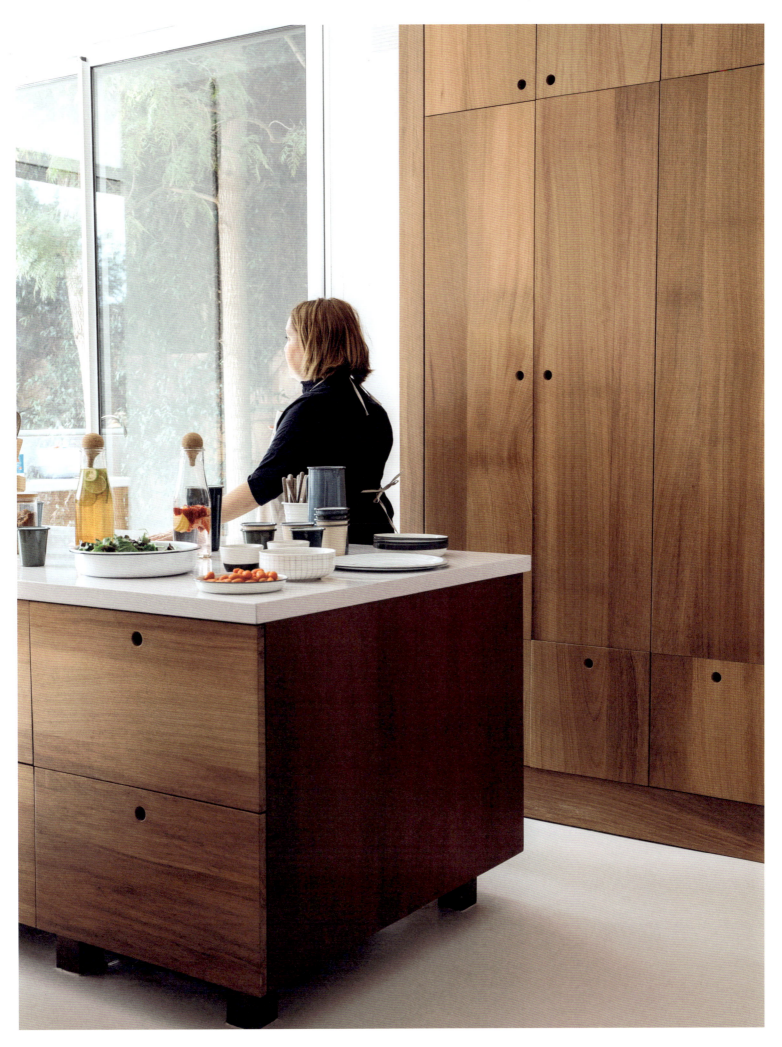

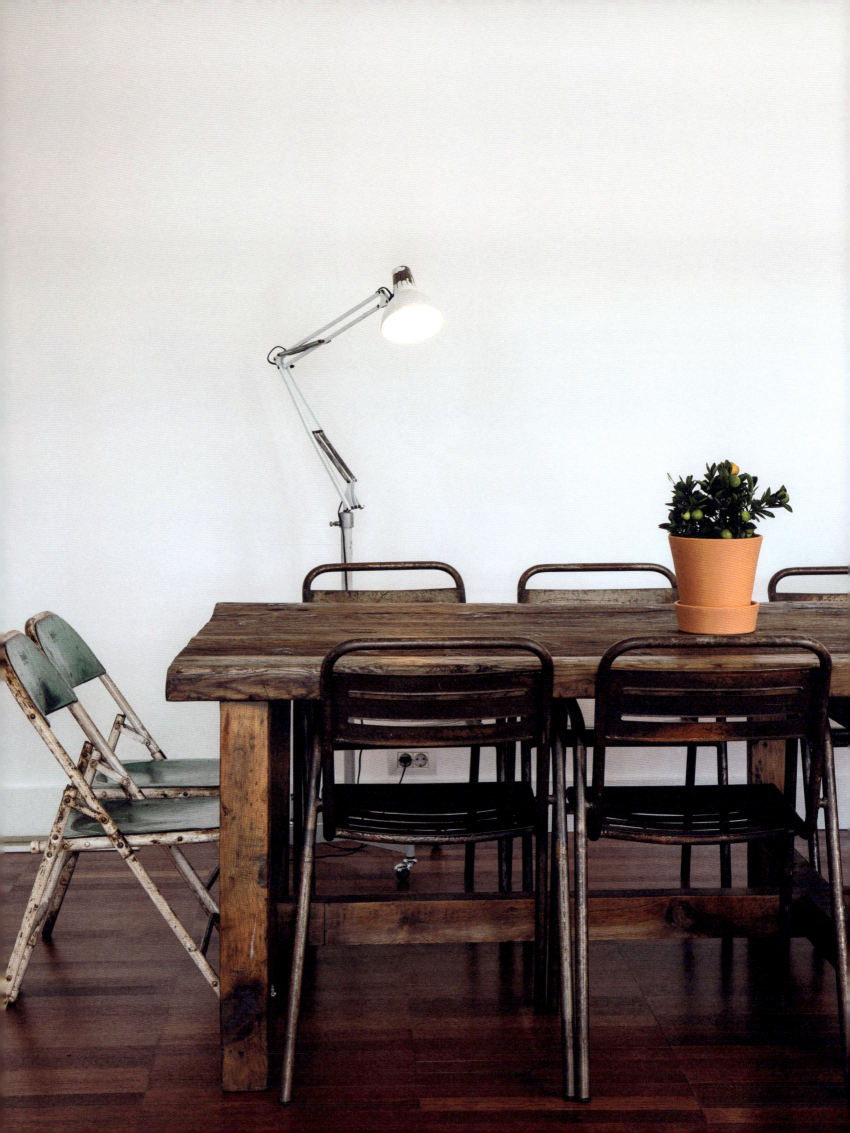

THE HOUSE'S LARGE KITCHEN OPENS ONTO THE LIVING-DINING ROOM WHERE PARENTS AND CHILDREN LOVE TO GATHER OVER TYPICAL ARGENTINIAN MEALS.

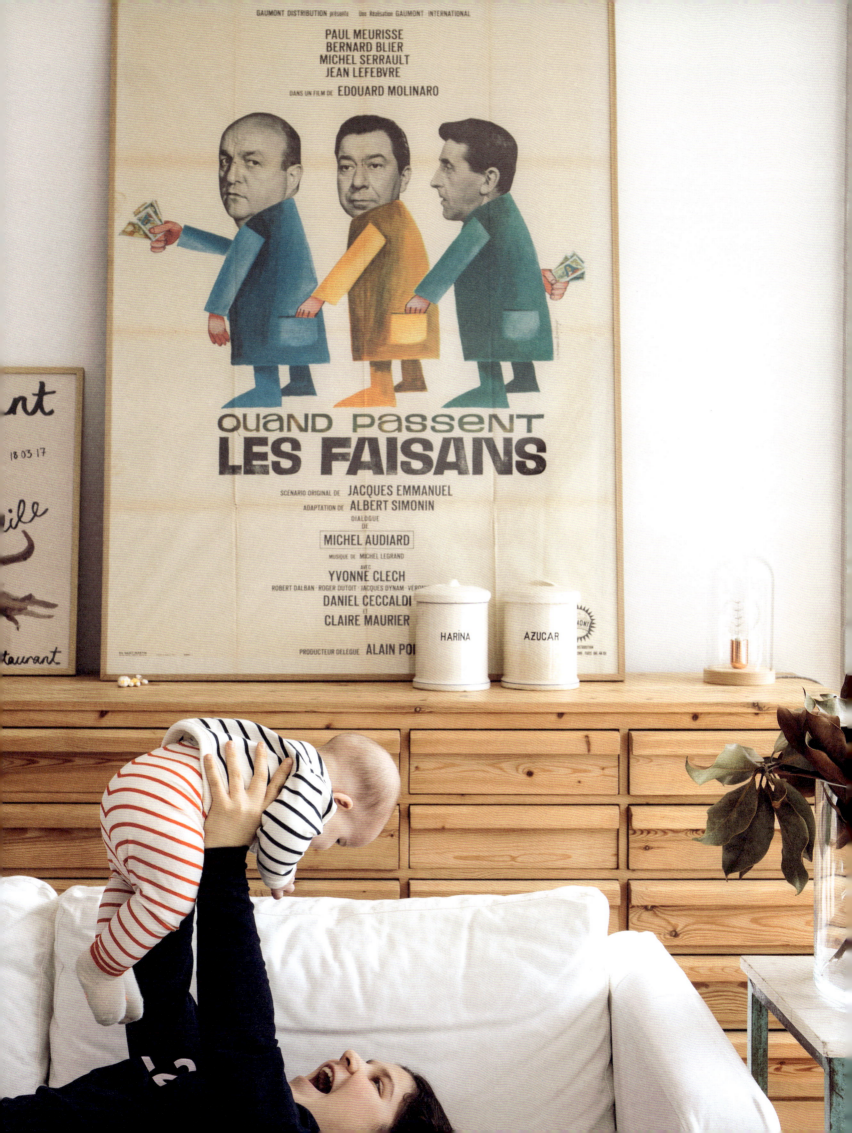

WHERE	WHO	WHAT
BIARRITZ FRANCE	PATRICK, DOROTHÉE, FELIX, ZOÉ	CONTEMPORARY CABIN

An elegant, contemporary cabin steps from the beach

"*We bought this house on an impulse while we were visiting friends here in Biarritz. We fell in love with its central location, its modest size, and simple facade while the inside was still in its original condition. We were excited to be able to work together on a project of our own, a unique space to share with our children,*" says Patrick Gilles, who, together with his wife, Dorothée Boissier, founded Gilles & Boissier, the architecture and design agency behind the thoughtful renovations of projects such as the Baccarat Hotel in New York City, the Four Seasons in Montreal, and the Mandarin Oriental Ritz in Madrid. But for their house near the beach in the family-friendly neighborhood of Saint-Charles in Biarritz, South of France, the couple envisioned a simple, essential interior conceived as a contemporary cabin to enjoy with their kids, Felix (11) and Zoé (9).

"*When we moved in, we felt the need to make this work as a single, central space where all functions would be fused together,*" says Dorothée about the open-plan ground floor where volumes and proportions were restructured, walls pushed away, and new openings created. To emphasize the length of the room, the couple created a long cedar wood bench seat as a structural backbone. Here the family can sit and gather to read, write, work, play, or have something to eat, while the tiny box-shaped kitchen is hidden behind an elegant double door. Favored natural materials including marble, stone, and cord are used to create a warm, timeless feeling, while lots of wood unifies the space and promotes the cabin concept.

Fine furniture and decoration pieces from their own Gilles & Boissier collection play into the classic black and white palette that is completed with antique pieces, objects from some client projects—like a puff created for the Mandarin Oriental in Marrakech—and an extra-large painting by friend and artist Christian Astuguevieille, which adds a bold artistic touch to the house. The first floor is a spacious oasis devoted to the kids, with a milky-white alcove that they can retreat to and read or play together. From there, a concealed staircase takes Zoé and Felix to their large room in the attic where they can look at the sky—as if they are in a cabin all of their own.

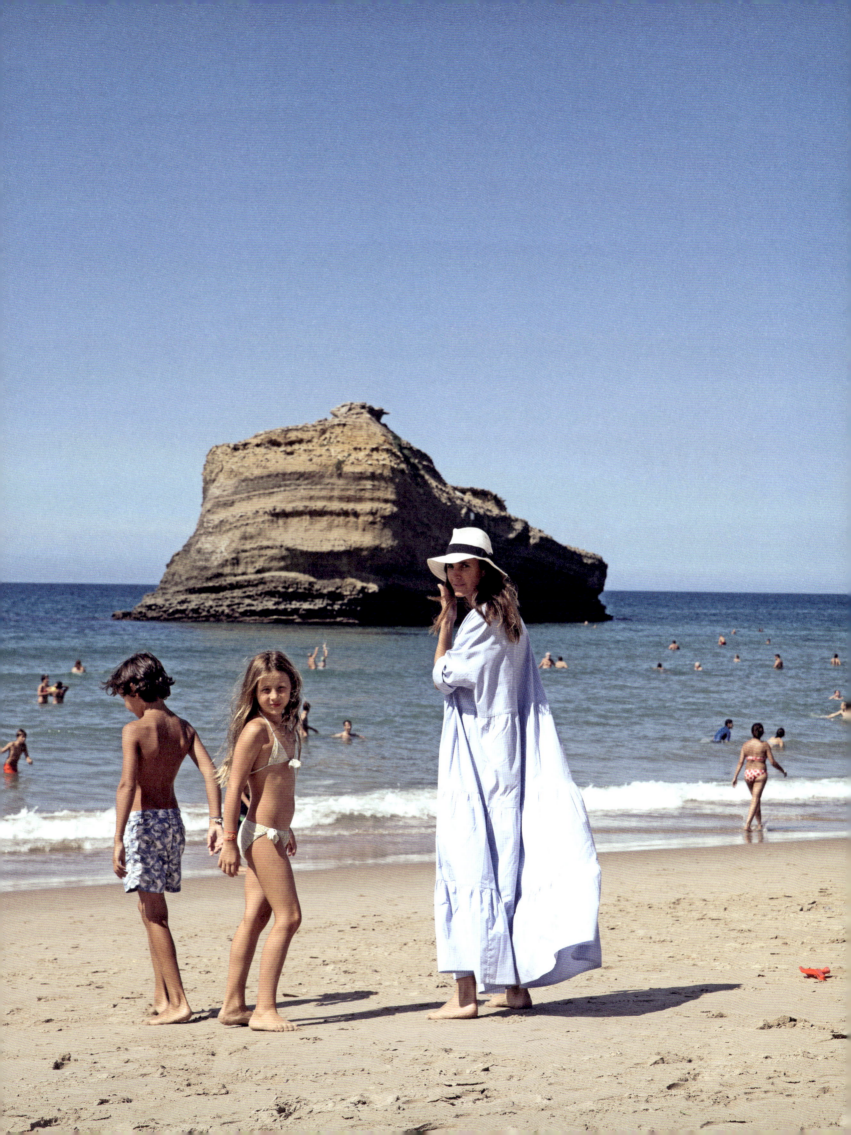

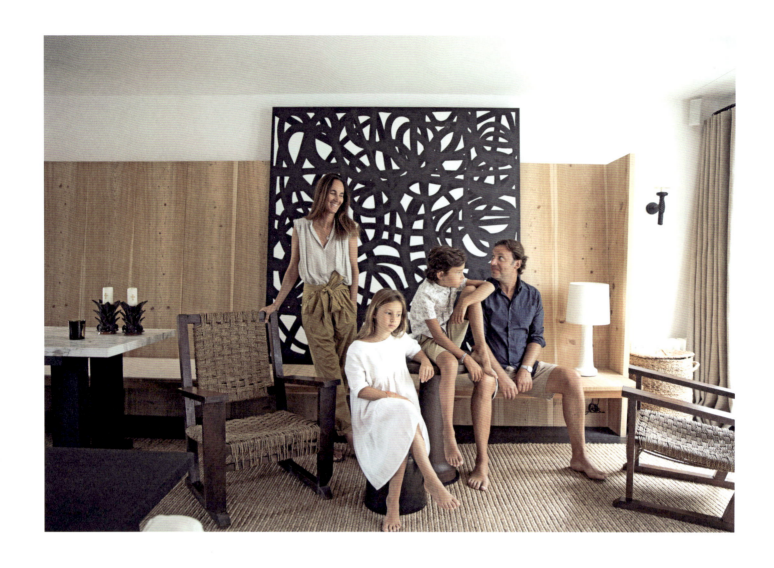

TO EMPHASIZE THE LENGTH OF THE ROOM, THE COUPLE CREATED
A LONG CEDAR WOOD BENCH SEAT AS A STRUCTURAL BACKBONE.
HERE THE FAMILY CAN SIT AND GATHER TO READ, WRITE, WORK,
PLAY, OR HAVE SOMETHING TO EAT.

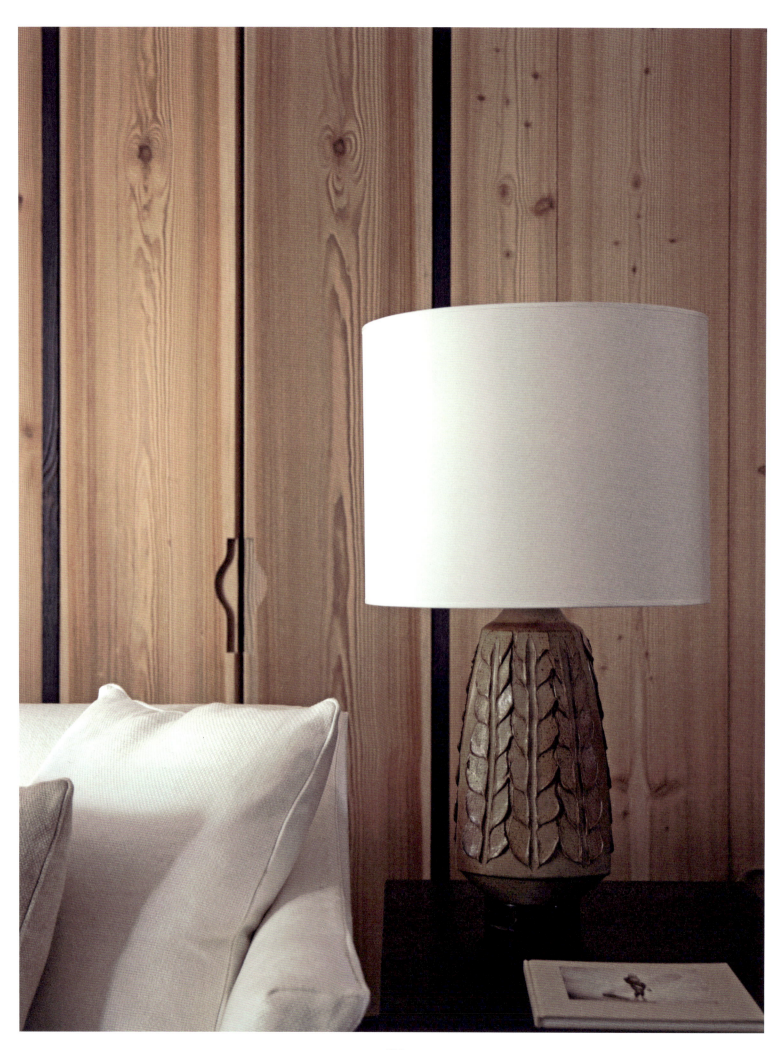

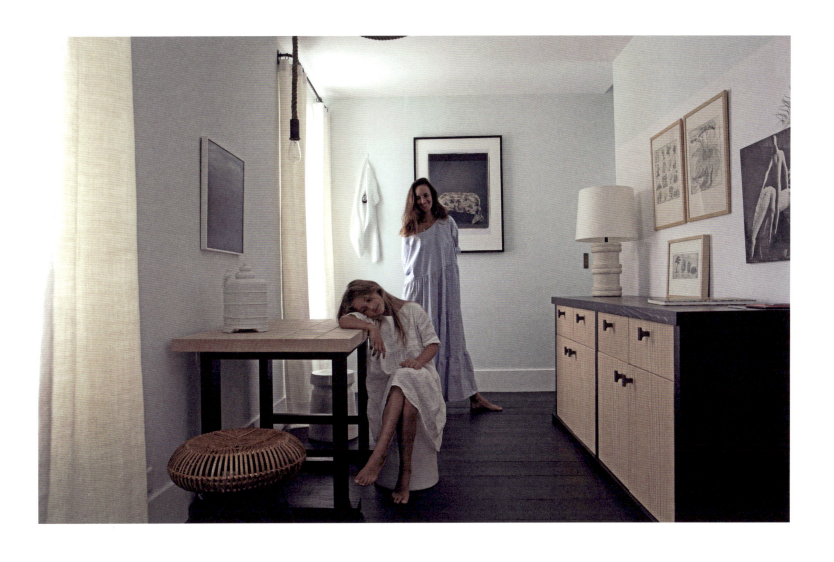

"WE BOUGHT THIS HOUSE ON AN IMPULSE WHILE WE WERE VISITING FRIENDS HERE IN BIARRITZ. WE FELL IN LOVE WITH ITS CENTRAL LOCATION, ITS MODEST SIZE, AND SIMPLE FACADE WHILE THE INSIDE WAS STILL IN ITS ORIGINAL CONDITION."

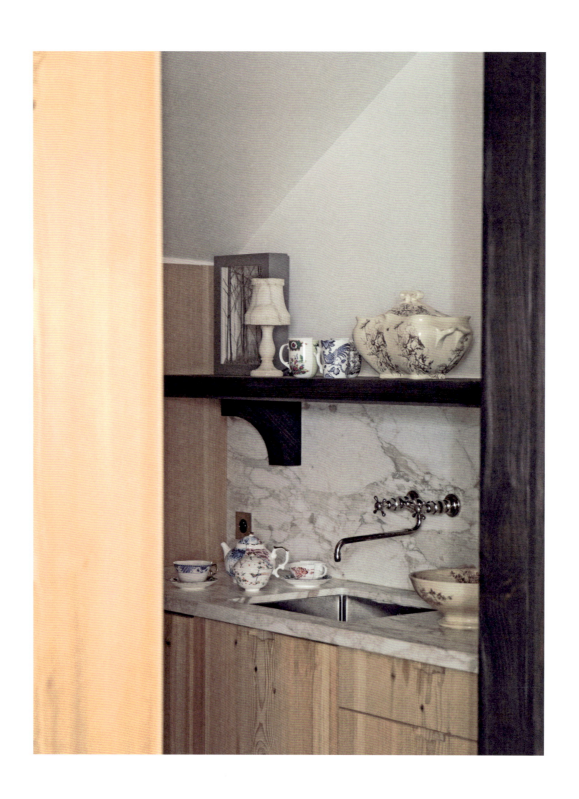

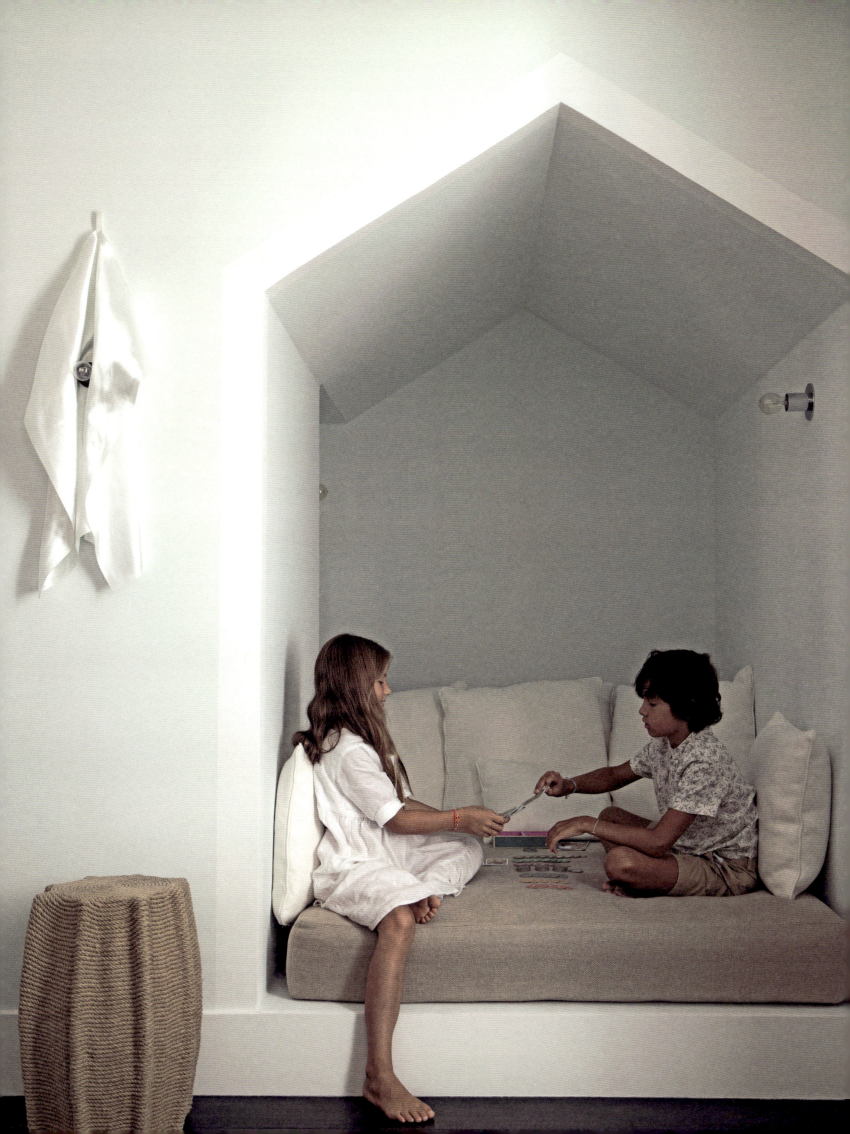

WHERE	WHO	WHAT
VEXIN FRANCE	ALIX, ONUR, ELLIS, PANDA	MINIMALIST BARN

A revived barn with floating volumes and minimalist lines

From bursting New York City to the peaceful French countryside, the life of Franco-Australian couple Alix Petit and Onur Kece is a colorful journey of inspiring and cosmopolitan creative energies. Founders of a women's fashion brand and a communications agency, respectively, Alix and Onur met in NYC and moved to Paris where they share a Haussmannian apartment with their two daughters, Ellis (6) and Panda (3). But, as the urge of the outdoors kept calling, the couple decided to also buy an old rural building in the Vexin region: an ideal location to unwind close to the capital and a perfect playground for the duo to shape the house of their dreams by blending their artistic universes.

A four-handed architectural adventure, Casa Kece began in May 2019 with the idea of mixing classical French architecture with contemporary, minimalist interior design. The dwelling—a main body, tower, and bar—has been radically transformed into a modern space envisioned by Onur, with massive floating volumes, bold geometrical proportions, and sharp clean lines that blend delicate craftsmanship and complex engineering. Cement—a key element of the project—is seen throughout the long house, subtly playing with velvety textures and soft hues, climbing onto walls and ceilings, enveloping tables or benches, and flowing over stairs and floors, morphing into some warm and flexible material that softly unifies the different areas. Alix's palette of gentle colors nicely counterbalances the home's raw structure with a clever mix of textiles and tiles that brings playfulness to the ultra-modern composition, completed by a few elegant design pieces like the "Camaleonda" sofa by B&B Italia, Saporiti table, or Hynek Gottwald chairs.

The heart of the house is now articulated around the state-of-the-art kitchen, a mix of oak panels and terracotta tiles. This opens onto the airy living-dining room where a five-meter-long (16-foot-long) light pink cement table morphs into the centerpiece fireplace, where the family gathers to eat, play, work, or relax. While the tower now hosts comfy bedrooms, the old barn was turned into a stunning main suite with a mezzanine bathroom and sauna accessed by a floating cement staircase. The floor-to-ceiling windows seamlessly integrate the garden into the room, with matching inside and outside chimneys providing a spot for the family to cuddle up and either watch a movie or grill some veggies.

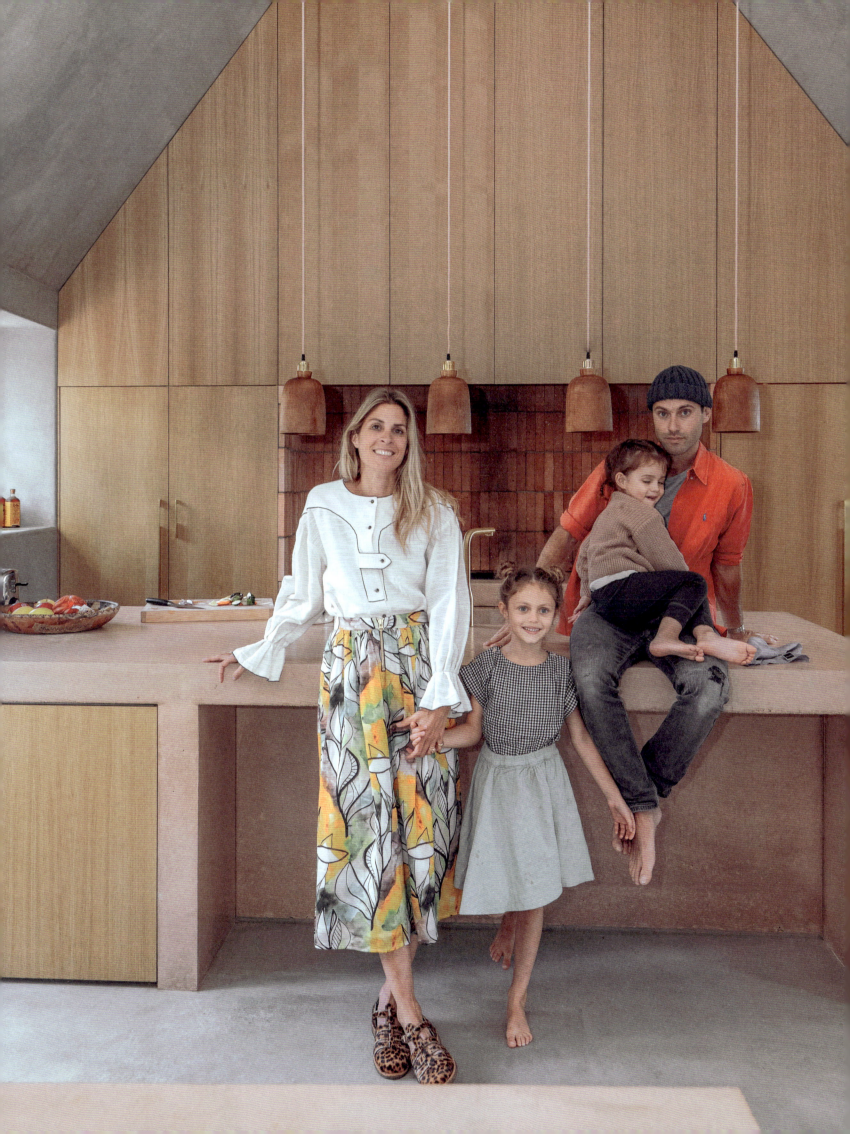

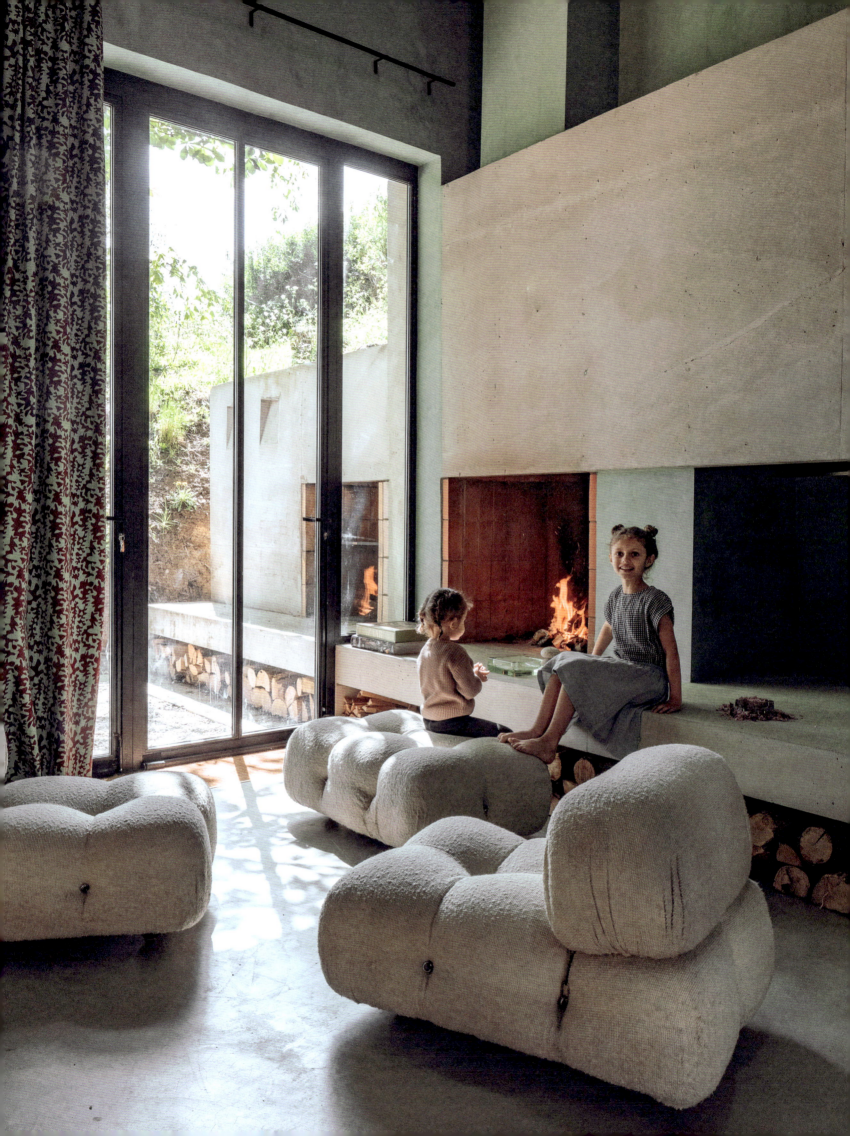

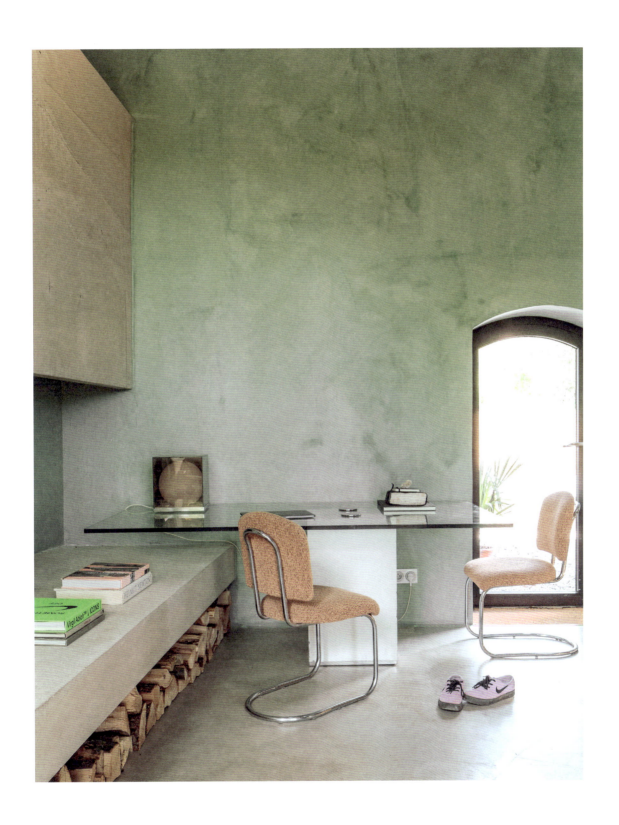

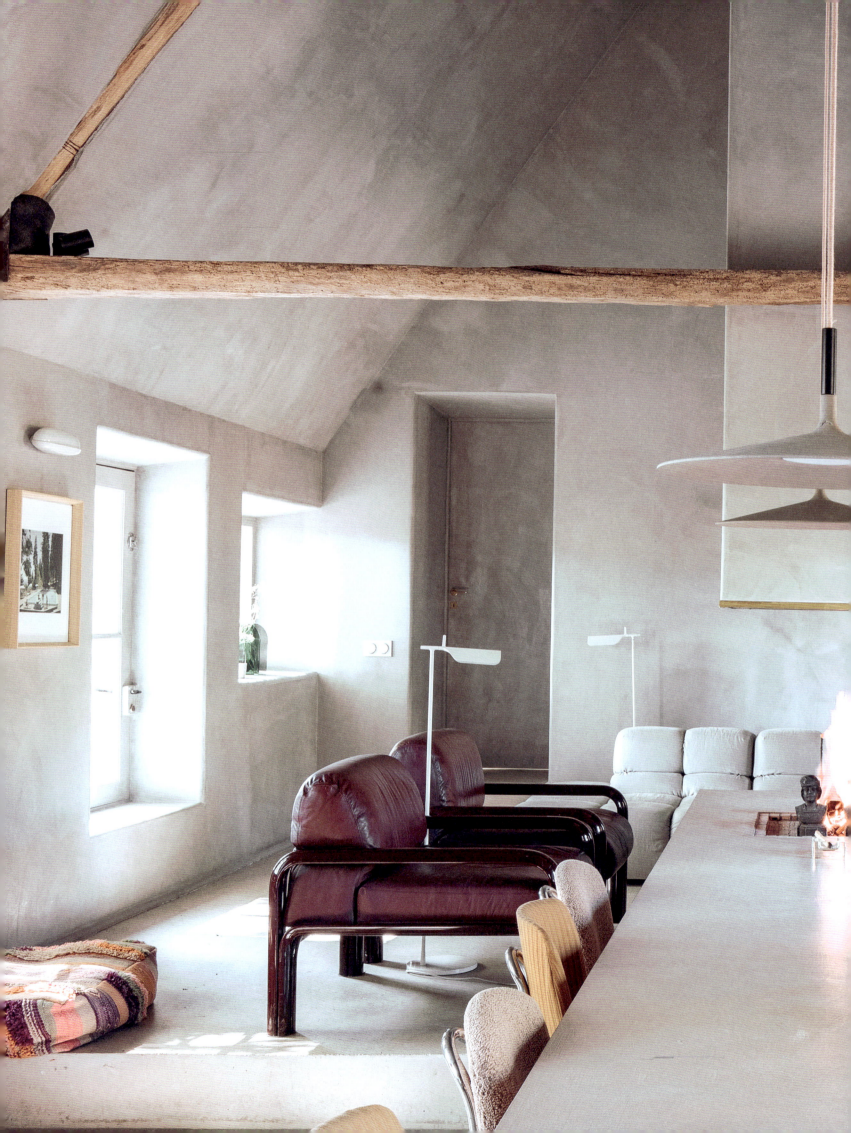

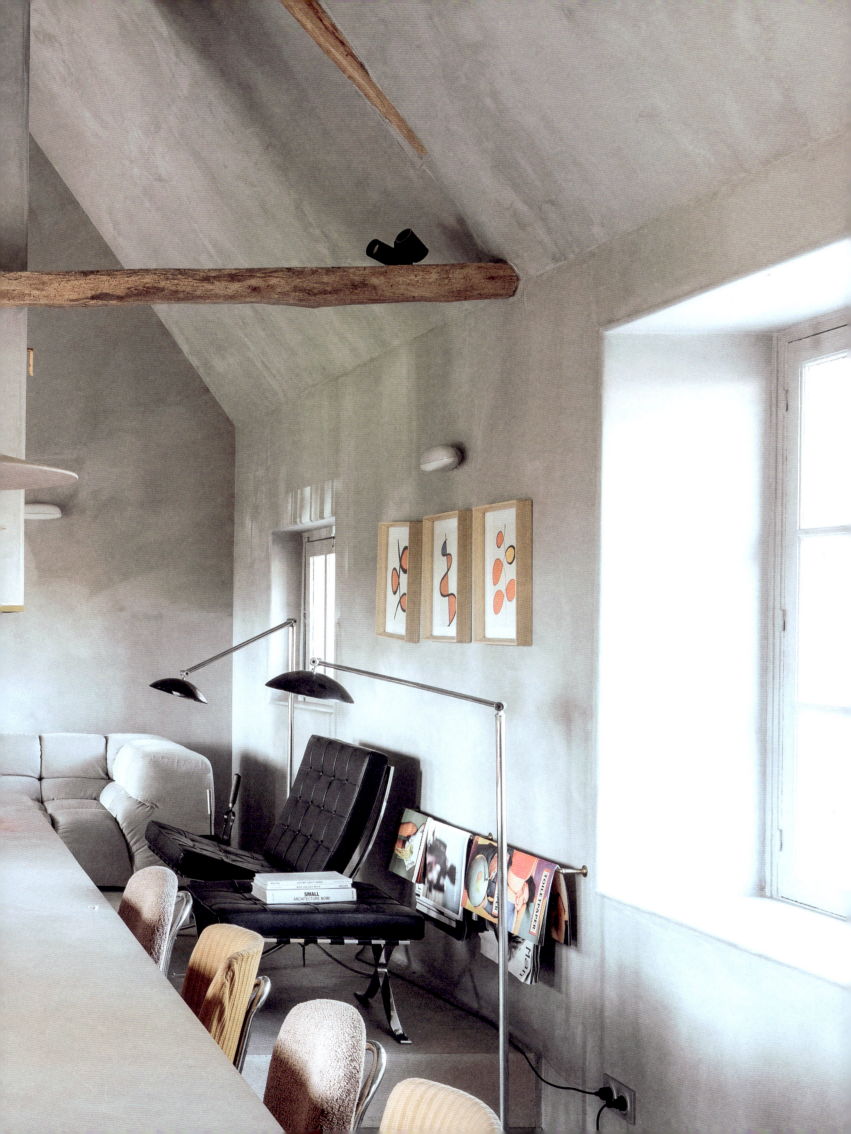

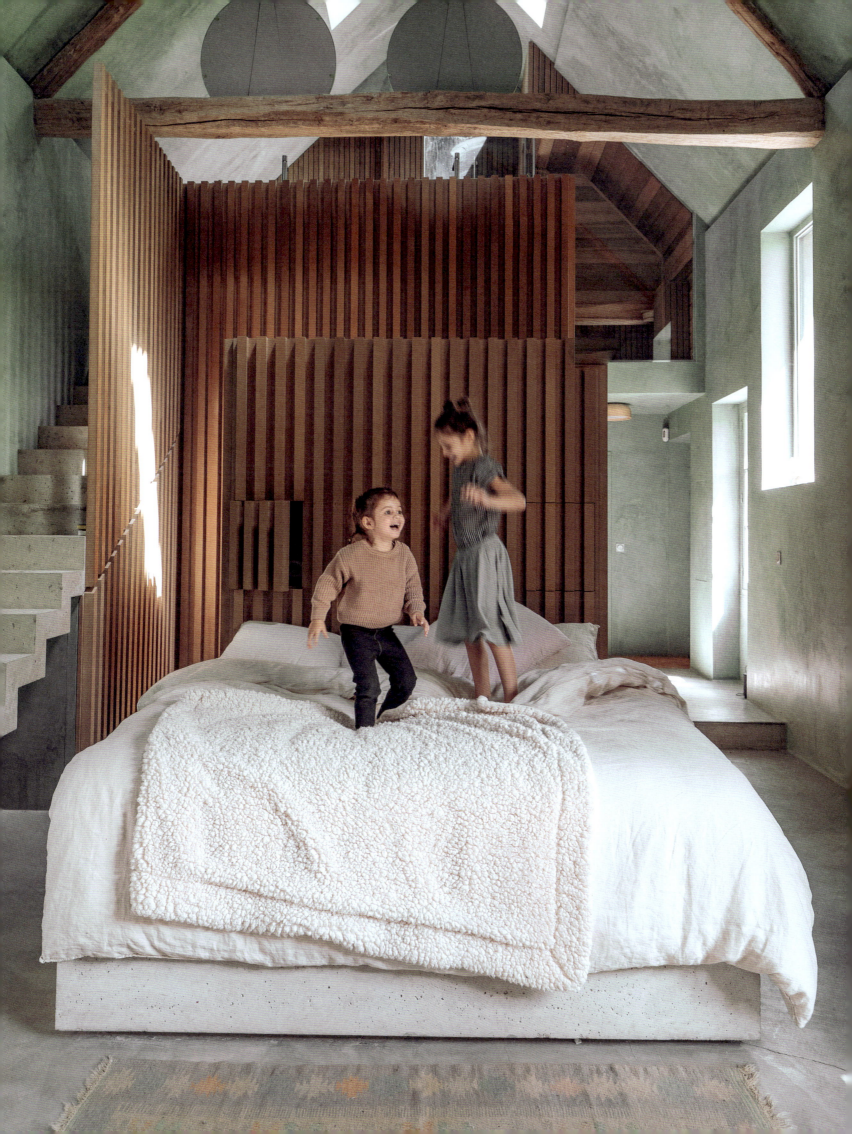

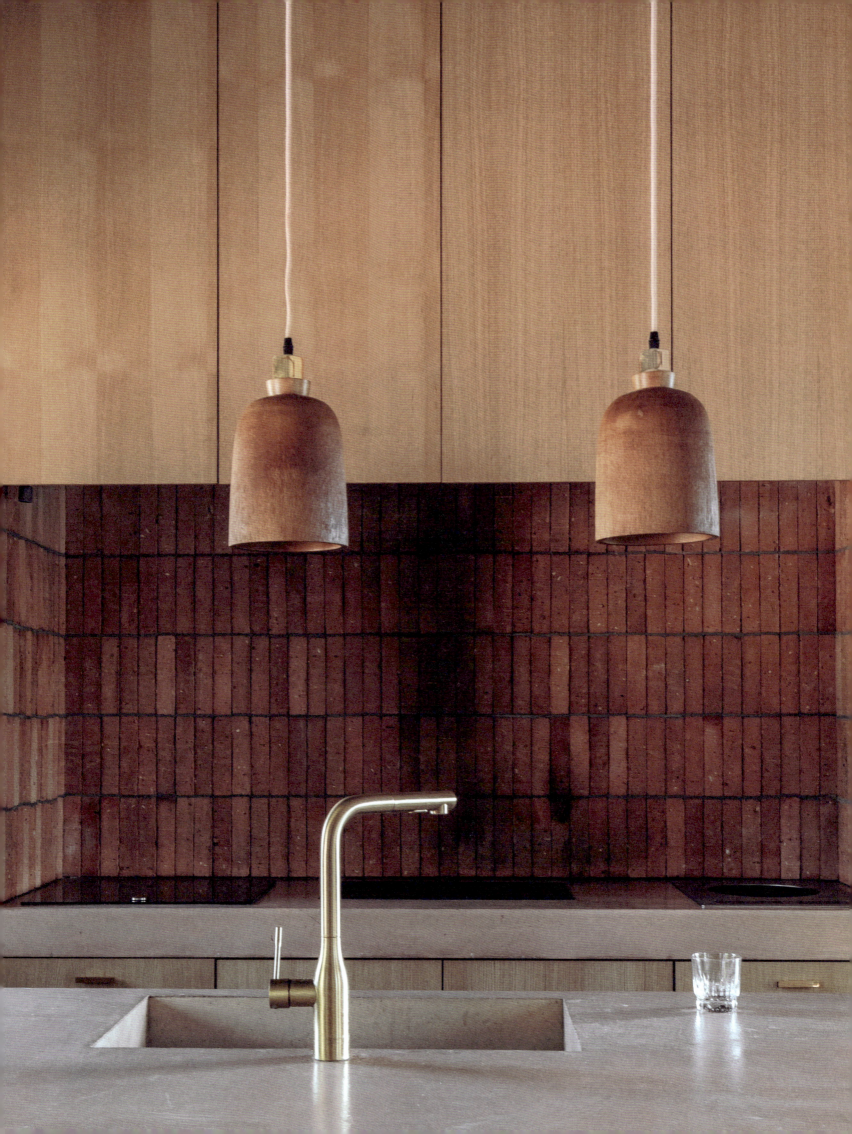

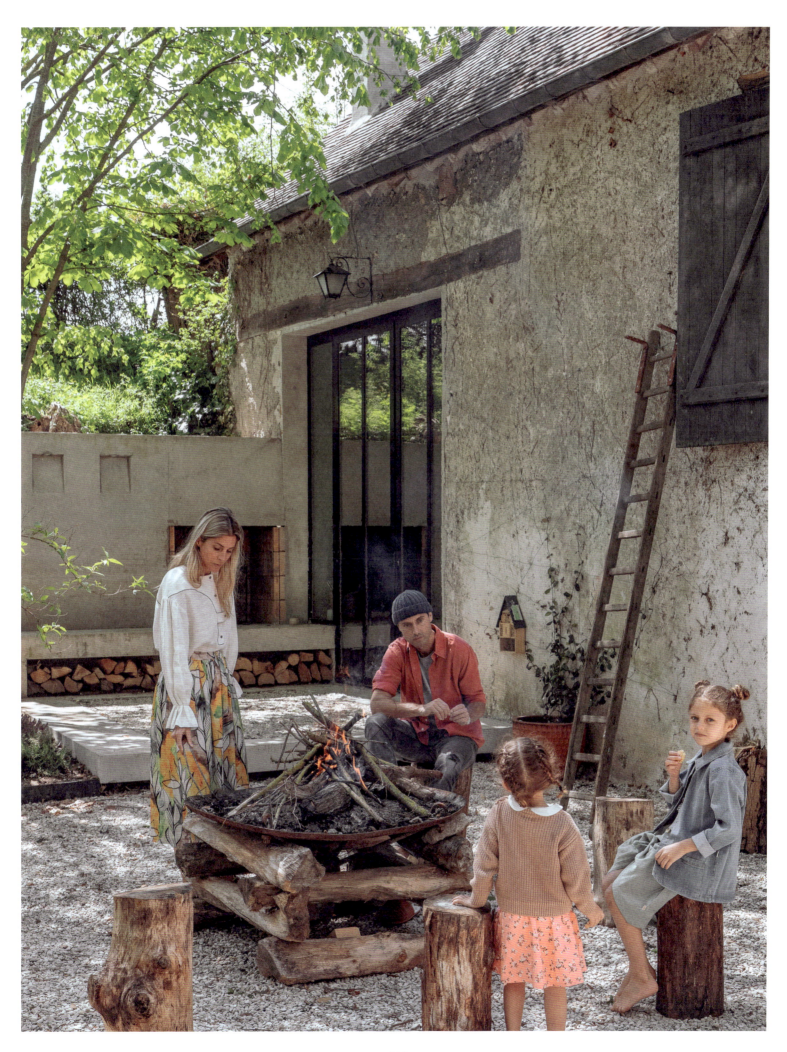

WHERE
THE HAGUE
NETHERLANDS

WHO
WENDY, REMCO, BERLIN,
DELTA, ISOLA

WHAT
LOFT-LIKE
HOUSE

A playful loft-like house full of collected memories

"My professional life definitely has an impact on my home's interior design. I have been collecting pieces from the designers I work with and they each play a part in creating the identity of my home, bringing me immense comfort and joy," says Wendy Plomp. She is the curator and artistic director of Dutch Invertuals, a design collective showcasing some of the Netherlands' most promising new talents. It is a creative position that requires Wendy to experiment, redefine, and turn things upside down in order to articulate fresh perspectives—something that is strongly reflected in the ingenious, playful home located in the south of Eindhoven that she shares with husband Remco and their three kids, Berlin (5), and twins Delta and Isola (2).

Six years ago, the couple moved to the Bloemenbuurt district—a pre-war residential area in The Hague—where they took part in a community project to co-develop an energy-neutral residence. The house's original 1930s facade was maintained, while the interior was transformed into a white box ideal for creative endeavors. But as the couple welcomed their three children, they soon outgrew the space and decided to exchange their house with a neighbor, whose larger home could accommodate their crew. While their new home's spirit remained intact, the floor plan changed radically. *"We chose to have a house without doors,"* says Wendy. *"It's a vast open space that encourages communication, where we can spend as much time together as possible. It's an entity that's constantly evolving, the atmosphere of which can be adapted to the different needs and periods of our lives."*

The airy, loft-like volumes on two levels—kitchen, dining room, and lounge on the first floor; sleeping area and bathroom on the second floor—work as a great experimental playground where Remco's "house-within-a-house" system orchestrates flow and movement. These tailor-made wooden structures frame cabin-like rooms for each child, defining intimate territories while ensuring adjustments can be easily made. Wendy's preference for natural, sustainable materials and white walls enables her beautiful designer pieces to stand out, adding elegance but also collected memories to her singular family space that is intended to grow freely and think outside of the box.

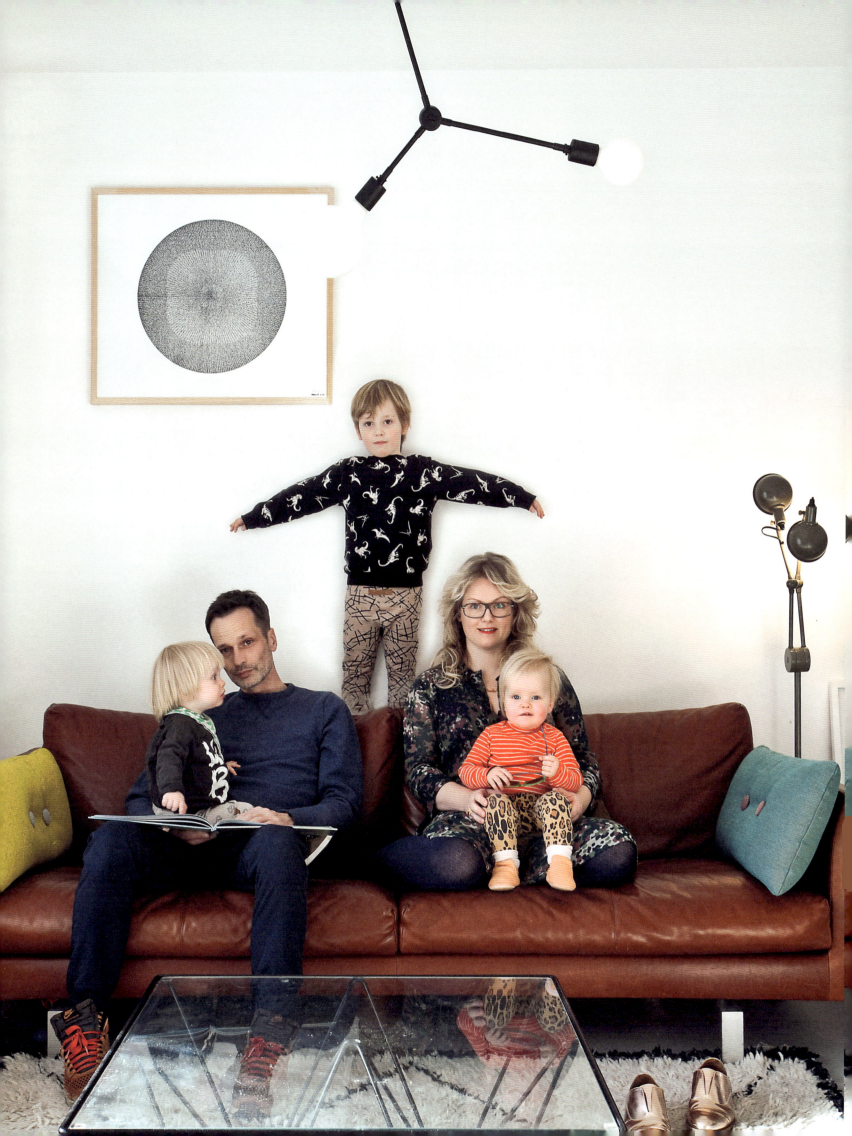

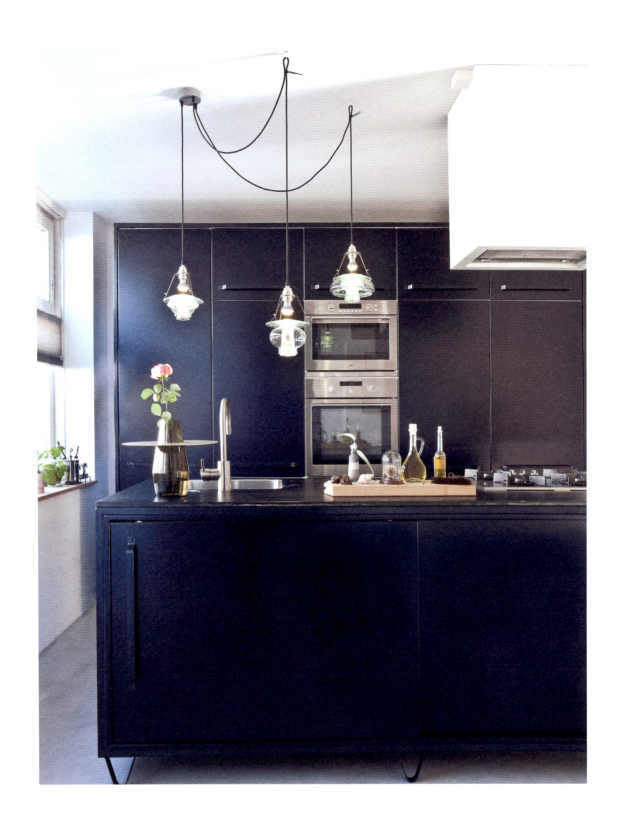

"WE CHOSE TO HAVE A HOUSE WITHOUT DOORS," SAYS WENDY. "IT'S A VAST OPEN SPACE THAT ENCOURAGES COMMUNICATION, WHERE WE CAN SPEND AS MUCH TIME TOGETHER AS POSSIBLE. IT'S AN ENTITY THAT'S CONSTANTLY EVOLVING, THE ATMOSPHERE OF WHICH CAN BE ADAPTED TO THE DIFFERENT NEEDS AND PERIODS OF OUR LIVES."

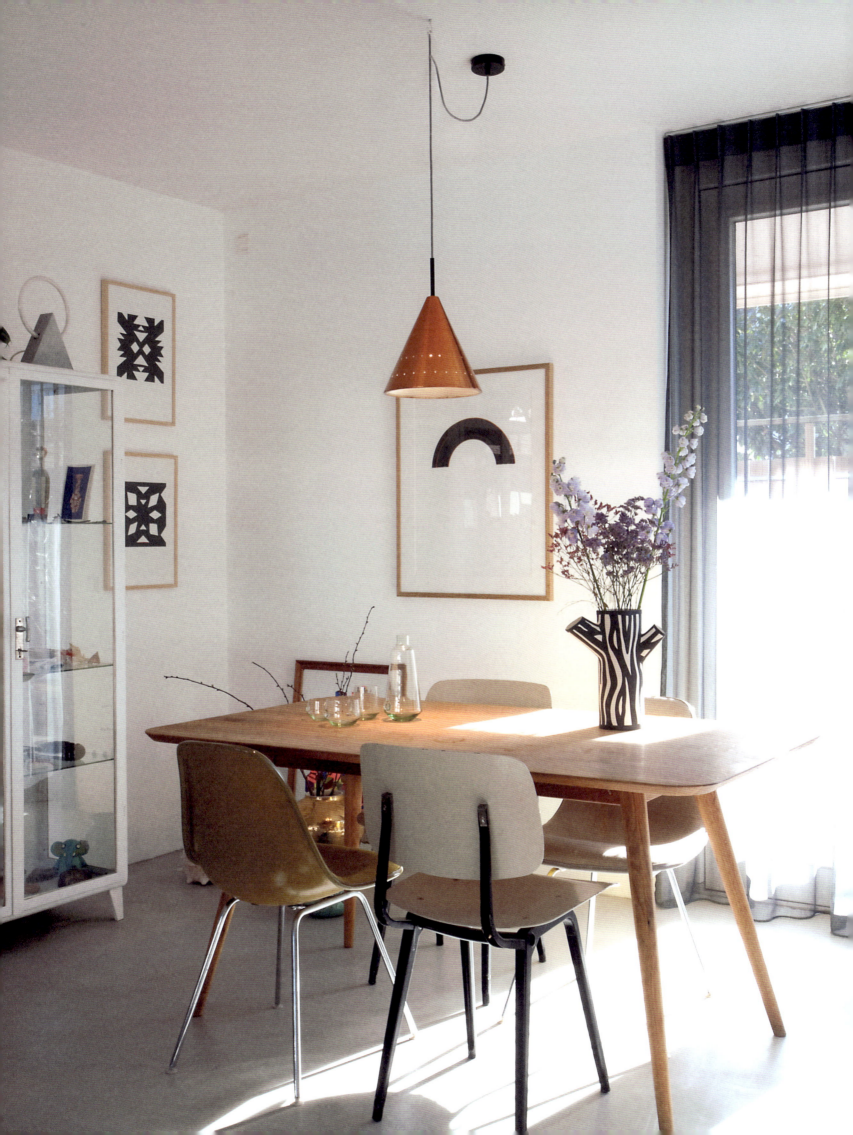

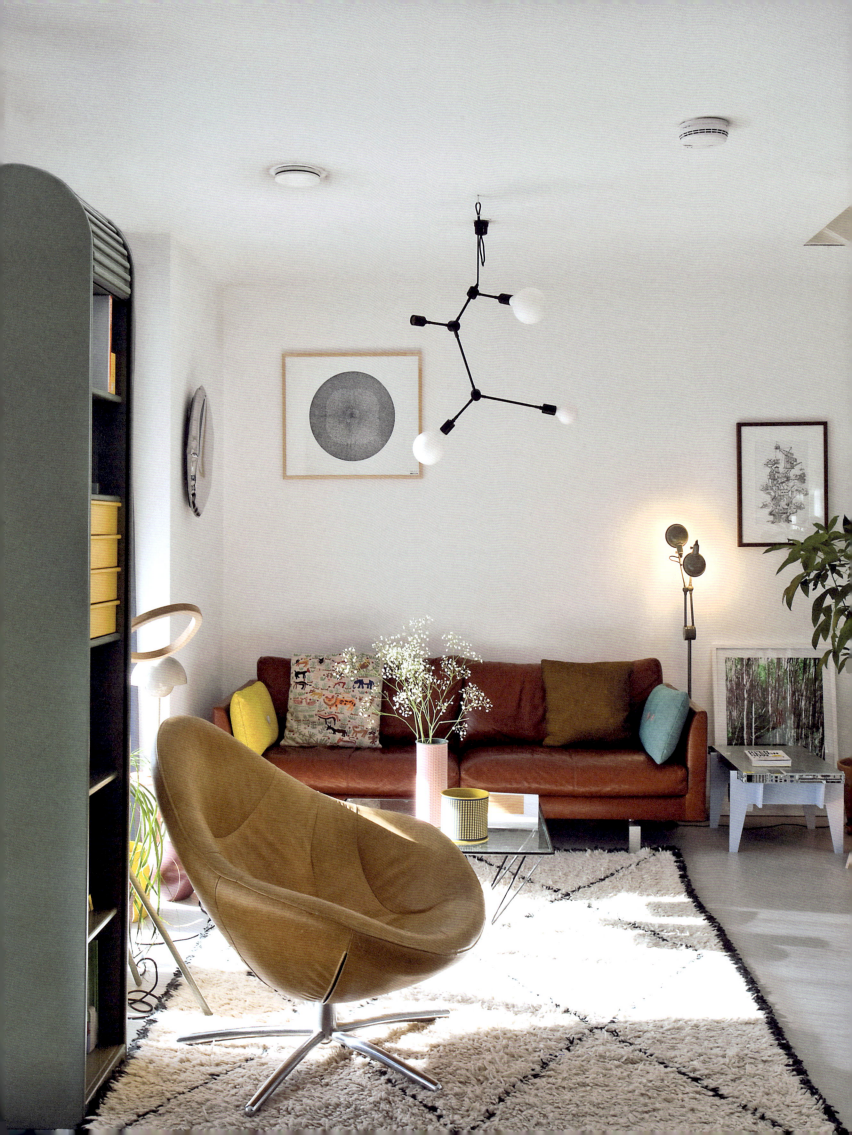

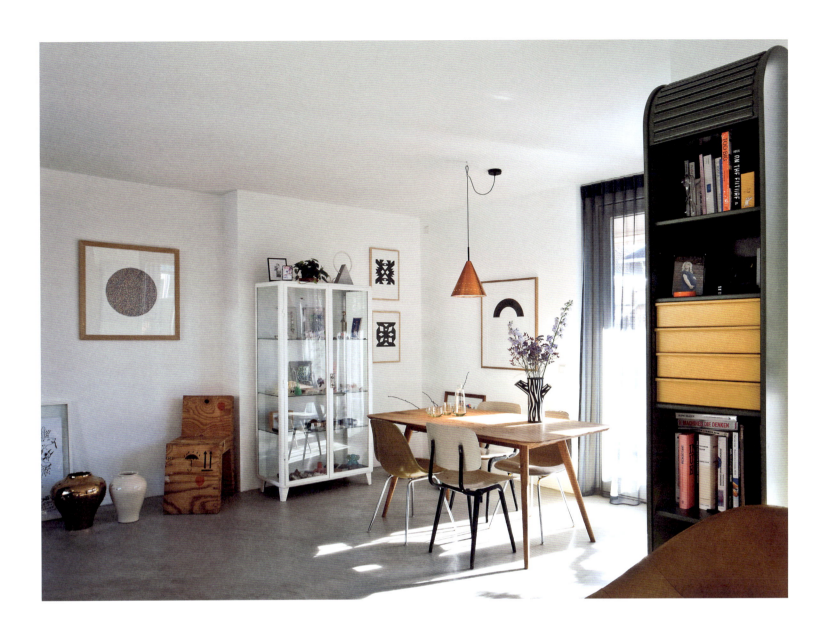

REMCO'S "HOUSE-WITHIN-A-HOUSE" SYSTEM ORCHESTRATES FLOW AND MOVEMENT. THESE TAILOR-MADE WOODEN STRUCTURES FRAME CABIN-LIKE ROOMS FOR EACH CHILD, DEFINING INTIMATE TERRITORIES WHILE ENSURING ADJUSTMENTS CAN BE EASILY MADE.

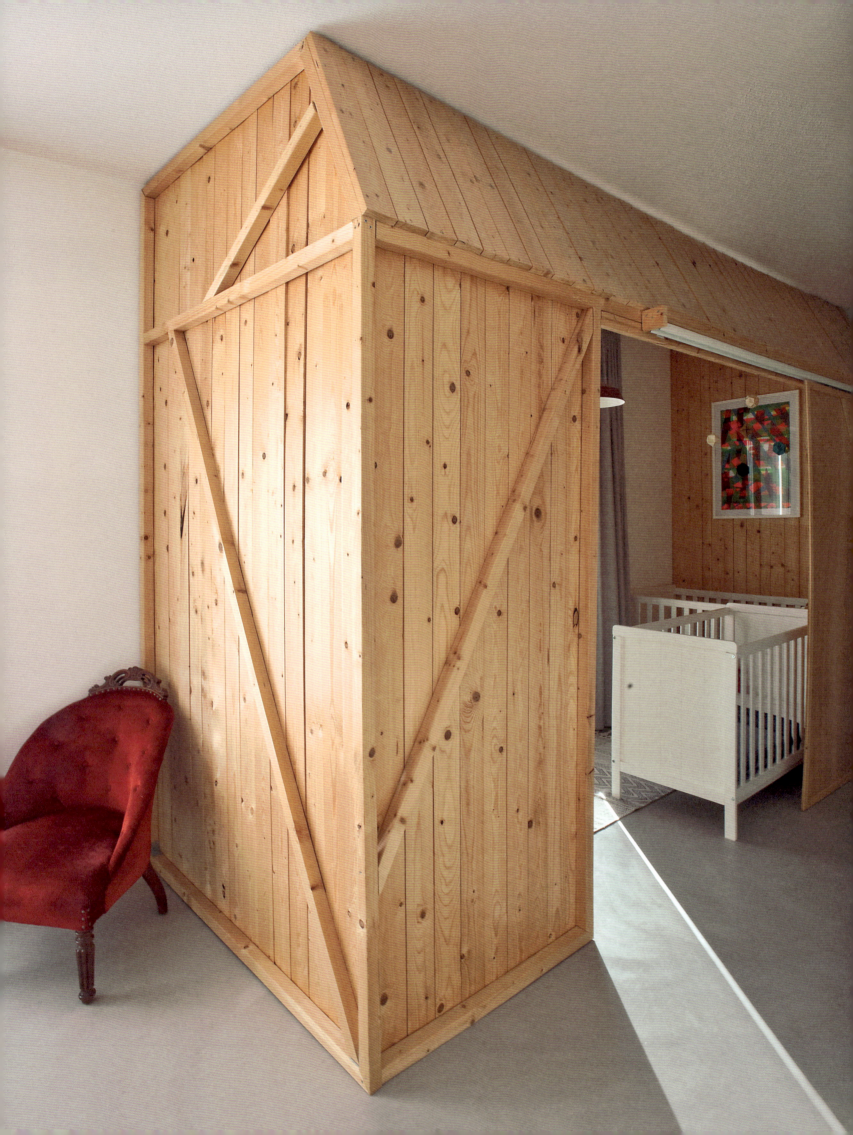

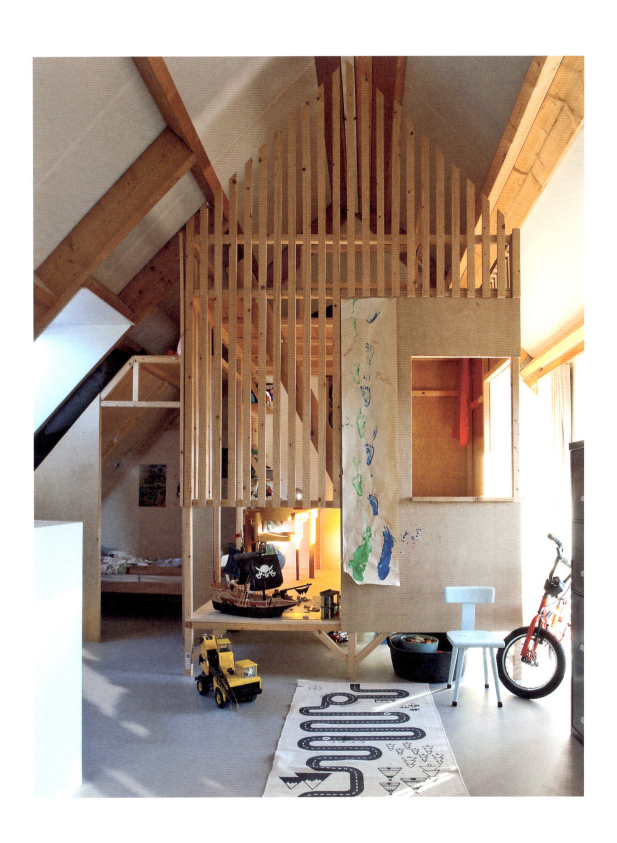

WHERE	WHO	WHAT
CORSICA FRANCE	NATHALIE, FRÉDÉRIC, CHARLES, HENRI, HADRIEN	MOUNTAIN REFUGE

A minimalist rustic refuge nestled in the mountains

"*I am very attached to family and childhood. I have fond memories of long summer holidays spent here in Corsica at my grandparents' cabin in the Marana plain,*" says Nathalie Ferrarini, the French founder of children's clothing brand We Are Kids. "*I loved that I would literally live in a simple terry cotton cloth all summer long, which is something my first collection celebrated: this special connection to this place and this moment of time.*" Together with husband Frédéric, Nathalie bought a rustic Corsican summerhouse made of drystone walls and flagstone roofs nestled in the heart of the mountains. It's a dreamy natural setting for the couple to escape to from their urban lives and enjoy breaks and holidays together with their three energetic sons, Charles (15), Henri (4), and Hadrien (2).

Once a destination for boho hippies, the charming mountainous village of Lapedina—where they bought their house in 2015—is today full of rehabilitated rustic houses, so preserving the character of their dwelling was important for the couple, who took three years to convert it into a cozy, minimalist refuge. "*The original interior decor was a bit strange and the renovation work has been a long and laborious process—but the house has a soul,*" says Nathalie. The interior of the duplex has been thoroughly decluttered to accommodate the young kids securely and enhance the structure's graceful details—imperfect whitewashed walls, little recesses, handsome fireplaces—reinforcing the pleasingly organic feel of the space, while the small outhouse below the main building is now Nathalie's design studio.

"*At home in Bastia, there's always friends or family swinging by, and the children liven up our daily routine so much—it never stops! Here, it's so different—this peacefulness helps me to clear my mind. And for the first time this year, we'll have time to fully enjoy the house, explore the other side of Cap Corse, go to the beach every day, and have friends to stay here with us.*" A taste of endless summer indeed, all encapsulated into the latest We are Kids collection of timeless pieces.

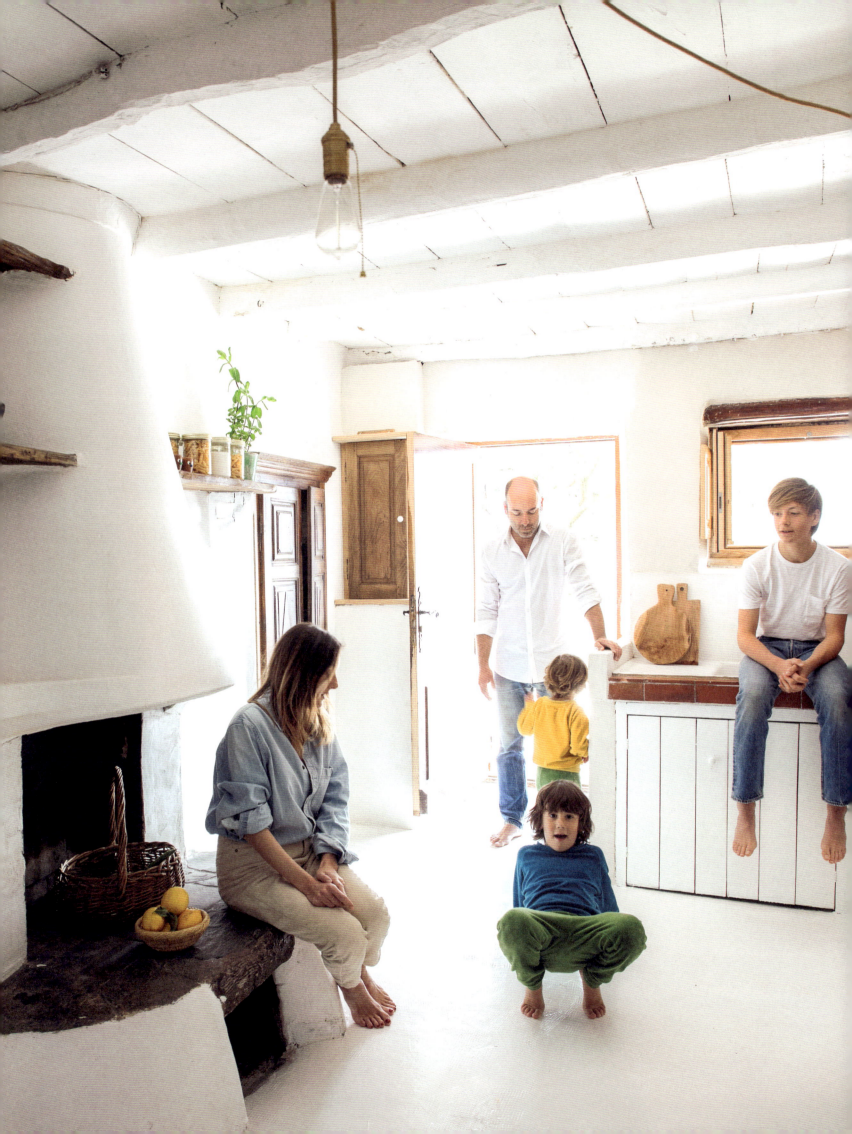

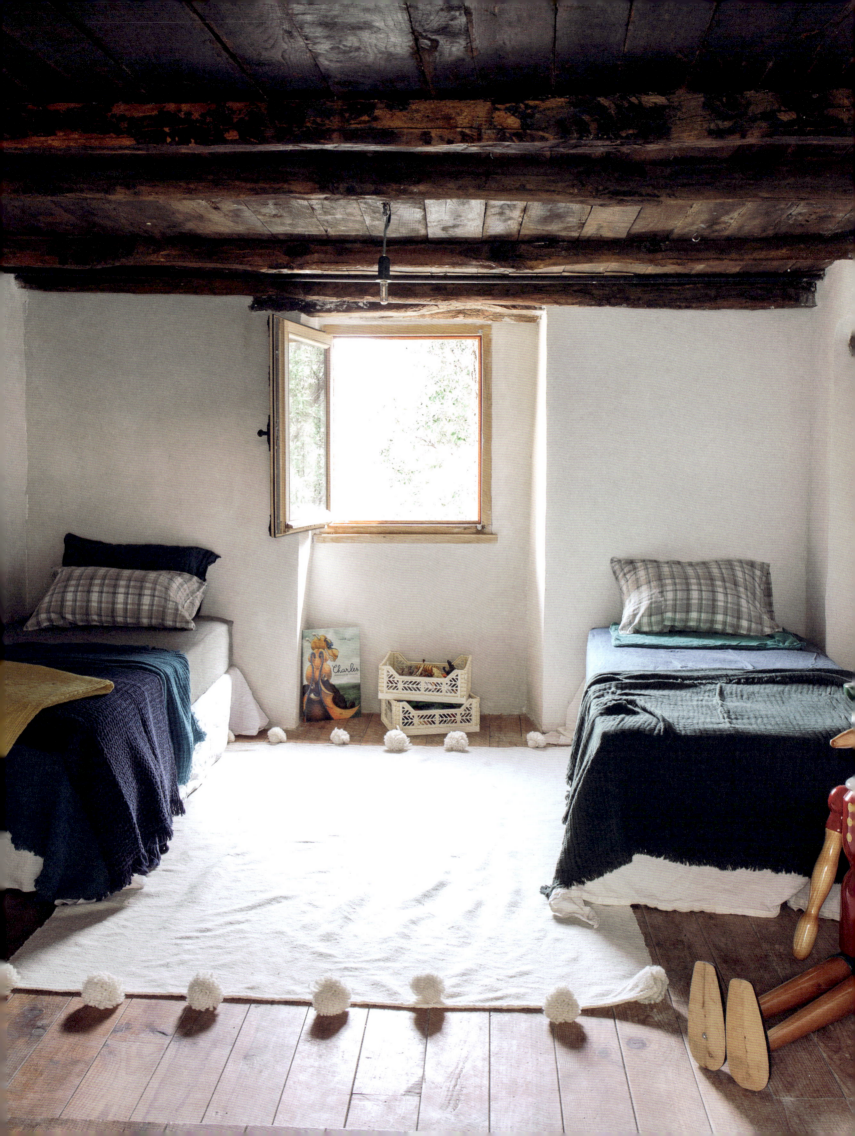

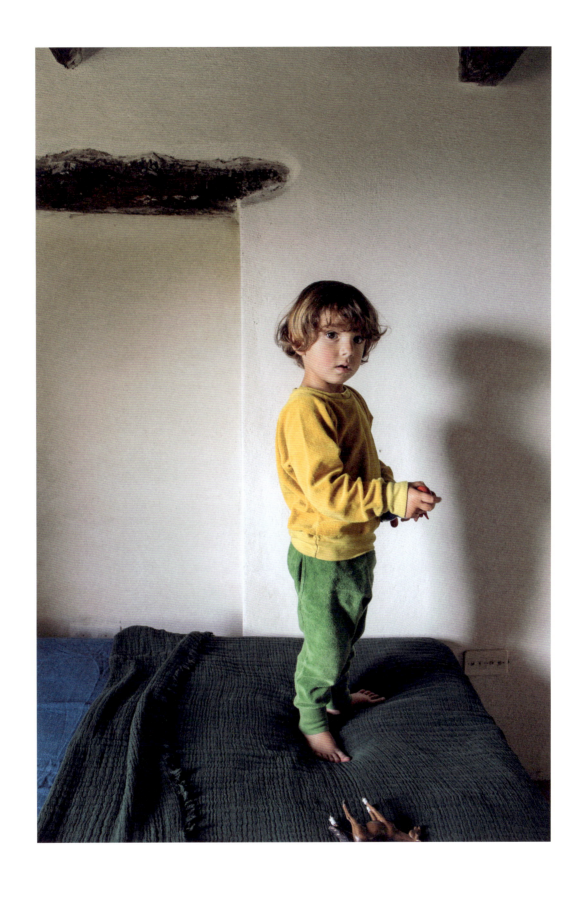

"I AM VERY ATTACHED TO FAMILY AND CHILDHOOD. I HAVE FOND MEMORIES OF LONG SUMMER HOLIDAYS SPENT HERE IN CORSICA AT MY GRANDPARENTS' CABIN IN THE MARANA PLAIN."

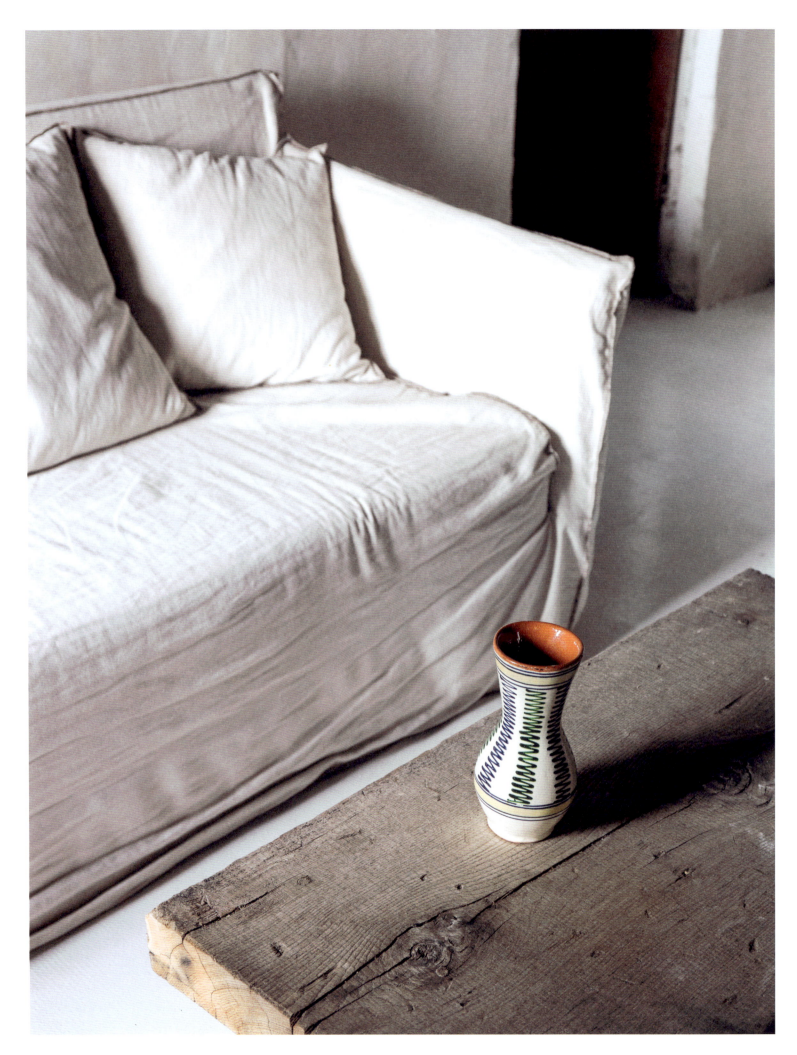

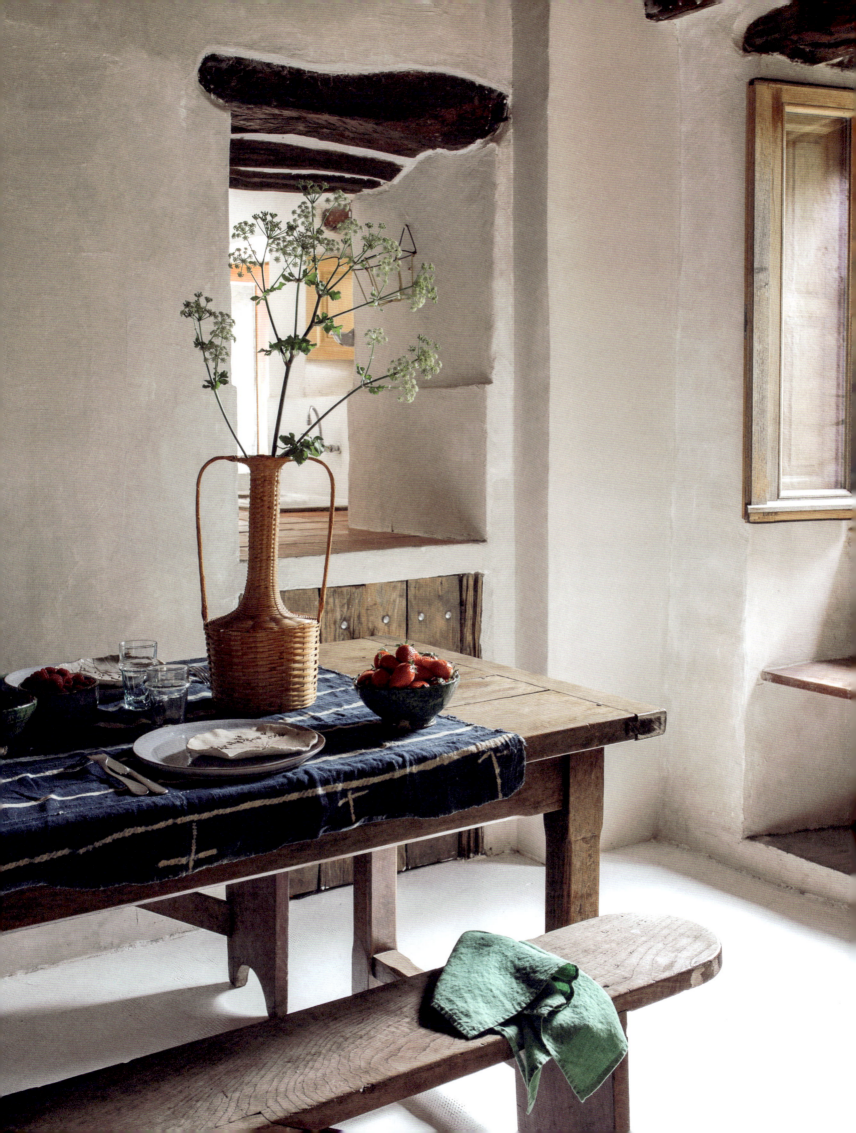

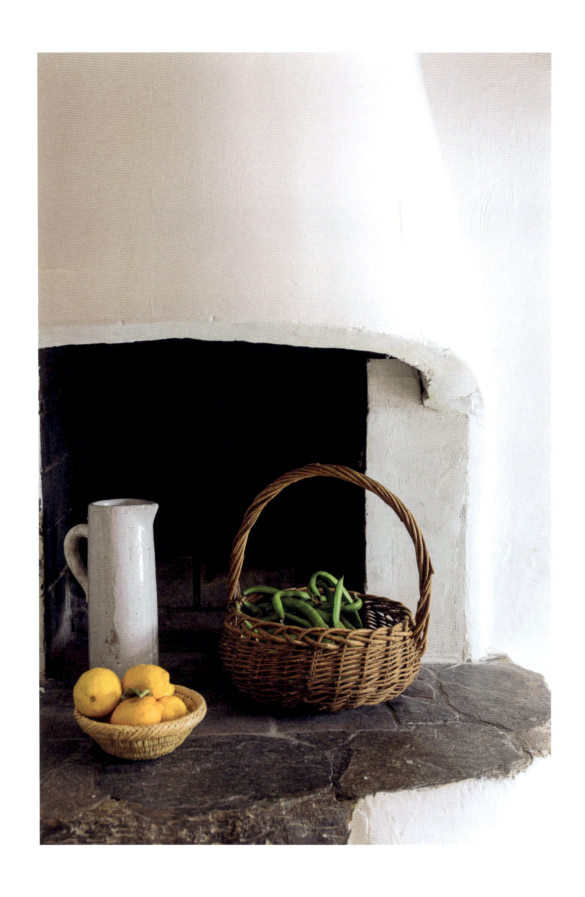

"AT HOME IN BASTIA, THERE'S ALWAYS FRIENDS OR FAMILY SWINGING BY, AND THE CHILDREN LIVEN UP OUR DAILY ROUTINE SO MUCH—IT NEVER STOPS! HERE, IT'S SO DIFFERENT —THIS PEACEFULNESS HELPS ME TO CLEAR MY MIND."

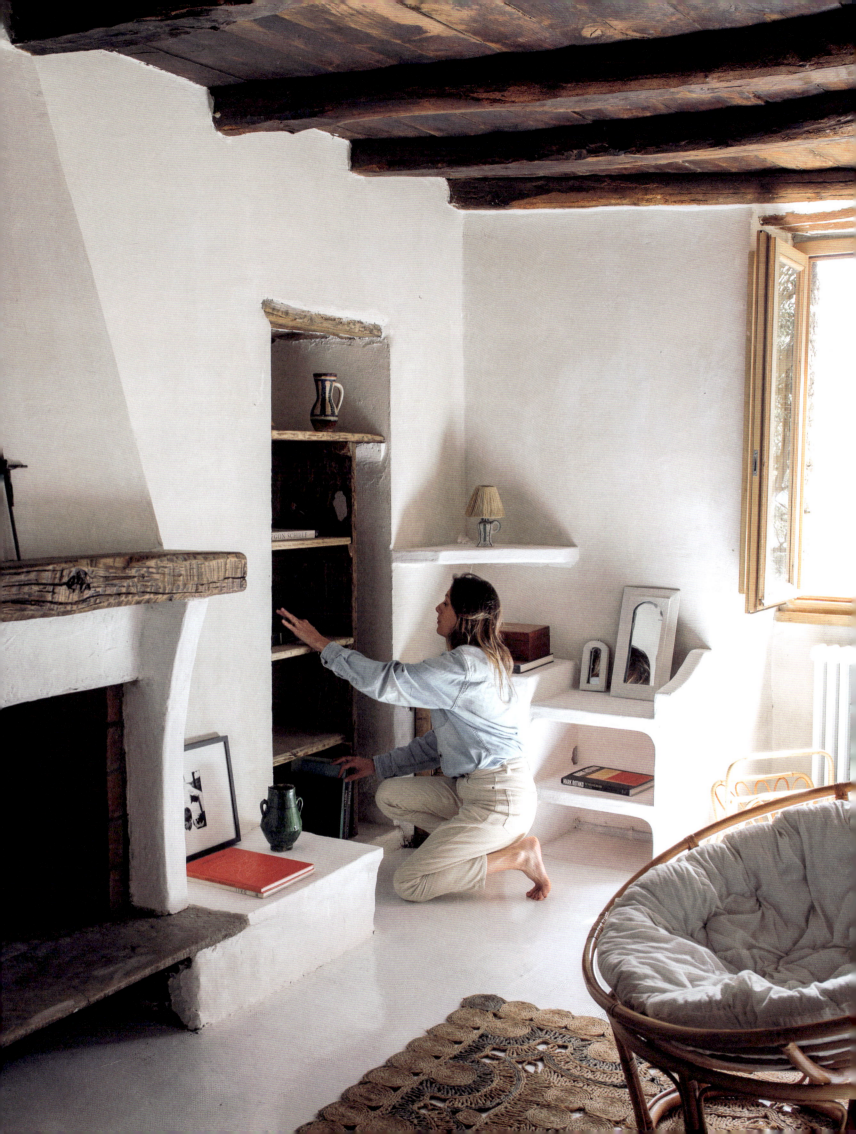

WHERE	WHO	WHAT
ALMERE NETHERLANDS	SANNE, WIM, OLE, HANNES, PIPPA, KAATJE	MODERN BUNGALOW

A modern house fosters free play and creative endeavors

"*It is a newly constructed neighborhood that a lot of families moved to in order to build their dream home, so there's a special dynamic here—we're all participating in creating a common atmosphere,*" says Dutch historian-turned-influencer Sanne Hop of the wood and concrete bungalow that she moved to with her family in 2018. After 20 happy years living in a historic building in Amsterdam, Sanne and her art director husband Wim de Boer decided to take the plunge and move to a greener, more peaceful environment where they could comfortably raise their four young children, Ole (10), Hannes (8), Pippa (6), and Kaatje (3). In Almere—25 minutes east of the capital—they fell in love with a six-house development designed by architect Michael van Leeuwen and centered around a large, shared garden. "*The kids can play outside in the garden or in the street, and the beach is close by so we feel like we're on holiday all the time,*" adds Sanne, whose slow-life ethics and keen eye for the simple beauty of day-to-day life inspire a large community of online followers.

Inside the modern, square house, the vast open-plan ground floor operates as a central hub with a polished concrete floor chosen to stand up to the free play and limitless creative activities that are at the core of the family's daily practices. Anchored along a 10-meter (33-foot) wall, the bamboo kitchen designed by Norwegian duo Ask og Eng is at the heart of the space. This is where the family gathers and spends time experimenting and cooking, before heading outside to the open-air patio. "*The house was left unfinished by the architect so that each family could adapt it to their own needs. There were a lot of decisions to be taken and we made sure to opt for sustainable solutions as much as possible.*" Exuding an easygoing vibe, the unpretentious interior design favors a palette of clay shades while the selection of vintage furniture reinforces an overall softness that balances out the cubic lines of the house's structure. The eye-catching concrete stairway leads to a serene first floor where each child has a bright bedroom of their own and access a big rooftop—yet another ideal playground to fully enjoy when the sun is out.

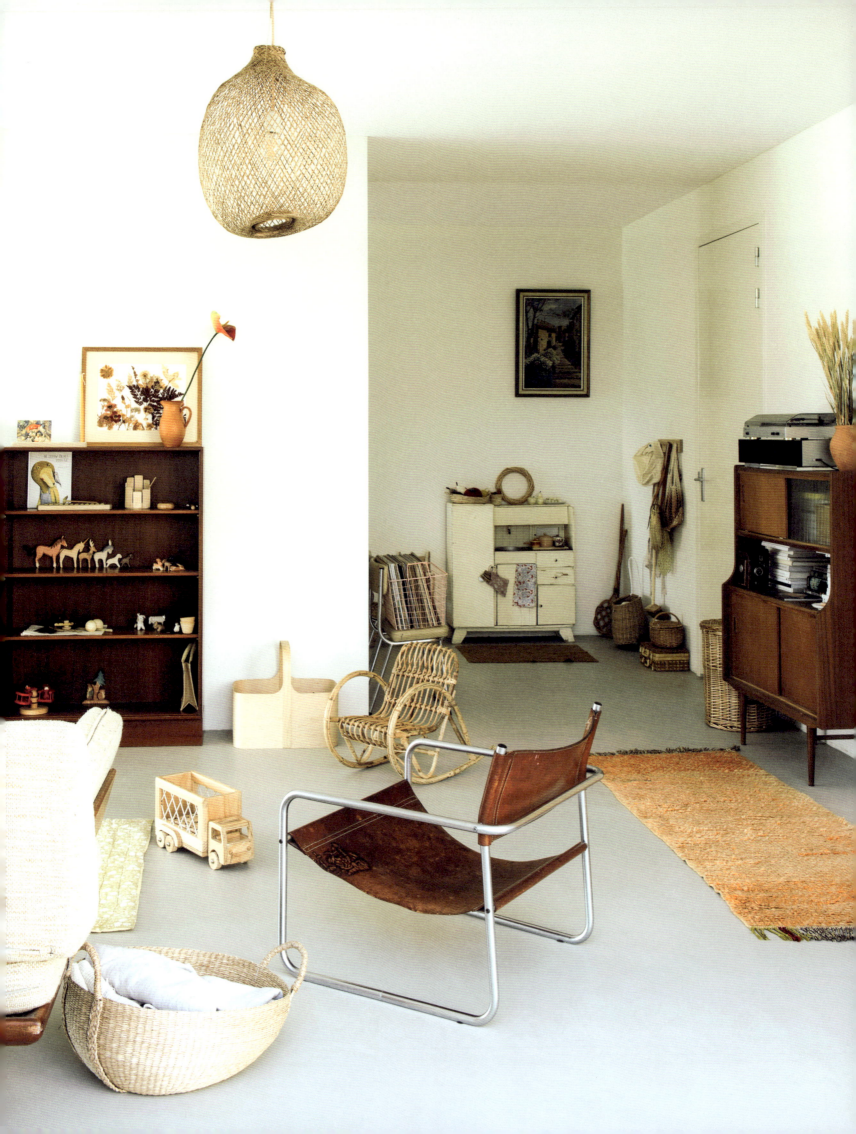

"IT IS A NEWLY CONSTRUCTED NEIGHBORHOOD THAT A LOT
OF FAMILIES MOVED TO IN ORDER TO BUILD THEIR DREAM HOME,
SO THERE'S A SPECIAL DYNAMIC HERE—WE'RE ALL PARTICIPATING
IN CREATING A COMMON ATMOSPHERE."

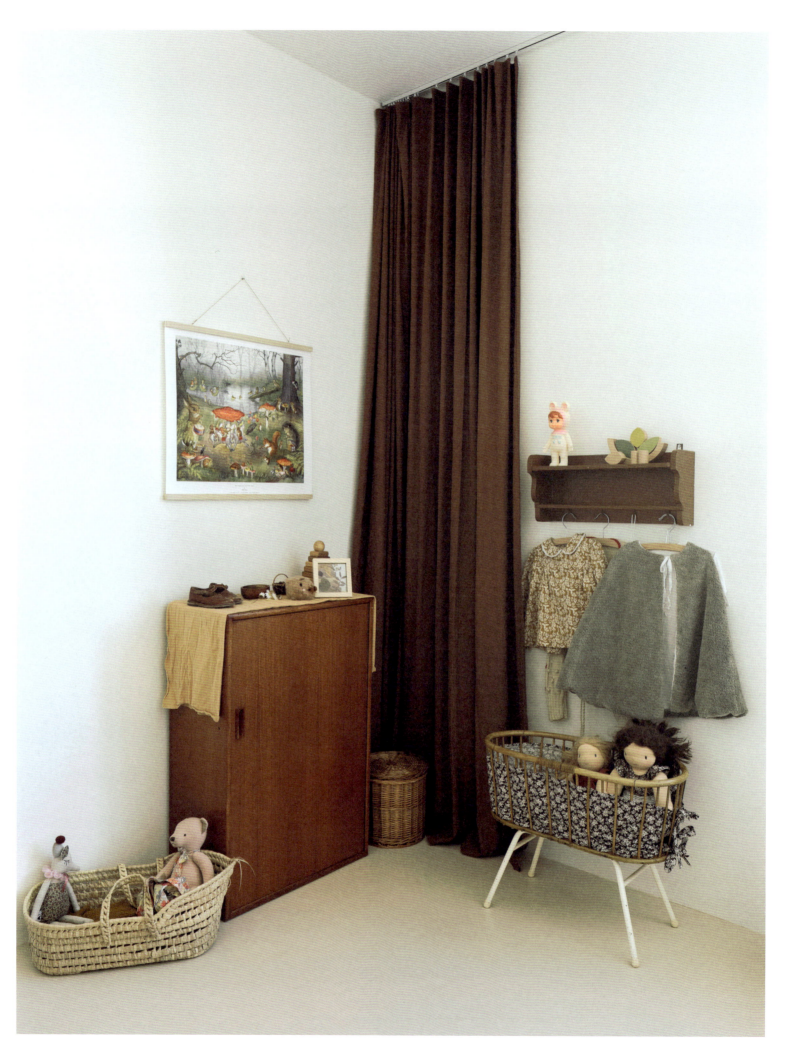

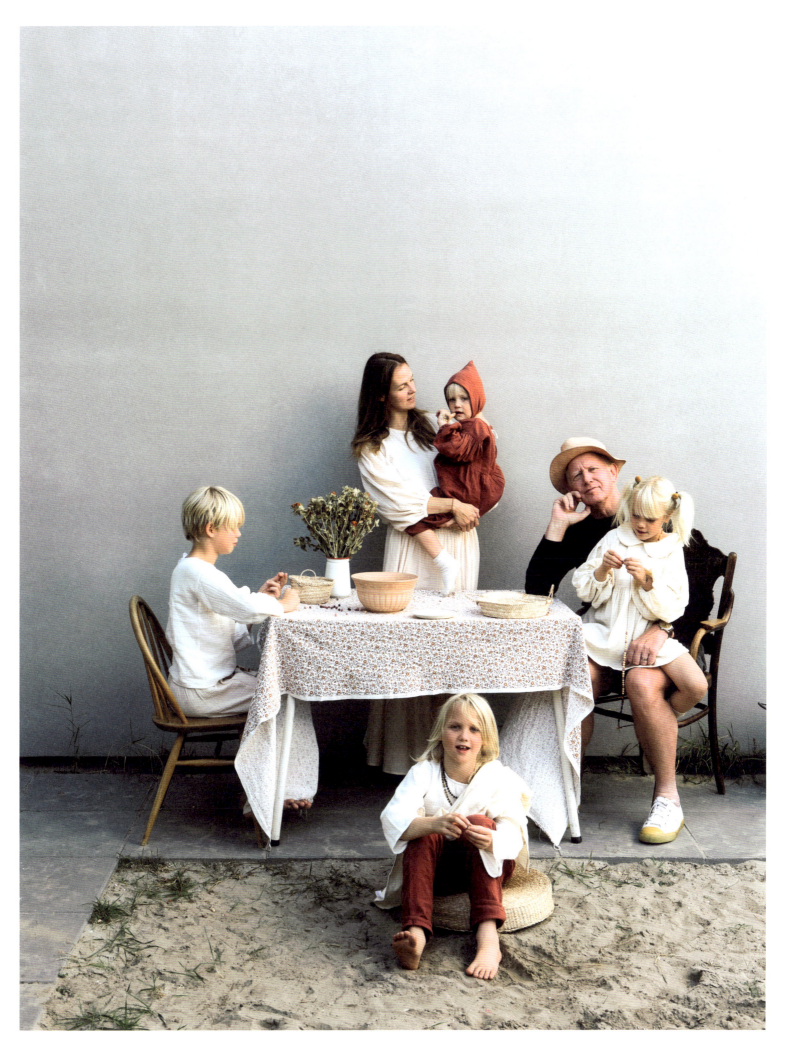

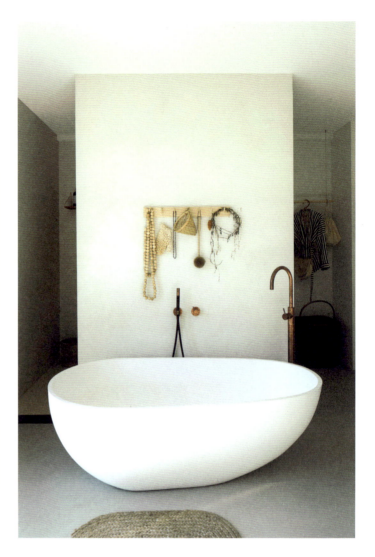

INSIDE THE MODERN, SQUARE HOUSE, THE VAST OPEN-PLAN
GROUND FLOOR OPERATES AS A CENTRAL HUB WITH A POLISHED
CONCRETE FLOOR CHOSEN TO STAND UP TO THE FREE PLAY
AND LIMITLESS CREATIVE ACTIVITIES THAT ARE AT THE CORE
OF THE FAMILY'S DAILY PRACTICES.

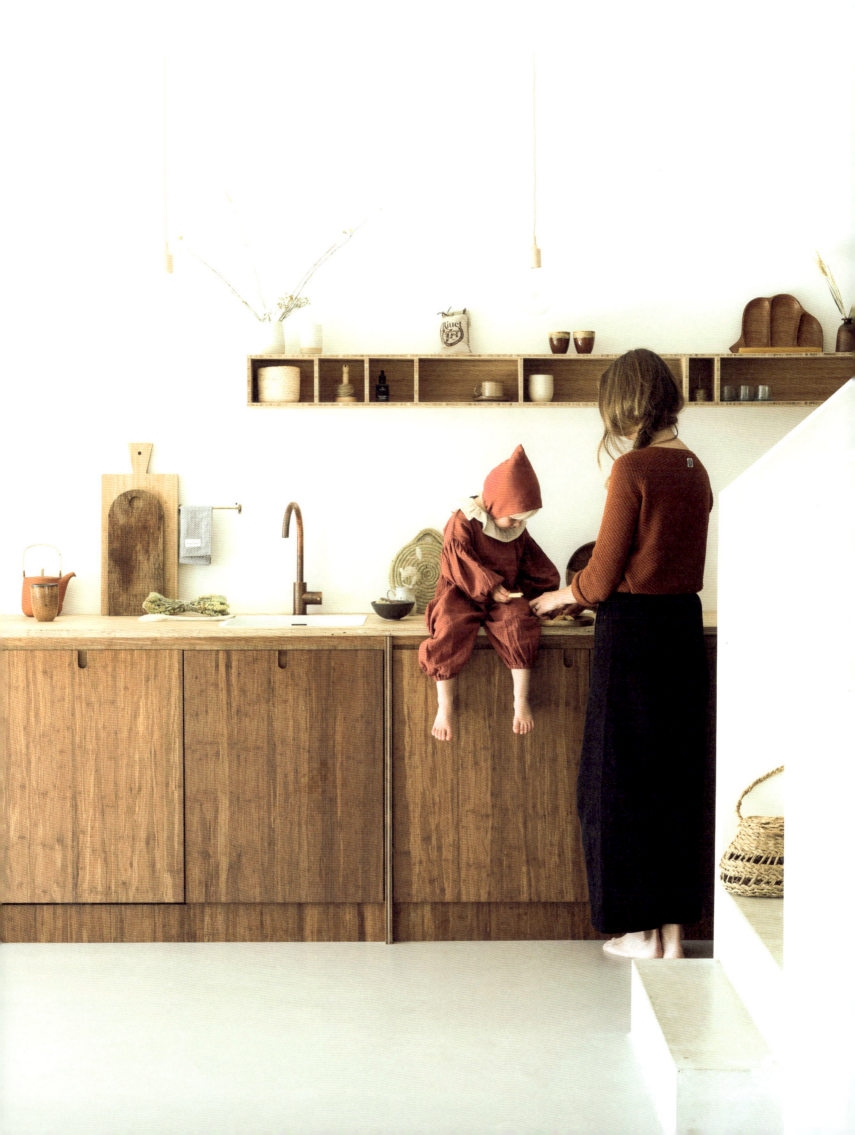

WHERE	WHO	WHAT
BYRON BAY AUSTRALIA	LIA-BELLE, LOTTE, OPHELIA	GLASS BOX HOUSE

A serene cottage works as a laboratory for ideas

Byron Bay, the Australian coastal town known for its sumptuous beaches and praised for its Epicurean "slow down" lifestyle—this is where couple and co-founders of Worn store, Lia-Belle King and Lotte Barnes, have found their little corner of paradise. "*We immediately fell in love with this mid-century glass box with large windows that open onto the surrounding vegetation. It's almost as if there was no real separation between the indoors and the outdoors, which means our daughter can wander in and out and play freely,*" says Lia-Belle. The charming little cottage is tucked away in a leafy residential area just steps from the beach—a perfect cocoon for the couple to relax with two-year-old Ophelia and their dog, Gray, while exploring new ideas for their decoration line in their ideal minimalist interior.

Inspired by Axel Vervoordt's wabi-sabi-inspired "less is more" aesthetic, the two designers created a serene decor where Japanese, Swedish, Indonesian, and Australian influences subtly mix together to best feature a few statement pieces full of memories. "*The original Marcel Breuer 'Wassily' chair has a very special meaning to us. I bought it just before I met Lotte and it is the only piece of furniture that we have kept ever since, so it became sort of a symbol of our relationship,*" adds Lia-Belle. Other curated pieces include the Otis Carey artwork, a ceramic vessel from Pān Pottery, a hand-woven rug by Pampa, and Worn's best-selling "The Cane Lounger" combine effortlessly, adding warm textures and joyous vibes to the bright, sunny space.

"*There's a monastic feel to our place, as calmness is a key element to us.*" But the uncluttered interior is not a rigid sanctuary; it evolves according to Lia-Belle and Lotte's experimentations with shape combinations or color palette testing. "*Sometimes an entire Worn collection can be the result of setting a new vase on our kitchen table and seeing the way in which it modifies or contrasts with the space. Other times, we are simply drawn to the sensations from the movement of the natural light and we reorganize the whole house in lighter colors. And sometimes, we just get bolder and try darker, antique Indonesian furniture.*" What a joyful, organic laboratory of ideas.

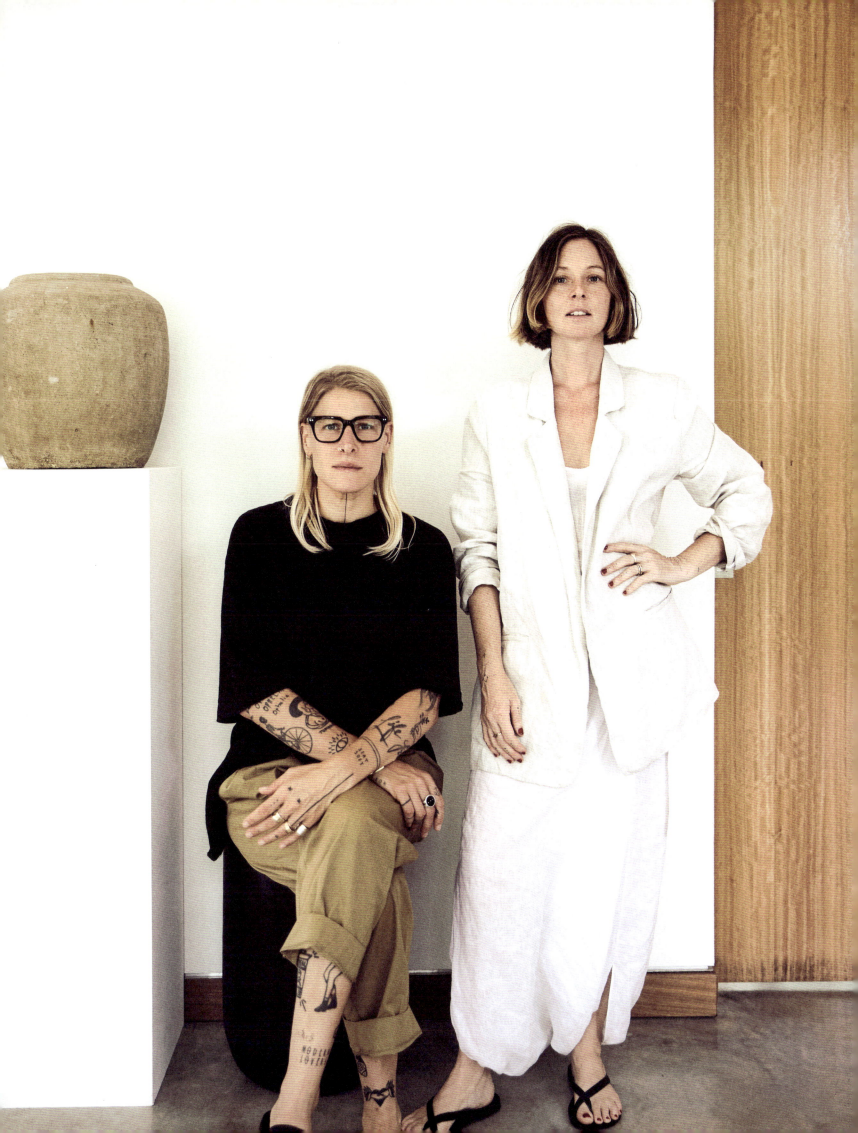

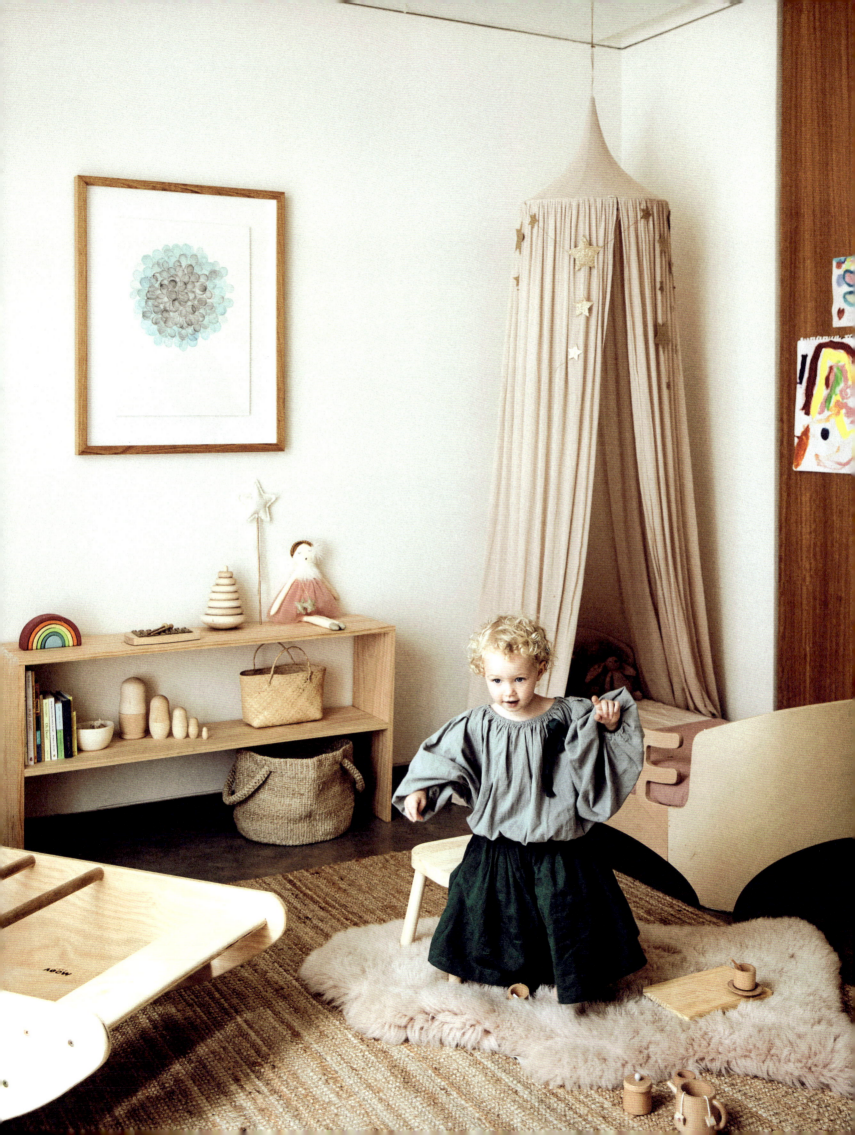

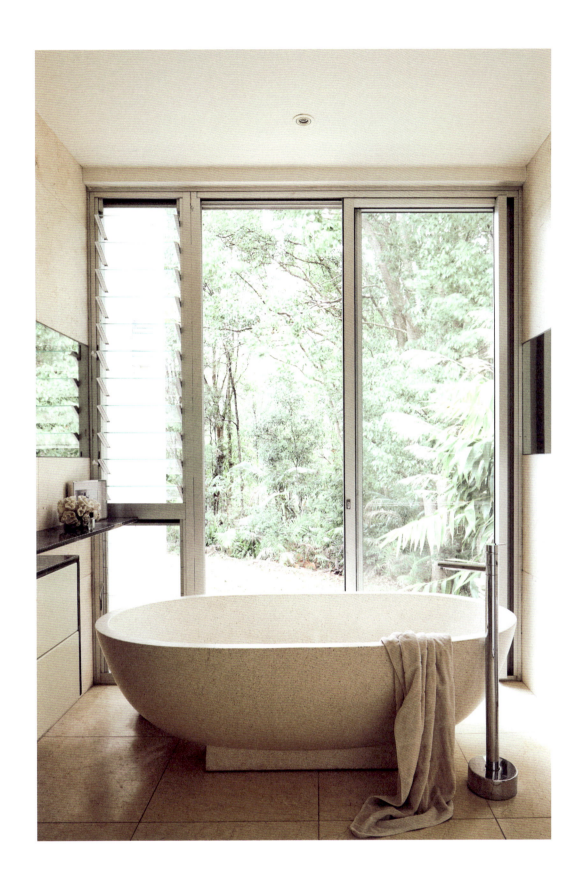

"WE IMMEDIATELY FELL IN LOVE WITH THIS MID-CENTURY GLASS BOX WITH LARGE WINDOWS THAT OPEN ONTO THE SURROUNDING VEGETATION. IT'S ALMOST AS IF THERE WAS NO REAL SEPARATION BETWEEN THE INDOORS AND THE OUTDOORS, WHICH MEANS OUR DAUGHTER CAN WANDER IN AND OUT AND PLAY FREELY."

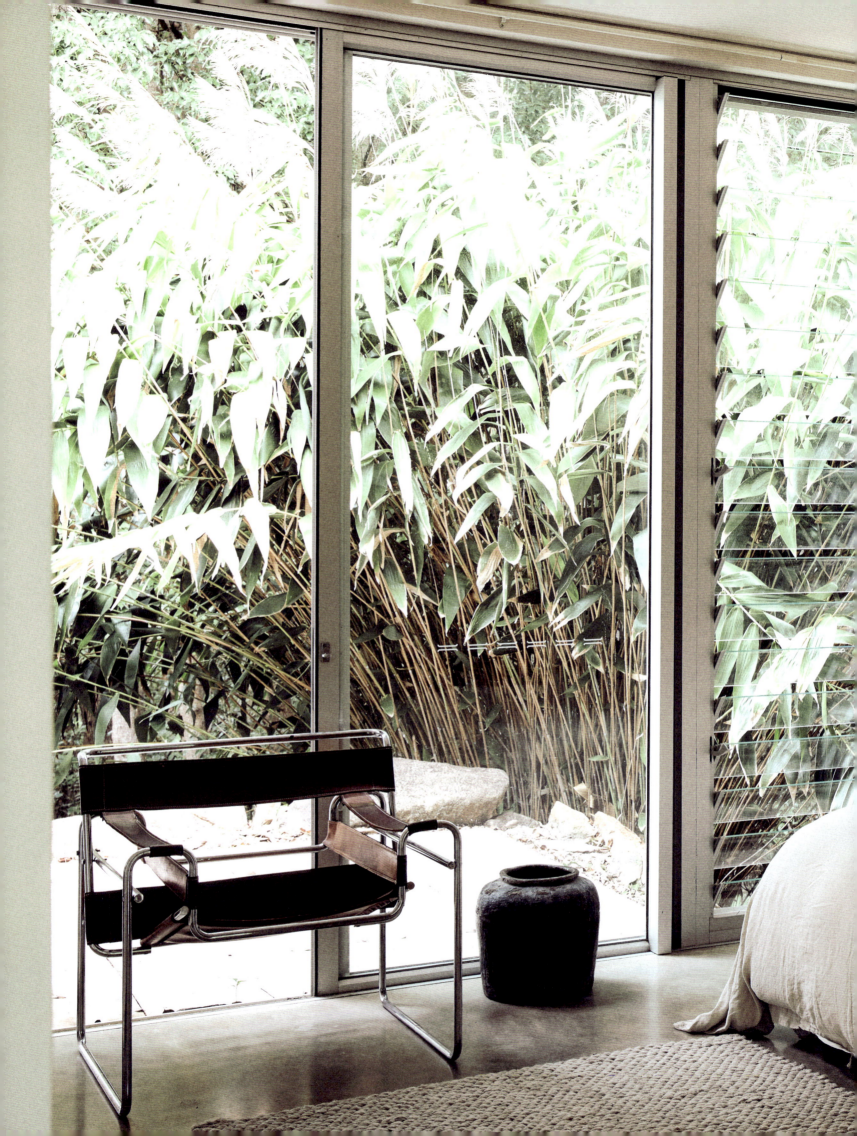

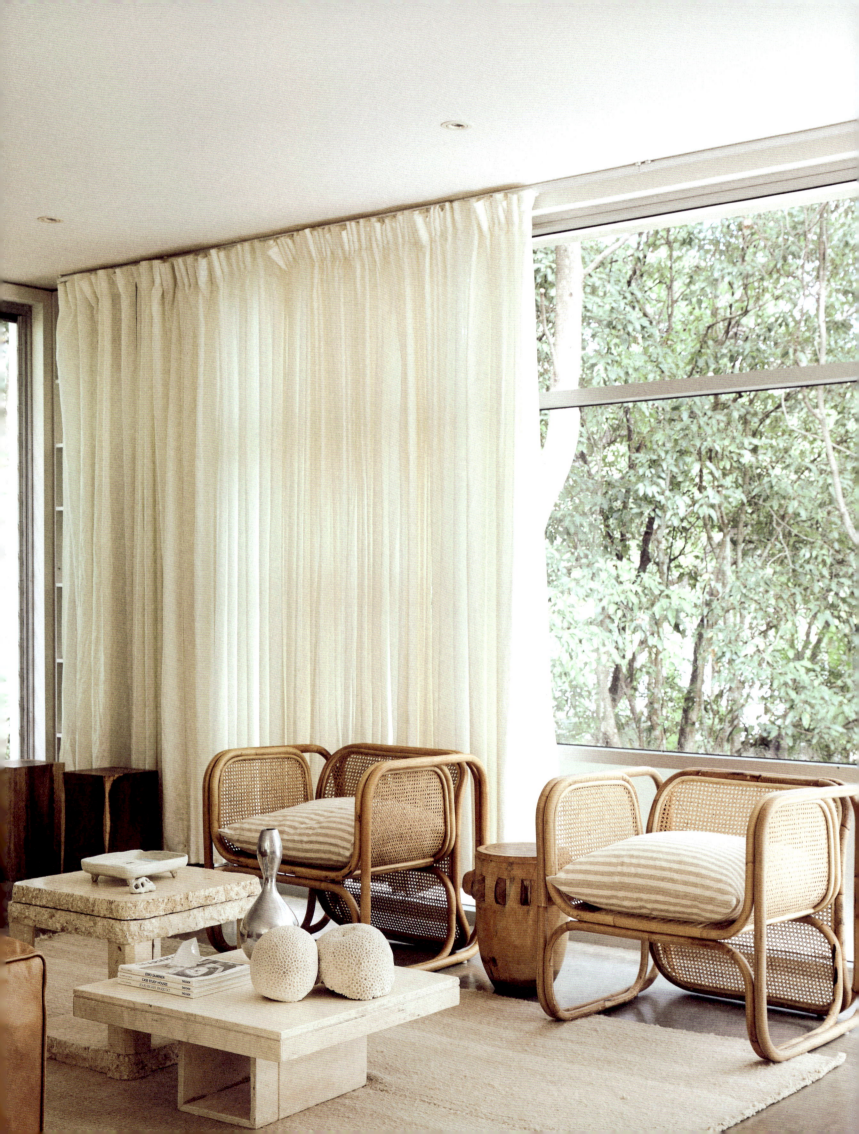

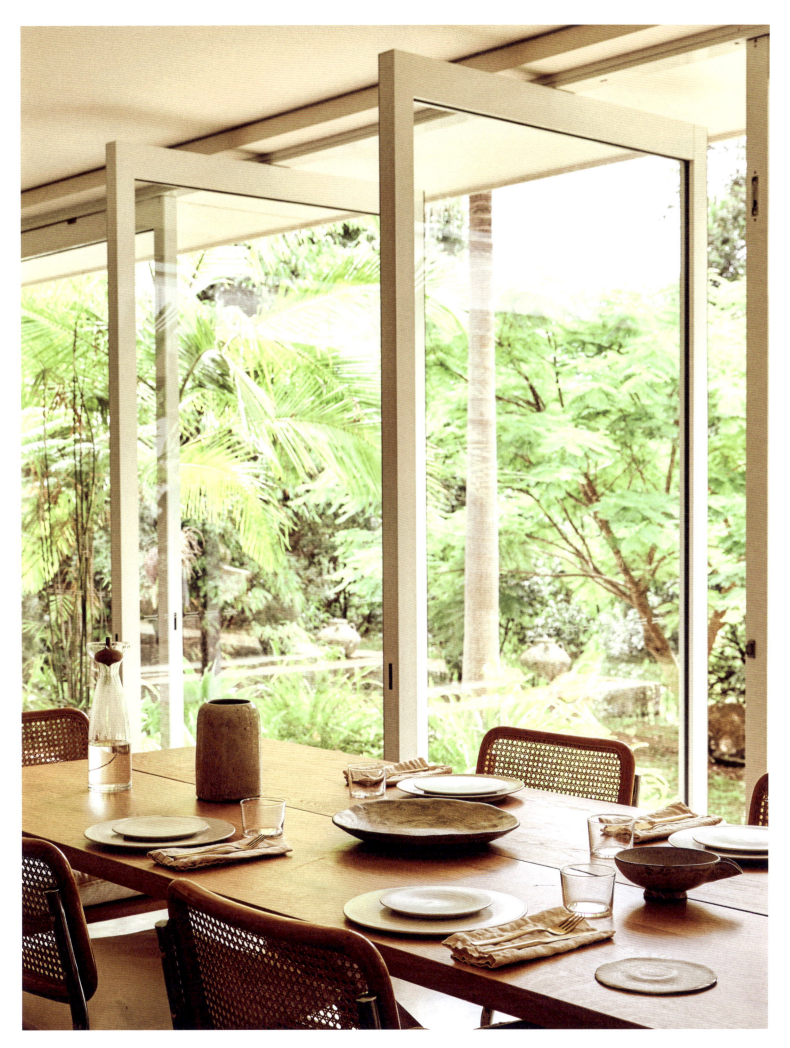

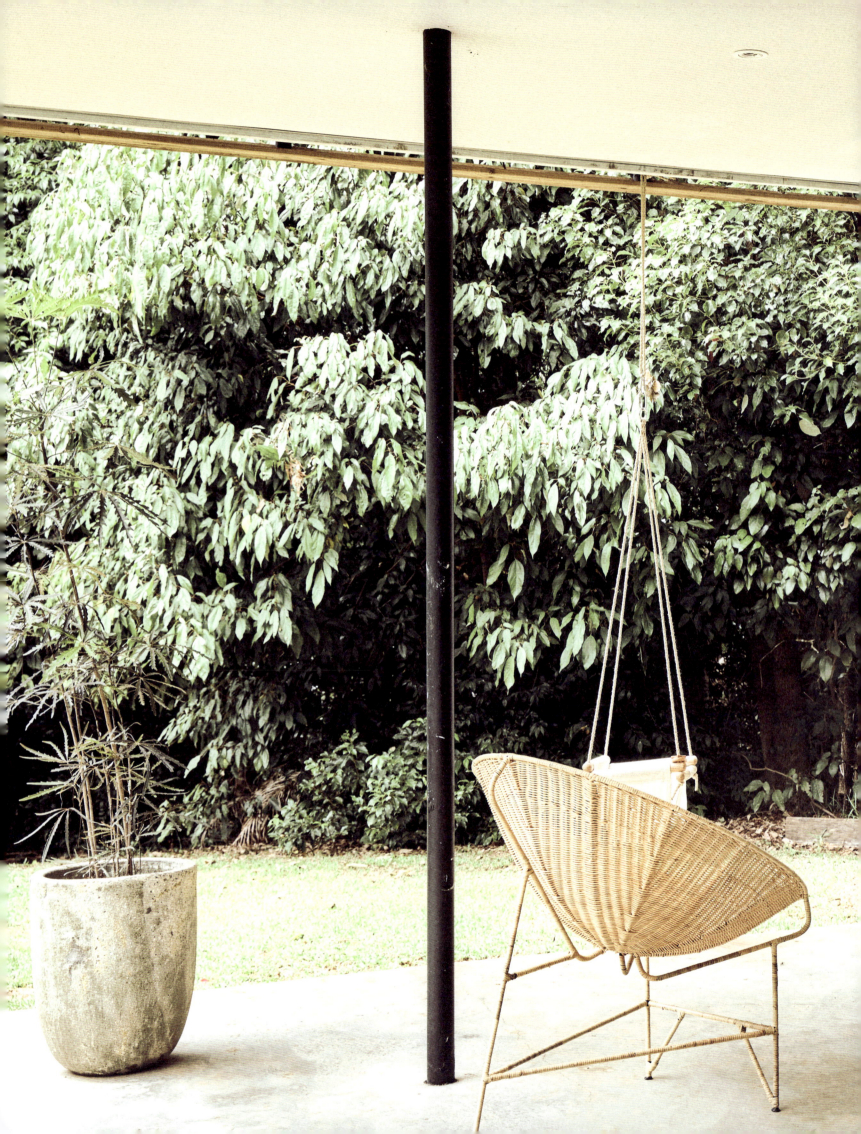

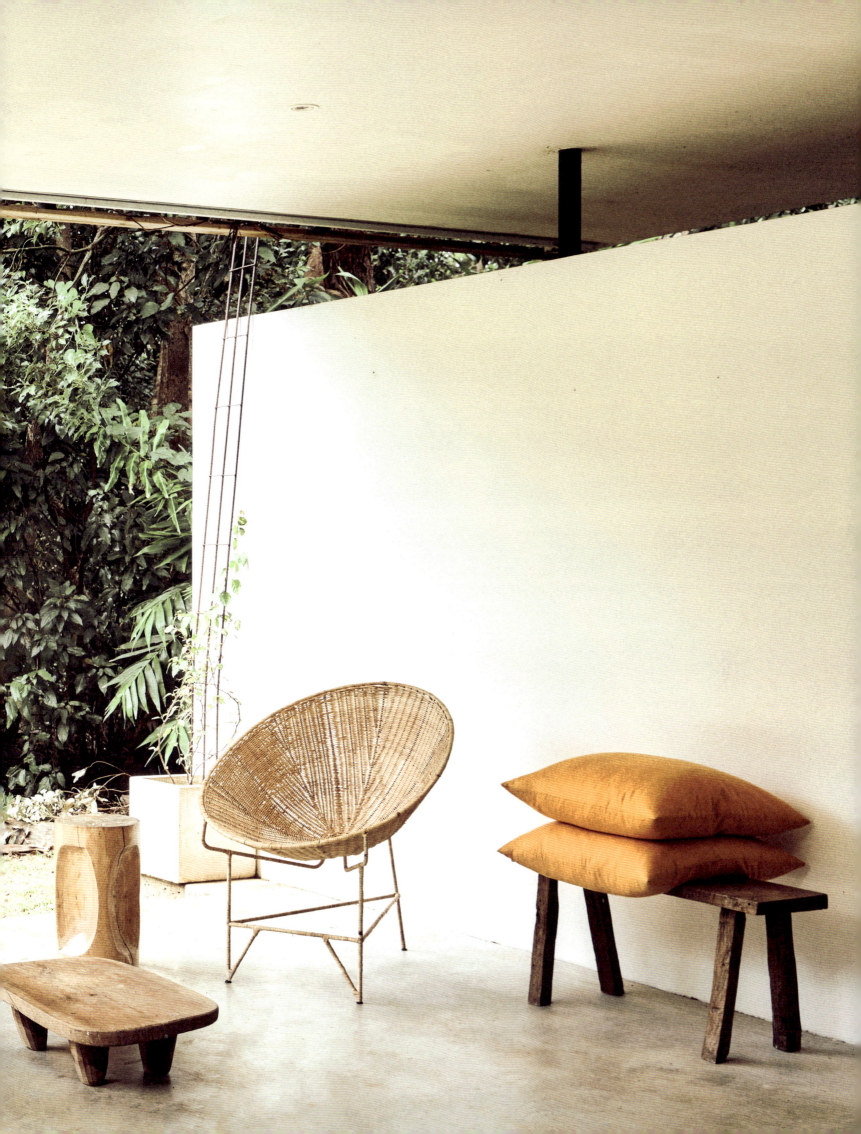

PHOTOGRAPHERS

Page 2. Lynden Foss/Living Inside
Page 4. Karel Balas
Pages 8–17. Anna Cor
Pages 18–27. Vincent Leroux
Pages 28–37. Eefje De Coninck & Senne Van Der Ven
Pages 38–49. Toby Lewis Thomas/Taran Wilkhu
Pages 50–59. Oliver Fritze
Pages 60–69. Fanny Rådvik
Pages 70–79. Akiko Baba
Pages 80–87. Karel Balas
Pages 88–97. Aurélie Lecuyer
Pages 98–105. François Roelants
Pages 106–115. Helena Nord
Pages 116–125. Marielle Leenders
Pages 126–133. Carola Ripamonti
Pages 134–141. Romain Ricard
Pages 142–151. Karel Balas
Pages 152–161. Helenio Barbetta/Living Inside
Pages 162–171. Oliver Fritze
Pages 172–179. Clément Pascal
Pages 180–187. Clément Pascal
Pages 188–195. Aurélie Lecuyer
Pages 196–203. Karel Balas
Pages 204–213. Karel Balas
Pages 214–223. Gianni Basso/Vega Mg
Pages 224–231. Aurélie Lecuyer
Pages 232–241. Eefje De Coninck & Senne Van Der Ven
Pages 242–251. Lynden Foss/Living Inside
Page 256. Clément Pascal

SPECIAL THANKS

Laurine Abrieu
Sarah Berger
Jeanne Brongniart
Julie Boucherat
Yukari Capelle
Chiara Dal Canto
Clara Dayet
Sarah Ellison
Murielle Françoise
Mélanie Hoepffner
Hélène Lahalle
Elsa Le Saux
Théo Leteissier
Karine Monié

INSPIRING FAMILY HOMES
Family-friendly interiors & design

This book was conceived by MilK Magazine.
Edited by MilK Magazine and gestalten.

CONTRIBUTING EDITORS
Isis-Colombe Combréas for MilK Magazine
Robert Klanten and Andrea Servert for gestalten

PREFACE
Isis-Colombe Combréas for MilK Magazine

INTRO
Lucy Baluteig

TEXT
Lucy Baluteig

TRANSLATION
from French to English, p.5
Kevin St. John

EDITORIAL MANAGEMENT
Isis-Colombe Combréas

GRAPHIC DESIGN
Karel Balas, Adèle Mabire,
and Amélie Raymond

PROJECT MANAGER
Abigail Garland for MilK Magazine
Anna Diekmann for gestalten

COVER PHOTOGRAPHY
© Anna Cor

PRINTED BY
NINO Druck, Neustadt an der Weinstraße
Made in GERMANY

PUBLISHED BY
gestalten, 2021
ISBN 978-3-96704-000-5

© Die Gestalten Verlag GmbH & Co. KG, Berlin 2021

All rights reserved. No part of this publication may be
reproduced or transmitted in any form or by any means,
electronic or mechanical, including photocopy or any
storage and retrieval system, without permission in writing
from the publisher.

Respect copyrights, encourage creativity!

For more information, and to order books, please visit
www.gestalten.com

Bibliographic information published by the Deutsche
Nationalbibliothek. The Deutsche Nationalbibliothek lists this
publication in the Deutsche Nationalbibliografie;
detailed bibliographic data is available online at www.dnb.de

None of the content in this book was published in exchange for
payment by commercial parties or designers; the inclusion of all
work is based solely on its artistic merit.

This book was printed on paper certified according to the
standards of the FSC®.

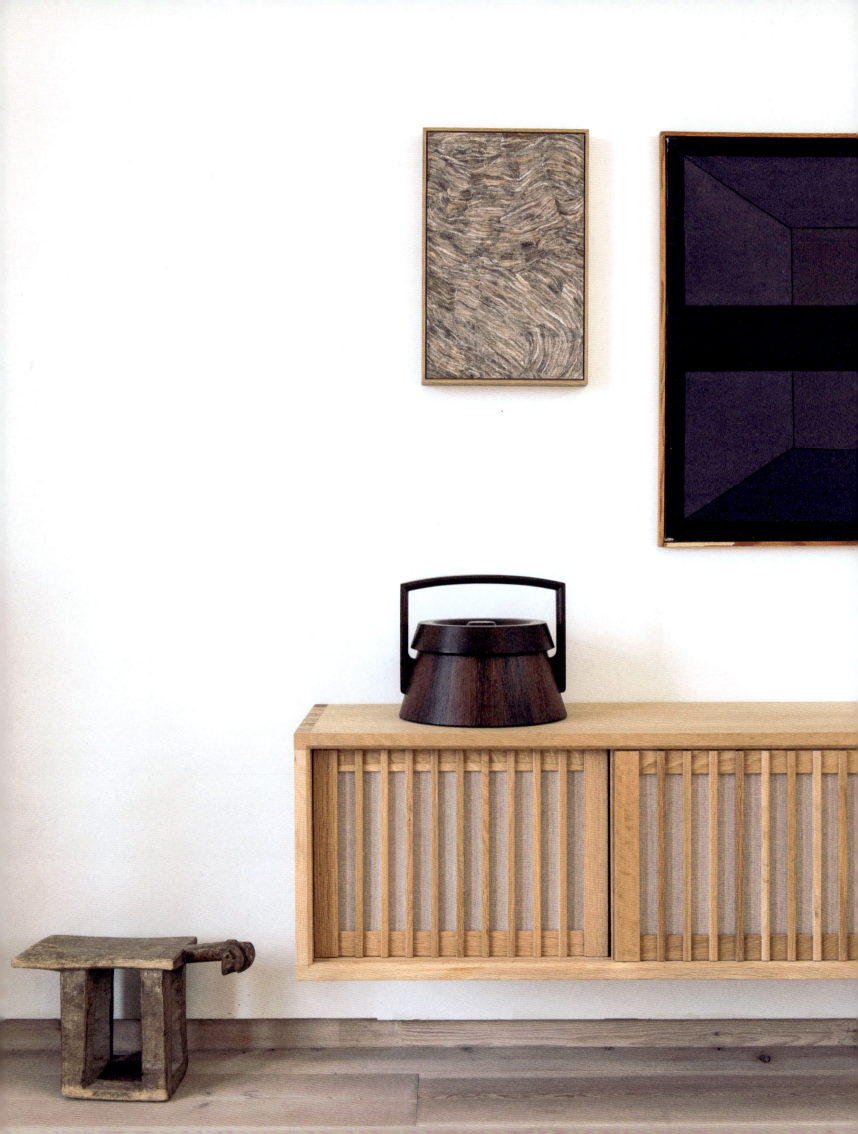